THE PLACE
OF ART
IN THE WORLD OF
ARCHITECTURE

THE PLACE OF ART
IN THE WORLD OF
ARCHITECTURE

DONALD W. THALACKER
Director, Art-in-Architecture Program, GSA

Preface by
PROFESSOR SAM HUNTER
Princeton University

1980
Chelsea House Publishers
in association with R.R. BOWKER COMPANY
New York, London

To Françoise and Christan

Editor: Joy Johannessen
Designer: Susan Lusk

LC: 79-3322
ISBN: 0-87754-098-5

Chelsea House Publishers
Harold Steinberg, Chairman & Publisher
Andrew E. Norman, President
Susan Lusk, Vice President
A Division of Chelsea House Educational Communications, Inc.
70 West 40th Street, New York 10018

Printed and bound in Canada by
T. H. Best Printing Company Limited, Don Mills, Ontario

CONTENTS

FOREWORD

The Art-in-Architecture Program of the General Services Administration (GSA) has made great contributions to the cause of monumental public art. In the early 1970s, by commissioning the magnificent Alexander Calder *Flamingo* for Mies van der Rohe's Chicago Federal Center, the agency inaugurated its commitment to contemporary public art with the highest possible quality. Subsequently, with great foresight, GSA has commissioned Mark di Suvero, Jack Beal, Robert Maki, Al Held, Claes Oldenburg, George Sugarman, and many others to create works for federal complexes all across the nation. Future GSA commissions will bring impressive works by such artists as Robert Hudson, Sol LeWitt, Jennifer Bartlett, Richard Fleischner, and John Chamberlain.

In a brief time, GSA has had a major impact on the development of public art in the United States. All the recent works of monumental sculpture and painting commissioned by GSA have been chosen for specific sites, making each work more responsive and responsible to its immediate environment and to its physical and symbolic context. Such considerations suggest that a new idea of public art is emerging—one that draws on the creative energy generated by American artists during the last fifteen years.

Under GSA auspices, an innovative and rapid proliferation of quality public art has taken place in cities throughout the United States. The federal government has always tapped our abundant resources of intelligence and talent in the fields of business, medicine, and science. Now, with increasing confidence, it is doing so in the field of art. It is a challenge for agencies such as GSA to continue their support for the visual arts and to maintain their commitment to the highest quality in public art.

Richard Koshalek, Director
The Hudson River Museum
May 1979

Any citizen with a curious eye and some degree of cultural mobility must have noticed that a sweeping transformation has taken place in the American landscape of the seventies. At airports and railroad stations, in urban office complexes and suburban industrial parks, and most of all in federal courthouses and office buildings, it has become commonplace to find large-scale sculptures, paintings, and examples of the decorative arts. In particular, monumental sculpture seems to be erupting everywhere we look. Challenging in form, material, and disposition, these new works are the result of a radical escalation in public and private patronage of the visual arts.

In the lobby of a federal courthouse in Philadelphia, a forest of intricately surfaced columns, gleaming white and mysterious in their architectural purity, punctuates an otherwise inert space. Another new courthouse in Dayton, Ohio, sports a new porch jamb ten feet high and sixty-eight feet wide, of volatile neon light on reflective enamel, relieving the austerity of the anonymous glass and concrete tower. An improbable hundred-foot-tall cylinder of latticed structural steel, with the unmistakable conformation of a baseball bat, rises provocatively before a new Social Security building in Chicago. In Buffalo, yet another federal plaza provides the stage for a sculpture tableau called *The Restaurant*. It consists of a glass and brick facade with a life-size figure seated behind it, and two figures slouching by the window, all frozen in bronze—as authentic in their self-absorbed reality as any casual street scene the building's neighborhood might offer. All these works, in a catholic range of styles, were commissioned by the federal government in recent years, from the hands of Louise Nevelson, Claes Oldenburg, Stephen Antonakos, and George Segal, respectively. The federal patronage that generated them represents the dominant force in the great public art flowering of the seventies.

This rapid growth of commissioned art has come to rival the ambitious Federal Art Program of the Work Projects Administration (WPA) in modern times, while inarguably surpassing it in artistic quality. Needless to say, the mood of desperation during the Depression years, and the response of government to the plight of the literally starving American artist, scarcely bear comparison with any feature of our own affluent age and its pervading (at least until very recently) social optimism. There is also more confidence today in the independent powers of American art, and in its still untapped aesthetic potential, for American creativity has led the postwar world.

The primary patron of the highly visible public art explosion is the General Services Administration (GSA). Despite well-publicized scandals at the top and a shake-up in the executive leadership of the GSA, the Art-in-Architecture Program remains intact and uncompromised. As the U.S. governmental agency charged with responsibility for the design, construction, renovation, and maintenance of all federal buildings, the GSA is the nation's most influential landlord —and potentially its most powerful art patron. In 1972, Chairman Nancy Hanks of the National Endowment for the Arts (NEA) urged Arthur Sampson, then GSA administrator, to reactivate an underutilized art program that had been established by President John Kennedy a decade earlier, and that allotted one half of one percent of the construction costs of new buildings for fine arts. Shortly thereafter, architects and administrators for federal buildings of all kinds began to commission first-rate sculpture, paintings, tapestries, and craft objects in a reckless abundance unmatched since the social compulsions of the Roosevelt era gave birth to the first uneasy alliance of art and public funding in our century.

Donald Thalacker, the energetic and resourceful director of GSA's Art-in-Architecture Program since 1972, here recounts the story of this brave adventure of public patronage in all its fascinating and controversial detail. A youthful architect and a serious student of modern art, Thalacker has fashioned a new job description for his position, building upon the rather sketchy suggestions inherited from the distant Kennedy administration. He is the new Maecenas of the visual arts, and the scourge of the unrepentant Philistine opposition that frets noisily in the press over the diversion of tax dollars for art purchases. His courage in endorsing a wide variety of expressions, including the more experimental forms of vanguard art, has created new opportunities for American artists and won him the respect of almost every shade of critical opinion in the chronically disaffected contemporary art world.

Historically, the tradition of official American patronage dates back more than a century to 1855, when frescoes were commissioned for the Capitol dome in Washington and an Italian refugee named Constantino Brumidi worked for twenty years at ten dollars a day to cover five thousand square feet of the ceiling space. Federal art patronage lapsed in our own century until the calamitous Depression period, but even after the signal success of the WPA programs, the U.S. government turned its back on the arts once again. It was only in the context of the postwar "culture boom" and of the sophisticated and stylish Kennedy White House that cultivating the arts on a national level gained a new foothold against America's dominant puritan ethic of self-denial.

With the formation of the National Endowment for the Arts, which flourished under Nancy Hanks's imaginative leadership, a concerted effort was made to raise the general level of artistic consciousness through a far-reaching, multipurpose art program. Miss Hanks's instructive apprenticeship as administrator of the Rockefeller Brothers Panel Report on the Per-

forming Arts had apparently persuaded her of the truth of the panel's concluding remarks, namely that the arts have now become "one of the essential elements of a good society, an essential of a full life for the many, not a luxury for the few." Almost overnight, these bold affirmations of the new cultural dispensation were transformed from a set of high-sounding recommendations designed to reassure academic idealists into effective and trend-setting public policy.

The National Endowment, with its vastly expanded public moneys, today primarily plays the role of a catalyst, both for the private sector and for other federal agencies, particularly through the ingenious device of the matching grant. For the GSA program, the NEA still provides a panel of museum professionals, artists, critics, and historians that nominates artists and on occasion advises architects on the artistic potential or needs of federal buildings. Though current expenditures for art are still voluntary, depending on the architect's tastes and wishes rather than on legal sanction, the performance record has been quite remarkable.

Since Don Thalacker became director of the Art-in-Architecture Program in 1972, over 130 commissions have been awarded, ranging from modest outlays for the work of community artists to an upper limit, thus far, of $250,000 for *Flamingo,* Alexander Calder's dramatic stabile for the Chicago Federal Center. (Typically, the work is a steal at the price, since it would easily fetch $1,000,000 on the open market.) Over a seven-year period, $5,000,000 has been dispensed to American artists for the embellishment of our public spaces, and in the past fiscal year alone nearly $2,000,000 was spent. Far from being open to charges of kickbacks or financial hanky-panky, GSA has gained the unenviable but respected reputation of driving a hard bargain, shamelessly appealing to artists' and dealers' patriotic spirit of *pro bono publico* to minimize commission fees. Reviewing the Oldenburg *Batcolumn* recently, critic Barbara Rose wrote that the fee hardly covered the costs of materials and manufacture, adding, "To my knowledge, no sculptor has made a dime of profit on a GSA commission."

Not surprisingly, a vociferous minority of taxpayers remain convinced that the public is being gulled and duped. A significant portion of Thalacker's book is devoted to the many diverting anecdotes that arise from the predictable cycle of initial public opposition followed by gradual conversion to GSA projects at the community level. While the stories make entertaining reading, some are painful and even sinister. For example, a Baltimore courthouse provided the occasion for a particularly trying display of irrational hostility to abstract art. The chief federal judge developed an *idée fixe* that George Sugarman's meandering and handsome abstract sculpture might make a convenient hide-

away for potential subversives, muggers, and bomb-throwing terrorists determined to bring the judicial system down. He let it be known that he would not permit the installation of the offending sculpture on his courthouse plaza. At that point, the art world rallied to Sugarman's support in public hearings. Even more effectively, a local art critic dispelled juridical misgivings by exposing them for what they were—bizarre and unfounded fantasies; her persistent efforts in articles and editorials finally shamed and silenced the opposition.

In St. Paul, Charles Ginnever's abstract sculpture elicited press commentaries comparing it to a pile of junk, or, more imaginatively, to "a potential machine-gun nest," an "undercarriage of a UFO-type flying saucer," and a "modern set of stocks [for] delinquent taxpayers." Senator Proxmire didn't help matters when he chimed in with the "Golden Fleece of the Month Award," bestowed upon GSA for wasting the taxpayers' money on the Ginnever sculpture. Local museum officials and cultural leaders finally smoothed the troubled waters, and the sculpture was accepted by the community. But the artist later commented ruefully:

> As usual there were a few citizens who expressed dismay at the U.S. government spending their tax money on art.... I've always found it hard to understand a society that thinks it's okay to spend so much on fear and immoral to spend anything at all on aspirations.

Another exemplary instance of overcoming a campaign of vituperation against unfamiliar public art took place recently in Seattle, where the GSA commissioned from Isamu Noguchi a work titled *Landscape of Time,* a gardenlike disposition of found and carved Japanese boulders, elegant and mysterious. Congressman Ted M. Risenhoover of Oklahoma felt impelled to comment for the scandal-mongering *National Enquirer:*

> With a pet rock craze sweeping the country, many Americans find it funny that anyone would actually pay $4 or so for a rock. They'd laugh even harder if they knew someone has paid $100,000 for five ordinary rocks.... You would think the nincompoops at GSA would have written a contract with Noguchi which would have required him to produce a real work of art—not a rip-off of the American taxpayer.

With the *National Enquirer* stirring the pot of prejudice, Noguchi wrote a thoughtful letter carefully explaining the immense time and effort that went into the process of selecting his natural boulders and painstakingly carving them into artistic existence. He added, "I must say it is not pleasant when the artist is criticized for what in his search he thinks leads to the best—a

let us hope that Europeans will come to us to see the results of the GSA program. — Louise Nevelson

reconciliation with nature and not pretentious monuments."

It took the articulate response of the community and the initiative of Vice President Nelson Rockefeller (himself a sensitive and experienced collector), who lauded Noguchi's achievement at the dedication ceremonies, to preserve a threatened GSA commitment. As is often the case, supportive statements were more eloquent and memorable than impulsive and reckless attacks on the sculpture. Writing in *Northwest Arts*, local actress Marjorie Nelson made her own peace with Noguchi's creation, as each citizen ultimately must:

> *The stones—five—emerge miraculously placed through and beyond the busyness and indifference of the metropolis, creating an urban oasis—a well-spring of quiet serenity and great power. . . .*
>
> *They always surprise and delight me with their quality of stillness as they elusively move and change with the day and the season. I find them hauntingly beautiful, and I feel that I have never been so affected by another work of modern sculpture.*

The American capacity for demagoguery, and our deep mistrust of educated values, remain appalling facts of public life. In their tense confrontations with irate citizens, GSA spokesmen must marshal support with tact and dedication to the values they pledge to uphold. Thus far, all these trying tales have had happy endings—which is all the more astonishing since GSA administrators might be expected to bend to public or congressional criticism in view of the fact that no law mandating their program yet exists.

The emotional experience of public sculpture obviously represents something more than proof of the dedication of public servants, another opportunity for the artist, or even the challenge of educating our sensibilities to new art forms. In truth it serves an age-old need to rally the community around visible symbols and environmental amenities that soothe and heal social divisions even while affording aesthetic delight. A public context for art establishes a common ground of values and experience, liberating art from the cloistered museum and placing it in the public realm of shared purposes. The fact that GSA-commissioned works have been so heatedly debated, eliciting strong reactions from politicians, bureaucrats, museum officials, and, above all, the ordinary citizens whose taxes pay for them, has for the first time since the Depression years opened up a genuine dialogue between the artist and his public. One hears a babel of voices expressing pride, bafflement, irritation. Yet one senses that public art is gathering new momentum daily and receiving such significant acceptance that neither party politics nor economic recession nor our serious energy and environmental problems can reverse the trend. Public

exposure of large-scale art in prominent urban spaces has, in fact, created a new framework for the discussion of the issues of modern art in relation to community values.

The traditional humanist cant about public art does not apply today, for contemporary monuments can no longer plausibly celebrate national heroes, patriotic or personal virtue, or great historic events. Both the mythologies and the sustaining artistic conventions for such themes have vanished. Nonetheless, contemporary public art of quality does reaffirm *communitas*, even if it acquires its social meanings primarily through the act of commission and display in public spaces. The deeper aesthetic levels of contemporary sculpture may communicate to the man in the street imperfectly, given the largely abstract nature of art today and the public's limited awareness of modern art forms. Yet citizens do want art in their lives. In a recent survey, the public was asked whether they understood the "message" of a variety of recent public sculptures, mostly abstract; whether the message was valid; and finally, whether they felt the works improved the "quality of life." The poll results show the contradictions we face. Most felt that the message of the sculptures, in either symbolic or humanist terms, was negligible, and certainly beyond their comprehension. Yet they overwhelmingly voted not to replace or change the works, and a clear majority also agreed that the works improved the quality of life.*

It has been our good fortune to be riding a sustained and significant wave of artistic creation in America since World War II, and there is still a large reservoir of untapped talent among a rising younger generation of artists. The GSA has been an effective spur and patron in bringing to public notice works by artists of both established and newer reputation. Clearly, this bold patronage has touched communal needs and feelings even as it has generated a certain amount of bewilderment and controversy.

The proliferation of public sculpture has also delivered art from the historical museum environment and now raises serious and beguiling questions about the meaning of art in its relationship to community values. Every civilization, great or small, sacred or secular, primitive, classical, or decadent, has had to come to terms with such questions. The answers we give will carry the message and meaning of our own civilization down to future generations and will undoubtedly form an important basis for posterity's judgment of our accomplishments.

Professor Sam Hunter
Princeton University
July 1979

*Margaret A. Robinette: *Outdoor Sculpture, Object and Environment*, Watson-Guptill Publications, New York, P. 92

ACKNOWLEDGMENTS

First and foremost, I wish to acknowledge the support given by my wife, Hélène, who encouraged me to write this book even though she understood it would put a strain on the family (it was to be written entirely at home —on weekends, in the evenings, and during vacation time). Her patience and skill in managing family life with an absentee husband/father was critical during the nearly two years of researching, writing, and proofing.

A book on the Art-in-Architecture Program would hardly have been possible without the contributions of those who have worked to make the program a success. Certainly, I would have been unable to undertake this project without full confidence that the Art-in-Architecture Program was in capable hands while I was on vacation. Marilyn Farley kept the office running smoothly at all times; but for her competent direction of administrative functions, it would have been very difficult for me to complete this book. I am indeed grateful for her support, as I am for the dedicated efforts of Julie Brown, who not only managed a number of art-in-architecture projects, but who served as head of the program in my absence. Several other former staff members also deserve special recognition: Dee Dee Brostoff, the first program assistant, who worked tirelessly on behalf of the program, and without whose photographic memory it would not have forged ahead; Jack Seeley, who assumed Dee Dee's position and kept the office correspondence and endless reporting system on track; and Gloria Jacobs, our present secretary—a blessing to the office.

The Visual Arts Program staff at the National Endowment for the Arts performed the critical job of selecting artist nominating panels and conducting the panel meetings. Brian O'Doherty, former director of the Visual Arts Program, deserves particular acknowledgment, for he worked with GSA officials to establish the nominating procedures, in addition to assembling panels, chairing the meetings, and writing supportive letters on behalf of the program. His assistant, Julie Moore Jackson, did much necessary legwork; her calm tactfulness will always be appreciated. Richard Koshalek, who served as O'Doherty's deputy and was responsible for conducting a great number of panel meetings, deserves special mention. Koshalek, now director of the Hudson River Museum in Yonkers, New York, distinguished himself by setting up meetings with record speed, by conducting them with flawless courtesy and steadfast determination to elicit the best nominations (often mercilessly extending the panel meetings well into the night), and perhaps most importantly, by devoting much of his endless energy to educating GSA officials, architects, and others about the work of America's leading artists.

Other NEA officials also made important contributions, particularly Stacey Paleologos, who is presently responsible for arranging nominating panel meetings, under the guidance of Pat Fuller, coordinator of the agency's Works of Art in Public Places Program. Although relatively new to the NEA, Fuller has established herself as a competent and diplomatic leader— no easy task, considering her grueling schedule. Special tribute is due to Nancy Hanks, former chairman of the NEA, and its present chairman, Livingston Biddle. The support of the current Visual Arts Program director, Jim Melchert, and his deputy, Renato Danese, has been as valuable as it has been welcome.

High-ranking officials of GSA, notably former administrators Arthur F. Sampson and Jay Solomon, deserve generous recognition for their wisdom and courage in backing the program since its reactivation in 1972 and defending it in the press, to the taxpayers, and to members of Congress. Solomon personally extended his support to such a degree that the program flourished as never before, in terms of both the number of works commissioned and favorable public reaction.

President Nixon, President and Mrs. Ford, and Vice President Nelson Rockefeller all lent their considerable support to the program's objectives, as have President and Mrs. Carter. Most of all, Joan Mondale deserves applause for her energetic, tireless, and creative efforts. Mrs. Mondale's executive assistant, Bess Able, as well as her former and present arts advisors, Mary Ann Tighe and Elena Canavier, respectively, have worked behind the scenes to promote interest in the program.

Of course, many other past and present GSA officials have devoted countless hours to the program. It would be impossible to credit each of them in such a short space, but some deserve special mention, notably former Public Buildings Service commissioners Larry F. Roush and James B. Shea, Jr., and former assistant commissioners Walter A. Meisen, Tom Peyton, and Frank Matzke. The present assistant commissioner for construction management, David Dibner, stands out above all others. His knowledge of and interest in contemporary art, combined with his professional abilities as an architect, have been instrumental in the accomplishments of nearly every part of the program for the past two years. His well-reasoned and articulate advocacy has been of great importance in gaining the support of members of Congress.

One or more of the fine arts officers in GSA's ten regional offices have participated in every step of each contract, frequently serving as guardians, defenders, and friends of the artists: Mike Jones (Boston), Bill Carew (New York), Quinton Smith (Washington, D.C.), Paul Abernathy and Betty Lemmon (Atlanta), Bob Stewart and Don Dodereau (Chicago), Tom Crawford (Kansas City), Georgia Peavler (Ft. Worth), Jack Bryant (Denver), Ted Reid (San Francisco), and Earl Morris and Harold Broomell (Auburn, Washing-

ton). The regional directors for construction management have also been very helpful, especially Kapriel Kaprielian (Boston), Herb Steinman (New York), Jim Stewart (Washington, D.C.), Jim Dreger (Atlanta), Art Schlanger (Chicago), Cal Spradley (Kansas City), Bob Miller (Ft. Worth), Gerry Hillenburg (Denver), Steve Lesko (San Francisco), and Harold Broomell (Auburn, Washington). No PBS regional commissioner extended himself as much as did William Morrison of the Chicago office. Taking an activist role, Morrison promoted art-in-architecture projects throughout his region, intelligently defended individual artworks, and gave generously of his time and attention down to the smallest detail, from concept presentation through formal dedication.

The task of making sure that dedications went like clockwork fell to GSA's ceremony staff, both in Washington and in other parts of the country. It is impossible for anyone but these dedicated public servants to appreciate the countless details involved in such events—addressing invitations, planning media coverage, staging dramatic "moment of dedication" theatrics, coordinating receptions, fund raising, writing thank-you notes, and on and on. To these hardworking people, especially to Jack Williams, Pat Thomasson, Linda Odorisio, Dale Bruce, Martin Pearlmutter, and Quincy Culpepper, I extend my appreciation—though this modest acknowledgment is hardly commensurate with the public support their efforts have generated.

There are many other GSA officials who deserve to be singled out, among them Bob Aaron, Peter Hickman, Faith Payne, Richard Q. Vawter, and the other writers, editors, and press officers who prepared press releases, edited dedication brochures, and conveyed the program's objectives to members of the press. For their valuable expertise in advising the GSA administrator on artist selections, credit must also go to the panelists who served on the Art-in-Architecture Design Review Panel, including Walter Roth, Karel Yasko, and other PBS commissioners and assistant commissioners mentioned previously. The efforts of GSA lawyers have been important in developing contracts and advising program staff members on various legal matters. Overworked as they were, Jack Mulligan and Vida Baugh, among others, always found time to offer assistance.

Mr. Solomon's private secretary, Beth Johnson, never failed to cheerfully make room in the administrator's crowded daily schedule for art-in-architecture presentations and briefings. Her husband, Phil, formerly with GSA, played an active role in the early phases of the program, assisting in the development of the nominating procedures. Administrator Solomon's key executives, Jean Allen and Kathy Hindman, also contributed enormously to the program's success.

Other GSA employees who deserve special mention include Gareth Wells, for his vocal support of the program, his role as a sounding board, and his creative contributions to various chapters in this book; Peter Masters and his staff in GSA's graphics department, for their patience, originality, and professionalism in designing dedication brochures (for which adequate lead time was never available); GSA photographers John Holland and John Drust, for visual documentation of artists' proposals; and the many other GSA employees who in one way or another have contributed to the complex support systems of the Art-in-Architecture Program.

Last, but certainly not least, I wish to acknowledge the truly creative genius of my editor, Joy Johannessen, who combined tact with seriousness of purpose, wit with otherwise routine reporting, and an ongoing sense of optimism with the year-long job of editing this book. My forward-looking and inventive publisher, Harold Steinberg, initiated this project, used his considerable persuasive skills to convince me to write the book, and carefully oversaw its progress from initial concept to final product. Art director Susan Lusk not only contributed to concept development but is also responsible for the design of the book, which was meticulously laid out for display purposes by Laura Giardina. Enid Stubin and Marion Wood provided valuable editorial assistance, suggesting numerous stylistic and substantive improvements. To these creative and dedicated people of Chelsea House Publishers, I owe an enormous debt.

It goes without saying that in the final analysis, it is the energy and talent, the generosity and patience, of the artists that is responsible for the accomplishments documented in this book. To them, and to Sam Hunter for his stimulating and forceful preface, I extend my personal and most sincere thanks.

Contrary to popular belief, there is no law mandating that a percentage of federal construction budgets be spent for fine art—and there never has been. Although countless bills to that effect have been introduced in both the House and the Senate, none have ever come up for a vote.

The Art-in-Architecture Program of the United States General Services Administration (GSA) is the result of a policy decision made in January 1963 by GSA administrator Bernard L. Boutin, who had served on the Ad Hoc Committee on Federal Office Space in 1961–62. At President Kennedy's request, this committee had prepared a report titled "Guiding Principles for Federal Architecture." Central to the origins of the Art-in-Architecture Program (originally called the Fine Arts in New Federal Buildings Program) were the committee's findings that ". . . the Federal Government, no less than other public and private organizations concerned with the construction of new buildings, should take advantage of the increasingly fruitful collaboration between architecture and the fine arts," and that "where appropriate, fine art should be incorporated in the designs [of federal buildings], with emphasis on the work of living American artists." Accepting the report in May 1962, President Kennedy wrote, "I am requesting each department and agency head to give immediate study to the report and take appropriate action." He also asked for a progress report from the GSA administrator in a year's time. Thus, Boutin approved a policy of commissioning works of art in public buildings under GSA's jurisdiction, at a cost not to exceed one half of one percent of the construction budget.

During that era, the commissioning process began with the architect, who not only determined the type and location of the artwork but was also responsible for nominating at least three artists. The nominations were then submitted to GSA for review. If the agency wished, it made additional nominations before forwarding the list to the Fine Arts Commission in Washington, D.C., for its advice. The commission stated a preference for one or more of the artists, but the final choice was made by GSA.

These procedures operated until August 12, 1966, when the acting commissioner of GSA's Public Buildings Service (PBS), William A. Schmidt, "suspended" the program at the direction of Administrator Lawson Knott, Jr.* The reason given for the suspension was "rising costs of construction" due to inflation. According to Karel Yasko, a GSA official involved in the program at the time, the real reason was Administrator Knott's concern over public reaction to certain works, particularly a Robert Motherwell mural that was in-

stalled in the John F. Kennedy Federal Building in Boston in the summer of 1966. Shortly after the installation, Yasko described the sequence of events in a letter worth quoting at length:

. . . A sensation-seeking sports reporter from the Boston Herald *came upon [the mural] in the passageway between the two building elements and asked the first person for her reaction to what he said depicted the assassination of President John F. Kennedy. The young clerk's immediate response was, "It's an outrage," and the reporter had his story. With the license of the tabloid, the headline appeared as "Boston Outraged."*

To give himself expert support he confronted an assistant curator of the Boston Museum of Fine Arts with a photo of the painting and the title he had invented. The naive curator took the bait, and on the basis of a black-and-white photograph, he read into it "the President's profile at the moment of death." To enlarge on it he said the lines could represent "either the trajectory of the bullets or splatters of blood." . . .

Never mind that the only title Motherwell had given it was New England Elegy, *"a representation of an emotion of grief—nothing to do with the assassination."*

The Herald's *front-page story, which the wire services sent across the country, brought out the largest crowd seen in downtown Boston since old Scollay Square was torn down. Comments from the crowd were hardly flattering.*

Even when the newspaper backtracked two days later with a statement issued by the Boston Museum of Fine Arts to "correct a false impression," because it was misled by the wrong title, the controversy continued. Then, suddenly, it subsided, and the workers went back to their desks.

The Fine Arts Program remained dormant until late in 1972, when it was reinstated by Arthur F. Sampson, then acting GSA administrator. In a statement prepared for the unveiling of the maquette for Alexander Calder's *Flamingo,* the first work commissioned under the reactivated program, Sampson briefly traced the ups and downs of efforts to incorporate artworks into federal buildings, stressing the Nixon administration's renewed support for fine arts: "The President has said that 'only if the arts are alive and flourishing can we experience the true meaning of our freedom, and know the full glory of the human spirit.' . . . The President's commitment is to forge a new partnership between Government and the arts 'to the benefit of the people of America.'"

The following day, Larry F. Roush, commissioner of GSA's Public Buildings Service, signed a powerful memo to all regional PBS commissioners:

*A list of artists commissioned between 1962 and 1966, and the type and location of their works, appears in Appendix A.

In support of President Nixon's commitment to improve and strengthen the relationship between Government and the arts, Acting Administrator Sampson has reactivated GSA's fine arts program for Federal buildings. The importance of vigorously promoting this program cannot be overemphasized.

In carrying out this policy, fine arts shall be treated as any other essential part of the building and shall not be deleted as a part of a cost-reducing expediency effort, without the written approval of the Commissioner, PBS.

Roush's instructions included new artist selection procedures that had been hammered out between GSA officials and Brian O'Doherty, then director of the Visual Arts Program at the National Endowment for the Arts (NEA). The nomination and selection process, which was approved by Sampson in February 1973 and has since remained essentially unchanged, is as follows:

1. The project architect is encouraged to submit an art-in-architecture proposal as part of his overall design concept. This proposal includes a description of the location and nature of the artwork(s) to be commissioned.

2. GSA asks the NEA to appoint a panel of qualified art professionals to nominate three to five artists for each proposed commission. This panel is constituted on an ad hoc basis for each specific project. The panelists, at least one of whom must be from the geographical area of the project, meet with the project architect and representatives of GSA and NEA at the project site to review visual materials on artists whose work would be appropriate for the proposed commission(s).*

3. The panel's nominations are submitted to GSA by formal letter from the NEA. After evaluation of the nominees' existing work by a Design Review Panel in GSA's Public Buildings Service, the GSA administrator selects the artist.

4. A fixed-price contract is negotiated with the artist for the design, execution, installation, and photography of the artwork. Artists' concepts are reviewed and approved by the Design Review Panel.

Under the leadership of Administrator Sampson, the Art-in-Architecture Program flourished. From February 1973 until November 1975, when Sampson

left office, forty artists were commissioned to create works for twenty-six federal buildings. (One artist, John Queen, was selected in the autumn of 1972, having been nominated under the guidelines of the 1962–1966 program to create an exterior sculpture for the federal building in Midland, Texas.)

President Ford's appointee Jack Eckerd succeeded Sampson, assuming office on November 21, 1975, and remaining until mid-February 1977. Many of the works commissioned under his predecessor were installed during Eckerd's tenure, and a number of them evoked considerable protest from taxpayers and congressmen, judges and other federal workers. In February 1976, Eckerd called a halt to new art-in-architecture commissions pending a review of all ongoing projects and a revision of the program's procedures. Ultimately new procedures were worked out under the direction of Nicholas A. Panuzio, then PBS commissioner. Designed to insure greater community acceptance of GSA-sponsored artworks, they stipulated that the artist nominating panel was to include "a representative selected by the NEA from nominations made by the mayor or an appropriate local government official," and that key civic and art groups were to be invited to the panel meeting as nonvoting participants. They also slashed the fine arts budget by twenty-five percent (from half a percent of the construction budget to three eighths of a percent) and encouraged contributions from the local community. During Eckerd's administration, twelve artworks were selected for three federal buildings; all but one were existing designs or completed pieces.

From the standpoint of the Art-in-Architecture Program, gloom turned to hope when, on April 6, 1977, President Carter nominated Jay Solomon to be the new GSA administrator. Solomon was confirmed by the Senate later that month, and within weeks of taking the oath of office, he had restored the full half-a-percent budget. He soon took other steps to broaden the scope of the program, including, for example, extending commissioning opportunities to completed federal buildings undergoing repairs and alterations. Under Solomon's leadership, seventy artists were selected to create works (or, in the case of the Oklahoma City project, to provide existing works) for thirty-two federal buildings.

Solomon's support for the Art-in-Architecture Program was unswerving; in turn, other prominent figures interested in the arts were vocal in their support for the administrator and his efforts. Joan Mondale, wife of the Vice President, hosted a luncheon to introduce Solomon to the art press and often spoke at artwork dedications, as did First Lady Rosalynn Carter. Solomon spoke enthusiastically about the program to members of Congress and the press; nearly every month, and sometimes more often, newspapers throughout the country ran editorials praising the program's accom-

*A list of architects and NEA-appointed panelists for each of the projects covered in this book appears in Appendix B.

plishments. During Solomon's twenty-two months in office, probably more magazine and news articles (nearly all of them supportive) appeared on the Art-in-Architecture Program than on any other single GSA program.

Addressing the Senate of the fall of 1977 (*Congressional Record,* Proceedings and Debates of the Ninety-fifth Congress, first session, October 7, 1977), Senator Pell said:

> . . . *I believe that the Federal Government should play a more substantial role in increasing the awareness of our society in the arts.*
>
> *In this regard, I am greatly encouraged by the progress, attitudes, and actions of the Carter administration. Specifically, I greet with real enthusiasm the announcement made by the Administrator of the General Services Administration, Jay Solomon, that he is revitalizing the art-in-architecture program of GSA.*

Nearly seven *Congressional Record* pages later, Senator Pell concluded, "Mr. President, I welcome this new phase of support for the arts. It appears to me that at last we have an Administrator of GSA who is willing to do something which is vital to our heritage and in the process humanize our public buildings."

On March 31, 1979, Jay Solomon left office, and President Carter appointed Rowland G. Freeman III as his successor. Administrator Freeman, who was confirmed by the Senate on June 27, has vowed to support the program, and his actions have reinforced that commitment.

Because there is no law mandating the activities of the Art-in-Architecture Program, its fortunes may well fluctuate in the future as they have in the past. It is to be hoped, however, that subsequent administrations, supported by the American people and their representatives, will see the wisdom of continuing and expanding federal support for the arts. As the *New York Times* said in its lead editorial on September 17, 1977, "Administrations and city councils come and go but the arts go on forever. Let's hope."

AUTHOR'S NOTE

This book covers artworks commissioned under the Art-in-Architecture Program of the United States General Services Administration (GSA) between 1972 and 1979. The works are treated alphabetically by city in which they are located (Appendix C lists them alphabetically by artist's name). Unless otherwise noted, all quotations come from letters to GSA or to the author, or from interviews conducted by the author. This book reflects the views of the author and is not an official expression of GSA policy.

THE PLACE OF ART IN THE WORLD OF ARCHITECTURE

WILLIAM KING

There would be no public artwork in the federal building and U.S. courthouse in Akron, Ohio, or the McNamara Federal Building in Detroit, Michigan, but for the prodding of David B. Cooper. As an associate editor of the *Detroit Free Press,* Cooper wrote several articles and editorials urging citizens of Greater Detroit to "Write for Art," which they did in considerable numbers. No sooner had GSA announced that a major work would be commissioned in Detroit than Cooper moved to Akron as associate editor of the *Akron Beacon Journal.* Discovering that no art projects were planned for the newly constructed federal facility in Akron, he began another one-man press crusade. Cooper's efforts were seconded by John F. Seiberling, U.S. congressman from Akron, who contacted GSA to express his hope that artworks would be commissioned, and by design architect Gordon W. Canute (of Tuchman, Canute, Ryan and Wyatt), who repeatedly wrote GSA of the necessity for sculpture as "a humanizing factor [in] the total building complex."

The timing of this coordinated campaign couldn't have been better. It ran through the fall of 1977, just as Administrator Solomon was deciding to expand the Art-in-Architecture Program's scope to include "existing buildings for which fine arts had been planned but were never implemented."

Opposite: William King's Caring, *created for the plaza of the federal building and U.S. courthouse in Akron, Ohio. It is made of aluminum and measures twenty-two feet high by six feet deep by thirty-two feet wide.*

Right: The sculptor and his crew begin to assemble the work and erect it at the site. During the installation, Caring *elicited energetic commentary from passersby and later became the center of a lively debate in the Akron press. King was undismayed by the controversy. "It's heady stuff, public sculpture," he wrote.*

On November 14, a Cooper editorial ("Progress through Art") proudly announced that GSA would commission artwork for the federal building in Akron "thanks to a more art-conscious administration now running the GSA and to the many Akron people who wrote to support this project."

★ ★ ★

The National Endowment panel met in Akron with architect Canute on February 16, 1978, to nominate artists. The panelists, each with established credentials in contemporary art, and all from Ohio, recommended that two sculptors be commissioned to create works for the front (east) plaza and the rear (west) plaza. Heading their list of nominees for the east plaza sculpture was William King, who was selected by the administrator later that month (Robert Morris was chosen for the west plaza commission).

Julie Brown, who was managing

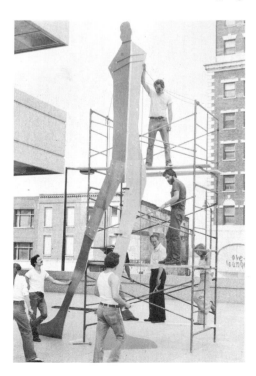

the Akron project in Washington, D.C., and who represented GSA at the NEA panel meeting, was delighted with the selections. She quickly called King to tell him the good news, but he wasn't in. As he later recounted,

I didn't return the call—it's a bad habit, I know. I thought, "Washington wants to know my social security number again," and I had other things on my mind. Next day I did call, and Julie Brown said, "Mr. King? You're going to make a sculpture for us—if you want to."

I was out of the chair and halfway down the telephone wire to Washington. "I *want* to, I *want* to" was all I could say.

Brown met King in Akron for contract negotiations on March 7. "Adrenalin was flowing in the sculptor's veins," wrote King later. "He kept looking out the window at the proposed site and thinking, 'Hot dog! Hot dog! A chance to work on *this* scale—nobody telling me what or where; just a little bit of when.' I felt I was among friends." A fee of $22,000 was agreed upon, and King responded with characteristic enthusiasm. "Twenty-two grand—and grand it was!" The contract was handled through GSA's Chicago office under the capable and supportive direction of Robert Stewart. Stewart, a veteran of several complex, administratively grueling commissions, found welcome respite in the optimistic, good-hearted King, who signed the contract without requesting a single modification.

King later described his experience with GSA warmly, with wry humor:

Contract was signed. Twenty-seven pages of it, and plenty of stipulations therein. "Use minority labor, if possible." Well, it's more than possible. It's probable, thought I. Graduate students. There's no smaller minority than art students!

The maquette, one inch to one foot scale, was made (by a real minority: me), and I took it to GSA in Washington for their, I hoped, final approval. Fear and trembling. Most artists are insecure, did you know that? Is *everybody* insecure? The maquette, anyway, was a hit.

This was a *completely* different feeling than the usual gallery/museum hat-in-hand humiliating experience. More than anything, I'm thankful for the adult treatment received from the GSA. Genuine vitamins! They *want* you to work. That is *rare,* believe me, *RARE.*

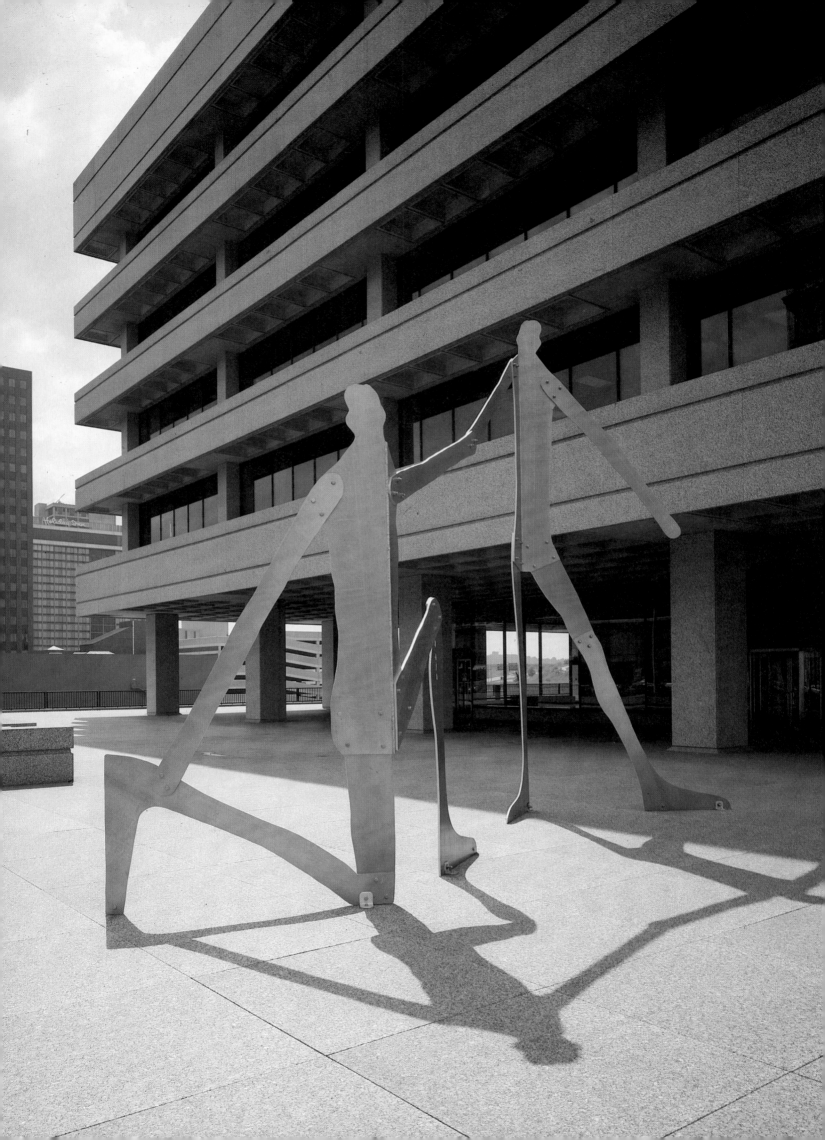

Actually, it is King who is rare. His zeal is infectious, and he displays a rare combination of exuberance and humility. In a catalogue essay for a 1970 King exhibition, *New York Times* art critic Hilton Kramer said of him, "He is an artist of uncommon intelligence and originality, who has kept sculpture alive—kept it vital and inventive as well as amusing and telling—as a medium of humanistic discourse. At the present moment there is—quite literally—no one else like him." And of his work Kramer wrote, "Nowhere is King's fundamental sociability more evident than in [his] new series of constructed aluminum structures. . . . These are, in conception at least, open-air sculptures. They have a large, robust, outdoor reach. And they must be just about the friendliest, least daunting, least impersonal open-air sculptures of real quality since Calder designed his first outdoor stabiles" (*William King: Sculpture,* Terry Dintenfass, Inc., 1970). Kramer's enthusiasm was matched by that of GSA administrator Solomon, who was so taken with King's maquette that he placed it in the center of his office for all to enjoy.

★ ★ ★

King's sculpture was initially titled *Caritas* (Latin for "charity," in the sense of caring) and renamed *Caring,* which, according to King, is a "more accurate description of subject and intent." Syracuse University students fabricated it carefully by hand, and it was ready for shipment to Akron in July 1978. King remembers the installation vividly.

. . . Terrifying moments, you know, in every event like this. We "got it up," as they say. No hitches at all *except* the granite paving on the plaza. Hard???! Stupefying! I remember in particular the look on my crewman's face as he nonchalantly applied the drill to it. *Nothing* happened. *Nothing* at all. Drill went in not one millimeter. It was like something out of a Buster Keaton movie, the way his face changed. Triumph to bitter defeat in three seconds!! We had a local wise man from the marble works come over and drill the anchor holes with a special Akron-warhorse drill. Whew!!

A federal plaza is not your usual too-private art gallery situation, and I was roundly told what my sculpture meant by a lot of on-

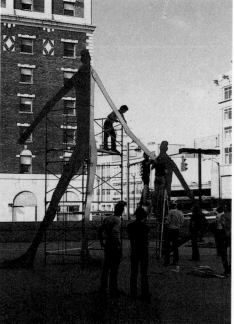

Above: The installation nears completion.

Opposite: Two views from the plaza. Caring exemplifies what Hilton Kramer has called King's "sculpture of comic gesture. It is sculpture that choreographs a scenario of sociability, of conscious affections and unavowed pretensions, transforming the world of observed manners and unacknowledged motives into mimelike structures of comic revelation. . . . it is sculpture that draws from the vast repertory of socialized human gesture a very personal vocabulary of contemporary sculptural forms" (William King: Sculpture, Terry Dintenfass, Inc., 1970).

lookers and passersby. "The heads are too small," "How much did *that* thing cost us!?!," "*Wow,* that's *terrific,*" "Who made this thing? Oh, *you* did!" "Leave it up," "Tear it down," "What's its name?," "I want one!" (the answer to that was "Make one, then"). I was busy but was aware enough to see that the pros and cons were divided pretty much along lines of age. Under fifty, I'd say they felt akin to it; over fifty, they were suspicious.

They certainly were, and King was well out of town when the sidewalk critics started writing to their congressmen and to the editor of the *Akron Beacon Journal.* According to David Cooper, who must have wondered what he'd started by urging artwork in the first place, letters simply poured in.

Fortunately, Donald Harvey, an NEA-appointed panelist, and director of Akron University's gallery, was prepared to answer the critics, to help them understand King's work and view it in the context of the history of public sculpture. Writing for the *Beacon Journal's* September 3 edition, Harvey called

his readers' attention to the Calder in Grand Rapids: "At first the object of protest and verbal abuse, its image now has become the city's logo, adorning letterheads and the sides of city vehicles." He continued, "Like the Calder sculpture, *Caritas* is a friendly work, quite direct in its content, and the product of one of this country's leading contemporary sculptors." After discussing King's career and the meaning of his work, he noted:

The placement of a sculpture in a public setting, even one by a major figure such as King or Morris, can represent for most of the public an isolated view of the artist's work. Realizing this, The University Galleries of the University of Akron have planned an exhibit of works by William King to allow the public a wider knowledge of his work. The exhibition will include 15 indoor sculptures, 20 drawings, and three outdoor sculptures to be placed on The University of Akron campus.

Harvey's intelligent educational effort is a fine example of the way in which art professionals can help to enrich a community's aesthetic experience. After the King exhibit, an increasing number of people began to view *Caring* more positively, and comments about the symbolism of one person giving a helping hand, of friendship, are now heard frequently. Of course, many people still regard the piece as a waste of tax dollars, but in any case, the citizens of Akron have not ignored it. It continues to challenge imaginations and provoke lively discussions.

"It's heady stuff, public sculpture!" wrote King after he'd seen firsthand the incredible amount of interest and energy, both positive and negative, generated by his work.

I dream of another crack at it. As I say, to be allowed to work on that scale . . . seems to have brought out the best in me. I spent quite some time on this sculpture deciding what and how to do with the opportunity. I know there are plenty of other artists who would be nourished as I was by the chance I got. More power to you, GSA! It's the ultimate compliment to pay to an artist.

I know the country will have a return on its investment five thousand times over. We've plenty of artists. Give 'em a chance and you'll see.

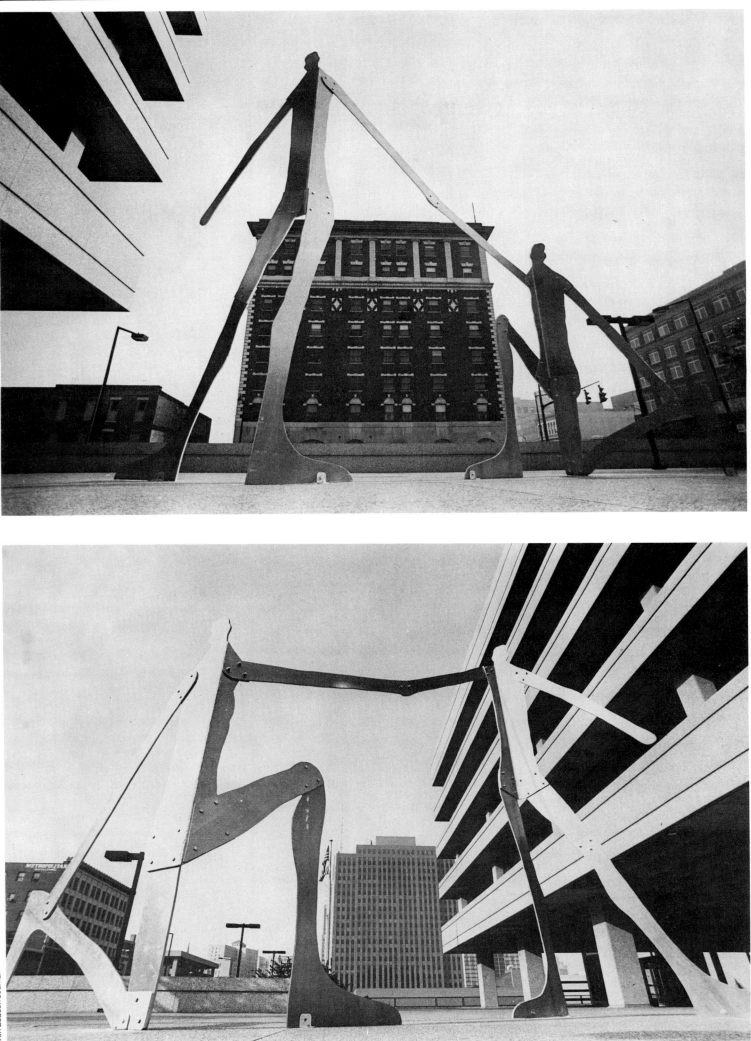

SHERRI SMITH

Within five days of taking the oath of office in May 1977, GSA administrator Jay Solomon had signed a letter to Nancy Hanks, chairman of the National Endowment for the Arts, requesting that the NEA appoint a panel "to nominate three to five qualified artists for a fiber work as proposed by the project architect for the Federal Office Building in Ann Arbor, Michigan."

The architect, Glen Paulsen (of Tarapata MacMahon Paulsen Associates in Bloomfield Hills, Michigan), had long hoped that an artwork would be commissioned for the project. As early as December 1975, Paulsen had written GSA urging the inclusion of art, and he reiterated his plea a year later:

> The interior spaces are now clearly defined, and it is quite obvious that a work of art in the space provided in the lobby would be a great addition to the interior and a highly visible contribution to the community as well.
>
> As architects and interior designers for the building, we have always considered the provision for art in the design and planning process. I hope that this opportunity for a meaningful integration of architecture and art can be fully realized.

Unfortunately, during the administration of Solomon's predecessor, Jack Eckerd, the commissioning of artworks had come to an abrupt halt pending the development and approval of new guidelines. The delay was critical for the Ann Arbor project because the available funding was to terminate in the spring of 1978—and all work had to be completed by March 31, just ten months from the date of Solomon's letter to Hanks.

★ ★ ★

In August 1977, an NEA-appointed panel met and nominated five artists for the Ann Arbor commission, among them Sherri Smith. The following month, GSA's Design Review Panel ranked the nominees for Administrator Solomon's review, and he selected Smith in November. With Julie Brown representing GSA, the contract was negotiated in Ann Arbor for a fee of $15,000 and officially executed in December.

An assistant professor of weaving and textile design at the University of

Michigan School of Art, Smith is well known to art professionals. She began exhibiting in 1968 and was barely twenty-six years old when her work was selected for the Museum of Modern Art's Wall Hangings exhibition (1968–69); since then, she has gained an international reputation, with major exhibitions at New York's Museum of Contemporary Crafts, the Centre International de la Tapisserie Ancienne et Moderne (in Lausanne, Switzerland), the Denver Art Museum, Chicago's Museum of Contemporary Art, and the Cleveland Museum of Art, to mention just a few.

Fortunately, Smith lives in Ann Arbor, so she didn't have to waste time traveling to and from the federal building. She went to work immediately, selecting her colors at the site itself so that she could correct for the distortion caused by the mercury vapor lamps in the lobby. And the lighting wasn't the only problem, as far as Smith was concerned. "The lobby of this building is bleak, uninteresting, and forbidding to a remarkable degree," she wrote. "Anything in it could only help, and I felt that . . . I ought to cover up as much as possible and introduce as much color as possible, considering that both the walls and floor are strong in color as well as highly patterned." On the positive side, she was excited about working on a large scale and being able to make use of two intersecting planes.

> The complexity . . . I am most vitally interested [in] makes it necessary for me to work quite large. I often have ideas for pieces that would be far too large to be sensible to make under normal circumstances. For this reason I was glad to have the opportunity to do this piece. . . . I was also enthusiastic about being able to install a piece in a corner, because this accentuates the changes one sees in one of these

pieces when seeing it from different angles.

Within a month of signing the contract, Smith had completed her proposal, and she submitted it to GSA's Design Review Panel on January 10, 1978. It was approved without delay, and Smith had the piece ready for installation by mid-February. Titled *Firedrake*, it is seven feet high by thirty-five feet long and is made of interwoven cotton webbing. Smith's weaving technique produced a many-faceted surface presenting a succession of colors that unfold as the viewer walks by. The colors shift and change, disappearing and reappearing throughout the work—an optical effect that is far from haphazard. In Smith's words,

> I am interested in the synthesis of the shifting and elusive and the very precise and highly ordered. I work with systems of color relationships which can best be described as having to do with the properties of numbers. I am interested in proposing a complex system of ordering the elements in a piece and then observing these elements work themselves out to their inevitable conclusions. In addition, and somewhat unrelated to the above, I prefer for the results to give a sense of spaciousness and vast sweeping movement.

Firedrake accomplishes Smith's goals admirably and has been favorably received by building employees, visitors, and residents of Ann Arbor. Nearly six months after it was installed, Smith returned to the lobby to photograph it—a difficult task. "I'm working on getting a more lifelike photo of my hanging," she wrote. "With mercury vapor lights, there is no way to take a true color photo, so I'll have to work at night with special high-power photo

floods." Although she found it hard to capture on film, Smith liked what she saw in her work, concluding, "It is very interesting to walk past."

Firedrake also accomplished the objectives of the NEA panel that originally nominated Smith. According to panelist Bret Waller, director of the Michigan University Art Museum,

> The panel's concern was to nominate several artists of national stature, any one of whom would be capable of creating a work of real distinction for the site. . . . I've viewed *Firedrake* many times since its installation and am impressed by its ability not only to hold its own in a challenging architectural space, but to actually enhance its surroundings.

The bold, geometric form of the piece represents something of a departure from Smith's earlier work. The commission seems to have been particularly opportune; it resulted in a first-rate work for a prominent public space, and at the same time enabled the artist to realize a new vision on a scale that otherwise wouldn't have been possible.

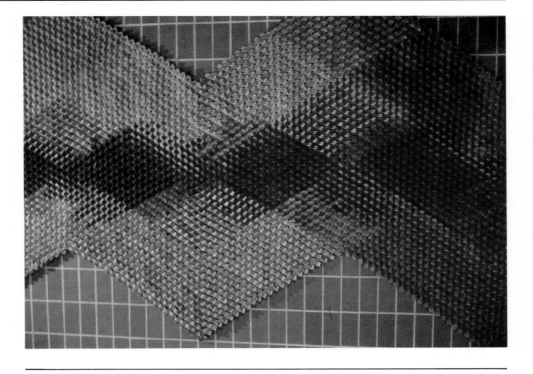

Above: A detail of Sherri Smith's Firedrake.

Below: Firedrake, *in the lobby of the federal building in Ann Arbor, Michigan. The strongly patterned lobby walls, surfaced with four- by eight-inch tan quarry tiles and lit by mercury vapor lamps, presented Smith with a formidable design challenge, but the site also gave her artistic elbowroom and a chance to experiment. "I had been interested in doing a piece that went around a corner to take maximum advantage of the different things one sees from different angles, and this seemed like the right place," she said.*

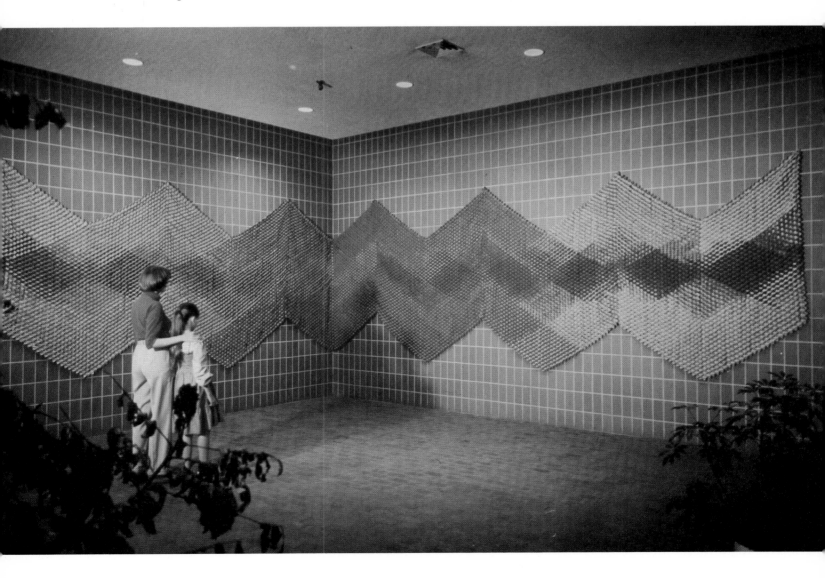

GEORGE SUGARMAN

Truth *is* stranger than fiction. If the story hadn't been so completely documented in the news media, it would be nearly impossible to believe. Twenty-eight or more separate stories appeared in such newspapers as the *Baltimore Sun*, the *New York Times*, the *Wall Street Journal*, the *Washington Post*, the *Baltimore News American*, and the *Washington Star*, among others. Editorials and letters to the editor sounded battle cries as GSA officials, senators, representatives, and judges matched wits, made power plays, and traded predictions. The tangled web became more tangled when the U.S. Marshals Service, the Baltimore City Police Department, and the FBI moved in. Artists, art critics, dealers, museum directors, bureaucrats, politicians, reporters, editors, and private citizens joined the cast of characters in ever-growing numbers. Things got confusing. Precedents were set. A public hearing was held. And in the eye of the hurricane was George Sugarman, who had been selected to create a monumentally scaled sculpture for the plaza of the new federal building and U.S. courthouse in Baltimore, Maryland.

Sugarman had been among the artists nominated for the Baltimore commission by the National Endowment for the Arts in late August 1974. Arthur Sampson, then GSA's administrator, selected him the following November, and a $98,000 contract was negotiated in December. In August 1975, Sugarman presented a maquette of his proposed sculpture to GSA's Design Review Panel, which, in an effort to involve the community to a greater degree, included representatives of the mayor's office, local architects, and citizens interested in the development of Baltimore's Inner Harbor. The panel received Sugarman's design enthusiastically.

The following month, excitement turned to panic when Edward S. Northrop, chief judge of the United States District Court of Maryland, wrote to Administrator Sampson "vigorously protesting" Sugarman's proposal. Northrop sent copies of this letter, dated September 24, to twelve other VIPs, including the entire Maryland congressional delegation. "The Judges of this Court were unanimous in feeling that the proposed sculpture is inappropriate for the Federal Building and Courthouse and is not in keeping with either the design or purpose of the building," he wrote, adding, "The contours of the structure itself present a danger both as to possible injury to individuals moving around it, as well as a potential shelter for persons bent on mischief or assault on the public." Northrop concluded with a call to action: "We therefore request that you take immediate steps to prevent any further implementation . . . of this artwork."

Believing that the judges were miffed about not having been consulted on the choice of the sculptor or the design proposal, Sampson requested that his counsellor for fine arts, Karel Yasko, meet with them in person. In October Yasko conferred with Chief Judge Northrop and Judge Stanley Blair and reported that they "expressed pleasure with the selection of Sugarman but objected to the design he proposed." Yasko explained the operating procedures of the Art-in-Architecture Program and said that the GSA had not been aware of requests the judges had made through the architects to confer with the sculptor. He then agreed to arrange a meeting between them and Sugarman.

On November 4, Sugarman took the Metroliner from New York to Baltimore to talk with Judges Northrop, Kaufman, and Blair. According to Yasko, the "exchange of ideas between sculptor and Judges [was] pleasant, philosophic and friendly." No decision was reached, but Sugarman agreed to consider the judges' objections. By December, GSA had received several letters from U.S. congressmen supporting the judges, notably Senator J. Glenn Beall, Jr., and Representative Paul S. Sarbanes, who wrote, "In view of the unanimous disapproval of the sculpture by these judges, the General Services Administration should stop work on the sculpture and, with the active participation of the federal judges, initiate a new selection process for a sculpture which is more acceptable to the judges." Yasko, who was very supportive of the sculpture, prepared the responses to these letters, inadvertently referring to the judges by incorrect names—an embarrassing oversight that was quickly picked up by Senator Beall:

While I appreciate the indica-

tion that you will take into consideration the feelings of the judges and other occupants of the building . . . I hope you will be more careful in fulfilling this promise than you were in properly identifying the people with whom you met on October 17th.

Your letter refers to Chief Judge Robert Northrop, Judge Harold Kaufman, and Judge David Blair. For your information the correct names of these judges are Edward Northrop, Frank Kaufman, and Stanley Blair.

GSA's answer to Senator Beall, drafted by Yasko and dated January 13, 1976 (yes, it *was* a Friday), was to cause further agony in the coming months.

Our Counsellor for Fine Arts and Historic Preservation, Mr. Karel Yasko, has met twice with the Judges' Committee, and one meeting included Mr. George Sugarman, the sculptor for the project. Both meetings were considered by all attendees to be fruitful and *the judges have been assured that the final work will not be executed without their concurrence* [emphasis added].

Meanwhile, Tom Freudenheim, then director of the Baltimore Museum of Art, and one of the NEA-appointed panelists who had nominated Sugarman, suggested that the judges were unhappy with Sugarman's proposal for reasons other than the GSA's failure to consult them. "It was quite obvious to me why the sculpture had caused such a negative reaction among the judges," he wrote. "The model is so shabby that it would take a reasonably sophisticated person to understand what is being proposed. . . . It seems to be a great tactical error on somebody's part." Sugarman, taking Freudenheim's point to heart, spent an additional $4,000 to have the original cardboard maquette made into a beautifully finished aluminum model by the Lippincott company. Sugarman himself presented the model to the judges on March 26, 1976, but it served only to reinforce their opposition. In a letter to Senator Beall dated April 1, Judge Northrop stressed the possibility of injury to children playing around the sculpture and again emphasized its potential as a haven for miscreants. "If anything," he said, "the model of Mr. Sugarman's revised concept is even more unacceptable than the original one." Then the January 13 GSA letter came back to haunt us as Northrop added, "I respectfully request that, in accordance with [GSA's] letter, you officially inform the General Services Administration of our position in the matter."

As usual, Northrop sent copies of his letter to the entire Maryland delegation, as well as to RTKL (the building's design architectural firm), former representative Edward A. Garmatz (for whom the building had been named), and those concerned with the development of Baltimore's Inner Harbor. He also wrote GSA's new administrator, Jack Eckerd: "We request that you take immediate steps to prevent any implementation by the sculptor or those working under his direction on the construction of the artwork and that you advise me promptly as to the steps taken to cancel whatever commission or contract exists with Mr. Sugarman for a proposed sculpture at the site of the new Baltimore building." More members of Congress sent letters supporting Judge Northrop's position, and Administrator Eckerd directed Nicholas A. Panuzio, commissioner of the Public Buildings Service, to meet with Judges Northrop, Kaufman, and Blair. On April 27 Eckerd wrote Northrop, "As a result of your meeting and subsequent conversations I have had with Mr. Panuzio, we have advised George Sugarman to suspend implementation of his initally proposed sculpture."

I remember thinking, upon hearing the news, that the citizens of Baltimore would be furious, that the national art community would be outraged, and that it was an altogether ill-advised decision. When I expressed these views, Panuzio laughed and asked me if I really thought the people of Baltimore would care. I said yes.

★ ★ ★

In the meantime, Sugarman had shown his maquette to curators at the Museum of Modern Art and the Whitney Museum of American Art; the Whitney's director, Thomas N. Armstrong; Dean Andrew Forge of Yale's Art and Architecture Graduate School; Deputy Director Stephen E. Weil of the Hirshhorn Museum and Sculpture Garden; *Art in America*'s managing editor, Joan Simon, and contributing editor Irving Sandler; and Director Jeffrey Hoffeld of the Neuberger Museum. They were unanimous in their support for the work. "One of the most exciting works for a public space that I have seen for some time," wrote Hoffeld. "What interests me as much as the quality of the piece is its appropriateness as public art . . . to humanize our environment. Your work does this admirably," stated Sandler. "A really beautiful and extraordinary piece. It combines . . . *joie de vivre* that your work always has with a marvellous sense of purpose," proclaimed Dean Forge. "Enormously appropriate for the site and occasion for which it will be used," wrote Weil, adding,

In particular, I liked the dignified way in which it is both protective and sheltering on the one hand, and communal on the other. . . . The ribbon forms that resolve into satellite benches suggest the continuity of the law; the re-

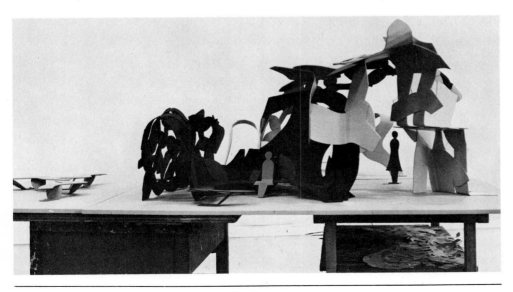

Opposite: George Sugarman's Baltimore Federal.

Above: Sugarman's second maquette, fabricated in aluminum after his original cardboard model was criticized as inadequate. The revised maquette did little to allay the fears of the sculpture's judicial critics, who considered it a potential threat to life and limb and a possible haven for criminals, radicals, and sundry undesirables.

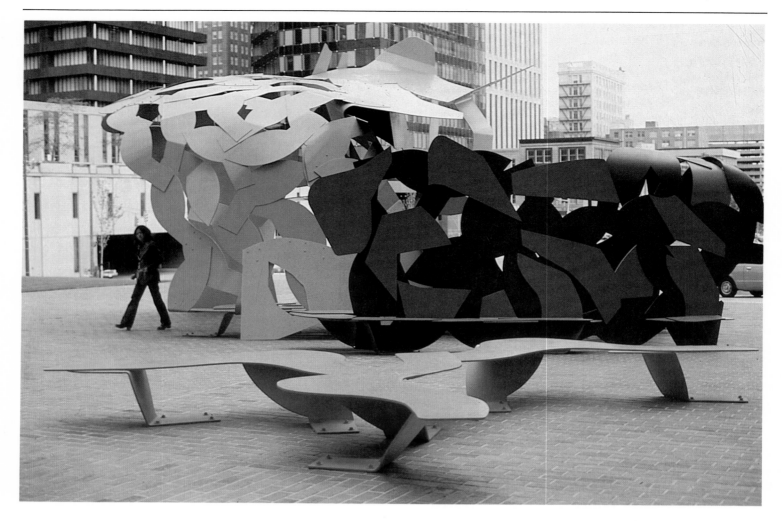

peated leaf-like forms that make up the central canopy are reminiscent of how the common law—itself organic—composes itself into an overarching structure from the incremental resolution of specific cases. Throughout, it is restrained but not rigid. . . . this seems to me a wonderful work; sculpture extended to its fullest in both aesthetic and social terms.

Artists Equity also took a stong stand. "That a small group of federal judges should attempt to subvert a due process procedure is indeed disquieting

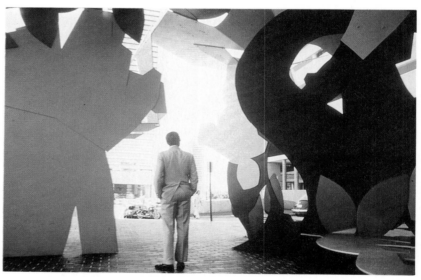

The many faces of George Sugarman's Baltimore Federal. *The controversial work, which is located in the plaza of the federal building and U.S. courthouse in Baltimore, Maryland, was offically dedicated on May 1, 1978. Writing for the dedication brochure, Sugarman said, "My sculpture . . . represents the coming together of many of my ideas in art. From a formal point of view, it is the culmination of many years of working with the concept of field sculpture—sculpture that extends itself into space rather than concentrating as a single object. The piece exemplifies my interest in the strength of internal and external forms—sometimes the interior is vibrant and expressive, at other times the exterior shell-form alone displays the nature of both the inside and outside of the work."*

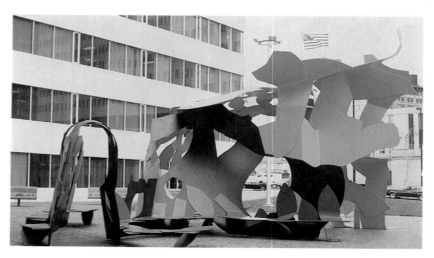

and should be resisted," wrote National President John Blair Mitchell to Administrator Eckerd.

On May 1, Eckerd's decision was made public by the *Baltimore Evening Sun* in an article by Thomas Hasler: "Bowing to pressure from U.S. District Court judges, the General Services Administration has ordered a nationally prominent artist to stop work on a sculpture for the new federal courthouse." About two weeks later, on the front page of the *Baltimore Sunday Sun* "Spectator" section (May 16, 1976), art and architecture critic Phoebe Stanton set forth the entire story, carefully and rationally dispelling the judges' concerns.

... There have been, to the best of my knowledge, no reported cases of impalement or laceration by the monumental metal sculpture which has become relatively common in American public places. Neither is children's play a hazard; the plaza will hardly be frequented by the very young and the odd climbing child can surely be controlled. The theory that thugs may lurk within its forms is another expression of the fear of vandalism and crime turning our cities into compositions of windowless buildings, set on streets lighted at night until they are brighter than day. It is, surely, a function of the arts to qualify the fortress-like character of many urban spaces. Mr. Sugarman's sculpture would do that.

Two days later, in a five-page, single-spaced, typewritten letter, Judge Northrop again wrote Administrator Eckerd, expounding the entire history of the sculpture commission from his perspective. Northrop said that the court had received telephone calls from people "who have, to say the least, a confused impression of the facts as we know them to be. . . . Obviously, various subtle and unsubtle pressures are being brought to play." As if to prove his point, he added, "A very real problem, from your standpoint, is the Federal Tort Claims Act which involves personal injury claims against federal agencies and which permits suits for damages arising from injury in federally-owned public buildings. . . . Congress could not have possibly intended to fund the Fine Arts program . . . if the artwork produced under its aegis presented a possible (indeed, probable) liability against the federal government."

At the very moment that the judges were intensifying their opposition, counterforces were beginning to rally in support of Sugarman. Representatives from Artists Equity, the mayor's office, Baltimore-area colleges, and the Baltimore Museum of Art wrote the administrator "to express our sense of outrage at the deviation from announced GSA policies for the selection of works of art [as represented in GSA's] letter to Senator J. Glenn Beall, Jr., of Maryland, dated January 13, 1976." The co-signers continued, "Whether or not it is legal to confer upon the judges (who, after all, are but a small handful of those who will use the building) a veto power over this project at this late date is a matter about which we can express no opinion. Legal or not, it seems grossly unfair." In responding to letters from the ever-increasing number of Sugarman supporters in Baltimore, GSA began to soften its position, thus paving the way for the sculpture's eventual installation. "Our shared concerns . . . were never intended to be interpreted as offering a 'veto-step' by select members of the using agency," wrote GSA's deputy administrator.

On July 7, Judge Northrop again wrote Administrator Eckerd, this time to let GSA know that the judges had had another meeting with the design architect, Charles Lamb of RTKL, who had given his "unqualified endorsement" to the work, and with Sugarman, who "pointed out that he had changed the original concept . . . to elongate certain of the secondary parts of the artwork, and to include openings in a number of the portions of the primary structure so as to eliminate certain possible hiding places for persons bent on mischief." This was heartening news which seemed to suggest that a compromise had been reached. There was more to the letter, however: ". . . we thought it desirable to seek the opinion of the U.S. Marshal for the District of Maryland . . . to give us a critique as to its features from a safety and security point-of-view. . . . we also requested representatives of the Baltimore City Police Department to give us their opinion of the artwork in the general area of safety and security. We also invited a similar inspection and opinion from both the FBI and Secret Service." Good grief, I wondered, are these the same judges who complained the previous May that "various subtle and unsubtle pressures are being brought to play"? Northrop's letter went on to note that the representatives of all these organizations agreed unanimously that Sugarman's design posed a security risk.

It was specifically pointed out that: the artwork could be utilized as a platform for speaking or hurling objects by dissident groups demonstrating in front of the building, and it would be extremely difficult to extricate anyone from the top of, or from within, its contours without injury to the offender or the officer; its proposed location would obstruct natural surveillance by passing patrol vehicles of the main entrance . . . ; it would be a natural attraction and point of congregation for those leaving functions at the Civic Center or other forms of entertainment in the general area; the configuration of the artwork lent itself to all types of molestation of the unsuspecting drawn to the artwork; its contours would provide an attractive hazard for youngsters naturally drawn to it; and most importantly, that the areas of concealment produced by the contours of the structure could well be used to secrete bombs or other explosive objects.

To emphasize the danger of the bomb scare, which "was raised by the demolition experts of the Baltimore City Police Department and the FBI," Northrop added, "If explosives were detonated from within the contours . . . the primary and secondary effects would result in great injury and damage to everyone and everything in the immediate area, and a further effect would be conversion of the aluminum strips or segments of the sculpture to flying shrapnel throughout the general area."

★ ★ ★

The newspapers had a field day with Northrop's renewed assault on the sculpture-as-public-menace. On July 18, Phoebe Stanton produced another piece for prominent placement in the *Sunday Sun*:

A sculpture proposed for the forecourt of the new federal building and courthouse . . . could be used by dissidents as a platform for speaking or hurling objects, and even could be used to conceal a terrorist's bomb, federal judges complain. Even after the sculptor, George Sugarman, agreed to modify his design to meet the judges'

security complaints, the judges continue to object to the artwork, citing such possible dangers as "flying shrapnel" caused by a bomb exploding in the sculpture itself. . . .

The judges of the District Court have found the sculpture guilty before it was responsible for any crime. . . . If the sculpture is dangerous then for the same reasons so are trees, benches, existing monuments, sculpture now in place, and even row houses. We all know that parked cars, mailboxes and refuse baskets, and dumpsters, can become shrapnel. Should they all go?

May we assume that rock concerts and other entertainments cause people to become riotous and attack courthouses, and that attempts to bring people together into urban spaces are subversive of peace and civic calm?

The attack on this sculpture is, in fact, an indictment of the public.

Following the publication of Stanton's article, certain members of Congress began to speak out in favor of the sculpture. One of the first was Representative Parren J. Mitchell, who on July 28 wrote Administrator Eckerd:

I was amazed to learn that apparently the Federal Judges have in effect "vetoed" the placement of a piece of modern sculpture. . . . Seemingly this "veto" was acted on because one of the Federal Judges did not like modern art, and another thought the modern sculpture would be dangerous in that "people might get on top of it to make speeches." If the reasons given above are sufficient to delay action on the Sugarman Sculpture, then we are in pitiful shape. The artwork was approved by the appropriate committee and by the City of Baltimore. Art censorship based upon alleged aesthetic sensibilities is not within the scope of the Federal Courts. Please move to place the approved modern art sculpture in place as quickly as possible.

On August 3, the *Morning Sun* editorialized, "Never has a piece of art raised more frightening prospects. Even a traditional statue of justice might well send their honors into a tizzy over what may lurk behind the marble robes. Perhaps a moat and drawbridge might assure their peace of mind, if the architects don't mind a few last-minute alter-

ations to keep the public at safe distance." And on August 12, the *Evening Sun* ran an editorial that concluded, "However the dispute is settled, the audience already holds its hands over its face, so as not to be spattered by the bits and pieces of solemn-robes dignity that have already been exploded, shrapnel-style."

The *Sun* published yet another editorial on August 13, reminding readers that

nothing in the federal arts program gives members of the federal bench the authority to exercise a veto over public art, in front of a courthouse or anywhere else. Yet the local federal judges have arrogated this power to themselves with such insistence that the federal General Services Administration now hesitates to abide by the established selection procedure. The judges' injudicial intrusion is not silly but shameful and should be viewed as such by the public, which may not know much about art but has more respect than the judges have for those who do.

On the same day, the *Washington Post* summarized the whole story in an editorial that asserted, "The world is chock-a-block with dangerous things. But the real hazard in this instance would be to let judges of law become the final arbiters of art." At long last the general public—not just the art community—was becoming aware of the issues at stake in the controversy.

On August 14, GSA announced that a public hearing would be held on September 8. The story was immediately carried in the *Evening Sun,* which noted that the hearing would be "the first one ever held by the GSA to resolve a controversy in its arts program." Up to this point, Sugarman had kept his peace while the debate raged around him, but on August 15, his first lengthy interview appeared in the *Sun* in an article headlined, "Sculptor Holds 9 Anti-Art Judges in Contempt," by Tracie Rozhon. Sugarman was quoted as saying, "The whole thing is ironic. I tried to make a sort of peaceable kingdom and they [the judges] are making it into a battleground. . . . My friends think these judges must be living in another world, in another century. The judges accuse me of inciting the public, but they started it, I didn't." Rozhon reported that Sugarman called the judges' attitude "paranoid" and said, "They can't see the human issues. They're so used to being the ultimate

judge of everything."

On September 8, at 10:00 A.M., the hearing began, with Commissioner Panuzio in the chair. Normally, one might expect less than twenty people to show up at that time of day on a Wednesday. Instead there were more than one hundred sixty people, and media coverage was extensive. All of those present testified in favor of the sculpture except Edward A. Garmatz, for whom the building had been named, and who was given the honor of speaking first. Using much of the language previously contained in Chief Judge Northrop's many letters, Garmatz said that the judges' reasons for opposing the sculpture were "legitimate" and that he didn't "see anything 'silly' about [their] views." (The *Sun*'s August 13 editorial had noted Northrop's complaint that his criticisms had been made to look "silly," which prompted several readers to react that the news coverage didn't have to make Northrop look silly since he was quite capable of doing that for himself.)

All kinds of people testified in addition to Garmatz: the president of Maryland's Artists Equity Chapter, the national president of Artists Equity, the deputy commissioner for Baltimore's Department of Housing and Community Development, the president of the Maryland Institute, art critics, artists, gallery directors, museum professionals, art professors, civic group leaders, lawyers, and others. One speaker addressed his comments to Garmatz, saying, "This building was named for him in order to honor him. If he feels so violently against this piece of work, he has every right to withdraw his name from the building." After the speeches, Commissioner Panuzio accepted comments from the floor. These, according to the report in the *Sun* (Tracie Rozhon, "Courthouse Sculpture Gets Raves," September 9, 1976), "were unanimously in favor of the sculpture." The article continued, "Finally Mr. Sugarman spoke. 'As an artist, I'm an idealist . . . maybe an optimist too. I don't look on people as a terrifying mass, . . . and the ideal of the law should be an expression of the people.' . . . As he spoke, the 62-year-old white-haired sculptor grew hoarse with emotion." Sugarman concluded with a tribute to the citizens of Baltimore (as recorded in the official transcripts of the hearing):

I envisioned this as a public sculpture in the full sense of the word, as a community, an expres-

sion of community, and I would just like to end by saying that my vision has become more true because what you people in Baltimore, even those who don't like the sculpture, how you have become interested and especially those who have supported me. It has been to me, whatever the outcome, one of the most wonderful experiences I have had and I think any artist could have.

The audience responded warmly to Sugarman's remarks, and the hearing closed on a moving note, as Rozhon reported. "At the end, as he thanked the group, his voice broke completely and his eyes grew moist behind his thick eyeglasses. Mumbling, 'I'm sorry,' he sat down to the longest applause of the day."

<center>★ ★ ★</center>

On October 13, 1976, GSA announced that "artist George Sugarman will go ahead with a proposed 50-foot-long sculpture for Baltimore's new federal building and courthouse." The long struggle seemed to be over at last. "But last night," said the *Sun* on October 14, "there were reports that the nine federal judges who had opposed the project were planning a further attempt to block it." On October 15 the *Wall Street Journal*, the *Washington Star*, and the *Washington Post* all reported GSA's acceptance of the sculpture, but on October 16 the *Post* also said that the judges were contemplating further action to prevent its installation. Sure enough, on October 19, Chief Judge Northrop wrote to Administrator Eckerd, "Courts have exercised . . . power to require examination of all packages and briefcases brought into a courthouse and electronic or other checking of persons entering the courthouse. This same power would extend to areas adjacent to the entrance of a courthouse and would include the power to prevent the erection of or require the removal of structures which would create security problems."

In response to Judge Northrop, GSA drafted a letter that was sent out without a single change on November 9, 1976. It noted, "The decision was a difficult one to make. . . . we were impressed with the preponderance of supporting testimony favoring the sculpture's placement. After reading the transcript of the hearing, you will agree that Commissioner Panuzio was im-

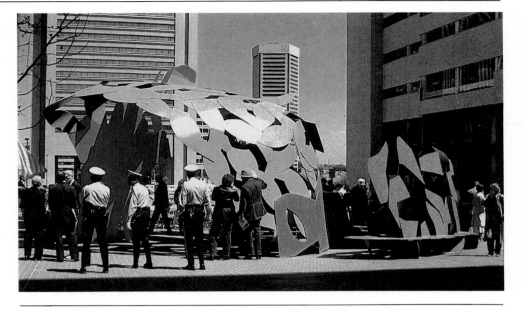

"The artwork could be utilized as a platform . . . by dissident groups demonstrating in front of the building," declared Chief Judge Edward S. Northrop of the United States District Court of Maryland. For "the tired and the lively, the idle and the harassed, . . . I can imagine it standing as a focal point and a favorite place," wrote Dean Andrew Forge of the Yale University School of Art. "The configuration of the artwork [lends] itself to all types of molestation of the unsuspecting," claimed the judge. "[Baltimore Federal] asserts freedom as well as communality and a kind of democratic respect," said Dean Forge.

partial and fair. . . . After careful review of the entire matter, we can find no other reasonable course of action than to confirm our decision to install the sculpture." In the end, Judge Northrop backed down on his implied threat, and the long struggle *was* over at last.

On May 1, 1978, George Sugarman returned to Baltimore for the dedication of his work, which he titled *Baltimore Federal*. GSA's new administrator, Jay Solomon, introduced Sugarman, who was greeted by the audience with unconcealed delight. In a statement prepared for the dedication brochure, Sugarman wrote:

My ideas about art . . . go beyond the merely formal. These provide the essential structure of any valid art, but art has also expressive values. Art means something above and beyond its formal values, and a lot of this meaning has to do with its context. *Baltimore Federal* was not going to be placed in a gallery or a museum. It was meant for a large public space that provided access to a government building. I quite consciously set myself the problem of making an abstract sculpture that would represent the relationship between the public and those government facilities.

If it is possible for an abstract sculpture to be symbolic, then *Baltimore Federal* is a symbol. The openness and accessibility of the

forms and the variety of experience that they allow, the fact that no special knowledge is needed to "understand" this art—these are some of the ideas about public/government relations that come to mind. As the city continues to live with *Baltimore Federal* other ideas and meanings will undoubtedly develop.

Apart from Sugarman's statement, the dedication was rather anticlimactic—a quiet denouement to a major reaffirmation of public principle. And that principle is this: art that is commissioned with public funds is art that belongs to the people. What the citizens of Baltimore defended in addition to the Sugarman sculpture, of course, was their right to have it in the first place.

Ironically, the judges' opposition gave a monumental boost to public art and to Sugarman's career by generating support for his work in many unanticipated ways. A gallery could never have attracted the media attention that resulted in countless editorials and magazine articles; art history books dealing with censorship will not be complete without the Baltimore saga; and the outpouring of public support for Sugarman surprised even the most optimistic art professionals. As Constance Stapleton concluded in *Baltimore Magazine* (September 1977) after recounting the complete story, "Baltimore, you've done it again! On with the Renaissance!"

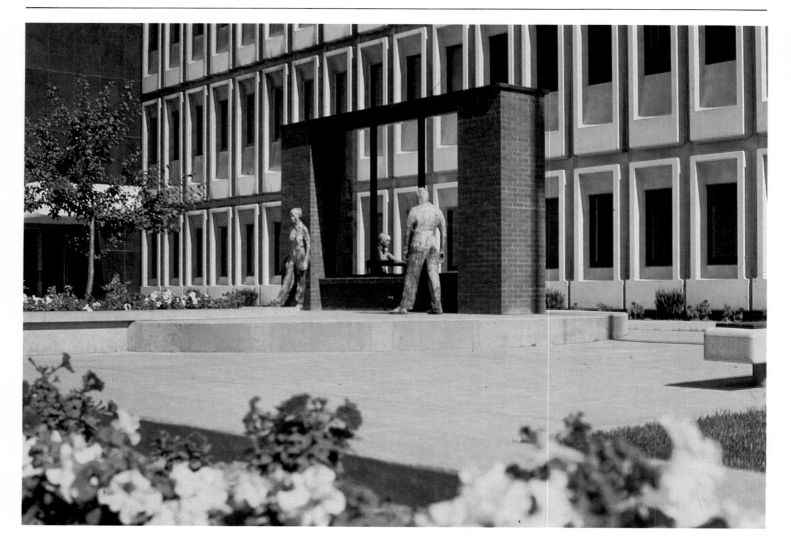

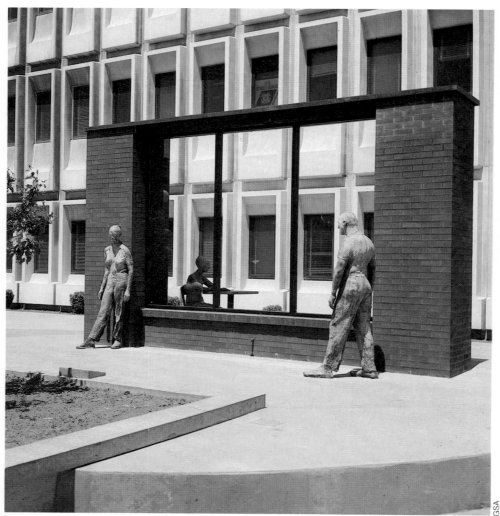

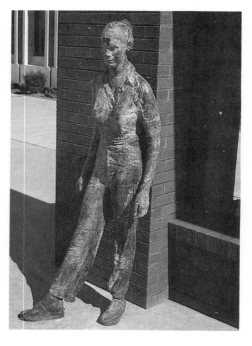

The Restaurant, *George Segal's "slice of life" sculptural tableau for the plaza of the federal building in Buffalo, New York, with a close-up of one of the life-size bronze figures (above). Segal said that he tried to make the piece "sober, austere, introverted, introspective, and yet quite calm and vertical and dignified at the same time," adding, "There's a long list of buried details in that work that are there for you to observe—that will unfold over a period of time."*

GEORGE SEGAL

Judy Olausen

The Commissioning Committee for the General Services Administration cordially invites you to the dedication of *Restaurant*, a sculpture by George Segal, Monday, June 28, 1976, 10:30 a.m., Federal Building Plaza, Delaware Avenue at Huron Street, Buffalo, New York. A dedication address will be given by the Honorable Jacob K. Javits, U.S. Senator, New York.

The invitations were printed on heavy stock, with a beautiful color photograph on the outside. They were produced and mailed out well in advance, without a penny of the taxpayers' money. In fact, the entire dedication was planned without GSA's knowledge or assistance; the agency had decided not to dedicate Segal's work because, according to Nicholas A. Panuzio, commissioner of the Public Buildings Service of GSA, it was "pornographic." Moreover, Panuzio would not permit any GSA officials to attend the dedication, which was held with Robert T. Buck, Jr., director of the Albright-Knox Art Gallery, serving as master of ceremonies. How unfortunate that the commissioning agency, under the direction of Administrator Jack Eckerd and Commissioner Panuzio, either could not or would not understand the importance of this sculpture—the internationally acclaimed Segal's first and, at the time, only permanent outdoor work.

The piece brought raves from the local press: "Segal Gives His Sculpture to the People," headlined the *Buffalo Evening News* on the day of dedication; "Motif of Segal Art Lauded," said the *Buffalo Courier-Express* the following day. In his dedication address, Senator Javits called Segal "one of the greatest of America's artists in modern times" and praised *The Restaurant* as "extraordinary," adding that for GSA to "actually commission and pay for such

an adventurous work of art as this one marks the real maturity of our country." The dedication, which concluded with Segal graciously thanking GSA "for granting me and all the other artists . . . complete aesthetic freedom," was conducted with enthusiasm and dignity.

★ ★ ★

Segal had been nominated in November 1974 by NEA-appointed panelists (one of whom was Robert Buck) and the building's architect, Theodore A. Biggie of Buffalo. In May 1975, Administrator Sampson selected Segal, and a contract was negotiated in June for $60,000. Initially, Segal was reluctant to accept the contract, for reasons primarily relating to the very nature of public art. As he later said during an interview,

I'm accustomed to keeping myself independent of the opinions of people who don't care about art. . . . I have a . . . history of insisting on the privacy of my work . . . working independently and not to satisfy any public taste. . . . I had all kinds of hesitations—reservations about what was public art. . . . I didn't want to lose the intensity of personal experience and response. I thought a long time—almost turned it down until I could figure out how to make something big enough that I could walk into, that would be intense enough and personal enough so that I would feel comfortable with the statement.

In October 1975, Segal submitted a wash, crayon, photo-collage rendering of his proposed sculpture. "The life-size figures are to be cast in bronze, with a matt white finish done by chemical oxidation, of the character and permanence of Statue of Liberty green," he

wrote in the accompanying letter. "The sculpture is designed as a space around which the spectator can walk, with the feeling that he or she is on the street outside with the walking man, and inside the restaurant with the seated girl, with the drama unspoken and in the heads of the observers."

Segal later spoke at length about his choice of the restaurant tableau. He described it as a slice of life—or, more precisely, a slice of the street behind the federal office building; it has "the same kind of architecture and people—except that it's frozen." At the same time, it is alive with meaning and possibility:

. . . this particular restaurant sculpture has the idea of the window in it . . . inside/outside. The thickness of a pane of window is deceptively transparent; you can see through it, but it is like a ton of lead separating different worlds. So the guy outside—walking outside on the street—is missing making contact with the girl inside. Like they're self-absorbed, looking in different directions, and the transparent window, where they could easily have turned their heads and glanced and locked glances—they're not, it's not happening. Then the girl leaning against the brick column—well, we don't know if she's going to connect with the guy or not, but she's a teenager. The guy is middle-aged and the girl inside is thirtyish. The ages were important to me.

I tried to make it sober, austere, introverted, introspective, and yet quite calm and vertical and dignified at the same time. You try to pack in a big list of qualities.

The Restaurant was Segal's first encounter with bronze, and he found it a rewarding one. "I've come to bronze very late, and I'm shocked by its beauty. It's a permanent material and keeps changing. And every stage is beautiful." He did not find the commission financially rewarding, however. "I blew most of the budget on production," Segal recalled. "I got intrigued with exploring the possibilities, and since it was my first outdoor bronze, . . . I figured I should at least offer their money's worth." Segal estimated that if the work were placed on the open market it would bring a minimum of $150,000—"and that's being cold-blooded hard realistic; it could go much higher."

And how did Segal feel about GSA's refusal to dedicate his work?

At the point of my completing the bronze and installing the piece, I was aware of the uproar and the protest about the Sugarman in Baltimore. . . . I'd read about it in the paper, discussed it with a lot of my artist friends, and my feeling was that if there's an uproar—a groundswell of protest from whatever source, whether it's the citizens of the town or the judges—and these people are convinced that this artwork is of terrible quality, and if I disagree and think this work is of excellent quality, then politeness should stop and there should be a standing of ground.

I was annoyed, frankly, that the GSA—after its history of being impeccable—turned cowardly in the face of criticism. . . . When Mr. Buck decided to have the dedication in the face of GSA disapproval (they were hoping I would sneak quietly into the woodwork), I instantly agreed out of pique and conviction that I liked the work I'd done. I thought it had fulfilled its purpose. I'd spent much more money on production than I thought I would. I had been ambitious, idealistic, non-self-seeking in the finishing of the

piece. I was unwilling to bend my head in the face of what I thought was bad-mannered and ignorant criticism. . . .

That may sound contentious, but it takes a certain amount of conviction and strength over a period of years to continue doing independent artwork.

Despite GSA's official response to

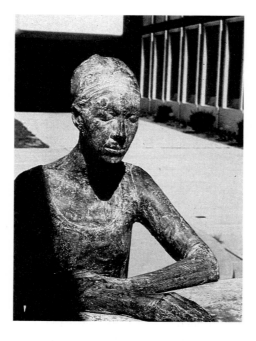

his piece, Segal's ultimate assessment of the Art-in-Architecture Program was a positive one. "I think that . . . the GSA, the National Endowment people, and all the artists involved in this program have been almost overwhelmingly idealistic and well-intentioned. The desire of a long list of artists to completely knock themselves out—to work to the best of their ability—certainly gives their government its money's worth."

Opposite: Two views of Segal's Restaurant. *The sculpture consists of three life-size figures arranged around a restaurant facade—a male pedestrian, a female pedestrian, and a seated female diner. The figures are cast in bronze and finished with a matt white patina. The table and chair are made of dark brown bronze. The wall, constructed of cinderblock faced with brick, measures sixteen feet wide by ten feet high and holds a window made of tempered glass.*

Left: A close-up of the figure at the table, as it appears from "inside" The Restaurant.

Below: The sculptor sits meditatively on The Restaurant's *window ledge, almost seeming to become one with his creation. "It's about people," says Segal, "about people not getting together, how big empty spaces are, or how charged they are."*

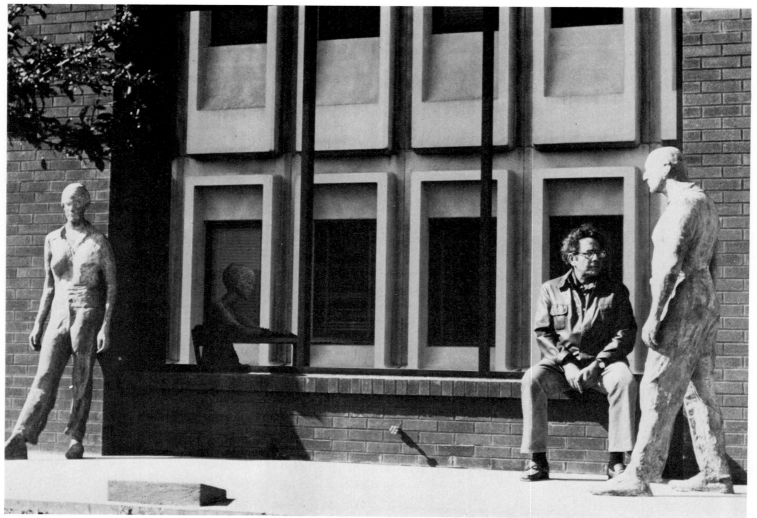

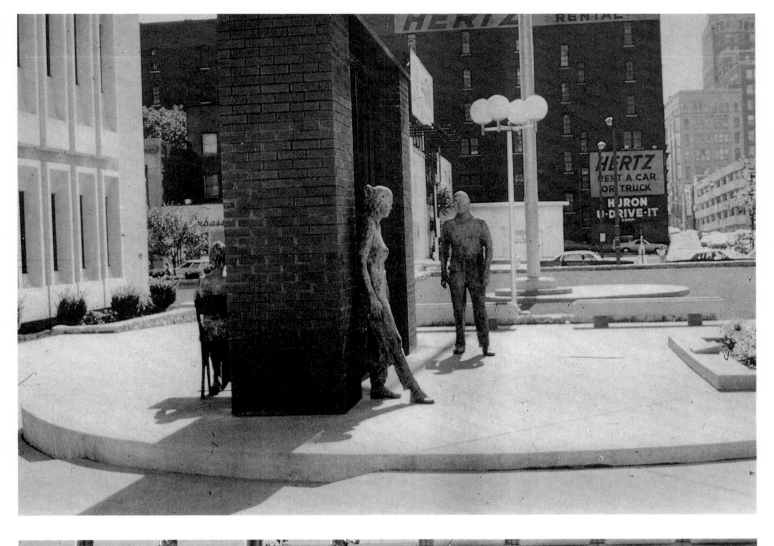

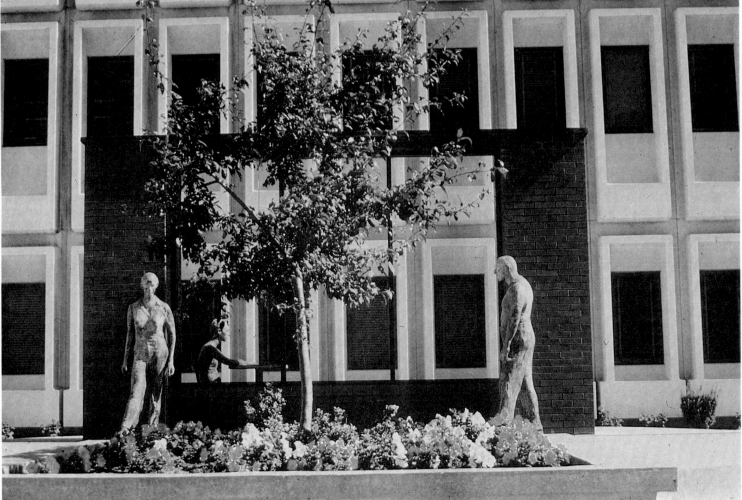

The task was formidable: four gigantic murals, the first fourteen feet high and forty-five feet wide, for the lobby of the Social Security Administration Great Lakes Program Center in Chicago, and three additional works for the cafeteria, two of them ten feet by forty-two feet, and the other ten feet by sixty feet. Design possibilities were further limited both by architectural interruptions in the cafeteria (doors and an open "pass-through" for dishes) and by the decision to construct the murals of baked porcelain enamel on steel panels. The appropriately named Challenge Porcelain Company of Grand Haven, Michigan, had already been awarded a contract to fabricate and install the panels for the artist, who would design the murals as well as supervise and approve fabrication and installation.

Ilya Bolotowsky was ideally equipped, professionally and temperamentally, for the job. Born in St. Petersburg, Russia, in 1907, he emigrated to

ILYA BOLOTOWSKY

Otto E. Nelson

Right: Ilya Bolotowsky's mural for the main lobby of the Great Lakes Program Center in Chicago, as seen from the entrance.

Below: An interior view of the mural.

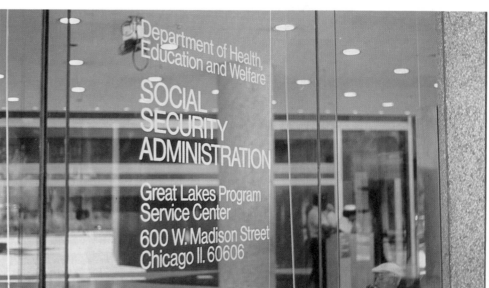

Nick Chaparos

Nick Chaparos

the United States in 1923 and studied at New York's National Academy of Design until 1930. During the Depression he received commissions through programs sponsored by the Work Projects Administration and the Treasury Section of Fine Arts. He was one of the few painters with long-standing credentials as a muralist, and his steadfast adherence to the stylistic ideals of neoplasticism was perfectly suited to a geometric design. Thus, when the NEA-appointed nominating panel met with architect Bill Baker of Lester B. Knight and Associates (the firm that designed the building), Bolotowsky was a logical choice.

★ ★ ★

Bolotowsky arrived in Chicago in mid-February 1975 to discuss the contract and fee. Prior to negotiations, the scope and nature of the work were thoroughly explored. Bolotowsky, the architects, and representatives from GSA's Chicago office, the Turner Construction Company (which installed the murals), and the Challenge Porcelain Company discussed the fabrication of the porcelain panels, construction schedules, and the unusual mercury vapor lighting system, which caused concern because it seemed likely to distort the artist's color scheme. Bolotowsky was unhappy about the mercury vapor lights but otherwise undeterred by the requirements of the project. As he later wrote,

When I was told that GSA wanted the mural to be indestructible, and so porcelainized steel plates would be ideal for it, I found it a challenge as a mural. If I were asked to do an easel painting in porcelainized steel, I would say it is too limiting a material. . . . But to use something that is strong and washable—and in texture a part of the whole building—I think it is perfectly legitimate.

The contract was negotiated for a fee of $45,000. Bolotowsky was something less than overwhelmed by the sum and noted in a letter to Administrator Solomon, ". . . the financial terms of the contract were way below the corresponding art market prices. For example, the four small sketches on paper for these murals [his design proposal] could have been sold for about one-sixth the fee, which also included costs for the four murals together." Gently

Bolotowsky created three large murals for the walls of the building's cafeteria area. They differ in design but use the same colors as the one pictured here. All four works —the three cafeteria murals and the lobby mural—are composed of porcelainized steel panels specially fabricated to Bolotowsky's exacting standards by the Challenge Porcelain Company.

taking a certain GSA official to task, he continued, "It's kind of remarkable that the artists who work for Mr. Thalacker don't hate him. . . . he's a very pleasant man, but he knows how to keep them at the lowest possible prices. Actually, and this is a fact, nobody calls him Scrooge; he doesn't do it for himself, but for his government. So, he's forgiven."

Bolotowsky was given the formal go-ahead in the spring of 1975 and started to plan the murals. He decided on vivid, bold colors—deep blue, red, yellow, black, and white—for the main lobby "because as you enter you should have the stongest effect . . . [and] because in that space the ceiling was the highest. . . . I could expand and use a stronger color scheme [because] the size of the room, on the whole, would be able to take it." For the cafeteria area, which was a smaller, triangular space, he chose a more subdued pastel color scheme—pale blue with yellow ochre, white, and accents of red and deep blue.

Bolotowsky kept a running liaison with the Challenge Porcelain Company from his New York studio, working with the company's representative, J. K. Keating. Trial colors were tested over and over. "I found the bunch very nice; especially Keating was very patient and very good-natured. . . . when I sent back some of the color samples and requested changes, they kept on trying

and trying. . . . it was nice working with them, and they didn't bother me. I *did* bother them a great deal, and I say this: they took it very well." However, Bolotowsky could not get the desired deep purplish blue for the lobby mural with the baked enamel process, and at this point the dreaded mercury vapor lights came to the rescue. Just as had been feared, they distorted the colors, but in so doing, they "created the effect of the blue I needed exactly. In other words, between the light—which many people disliked—and the limitations in the porcelainized steel colors, I managed to get the colors I really wanted."

To minimize potential damage from other construction activity in the mural areas, the panels were not put up until the building was nearly complete. They were then carefully laid out and numbered for sequential installation. Once in place, the four murals transformed the spaces instantly, as if by magic. It was the first time Bolotowsky had been able to see the total effect, since it was only after they were installed that the panels became whole compositions. Clearly satisfied, he wrote,

One thing that pleased me was that the staff in the building came to me and told me how much they liked it. They said this makes the building much nicer to work in. . . . They were very appreciative, and I found that very touching. Their feelings mean a lot to me because . . . they have to stay there five days a week, eight hours a day. It's like listening to a piece of music over and over; if you can put up with it, it must be okay.

The results so impressed the Lester B. Knight architects that the firm decided to fill the vacuum left by GSA's decision not to dedicate artworks during that administration. On October 28, 1976, they sponsored an unveiling ceremony and reception in honor of the monumental project and its creator. Bolotowsky, who was the recipient of well-deserved applause, passed the compliment along to GSA, putting the accomplishments of the Art-in-Architecture Program in flattering perspective: "The GSA art program may be compared with that of Pericles in ancient Athens. It is artistically, culturally, and historically important. Its importance for the general public and for the artists needs no explanations."

"54-foot Calder Sculpture Arrives for Erection Here," headlined the *Chicago Daily News* on October 8, 1974. "Windy Birth for Calder Stabile," said the *Chicago Tribune* on October 9. "Workmen are putting the final touches on another piece of art for downtown Chicago. Unlike Calder's famous mobiles, the *Flamingo* is . . . firmly anchored to the ground and doesn't move," reported WLS-TV's six o'clock Eyewitness News on October 10. And for weeks thereafter the stories and headlines kept coming.

October 16: "Mayor Richard J. Daley has officially proclaimed Oct. 25 as Alexander Calder Day" (*Daily News*).

October 17: "Chicago Gives Calder a Circus" (*Daily News*).

October 18: "'Flamingo' Primed for View" (*Daily News*); "'Flamingo' Gets Ready for a Big Day" (*Sun Times*).

October 19: "Calder Calendar" (*Daily News*).

October 20: "Calder in the '20s–'I Remember Sandy'" (*Sun Times*).

October 21: "Circus Gets on Calder Bandwagon" (*Tribune*).

October 24: "And Now It's Calder's Turn in the Plaza" (*Tribune*); "Circus Parade Salute Here Set as Calder Comes to Chicago" (*Daily News*).

October 25: "Calder and His 'Flamingo'" (*Sun Times*); "Loop Circus Hoopla Welcomes Calder" (*Daily News*).

October 26: "A Great Day for ChiCalder!" (*Sun Times*); "A Whatchama-Calder Sculpture Conquers the City" and "To Chicago with Love: Calder" (*Tribune*).

Never has there been such a public outpouring of praise and affection for an American artist as attended the dedication of Alexander Calder's *Flamingo* in the Chicago Federal Center plaza. As Calder made his ceremonial entrance into the Windy City, tens of thousands of people lined State Street to give him the sort of welcome usually reserved for military heroes and athletes. Sitting atop the famous Schlitz circus bandwagon, Calder and two of his grandsons were able to survey the entire spectacle, complete with marching bands, calliopes, clowns, antique red-and-gold circus wagons, elephants, and balloons. The parade even featured a ringmaster, architect Carter Manny, Jr. (who, as one of the design architects for the building,

ALEXANDER CALDER

A. Calder

had initiated the selection of Calder for the project). When the wagon, drawn by forty horses, pulled up in front of the Federal Center, Manny blew his whistle and, his voice booming through countless loudspeakers, announced, "Ladies and gentlemen and children of all ages, I present to the people the one and only Alexander the Great—Sandy Calder!"

Mayor Daley officially escorted Calder from the wagon as an Air Force band played "Stars and Stripes Forever." Hailing Calder as "one of the world's truly great artists," Daley spoke briefly of Calder's achievements. Senator Charles Percy, GSA administrator Arthur Sampson, and NEA deputy chairman Michael Straight also made speeches, and President Ford sent a congratulatory letter, noting that it was the Calder stabile in his hometown of Grand Rapids "which encouraged me to support the arts when I was in Congress." Then, with a huge pair of cardboard scissors, Calder ceremoniously cut a rope to release thousands of balloons from within the sculpture. As Henry Hanson reported in the *Chicago Daily News* (October 25), "The balloons —red, blue and green—soared higher and higher and finally broke into the sunlight as the mantle fell from the stunning, bright red abstract sculpture."

Calder, with his wife, Louisa, at his side, said hardly a word and made no official speech. He didn't have to; his work spoke eloquently for him—and his work was in ample supply in Chicago. In addition to *Flamingo*, Calder was on hand to dedicate another major commission, a moving, electrically powered abstract mural titled *Wood's Universe*, created for the lobby of the Sears Tower. Furthermore, the Museum of Contemporary Art had opened a Calder retrospective to coincide with the dedications.

★ ★ ★

The road to this brilliant finale was neither particularly long nor complicated. But it was terribly important, because it represented GSA's public kickoff of the Art-in-Architecture Program (then called the Fine Arts in New Federal Buildings Program) shortly after Administrator Sampson reactivated it late in 1972. Within months of the reactivation, in consultation with Karel Yasko (GSA's counsellor for fine arts and historic preservation), the architects for the Chicago Federal Center had begun quietly pursuing the possibility of commissioning a major work by Calder.

Left: The maquette for Alexander Calder's Flamingo, *mirrored by a photograph of the maquette in a mock-up of the site.*

Opposite: Flamingo, *in the plaza of Mies van der Rohe's Chicago Federal Center. "This magnificent piece by America's greatest living sculptor will greatly enhance Chicago's already impressive downtown environment," said GSA administrator Arthur F. Sampson at the dedication ceremonies in October 1974. "No more appropriate community could have received a major work of Alexander Calder's than Chicago, where the cityscape has been constantly revitalized by the nation's foremost architects of the Chicago school."*

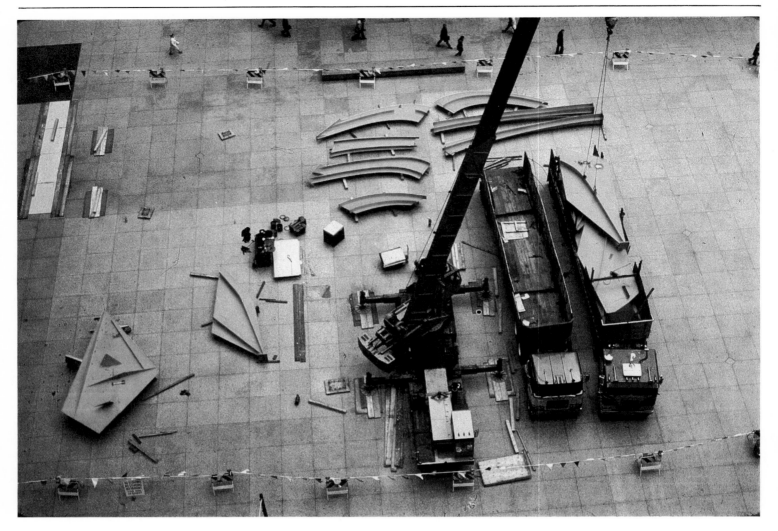

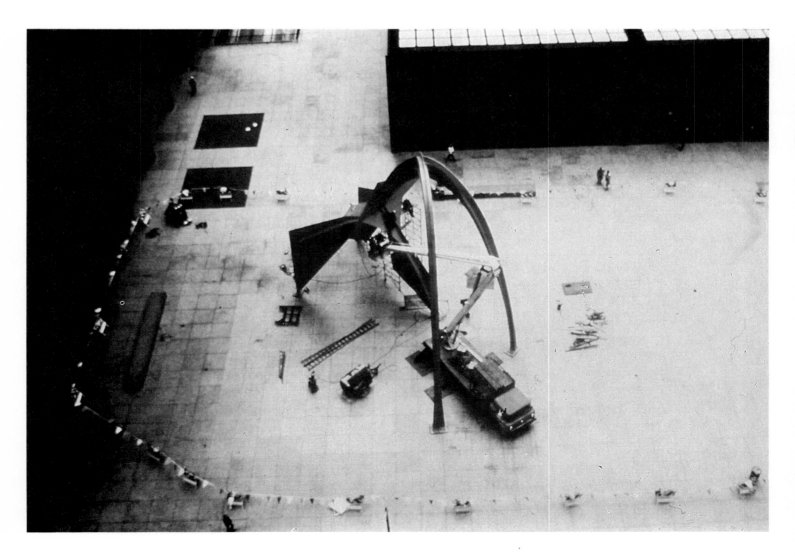

On January 29, 1973, architect Carter H. Manny, Jr., wrote GSA on behalf of his joint-venture firm (Chicago Federal Center Architects, which included Mies van der Rohe as principal design architect): "How great it would be to have a monumental work of sculpture to adorn the Federal Center plaza.... Clearly the artist should be an American, and someone of comparable stature to Picasso and Chagall [each of whom have major works in Chicago]. There is only one man who meets these two requirements," concluded Manny. "Alexander Calder."

Calder, unquestionably one of the Olympian figures of modern art, was born in Pennsylvania in 1898. His father and grandfather were sculptors, his mother a painter. He studied engineering, enlisted in the navy during World War I, and then held a succession of jobs, working as a journalist, setting sail on a freighter, serving as a timekeeper in a logging camp, and drawing all the while. In the 1920s, he began creating his *Circus*, articulated miniatures made of wire, cork, and wood (this work inspired the theme of the Chicago celebrations). In the late 1920s and 1930s, he divided his time between the United States and Europe, especially Paris, where he became acquainted with leading modernists of various aesthetic persuasions. Soon he was building his famous mobiles and stabiles, unique creations that in many ways redefined the concept of "sculpture." Writing more than a quarter-century ago, James Johnson Sweeney said:

Exuberance, buoyancy, vigor are characteristics of a young art. Humor, when it is a vitalizing force, not a surface distraction, adds a dimension to dignity. Dignity is the

Above: The artist models a T-shirt bearing a motif drawn from his Circus, *a whimsical collection of miniatures he constructed of wire, wood, and cork in the 1920s.*

Opposite, top: Flamingo *awaits assembly in the Federal Center plaza. Calder's sculpture was fabricated by Segre's Iron Works in Waterbury, Connecticut, and shipped to Chicago in sections on two large flatcars.*

Opposite, bottom: The installation proceeds. Calder's brightly painted steel stabile was the first work commissioned under the 1972 reactivation of GSA's Art-in-Architecture Program. Once in place, it joined major works by Picasso and Chagall in enlivening Chicago's Loop and infusing it with "a Renaissance quality ... reminiscent of the era when people's art in public places of Rome and Florence reached a high point," in the words of Administrator Sampson.

product of an artist's whole-hearted abandon to his work. All these are features of Alexander Calder's work, together with a sensibility to materials that induces new forms and an insatiable interest in fresh patterns of order. [*Alexander Calder*, The Museum of Modern Art, New York, 1951]

Indeed, there *was* only one man who met Manny's requirements.

Manny had done his homework. His firm had already been in touch with Calder about the possibility of the project, and Calder had responded positively. "He has created a maquette for a magnificent piece for the Federal Center," Manny wrote. "The tip of the highest arch would be approximately fifty-three feet high. It would be made of steel and be painted red—a magnificent abstraction to look at from afar, but even more to experience while walking around and underneath." Manny had also secured from Calder's dealer, Klaus Perls, a price ($250,000 plus installation) that was reasonable in terms of GSA's guideline (one half of one percent of the construction cost of the building). "There is another point that makes this project enormously appealing," he added.

We have said nothing so far of the Federal Center buildings themselves and of Mies van der Rohe, the architect who conceived them. Clearly he was a creative giant who himself belongs in the same company with Picasso, Chagall, and Calder as one of the greatest artists of our time. In the view of several who were his longtime friends and associates, he admired Calder's work very much. We thus find it doubly appropriate to realize our goal.

Manny also had the future of the Art-in-Architecture Program in mind as he concluded, "... we can think of no more appropriate way to launch the program of incorporating artwork into federal buildings."

In less than two weeks, Commissioner Larry F. Roush of the Public Buildings Service had sent Administrator Sampson a memo requesting that Calder be awarded the commission, noting that although selection procedures had not yet been worked out with the National Endowment for the Arts, it was believed that the NEA would

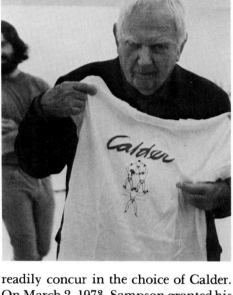

readily concur in the choice of Calder. On March 2, 1973, Sampson granted his approval, and on March 20 the assistant commissioner for construction management, Walter A. Meisen, sent Calder and Perls a proposed contract, which was in essence the standard contract for architectural-engineering services— a more complex document than all artists since Calder have used.

On April 6, Perls informed Meisen that Calder had signed the contract earlier that week. His letter was filled with very exciting news:

All Sunday morning Calder worked on the detailed engineering plans for the Chicago stabile, drawing in gussets and ribs, changing the width of certain parts of the arches, and generally giving instructions to Carmen Segre for the fabrication of the Intermediate Model.

Once that model will have been made, Calder will be able ... to make last-minute changes before work on the large stabile will begin.

Administrator Sampson could hardly wait to announce the good news. On April 13, GSA issued a press release briefly describing Calder's proposed work and promising further details at a news conference to be held on Monday, April 23, at the Federal Center. It would be an understatement to say that the press was waiting for Sampson in Chicago. The conference room was packed as he expanded on the nature and significance of the Calder commission, stating in part:

The President has said that "only if the arts are alive and flourishing can we experience the true meaning of our freedom, and know the full glory of the human spirit." No artist in America today more typifies

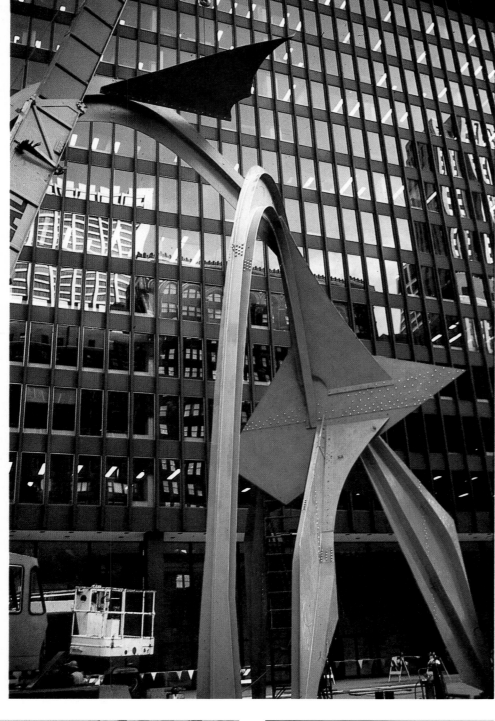

that same freedom and human spirit than Alexander Calder. And no city better represents America's freedom and spirit than Chicago. . . .

It was 1962 when sufficient Congressional and Presidential interest prompted renewed efforts to include fine art in Federal buildings. . . . For the next three years, an effective arts program was again a priority of the Federal Government.

Unfortunately, history has a way of repeating itself. Just as the rejuvenated Federal arts program was beginning . . . economic considerations forced it to a back shelf one more time in 1966. . . .

Fine art remained in the background until President Nixon urged greater Government involvement in and support of the arts two years ago. . . . It is this commitment that brings me to Chicago today, and will in the years ahead bring art to all the people of America.

Calder's sculpture is even more significant [as] the first in a new program to place fine art in Federal buildings. The President's commitment is to forge a new partnership between Government and the arts "to the benefit of the people of America."

The newspapers picked up on Sampson's statement with lightning speed and bold headlines, and the citizens of Chicago eagerly awaited their Calder. Meanwhile, Segre's Iron Works in Waterbury, Connecticut, worked diligently at its fabrication. By the end of 1973 the stabile was almost complete, and on December 28 Karel Yasko made an inspection, the results of which he reported in a memo dated January 2:

It is a graceful and impressive piece of sculpture with excellent scale for its place in the center. Calder supervised the final development this fall and inserted some

Above: The installation draws to a close as the final section of Flamingo *is carefully lowered into place by a giant crane.*

Bottom left: The artist and one of his grandsons atop the Schlitz circus bandwagon during the parade that kicked off Chicago's Calder festival. An exuberant crowd of thousands lined State Street to welcome Calder to the Windy City and attend the dedication of Flamingo *after the parade.*

Bottom right: Two confirmed Calder fans gaze raptly towards the upper reaches of Calder's stunning stabile during the dedication ceremonies.

secondary vertical planes which appear to spring from the base of the main arches and add greatly to the texture at the human scale. His final hand is also apparent in the richness of detail throughout, which was not apparent in either the maquette or the preliminary study, both of which I have viewed.

The sculpture is signed by Calder about seven feet above the base of one of the main arches.

Flamingo was shipped to Chicago for installation ten months later, following substantial underground structural modifications to support the work. Its bright orange-red arches and planes enliven the plaza, bringing Calder's grace, wit, and intelligence into the lives of passersby. Writing for the dedication brochure, Calder said:

I feel an artist should go about his work simply with great respect for his materials. . . . Sculptors of all places and climates have used what came ready to hand. They did not search for exotic and precious materials. It was their acknowledge and invention which gave value to the result of the labours. . . . Simplicity of equipment and an adventurous spirit in attacking the unfamiliar or unknown. . . . In my own work, when I began using wire, . . . I was working in a medium I had known since a child. For I used to gather up the ends of copper wire discarded when a cable had been spliced and with these and some beads would make jewelry for my sisters' dolls.

Disparity in form, color, size, weight, motion, is what makes a composition, and if this is allowed, then the number of elements can be very few. Symmetry and order do not make a composition. It is the apparent accident to regularity which the artist actually controls by which he makes or mars a work.

★ ★ ★

A few days after the dedication, William Morrison, the Chicago regional commissioner of the Public Buildings Service, overheard two men complaining about the waste of their

Helium balloons soar skyward through Flamingo's *arches at the moment of dedication. "The apparent spontaneity of Calder's work is no accident," wrote James Johnson Sweeney (*Alexander Calder, New York, 1951*). "It is rather what John Dewey describes as 'complete absorption in subject matter that is fresh, the freshness of which holds and sustains emotion.'"*

tax money on "that piece of junk." He moved closer, interested to learn more about their views. When he heard one man say to the other that he wished the government would refund the "wasted money," Morrison took two pennies from his pocket and, interrupting their conversation, gave one to each man. "Considering that all the people of America paid for this work, and that you, believing it to be a waste, wish to have your portion returned to you, I am giving you each one penny, which is more than your share," he said. "Now that you've been repaid, let me tell you that this work of art belongs to all of the American people except you and your heirs." The men were stunned. They tried to return the pennies as Morrison went back to his office overlooking Calder's magnificent *Flamingo*.

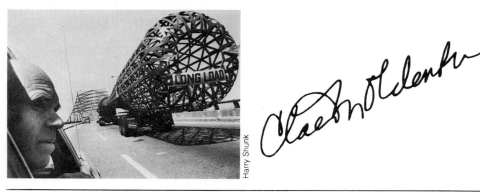

CLAES OLDENBURG

"If you're traveling over the turnpikes between Connecticut and Illinois next week, keep a tight grip on the steering wheel. You may encounter a 100-foot baseball bat enroute to Chicago," warned a GSA news release on March 31, 1977. And indeed, Claes Oldenburg's gigantic twenty-ton *Batcolumn* made quite a spectacle as it rolled along the nation's highways on its way to a permanent site in the plaza of Chicago's new Social Security Administration building. As Paul Galloway reported in the *Chicago Sun-Times* ("A Truckload of Clout's Swinging Its Way into City," April 8, 1977), "It doesn't look like a baseball bat to everybody. Five-year-old Bill Sprenghether of Sturgis, Mich., just didn't see it that way. Bill had stopped at the tollroad service station with his family to get gasoline. 'It's a cage, daddy. It goes under the water and keeps the sharks from getting you,' Bill said. 'No, it's not, honey,' his father, Bob, said. 'It's a baseball bat. It's an imaginary baseball bat. Sort of.'"

Well, yes—sort of. In April 1976, one year before the *Batcolumn* was installed, Claes Oldenburg sent GSA his thoughts on the background of the sculpture.

There are several reasons why I should come to the *Bat* as a Chicago subject. One is the insistent presence there of chimneys, or the awareness of chimneys, because of the horizontality of the landscape. The chimney, the sort of ordinary subject I like to use, subjected to inversion—a favorite device of dislocating the object from its function, freeing it for art—gives the *Bat*-shape. The *Bat* itself is of course an ordinary subject, and like the chimney has the formal values that lend themselves to development as art. The *Bat* has no up or down, but it is presented here as being held. The *Bat* points to the sky, calls attention to the sky, to space. I find the heightened awareness of space characteristic of the city of Chicago. . . .

As I imagine the *Bat*, it rises from a pile-type foundation. Thus, in effect, a similar form extends down into the earth.

Some coincidences:

The columns of the Northwestern station to the east of the site, which were the first thing I noticed about the site.

The site is open, with chim-

neys and water towers (tanks) on their linear silhouetted bases much in evidence.

The top of the Salvation Army mission to the west is a replica of a lighthouse, also a column form. . . .

The diamond pattern which is repeated throughout the structure refers to Brancusi's *Endless Column,* and the diamonds are an unintended visual pun reference to

baseball, as is the (batting) "cage."

The *Bat* could be called a monument both to baseball and to the construction industry. And undoubtedly to the ambition and vigor Chicago likes to see in itself.

The *Bat* stands on Madison Ave., which is the dividing line between north and south numbering in the city. A compass, or circular and symmetrical form, has been part of the concept from the beginning.

Within my private system of references: bat equals icebag, inverted and extended.

★ ★ ★

Oldenburg had been nominated for the Chicago commission by the building's architect and a panel of art professionals appointed by the National Endowment for the Arts. He was subsequently selected by GSA administrator Sampson, and on February 14, 1975, the contract was negotiated in the architect's office in Chicago for a fee of $100,000. He began work immediately, but his final design was the fruit of a long creative search. In a penetrating article on Oldenburg for the *New Yorker* (December 1977), Calvin Tomkins discussed the genesis of the *Batcolumn,* noting that Oldenburg had originally contemplated an inverted four-outlet fireplug as the form for the sculpture. He made a small cardboard representation of the fireplug concept and took it to Chicago to study it in relation to the building, a model of which had been provided by the architectural firm of Lester B. Knight and Associates. Oldenburg and the project architect, William R. Baker, had already discussed the site and its surroundings and concluded that the work should be vertical. They considered the fireplug design, as well as one based on a long-handled spoon, but rejected both. Then, according to Tomkins,

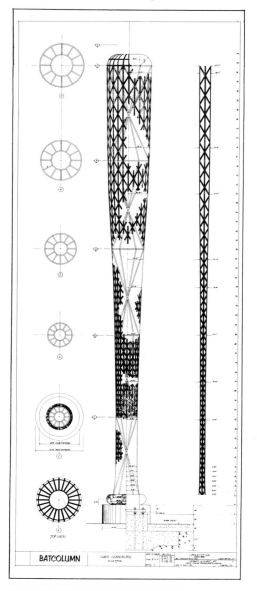

Oldenburg's design for the Batcolumn.

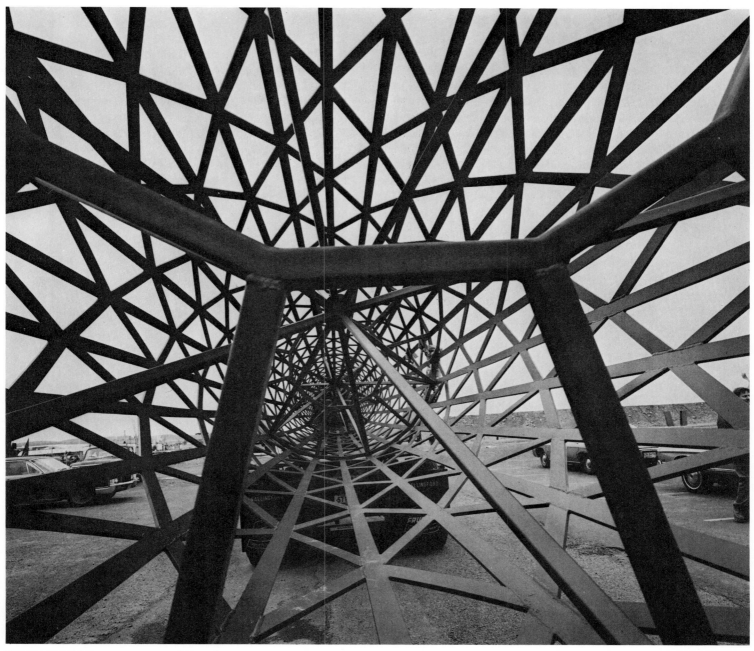

Harry Shunk

The Bat *on wheels. The intricate latticework of the column emerges
clearly in this interior view along its central axis, from top to bottom.*

inspiration visited [Oldenburg] on a trip to Chicago, when he saw on the front page of a Chicago paper a photograph of a tornado that had hit Kansas the day before. Tornadoes have always fascinated him. The twister's black funnel made him think of his *Bat Spinning at the Speed of Light* [a 1967 lithograph], and he decided then and there that what Chicago needed was a monumental (stationary) *Batcolumn,* standing on end, handle down. The next day, when he was out at the building site, his eye lingered on the cross-bracing of a huge construction crane. Seeing the crane against the building made him decide to make his *Batcolumn* an open form, rather than a solid, Louisville Slugger type, so that one could see through it to the open sky beyond.

Fabrication of the *Batcolumn,* which took place at the Lippincott company in North Haven, Connecticut, began in November 1975, after a delay of several months due to the steel mill's inability to deliver the Cor-ten steel (of which the piece is made) on the originally promised date. The Lippincott crew—Edward Giza (plant manager), Robert Giza (welder, construction worker), and Robert Jennings (engineer), among others—worked out all the fabrication details in collaboration with Don Lippincott and Claes Oldenburg. According to Calvin Tomkins, the first *Bat*-raising took place "on a cold, windy day in late March . . . in the parking lot behind the factory. . . . when the still unpainted monolith was fully upright, against a sky of broken scudding clouds, everyone there felt very good about it. Roxanne Everett said she had never before seen Oldenburg get really excited about his work. The raised *Bat* looked much longer than it had looked lying on its side. 'It really does a lot of interesting things,' Oldenburg said."

Once the *Batcolumn* was painted, there remained only to transport it to Chicago—a not inconsiderable feat that was accomplished with great ingenuity. In the absence of a truck large enough to accommodate it, the *Batcolumn* itself *became* the truck, with axles and wheels mounted at either end. The story was

picked up by AP and UPI, and news-papers from coast to coast covered the sculpture's odyssey. In particular, the Chicago papers had fun with the event, and Paul Galloway wrote in his April 8 *Sun-Times* story, "Even lying horizontal on its truck carrier, it's an imposing sight. . . . There are those who feel the open-lattice construction is appropriate. Considering the ability of the Cubs and the White Sox, it makes sense for Chicago to display a giant bat with holes in it."

On April 12, 1977, the second and final *Bat*-raising took place on the site in Chicago. Beginning at 1:45 P.M., a crane started to lift the top of the bat, and by 2:15 it was fully upright. AP and UPI followed the entire sequence of the erection photographically. The work was officially dedicated on April 14 by former Chicago Cubs shortstop and first baseman Ernie Banks, acting Chicago mayor Michael Bilandic, Joan Mondale, and other dignitaries from the world of sports, politics, and the arts. By that time, the *Batcolumn* was the most widely publicized project in the history of the Art-in-Architecture Program. Stories and photographs were featured on the front pages or in the headlines of nearly three hundred newspapers, I was told.

Unfortunately, not all of this attention was positive. Eight months earlier, on August 30, 1976, Senator William Proxmire had awarded his "Fleece of the Month" award to GSA. In his press release, he dwelt on the *Batcolumn* at length.

Consider the case in Chicago where GSA plans to spend $100,000 for a gigantic 80–100 foot baseball bat. That's right—a baseball bat made of red painted steel to be put in a plaza of a federal building. [Oldenburg's original maquette was red, but he later decided that the full-sized work would be better in gray.] The bat is called a "high structural latticed column in red painted steel." But if it's not a baseball bat, then I'm blind as a bat. Baseball is indeed our national game. A statue of Babe Ruth, Ernie Banks or Bill Madlock, the Cub's current star, would have some merit. But a $100,000 bat paid for by all of America's taxpayers is a strike-

out with the bases loaded.

Proxmire also took exception to several other "questionable" GSA-commissioned works, including Alexander Calder's *Flamingo* in Chicago, Frank Stella's mural in Wilmington, and Charles Ginnever's sculpture in Saint Paul, which he likened to "a rusty piece of farm machinery left out in the field." He did, however, like Isamu Noguchi's sculptural environment of granite boulders in Seattle. Since one of his colleagues in the House of Represen-

tatives, Ted M. Risenhoover of Oklahoma, called this same work part of "a pet rock craze sweeping the country," it was hard to agree with Proxmire when he concluded, "What we have here is not a question of 'what is art.' That can be debated endlessly and without solution. Luckily, we have a standard by which to judge. . . . I am sure the American public agrees that this baseball bat does not represent 'the finest works of art' standard applied by GSA and the National Endowment of [*sic*] the Arts." The *Chicago Sun-*

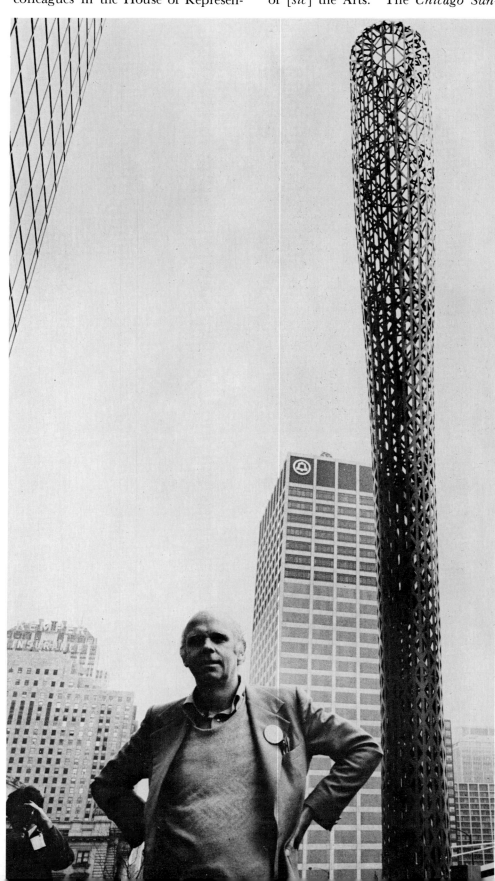

Opposite: Claes Oldenburg's Batcolumn *in the plaza of the Social Security Administration building in Chicago.*

Right: The sculptor and his creation.

Harry Shunk

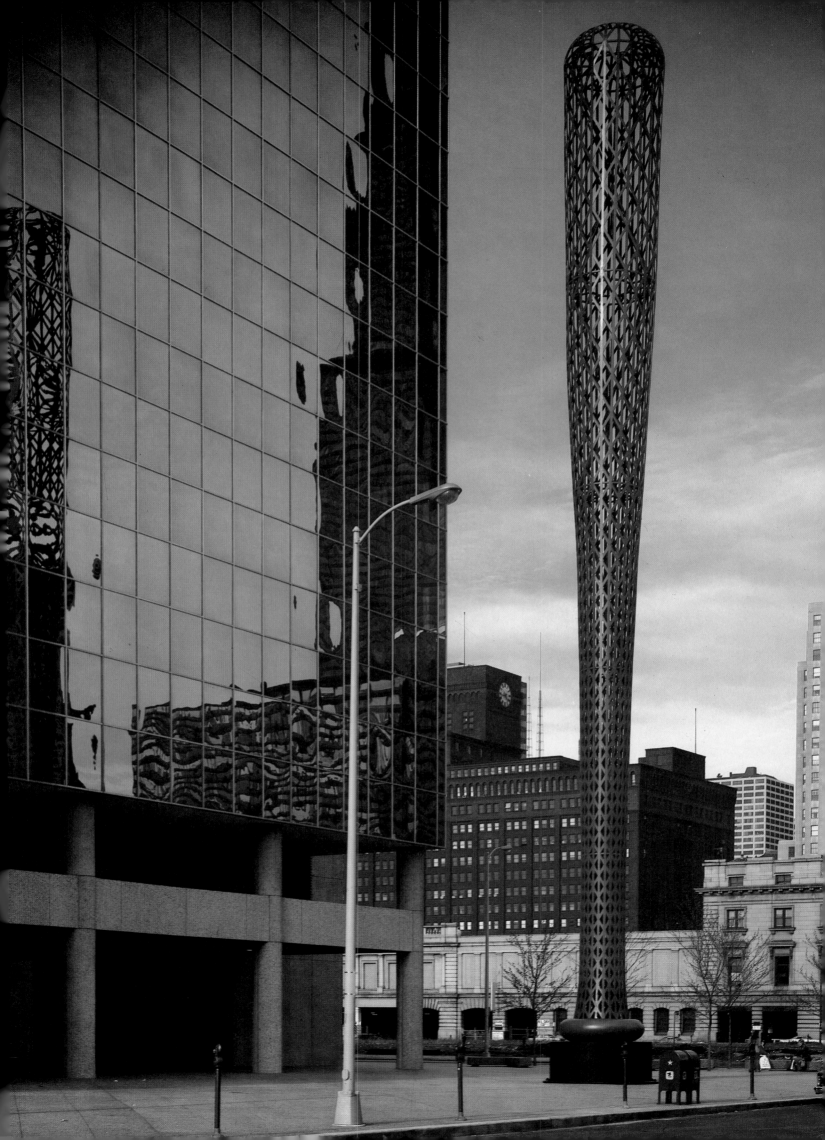

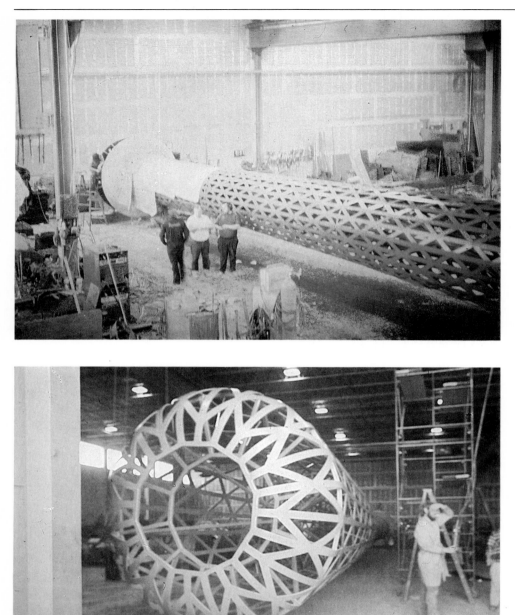

In the brochure published by GSA for the dedication of the *Batcolumn*, Oldenburg wrote:

> Many people have contributed to this work. *Batcolumn* has been a labor of enthusiasm, sacrifice and love, with no other goal than the achievement of a beautiful work of art. I wish to thank the General Services Administration for support and patience and for the opportunity to create such an unusual project without compromise—truly an encouragement to the creativity of American society.

In reality, it was GSA and the public who should have been thanking Oldenburg. As Barbara Rose noted in *Vogue* magazine ("Public Art's Big Hit: Oldenburg Bats High in Chicago," July 1977), *Batcolumn* was Oldenburg's first direct federal commission, and he went all out for it.

Although it is popularly believed that artists like Oldenburg receive enormous fees from the GSA, the sums handed out, which are considerable, hardly cover the cost of materials and manufacture. To my knowledge, no sculptor has made a dime of profit on a GSA public commission; Oldenburg, for example, could not have had the *Batcolumn* fabricated without unlimited credit at Lippincott, and he is currently out of pocket about $20,000. For the most part, these public monuments, which will express to the future the goals and achievements of our civilization, are essentially gifts to the American people by their artists, who finally are appreciated as being as American as apple pie.

A week after the dedication, the *Los Angeles Times* covetously editorialized upon the virtues of the *Batcolumn*, expressing a desire to swap that city's near-million-dollar *Triforium* sculpture "for Chicago's simple, mute, gray $100,000 baseball bat" (April 21, 1977). Thanks, but no thanks, Chicago replied. And in a fitting final tribute, the lead editorial in the *New York Times* on September 17, 1977, proclaimed: "There is a certain relaxed satisfaction in the public attitude toward the arts today: They're doing fine, thank you; creativity and attendance have never been greater; more people go to museums than to baseball games. . . . any government that has the wit and spirit to put up Claes Oldenburg's *Batcolumn* . . . can't be all bad. Administrations and city councils come and go but the arts go on forever. Let's hope."

Times, for one, didn't agree and replied to Proxmire with an editorial strongly defending the *Batcolumn* (September 2, 1976): " . . . we have an award for Proxmire: Batty boob of the week. His pitch against public-works art was low and outside."

Nevertheless, letters began pouring into the agency from New England to southern California and all points in between. By the time of the dedication, we were swamped with them—and they didn't stop until three months later. In addition, the timing of the dedication was particularly inauspicious. It had originally been scheduled for April 7, to coincide with the opening of the baseball season in Chicago, but had to be postponed for a week because the work wasn't finished. To make matters worse, Walter Cronkite concluded his April 14 news broadcast with a comment on the *Batcolumn,* noting that on the evening when people were putting the finishing

touches on their tax returns, they might be interested in seeing just how their tax dollars were being spent.

Fortunately for the Art-in-Architecture Program, President Carter had just appointed a new GSA administrator, Jay Solomon. Solomon had gone to the Oldenburg dedication at his own expense with his wife, Rosalind, herself an artist (a professional photographer). They were both impressed with the Oldenburg sculpture and had seen for themselves the enthusiasm with which it was greeted by Chicago's citizens. When Solomon took the helm at GSA, one of his first actions was to come to bat (as it were) for Oldenburg and for art-in-architecture activities. Under a less supportive administrator, the outcry might have led to the suspension of the program.

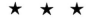

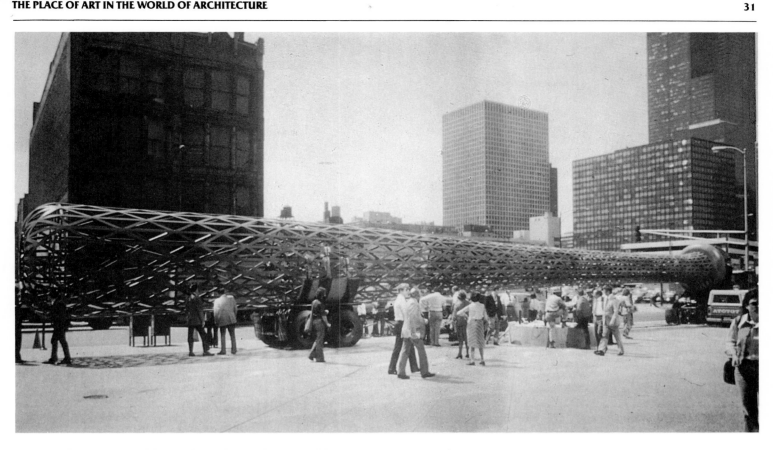

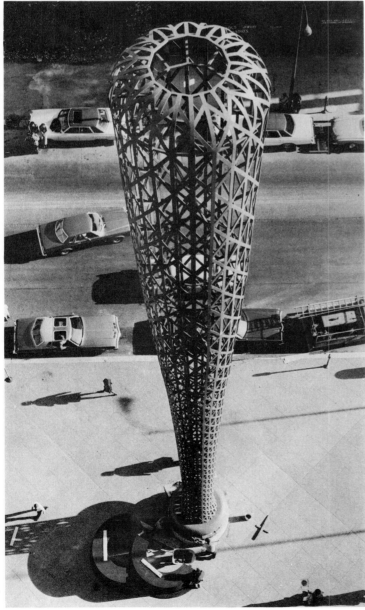

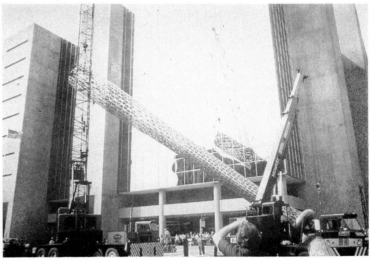

Harry Shunk

Opposite: The Bat *in the making. The Lippincott crew oversees fabrication of the work at the factory in North Haven, Connecticut.*

Above and left: The Bat *arrives. After its cross-country trek from Connecticut to Chicago, the* Batcolumn *made the journey from horizontal to vertical in a half-hour flat. The erection, which took place on April 12, 1977, went off smoothly, and the sculpture was formally dedicated two days later. Writing for the dedication brochure, Chicago art historian and critic Dennis Adrian said, "Claes Oldenburg's sculptures are a combination of contemporary imagery and technology. His work depicts common objects transformed to enormous scale and placed in urban settings. Chicago, with its rich architectural tradition and lively countenance, is particularly suitable to be the home of Oldenburg's* Batcolumn." *Predictably, reactions to the piece varied, as David W. Hacker reported in the* National Observer *when plans for the project were first disclosed ("Chicago's Arty Big Stick," June 21, 1976). "It's going to be the U.S. Eiffel Tower," an official of the Art-in-Architecture Program was quoted as saying. "I suppose it's better than nothing," said a systems analyst for Illinois Bell Telephone. For his part, Hacker called the* Batcolumn *part of "an accumulating collection of civic sculpture that is transforming the once-fading downtown area into a bit of a Loop Louvre."*

It was a race against time. In terms of commissioning new works, GSA's Art-in-Architecture Program had been all but halted during most of the Eckerd/Panuzio administration; with the arrival of the new administrator, Jay Solomon, in early May 1977, the commissioning process resumed—just in the nick of time. There were several projects where the funds available for GSA commissions were linked with a deadline that allowed less than a year for the entire process, from the initial request for nominations to the installation of the work. The federal building in Columbus, Ohio, was among these projects. Within a week of taking the oath of office, Solomon had signed the letter requesting artist nominations from the NEA for the Columbus commission. Although GSA's staff stressed the urgency of the situation, the panel meeting was not scheduled until August 31. By then, there were only seven months left.

Robert Mangold, a native of New York State who has achieved considerable stature as a minimalist painter concerned with form, illusionism, and the concept of irregularity within symmetry, was the artist eventually selected for the commission. For a number of reasons, he had serious reservations about the project. "I was haunted," he later wrote, "by the question of the suitabil-

ROBERT MANGOLD

James Mangold

Robert Mangold [signature]

ity of my work for an outdoor mural—whether I could take my work or ideas, enlarge the size, use radically different materials and put it up on a public wall, and still end up with a personal statement." Added to these artistic concerns was "the most critical question . . . the limited time available. Obviously a time limitation creates problems and limits choices, but in spite of this I was interested in the creative problems it presented." Deciding that the challenge of the commission outweighed its drawbacks, Mangold accepted it, and the contract was negotiated in November for $70,000. He had four months to complete the work.

★ ★ ★

On January 10, 1978, Mangold presented his proposal to GSA in the form

of both a model and a painting. These represented a mural in three enameled sections: two large sections on one wall and a smaller section on a wall around the corner. On the mural was an arc, a fine line beginning on the two larger panels and completing its symmetry on the third. "I started working on the idea of two works, related but separate, the main set of panels on the facade facing west, and a smaller but related set of panels near the entranceway facing south. . . . This is the part of the building that relates to the passerby on the street, and it was this area I felt I could work with," Mangold explained.

The concept was approved, and with less than three months remaining, the work of fabrication began. Following the advice of the contractor he had selected to install the murals, Mangold had the work fabricated in Houston, Texas, by the American Porcelain Com-

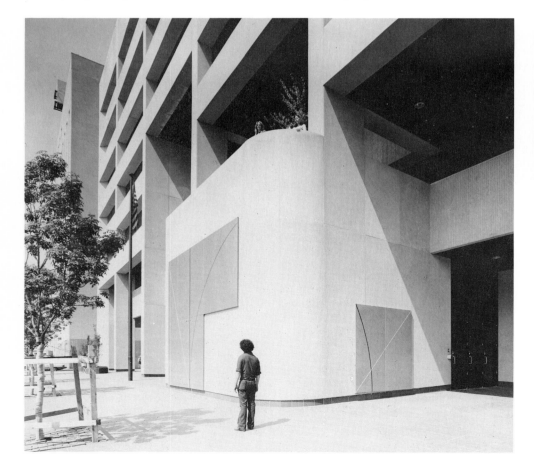

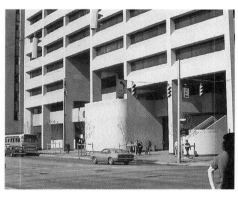

Left: Robert Mangold's Correlation: Two White Line Diagonals and Two Arcs with a Sixteen Foot Radius, *for the federal building in Columbus, Ohio. The larger mural consists of eight 48- by 96-inch panels, and the smaller of two 48- by 76-inch panels. The two murals, situated at right angles to one another, "have a visual dialogue and relationship that unites them," according to Mangold. "The arc in both sets of panels is drawn with the same measured radius, but they are not continuous."*

Above: The federal building before Mangold's murals were installed.

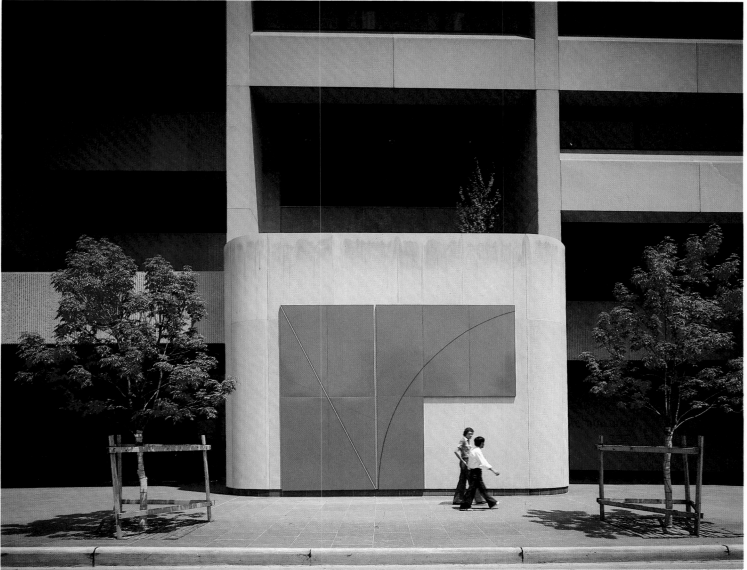

GSA

pany—a firm with large enough kilns to bake porcelain enamel onto four- by eight-foot panels. Mangold "wanted to work with large panels to avoid a tile-like quality on the facade," and the enameled steel was ideal for his purposes because it "permitted working with color in a climate-resistant material." Although he would have preferred a matt finish, he settled for a satin finish because the manufacturing company advised that it would be more durable and less difficult to control for color.

After two trips to the fabricator, Mangold was satisfied with the panels, and they were shipped to Columbus only days before the deadline. By April 1978, the mural was safely in place. Mangold and the staff of the Art-in-Architecture Program—especially Julie Brown, who coordinated the project for GSA in Washington, D.C.—breathed a sigh of relief. The race against time had been won.

The work, *Correlation: Two White Line Diagonals and Two Arcs with a Sixteen Foot Radius,* is more illusion-istic than it appears at first glance. "The final structure or form the mural took is complicated, and I chose to empha-size this with its title," said Mangold, adding, "It is both two works and one work." He was pleased with the result and, despite the time pressure, with the process of achieving it. "Generally everyone was helpful," he wrote, "from the architects [Brubaker/Brandt, of Columbus] to the fabricators and gen-eral contractor [Art-Glo Sign Corp.]—and in the end, when it was installed, I felt it worked out very well. I think the experience was a good one, as the works I am doing now are directly re-lated to ideas that started with the mural project."

Mangold was also impressed with the direction of the Art-in-Architecture Program, which he termed "exciting" because of the wide variety of works being commissioned and because of the agency's willingness to seek out not only artists who have long worked on public art projects but also those who have not executed a major public art-work before.

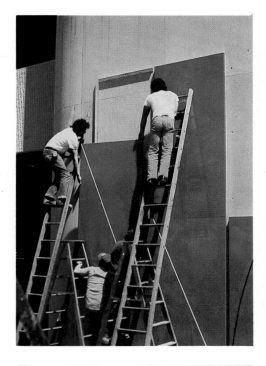

Top: From a vantage point directly in front of the building, the smaller mural is not vi-sible, but, says Mangold, "in walking past the two works, you form the connection."

Above: Workers install the larger mural.

STEPHEN ANTONAKOS

In the early summer of 1977 I got a call from the GSA saying that I had been selected to do a neon on the federal building in Dayton, Ohio. I know I said yes right away. . . .

On August 10, I went to Dayton to see the building. At first sight I liked it, that is, if you were just passing by. But after studying it for awhile, I felt it was much too heavy-looking, even with all the mirror windows. The entrance . . . did not feel like an entrance for the "people." It did not invite, it put you on your guard. It was not a doorway for a free government; it was too dark and gloomy. I didn't mind the general boxlike shape of the building, but somehow the reddish broken stones imbedded in the poured concrete only added to its heaviness.

So wrote Stephen Antonakos about his first impressions of the Dayton Federal Building before his creative solution became part of the structure. The "after" assessment was considerably brighter.

. . . When the blue strip, which was almost the width of the building, was put up, it was an amazing change. That dark, heavy bottom area of the building was completely transformed. The blue surface brought out the entrance visually. . . . It was much more cheerful,

a band of life. "I can't believe it, I can't believe it," I said to myself as I stood there. . . . as the neons were installed and turned on, the blue receded visually a bit. Together, the neon forms and the blue ground did just what I wanted: they lifted up the mood of the entrance, they made it inviting. . . .

And the change in the way the entrance area looks from morning [to] evening . . . is just unbelievable. At times the blue surface is just a dark background, and the glowing neon forms just float there, each one on its own and also relating to the others. And then, during the day, the blue is much more visible. I am very satisfied.

In expressing satisfaction with the results, Antonakos was not alone. Paul R. Wick, the administrator of Dayton's City Beautiful Council (part of the city government), wrote to the building manager to praise the federal government for giving Dayton its first perma-

nent public artworks of major importance (in addition to the Antonakos neon, GSA had commissioned a steel sculpture by Joseph Konzal for the building's northwest plaza). "Dayton's been waiting for a long time. Although there is quite a lot of controversy over the pieces it's a healthy interaction which, at the very least, produces a public awareness. As time passes, we think our citizenry will grow to cherish the artwork as one of the most vital parts of Dayton's cityscape."

★　★　★

The controversy Wick mentioned (which, while mostly directed at the Antonakos neon work, didn't escape the Cor-ten steel sculpture by Joseph Konzal) had been a lively one from the moment it began—one day after contract negotiations. On August 10–11, 1977, negotiations with Antonakos and Konzal took place at the site. On August 12, Walt McCaslin of the *Dayton Journal Herald* wrote an article headlined "Choice of Sculptor, Neon May Raise Art Flap Here," noting that the director of Dayton's Art Institute, Bruce Evans, "said he doubts the 'appropriateness' of a neon sculpture on a federal building." As art columnist for the *Journal Herald*, McCaslin was supportive of the Art-in-Architecture Program's objectives and well grounded in Antonakos's work. Several days later, with the controversy going full steam and the community responding with letters to the editor, McCaslin did another article ("Objections Aside, HOORAY for Antonakos, HOORAY for Neon"), in which he kayoed the criticism as "superficial":

It has been claimed that neon tubing isn't durable enough for a permanent work—which seems to me a dubious argument. With a minimum of service neon signs have lasted for generations, and they're economical to operate. . . . Vandalism? . . . The Antonakos neon won't be at ground level. It's planned for a position high under

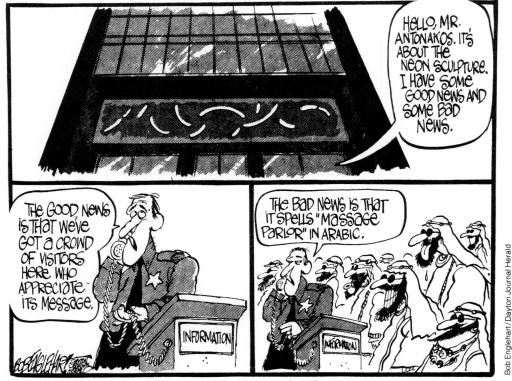

HELLO, MR. ANTONAKOS. IT'S ABOUT THE NEON SCULPTURE. I HAVE SOME GOOD NEWS AND SOME BAD NEWS.

THE GOOD NEWS IS THAT WE'VE GOT A CROWD OF VISITORS HERE WHO APPRECIATE ITS MESSAGE.

THE BAD NEWS IS THAT IT SPELLS "MASSAGE PARLOR" IN ARABIC.

INFORMATION

Bob Englehart / Dayton Journal Herald

On the day Red Neon Circle Fragments on a Blue Wall *was installed, the* Dayton Journal Herald *ran a large photo of it captioned "Sign Language" and wondered in the accompanying text if it was "a new form of shorthand, or . . . a cryptic message inscribed by some alien." The next day, the editors no doubt chuckled as they answered their question with this cartoon.*

the overhang at the building's entrance—which introduces a point in favor of neon. The alcove is dark, and a "light piece" obviously would work better than most types of art. . . .

It also has been mentioned that neon, because of its commercial association, isn't a dignified art material. But what material nowadays doesn't have strong commercial ties—including the very aggregate with which the Federal building is sheathed, which would do as well for a suburban bank or the office annex of a pretzel factory? And paint itself is the ultimate in advertising media.

On the whole, the press assumed the responsibility to educate; most articles centered on previous work by the sculptor, critical assessment of the impact of other GSA installations, and the Art-in-Architecture Program's history—with just enough humor to keep reader interest. An August 17 *Journal Herald* editorial ("Neon Sculpture Commission for Controversial Work Is Exciting Project") that expressed support for Antonakos seemed to keep the level of controversy to a minimum—temporarily, at least.

Meanwhile, Antonakos worked up his design on paper and then made a small model to present to GSA. The Design Review Panel, with Administrator Solomon in attendance, approved the proposal, and Antonakos proceeded to arrange for the fabrication of the work. He contacted the Blommel Sign Company, an established Dayton firm. According to Antonakos,

> The construction was not complicated. I needed a surface of heavy-gauge aluminum sprayed medium blue. With a structure made of right angles in the back for support, it was a simple task for Blommel. Now, the wall this surface was to be mounted on had a crawl space behind it, where all the transformers for the neons could be placed. . . .
>
> I made six trips to Dayton at different stages of the construction to check on the progress. All the building was done at the shop, and as the different sections were needed at the site, they would be brought there. The tubes were secured to the surface with silicone.

The work was installed on March 14, 1978, but the newspapers couldn't wait. The previous week, staff writer Robert France of the *Journal Herald*

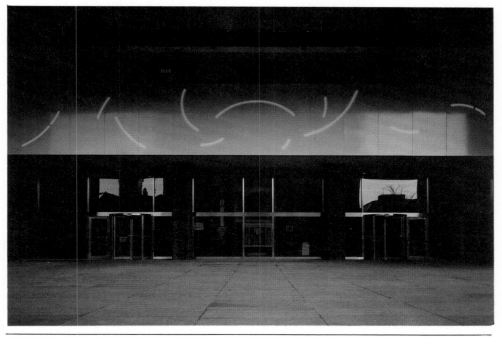

Stephen Antonakos's Red Neon Circle Fragments on a Blue Wall, *by day and at night. "The blue and red-orange glow of the neon helps make the building lighter and at the same time warmer and livelier," says Antonakos. "Also, at a distance, the visual busyness of all the reflective glass above it makes the concentrated neon sculpture the clear focal point of the facade."*

had renewed the controversy under the banner "It May Be Art—But Is It ART?" Citing positive and negative reactions to the as yet unseen work, France included a word of reassurance to the conservation-minded: "the neon will only use 360 watts—about the same as two 100-watt bulbs."

On a more serious note—one which must surely have pleased Antonakos—McCaslin described the impact of the piece, titled *Red Neon Circle Fragments on a Blue Wall* (*Journal Herald*, March 16, 1978):

> The building . . . is ponderous. It's earthbound, dour in hue. It

lacks drama and focus at ground level, where it slumps down and meets its esplanade. The light-blue backing of Antonakos' piece is intended to lighten the building, relate its heavy undermass to the sky. The first time I glanced at the completed project from across the street, it was hard to believe the success he has had with this subtle strategy.

McCaslin urged his readers to "become a passerby and inspect the work by day and by night. . . . Put aside preconception, gossipy prejudice, hearsay. Go and look—and then report back." In the year since the installation, all reports have been positive.

JOSEPH KONZAL

Like the lost sheep of the parable, Joseph Konzal had left the fold of GSA-commissioned artists, and as in the parable, we missed him. In this case, however, it was not Konzal but his commission that strayed. Konzal had been nominated by the National Endowment in 1974 to do a sculpture for a federal building and post office in Mansfield, Ohio. No sooner was the contract negotiated than the U.S. Postal Service, which occupied a major portion of the building in Mansfield, became a quasi-governmental organization and withdrew its buildings from GSA's jurisdiction. (Technically, the Postal Service controls the buildings in which it occupies fifty-five percent or more of the space.) It was a bitter experience—and the first time the agency had been forced to rescind a contract.

The situation was rectified three years later, in 1977, when Konzal was selected for the sculpture commission in Dayton, Ohio. Konzal was somewhat leery of GSA's second offer and quite understandably wanted everything in writing. With characteristic good will and optimism, however, he accepted the contract, which was negotiated at the site in August 1977 for a fee of $17,000.

Konzal is a highly respected sculptor whose work was selected for the Museum of Modern Art's Recent Sculpture–USA exhibition in 1959 and for six annual Whitney exhibitions between 1948 and 1968. He is represented in the permanent collections of the Whitney, the Tate Gallery in London, and the Storm King Art Center, among others. In the early 1970s, he became an associate professor of art at Kent State University, and while in Ohio, he created numerous works, among them one for the grounds of the Canton Art Institute. Reviewing the Canton piece in the *Cleveland Plain Dealer* (June 13, 1976), Helen Cullinan wrote, "Sculpturally,

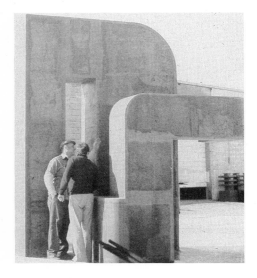

Konzal ranks in the league of the late David Smith, his former friend and colleague. He works in wood, aluminum or steel in a starkly abstract way derived from Cubism, De Stijl and Frank Lloyd Wright." It wasn't surprising, then, that Konzal was nominated for the commission in Dayton; he had, so to speak, paid his dues.

Konzal didn't waste any time getting to work. Within two months, he had developed a maquette to present to GSA's review panel in Washington, D.C. The maquette was made of solid wood and represented a piece that in its completed form would weigh four tons. Konzal had moved from Kent State to New York in mid-1976 and didn't have the facilities to make the sculpture in his New York studio, so it was fabricated by Milgo Art Systems under his watchful eye. Work began in November 1977, and the installation took place on March 15, 1978. When asked if he made much money on the commission, Konzal responded, "Definitely not!" He recalled that during his nine-month effort he had made several trips to Dayton and Washington, D.C., and paid for fabrication, shipping, installation (including a crane to set the piece in place at $500 per day), and professional photographs of the piece. He estimated that he might have made $4,000—minus living and working expenses. As for so many artists, it was not money that motivated him, but the opportunity to create a major work.

Gateway, as Konzal titled his sculpture, is one of two pieces commissioned for the Dayton Federal Building (the other, a wall-mounted neon work serving as a contemporary frieze over the main entrance, is by Stephen Antonakos). Looming considerably larger than its twelve-foot height, it stands in the northwest plaza and "announces" the building to arriving visitors and occupants. Typically, not all visitors and

occupants are pleased with the announcement. "Beauty, it's said, is in the eyes of the beholder. And two beholders on the ninth floor of the federal building don't like what they've beheld: U.S. District Court Judges Carl B. Rubin and Carl A. Weinman are, safe to say, less than enthralled with a . . . red neon sculpture . . . and a . . . rust-colored, free-standing steel sculpture," Robert France reported in Dayton's *Journal Herald* (March 16, 1978). According to the article, Rubin, who had wanted a traditional artwork to reflect the traditional role of the court, was quite prepared to see *Gateway* "returned to the senders"; Weinman felt that it detracted from the building and said, "Everybody I've met is trying to find out what it means."

Well, perhaps that's not so bad. The good people of Dayton may well find in the search for the meaning of a contemporary art form welcome relief from daily reports of crime and violence, of which judges are generally all too aware. To contemplate a work of art like Joe Konzal's *Gateway* adds an extra dimension to everyday life and, it is to be hoped, enlarges the heritage of future generations. As Konzal wrote to GSA,

> I believe the sculptors who placed the two bronze monuments in Union Square, New York City, of our first president and his ally, the Marquis de Lafayette, the one seated on a horse and the other sword in hand, did a beautiful thing, and it will remain so as past history. Today we must look to the future. The problem of contemporary sculptures is to speak in a forthright contemporary sculptural syntax to be truly effective. Our task, then, is to create a spare, challenging, austere shape—enigmatic and provocative—that will stir the mind and heart, evoking a feeling of strength and confidence.

Joseph Konzal's Gateway, *a massive volumetric sculpture made of quarter-inch Cor-ten steel plate. "In my search for a significant, full three-dimensional statement, I have become interested in the ideal of an inner tension in the design through the contradiction of opposing an exclusively open modular scheme against the force of masses," says Konzal.*

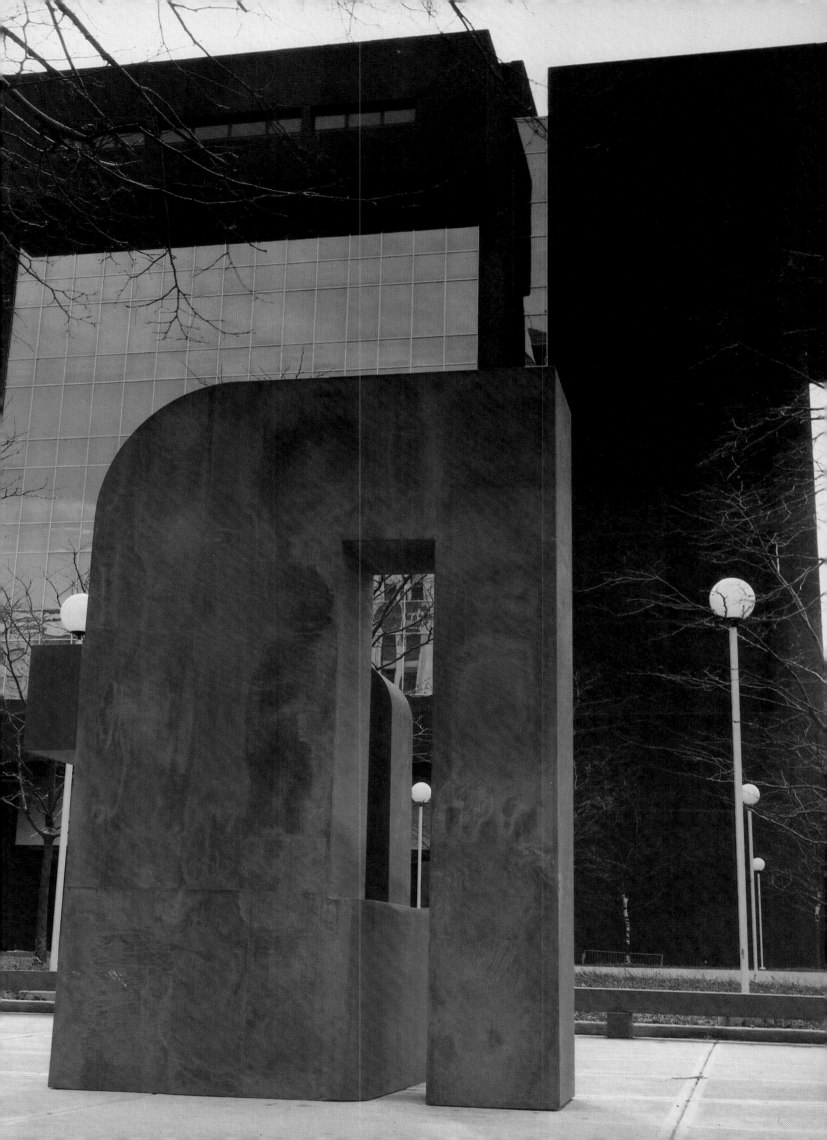

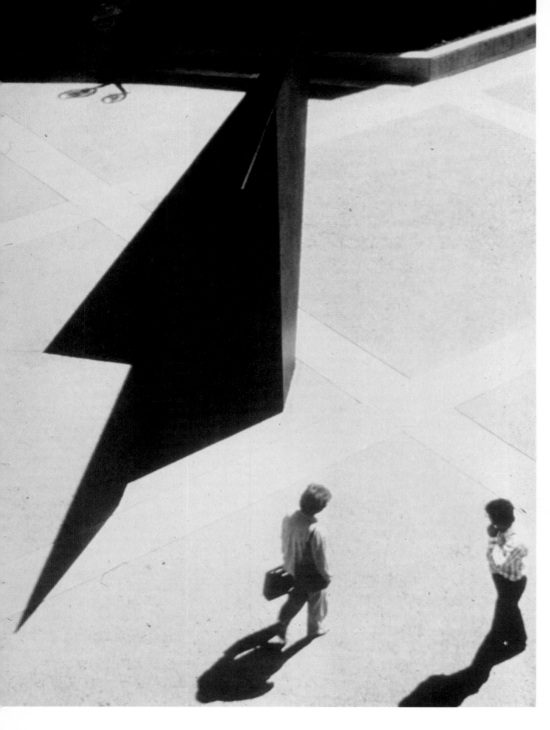

 Robert Maki's sculpture for the plaza of the federal building and U.S. court-house in Eugene, Oregon, was the culmination of a series of works based on the fifth letter of the alphabet. Why did he title it *Trapezoid E?* "Because it is trapezoidal, and from the air it looks like an *E.*" A straightforward and uncomplicated answer—just like the sculptor.

Maki is a serious and unusually gifted artist with a growing reputation. In 1974 the highly regarded critic Jan van der Marck began a review of his work by proclaiming, "His recent accomplishments have established Robert Maki as the most serious monumental sculptor in Seattle" (*Art in America*, September–October 1974). In 1976, *Seattle Times* art critic Deloris Tarzan wrote, "Robert Maki is arguably one of the best and most original sculptors in the nation" (March 2, 1976). Maki's skyrocketing career is solidly based, and his success well deserved—a remarkable achievement for a young artist working without benefit of the New York art press and gallery system. His nomination for the GSA commission in 1974 was a potentially important event for the then thirty-six-year-old sculptor.

The contract was negotiated for $20,000—a bargain, as it turned out. Maki was grateful for the careful and complete explanation of the contract and especially appreciated his "complete latitude to deal with the space and execute a sculpture without interference." Commenting on the cost, Maki said, "A $20,000 budget for a site that required a major sculpture was a formidable challenge, and needless to say, the public received a sculpture far in excess of the budget—but it wasn't a competition, and I had the freedom and no dealer fee."

The completed model was unveiled by GSA administrator Arthur Sampson following the building's dedication in July 1975. Sampson "was praised by [Senator Mark] Hatfield for fighting for the continuance of a federal allocation for works of art for federal buildings" (*Eugene Register-Guard*, July 22, 1975). Pleased as we were with the proposal, it was additionally rewarding to learn that Gareth Wells, one of the federal government's brightest young designers and architects, appreciated Maki's aesthetic so much that he selected the maquette as the only one to be displayed in his office.

Maki's piece is impressive in its complexity of design. Technically, its

Robert Maki's Trapezoid E, *on the site and in transit. It "aligns with horizontals and verticals of the architecture while shadows align to extend prominent diagonals," in Maki's words.*

ROBERT MAKI

©Michael Cohen

Robert Maki

fabrication was subcontracted, but in fact Maki did most of the work, personally laying out the templates, cutting the one-inch-thick aluminum plate, edging, beveling, and painting. Only the actual welding was done by others. The twelve-foot-high by fifteen-foot-wide by ten-foot-deep structure consists of aluminum plates welded together at ninety-degree angles. The top view is based on an *E* configuration, with the end view reduced to a triangle, and the front and back views an inverted trapezoid. From four oblique viewing angles, the outermost edges of the sculpture (which are skew lines) are perceived as parallels of a rhomboid. It is painted with a dark gray enamel to facilitate an illusionary reading and add to its ambiguity. *Trapezoid E* is endlessly intriguing because, while the shapes appear to be so clean and the overall composition so clear, there is an elusive, "now you

see it, now you don't" quality in the viewer's attempt to recall the forms. To the casual observer, it looks almost *too* simple; for the contemplative viewer, its intricacies multiply.

★ ★ ★

On the evening of August 6, 1975, after twelve solid hours of effort, the work was installed. Maki met and talked with the general public and many federal employees as he supervised the installation. The Treasury Department's regional director decided he liked the work and took Maki to lunch, but other building occupants were distinctly less impressed. According to a local newspaper, one said, "Can you imagine . . . they tell us, as an energy conservation measure, we must keep the building to a near 80 degree tem-

perature in the summer and less than 70 degrees in the winter. Then they spend $20,000 for that hemorrhoidal E, or whatever they call it" (*Valley News*, August 7, 1975). It was the typical sort of complaint, if couched rather more picturesquely than usual.

As for Robert Maki, he was pleased with his creation and gave a positive assessment of his experience with the GSA. Reflecting on the objectives, direction, and future of the Art-in-Architecture Program, he said, "The GSA program is critical in encouraging and participating in the short history of large-scale, nonacademic sculpture. The credibility of the program rests with maintaining the highest aesthetic standards. As a sculptor represented in the program, I recommend that the standards by which I was selected be maintained. Neither regionalism nor political pressure nor economics should subvert the stature of this program, which any artist would be complimented to participate in."

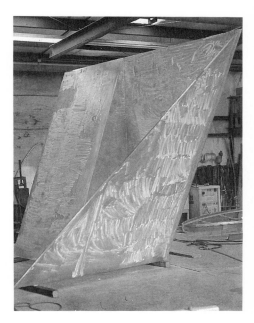

Right: Trapezoid E *during fabrication, before it received its coat of gray enamel.*

Below: Two views of Maki's seemingly straightforward work, which changes dramatically from various vantage points. "The sculpture is oriented to the geometry of the site and movement of the sun. The court area opens to the south, allowing for internal shadow activity that functions to visually restructure the sculpture and articulate otherwise implied geometrics," says Maki.

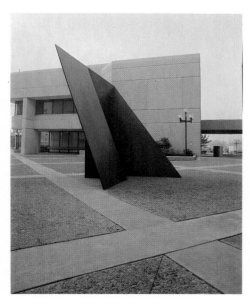

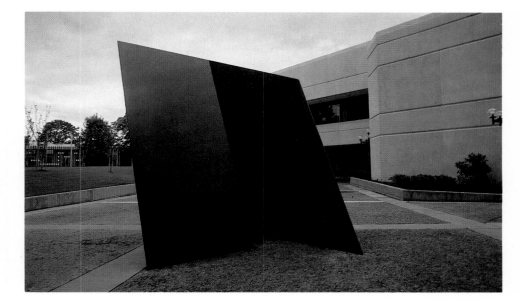

BLUE SKY

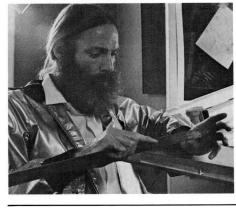

"Hello, this is Don Thalacker calling from the General Services Administration in Washington, D.C. Is Warren Johnson there?"

"No. There is no Warren Johnson anymore."

"Oh."

"But there is Blue Sky."

"Well, then, can I speak to Blue Sky?"

"Yes. This is Blue Sky speaking."

"Er—ah—Mr., er—Mr. Sky? Are you also Warren Johnson?"

"No. Mr. Johnson no longer exists."

It was a strange feeling to be talking on the telephone to someone who no longer existed—and moreso because I had been forewarned by Nicholas Panuzio, commissioner of the Public Buildings Service, that while it would be fine to award a contract to Warren Johnson, under no circumstances could we award a contract to "Blue Sky." Also, I didn't know what to call him. Blue? Mr. Sky? I felt momentarily uncomfortable.

Although I was aware that Warren Johnson was also known as Blue Sky, I hadn't realized that he'd legally changed his name. Blue Sky explained that all his papers—his driver's license, county records, even his birth certificate—were now in his new name. I told him I'd call back shortly and informed Panuzio that Warren Johnson was legally non-existent. In view of which, Panuzio said we could award the contract to Blue Sky.

"Hello, Blue? You have been selected to create a mural for the lobby of the federal building in Florence, South Carolina."

★ ★ ★

Blue Sky, who lives in Columbia, South Carolina, had been nominated by the National Endowment panelists on March 16, 1976. On March 1, 1977, acting GSA administrator Robert T. Griffin accepted the recommendations of the Design Review Panel and selected "Warren Johnson." A contract was negotiated at the site on May 17 for $12,000 to create and install a mural "depicting a historic event related to Florence, South Carolina."

Blue Sky was delighted at the prospect of painting a mural for his home state and enthusiastically set to work.

I spent weeks researching the history of the area. This included eavesdropping on conversations while dining at Macdonald's, Hardee's, and Shoney's Big-Boy restaurants. I am a *public* artist. I need to know what people are interested in. Women, cars, and fishing were usually the topics of conversation. Nobody talked about history. Lucky for me, the most historic spot in Florence was also a lovers' lane and fishing spot along the Great Pee Dee River.

It was then that I decided to paint it, but since it was so popular with the public, it was littered with beer bottles (usually shot to pieces) and dead fish heads; consequently the view was quite breathtaking, especially at night.

While the ideal composition might have been a picture of Miss South Carolina trolling for catfish in a Pontiac convertible, I yielded to better judgment and painted the river as it would appear to a car passing over the bridge on Highway 76—a present-day perspective on a historic subject.

By August, the proposal was ready. Blue Sky and his associate, Jan Sigmon, first presented it to officials in GSA's Atlanta office, which was administering the contract. The contracting officer, Jim Dreger, liked what he saw and wrote to the Washington, D.C., office, "This is to let you know that we endorse the mural, as presented, as a suitable fine art expression for this building." On September 1, Sky made his presentation in Washington, and the GSA panelists were enchanted by the artist as well as by the work of art.

Working diligently, Sky had the seven- by fifteen-foot mural completed and ready for installation in less than three months. But he had been disillusioned with previous installations in privately owned buildings, where several of his murals had been abused or destroyed. "Since a painting on canvas is vulnerable to vandalism, some sort of . . . railing and framework was necessary to protect the mural," he said. Sky wanted to construct a simulated highway rail that would "bridge the gap between the traditional style of the painting and the modern lobby interior" in addition to serving a protective function. "Not only does the rail complete the foreground perspective of the scene," Sky later wrote, "but being of the actual size, color and texture of a real South Carolina highway bridge rail, it counterpoints the softness and distance of the river scene, adding a depth of dimension. The concrete-coated wood structure and the brick interior are now united, both being members of the masonry family."

The mural and bridge railing were installed in February 1978, and real highway high-pressure sodium lights were added at Sky's request. He was pleased with the results. "The public now has a place to sit in the lobby . . . to contemplate a scene that is rich in history, as familiar as a friend, and for many, an introduction to art," he wrote in a concluding statement to his entry for GSA's Third Design Awards Program. (His work was judged one of the best and was a winner, along with the Noguchi and Oldenburg pieces.)

After the installation, Sky added "a few bonus features" (as he called them) to the painting, including the reflection of the "luminous crescent moon . . . in the undulating surface of the river, numerous pulsating fireflies probing the mysterious depths of the riverbanks," and "stars, arranged according to magnitude and constellation" (for which Sky used star charts for the northern horizon in the month of June). "These chromatically shifting points of light twinkle seemingly through a hazy morning atmosphere" and "are intended to give the illusion of

reality which is becoming characteristic of my art," Sky said.

On May 8, 1978, the mural was dedicated formally—but not so formally as usual. To the acute distress of the dedication ceremony staff, Sky had planned some novel departures from the customary (and somewhat pompous) proceedings. Master of ceremonies Jay Solomon took Sky's innovations in stride, however, and the ceremony—featuring "actual recordings of early morning river sounds (owls, birds, crickets, frogs, water turbulence, and distant train whistles) superimposed on Beethoven's Moonlight Sonata"—went off without a hitch.

Sky's finished effort, titled *Moonlight on the Great Pee Dee*, was called "awe-inspiring" by John B. Burks, Jr., of the Classic Gallery in Augusta, Georgia. Reviewing the mural for the dedication brochure, Burks noted that Sky's technique "enhances the sense of reality. It implies that the view is being seen from one's car window. As the auto dashes through the night and across the

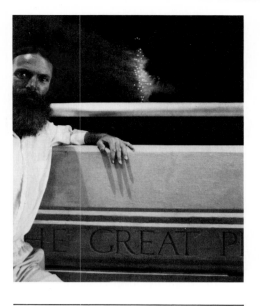

Blue Sky's Moonlight on the Great Pee Dee *is not "a photographically rendered panorama," wrote John B. Burks, Jr. "Instead [Sky] focuses keen attention on the central point of the composition, the crescent moon reflected in the rippling waters below and in the mist that wraps the bend of the river in a veil of mystery while the tree-lined banks melt away into the darkness."*

bridge, one glances to the side and for a brief moment sees the river bathed in moonlight. But the fleeting glimpse lingers on in the memory." Sky himself aptly evoked the mood of his painting in a poem entitled "Pee Dee Feelings."

PEE DEE FEELINGS

THE GREAT PEE DEE RIVER
WINDS THROUGH MY MIND
HALF SUBMERGED MEMORIES
DRIFTING...
TWEEN MOSSY BANKS OF TIME

MY TRIBUTE TO THIS TRIBUTARY
SWELLS PERCEPTIONS TO THE
SUBLIME
SPILLING ON SURFACE OF LINEN
HOUSE-PAINT TRANSFORMED
DIVINE

DARK TREES DEFINED
REFLECTIONS ENTWINE
REFLECTION IN WATER
REFLECTING IN MIND

THE MUDDY FLOW BEHELD
NEATH THE PALE MISTY VEIL
IS THE MOONLIGHT BATHED
SCENE
BEHIND MEMORIES OF
DREAMS
BLUE SKY 1978

GSA

GSA

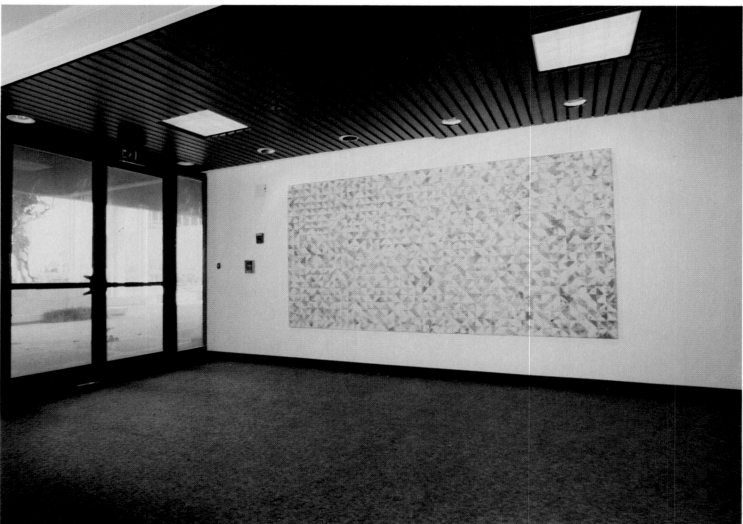

Lynne Golob Gelfman's untitled acrylic painting for the federal building and U.S. court-house in Ft. Lauderdale, Florida. Gelfman, who is intensely concerned with pattern and color in her work, strives for "an interaction of paint and canvas." She utilizes both sides of the canvas, moving the paint back and forth. "I work in layers of colors and layers of triangular patterning," she says, describing her technique. "My paintings are very much involved with subtle interactions of paint bleeding through canvas, of one or two or three colors bleeding with each other, and with the way the color can alter the perception of a mechanized grid."

LYNNE GOLOB GELFMAN

Lynne Golob Gelfman received two "gifts" in the last week of February 1978. One she expected— the birth of her baby (a girl, Laura); the other was a complete surprise—a GSA commission that arrived a few days before Laura. Upon hearing that she'd been selected to create a large painting for the new federal building and U.S. courthouse in Ft. Lauderdale, Florida, Gelfman was "thrilled that GSA was giving me, an 'emerging artist,' as it were, an opportunity. I couldn't get over the fact that someone out there was pushing my work, and that I did not have to do a maquette for the selection process. Marvelous, also, to work for a specific spot, to know that the painting already had a home of its own."

Gelfman, who graduated from Sarah Lawrence College (B.A., 1966) and Columbia University (M.F.A., 1968) established herself as a serious artist in a relatively short period of time. By 1978 she had had six solo exhibitions and had participated in numerous group shows from Florida to New York, and abroad in France, the Netherlands, and Belgium. Art critic Ellen Edwards once said of her work, "Her paintings are about structure. . . . Since [her] structures are pre-established, Gelfman is more and more free to explore the nature of color and color interrelationships. The paintings are moody and contemplative" (*Artnews,* February 1979). Reviewing one of Gelfman's shows, *Miami News* art critic Lillian Dobbs exclaimed, "The artist explores myriad color relationships which she executes with acrylic on unsized muslin or duck. The combination of colors— whether brilliant or subdued—bleed into exquisite harmony with no suggestion of monotony in her repeated subject" (October 27, 1978). Gelfman herself describes her work as follows:

For the past four to five years, I have been working on painting variations of a triangular grid format. My paintings vary in color intensity, in size, and from the "all-overness" of the triangles to very playful changes of triangular positioning. They alter in the degree to which accident is allowed or accepted and as to how self-conscious my markings are. Always, however, they are involved with a juxtaposition—grid vs. accident; order vs. chaos; front vs. back; illusion vs. surface; primitive patterning, textiles, handmade baskets vs. machine-made images and industrial wallpaper.

<div align="center">★ ★ ★</div>

Gelfman was nominated by NEA-appointed panelists in December 1977 and selected by GSA administrator Solomon the following February. The contract negotiations were postponed until after the baby was born; then, as Gelfman said, "I took off on my postpartum pilgrimage to Ft. Lauderdale" (she lives in Miami).

. . . I was presented with the twenty-seven-page contract. My knowledge of legalese is limited, and my mind doesn't think on that wavelength. . . . Everything went smoothly, I thought, but again, this was my first government contract. I was in a new ballgame. I was beginning to fully realize the honor of the commission and to believe in the freedom to pursue whatever image I chose for the painting. I must say that when I finally made it home, I was a bit dizzy from the contract, and I was pleased that I could soon get down to work.

Within five months, Gelfman had developed her proposal, which she termed a "model." It was presented to, and approved by, the GSA Design Review Panel in August. Consisting of three parts, the model visually elaborated Gelfman's process of painting rather than representing the work in its final form. "The evolution and completion, or 'abandonment,' of an image for me is an intuitive process," she wrote.

For this reason, I found the model very difficult. How could I present a model of a painting that I had never painted? That is why my model or concept has three parts. The first suggests the allover format and layering of color without accident. . . . The second part of the model shows the same format, but it has been torn. It has random markings. It shows the support (coming through from back). This second part shows how the first part will be altered through the process of painting. The third part of the model shows a fragment of actual canvas with paint. I believed this third part was important, as it could give a feeling of what happens in the interaction of paint and canvas in my paintings. . . .

So there was the model in three parts. I shipped it to Washington and still was not sure what the final painting was to look like. Yet I knew I would begin the journey. In some ways, I would say, the three parts were a way of showing my process for working without making a commitment to a fixed image that I could not keep.

Gelfman labored over the painting until January 1979. She methodically covered the five-foot-six-inch-high by eleven-foot-wide surface, painting "on both sides of the canvas—pushing paint, moving it with brushes, my hands, sticks, rags—whatever to get the paint to move from the back of the canvas to the front." Once she had laid out the triangular grid, she began adding colors—"and then the fun starts—I accept or reject the accidents that occur and go on to more layers, painting now on both sides of the canvas."

The work, for which GSA paid $3,500, was installed in the early spring. Gelfman was pleased, not only with the result of her efforts, but with the Art-in-Architecture Program in general. "What more can I say but *great* to have been selected. . . . I feel like doors have been opened, and in the art world it is very difficult to find the door open. GSA also has brought art and architecture together and has given exposure to artists and enrichment to onlookers."

DOUG MORAN

"Following are a few notes which will help all concerned with understanding the construction I've designed for the federal courthouse in Ft. Lauderdale," wrote Doug Moran in a letter accompanying a large drawing he sent to GSA in May 1978. Moran was not one to waste time. Two months earlier, he'd participated in contract negotiations at the site, agreeing to create a "wallscape" for the second-floor lobby at a fee of $8,500.

Moran was nominated for the commission in December 1977 by an NEA-appointed panel, meeting with design architect Jim Rink (of William Morgan Architects, Jacksonville). At the time, he was a twenty-eight-year-old studio art instructor at Miami–Dade Community College and had had several group and one-man shows in Florida. The panelists, all Miami-area art professionals, knew and respected Moran's work, which is included in the permanent collections of Joseph Hirshhorn, the Metropolitan Museum of Art in Miami, and the Ft. Lauderdale Museum of Art. Recommended for the commission by GSA's Design Review Panel in January, Moran was selected by Administrator Solomon in February 1978.

In his May letter, Moran explained that the piece would consist of five main sections bolted together to form a continuous horizontal work thirty-two feet six inches long. It was to hang on the south wall of the room, favoring the left side, and supported by hangers that would be invisible and would allow for easy removal. As for its composition, it was to be made of Douglas fir covered with heavy cotton fabric and painted with an encaustic solution made of white refined beeswax, dry pigments, and palette varnish. Concluding his description, Moran wrote:

> All panels will be three and three-eighths inches thick, allowing for the various internal sculptural relationships to occur.
>
> In terms of color, basically the work will be a creamy white encaustic surface interrupted by either dark negative space or the natural color of Douglas fir.

Moran presented his concept to GSA in Washington, D.C., on June 1, along with another detailed elaboration of its final form. The proposal was approved, and Moran returned to Flori-

da to work on it during the summer months. By September, the wallscape was complete and ready for inspection by Paul Abernathy and Betty Lemmon, GSA regional fine arts officers from the Atlanta office. Clearly impressed with Moran's meticulous craftsmanship, and curious about his work, they probed him and elicited some revealing comments about his artistic technique and philosophy.

> My approach to constructing a painting is based upon carpenters' logic, . . . the "right" way to put things together—efficiency, function, strength, and so on. Carpenters' logic is all those decisions made by a vast number of people who pick up tools to construct, reconstruct, or add to some functional assemblage such as a dwelling. . . .
>
> The paintings emphasize wall as volume as well as surface. . . . I am concerned about the ability of the painting/construction to reveal, or clue the viewer about, what is there

Doug Moran's Southeast Wallscape Wesgate, *in the second-floor lobby of the federal courthouse in Ft. Lauderdale, Florida.*

GSA

structurally, logically—what needs to happen inside to produce what is physically present on the surface. Thus, the situations within the work may vary from white surface, painted with a sort of union-labor attitude, to areas of rough construction to references to functional intrusions in real wall surfaces.

I find especially interesting intrusions which in real walls allow for access into the volume within the wall itself—vents, air registers, mail slots, intercoms, etc. They all serve as intercoms between those two very different kinds of space—the room and the wall, the viewer's space and the space inside the painting.

The completed work was approved, and the next day Moran went fishing— one of his favorite pastimes. (Uncharacteristically, he boasted of his success in a subsequent letter: "I probably shouldn't say this, but boy, did we ever catch the fish Saturday. I took first place with an eight-foot black-tip shark

that made the girls cry.") Moran titled his creation *Southeast Wallscape Wesgate*—in part a reference to his decision to move from the Southeast to the West Coast, where he now lives and works. In addition, according to Moran, the term *wallscape* conveys "an idea of modern industrial and residential complexes under construction in rapid-growth areas, replacing landscape." It also suggests "an ongoing sequence of events happening along a linear space of a common wall." In the context of his painting, "the white surface acts more as a vehicle (in which the various events are carried) than as a framing element," directing attention to inner structural relationships.

Southeast Wallscape Wesgate was installed in January 1979, as soon as the federal building and U.S. courthouse in Ft. Lauderdale was sufficiently complete to house it. It is a handsome and intriguing work, and Moran was pleased with his efforts. Reflecting on his experience with the Art-in-Archi-

tecture Program, he expressed both his eagerness to work with GSA again and his hope that many other artists would have the chance he had.

Sure did appreciate the commission with GSA. The funds gave me the opportunity to undertake a work which:
—otherwise would not have been financially possible;
—was a size that simply wouldn't have been reasonable without such a place to put it;
—could begin to illustrate my abilities to express worthwhile thought in most efficient time and budget;
—in the end I'm very proud to have made available for a public space.

These are my valid thoughts concerning the event of the commission—other than this: I simply hope some people have a positive retinal experience because of it all.

SYLVIA STONE

The federal building and U.S. courthouse in Ft. Lauderdale, Florida, is the site of three GSA-commissioned artworks, among them a major piece by Sylvia Stone for the courthouse exterior entrance wall. Meeting with architect Jim Rink (of William Morgan Architects, the firm that designed the building), panelists appointed by the National Endowment for the Arts nominated Stone in December 1977, and GSA administrator Solomon selected her for the commission the following February. "When I received a call from the GSA, I was delighted to finally be chosen for a public site," said the widely acclaimed sculptor. (Stone's "finally" was a gentle reference to the fact that so many of her peers, including her husband, Al Held, had already received GSA commissions.)

The contract, negotiated in March for a fee of $65,000, was not entirely satisfactory to Stone's attorney, Herbert Hirsch. A stickler for details, he advised a number of minor changes. For several months, GSA lawyers from the Atlanta office worked with Hirsch, Stone, and the regional fine arts officer, Paul Abernathy, ironing out contract modifications. The whole process was no picnic for Stone. "This is the time I like least because I hate to be out of my studio, and my mind fogs over with details," she said. On the other hand, the experience was not without its minor compensations. "Though we all hear a great deal about bureaucracy, I was impressed with the attentive civility and the respect I was accorded as an artist. I walked away feeling good." By July 1978, the offending clauses had been adjusted to everyone's satisfaction, and the contract went into effect.

Stone visited the site and was impressed with what she saw. As she later wrote:

I had spent three days viewing the building, photographing the walls, thinking of the traffic pattern, the light reflection, the way the building played with tropical light and shade, the hardness of that light. This was not an anonymous federal building. It was unique, tropical, and I think influenced by Mayan architecture. It was the right kind of a building for the terrain and climate.

Thus inspired by the architectural design, Stone decided to "just start working on my own and let the juices flow, confident that they would flow to that location." Evidently, however, they flowed elsewhere, and for awhile she was stuck: "No results; plenty of sculpture, but no results for Florida."

Finally Stone stopped all her other work and forced herself to concentrate on the Ft. Lauderdale project, to "look at that wall." Using a facsimile of the wall that was strong enough for her to build on, she considered various designs. "I made about twenty constructions before I found one that excited me with its possibilities," she said later. On the basis of the one design that pleased her, Stone built a scale model for the inspection of GSA's Design Review Panel. "The real test," she said, "was presenting the model."

Accompanied by her assistant, Susan White, Stone drove her model to Washington, D.C., in a station wagon. At the panel meeting, she explained her concept with clarity, dignity, and élan, and the GSA panelists approved it without a moment's hesitation. Stone later recalled the occasion:

I was amazed at the turnout. Members of the National Endowment for the Arts, and the head of GSA, Jay Solomon, found time to come [actually, Solomon and his wife, Rosalind, never had time to come; they made time because they cared]. The architects really liked and understood what I was trying to do, and we talked about practical matters of construction. Suddenly, I lost my nervousness—nice people.

Far from being drained by her presentation, Stone was galvanized by it. "I went back to my studio, all clear and full speed," she said. In fact, the real test was yet to come.

After waiting several months for the material to arrive (brass and Plexiglas specially made to her exacting specifications), Stone began construction of the work.

It's so beautiful, so luxurious, and such a pain in the neck to work with. I don't use fabricators, and we do all the cutting and fabricating ourselves. . . . I called in my good friend and emergency assistant, the sculptor Tony Kosloski, and we started installing the [Plexiglas] sections.

First section up—great, very excited. Second section—"hmmm." Then all the brass rod "writing," as I prefer to call it, and the two grids that I had had welded there in my studio at tremendous cost. And then: disaster. I did not like it.

What a crash. . . . Silence from Susan. Anguish—all this emotional involvement (not to mention financial), and it just did not work. I tried to talk myself into it. "Just not used to it—loved the model— it *has* to work." Home. Sleep on it. Woke up the next day and was determined to go for that first impression when I entered the studio. I walked in, looked, and said, "Absolutely no go; we start over."

For Sylvia Stone, nothing but perfection would do, and in her view, she was far from perfection. "That's when I realized that I had not allowed myself to recognize the way I must work. I never build from models exactly; I take off from them. Pieces evolve daily through living with them, and this commission could be no different," she said. She scrapped her original concept and began anew, working with Susan and Tony. It was an exhilarating collaboration:

Move it there . . . no, over about three inches (what a difference three inches can make on a thirty-foot wall). . . . Let's put a parallelogram

there to swing the eye over. . . . Something's wrong. Put the back of it under the triangle. Let's all three of us walk by; don't forget, people just don't view it, they pass it. Good. Nice. . . .

Brass comes, and we really get excited. . . . We put it up . . . discuss joints. . . . Suggestions, shifting and moving. . . . Call it quits because we really feel we have it right, and we all go home.

But the next day I'm restless, and there's a little churning in my stomach that tells me that it's not quite right. I wait until the quiet of evening and go back to the studio alone. I'm waiting to surprise myself, looking for that instant recognition of what is right or wrong. I started to play with more lengths of thinner, more linear brass that was in the studio, and within half an hour the piece was at last "done," aesthetically, at least.

By April 30, reality had caught up with art, and the piece was fully completed. Betty Lemmon, GSA's representative from the Atlanta office, inspected it, and it was approved. Reflecting on the entire experience, Stone said, "I am now convinced that any sculpture I do, no matter how large, must evolve organically. My best pieces always have. If the GSA hadn't been so cooperative

in recognizing an artist's needs and the problems of creativity, I would not have been able to change the piece even if I thought I could make it better—and I could not have given the GSA and the public a work of art that was the result of my best efforts."

On June 2, as the temperature climbed to ninety-four degrees in the shade, Stone began sweating out the installation with Susan and Tony. Working eight- to ten-hour days for over a week, they imbedded the components of the piece into the concrete wall and floor. "It looks even better on the site than it did in my studio," exclaimed Stone on June 11, the day the work was finished—and that *was* the real test.

★ ★ ★

Dead Heat, as Stone titled her work, was dedicated in mid-August 1979. Writing for the dedication brochure, Stone said:

Since I had used transparency and reflectivity as a visual language for many years, I had to edit my predilections carefully. . . . Dark bronze Plexiglas was selected . . . to give more reflective detail.

. . . The linear brass elements are meant to reflect [in the Plexiglas]

and create another illusion of spacial depth that changes with each step. Illusionistically, the brass lines pierce the flat planes of Plexiglas. I consider it a unique piece, meant to function in only this space, this light, and this building.

I would like to acknowledge the cooperation and flexibility of the General Services Administration, which allowed me to express a visual statement without hindrance and with full support. It has been a very satisfying experience.

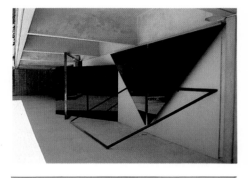

Two views of Dead Heat, *Sylvia Stone's sculpture for the exterior entrance wall of the federal courthouse in Ft. Lauderdale, Florida. The piece, which was installed early in June 1979 and dedicated in August, measures eight feet high by twenty-eight feet wide by six feet deep. It is made of dark, highly reflective Plexiglas and linear brass elements that Stone refers to as "writing."*

MARK DI SUVERO

"Grand Rapids' Love Affair with Art," headlined the *Detroit Free Press* in an article prominently placed on the editorial page on June 18, 1977. The article continued, "Both art and city are being reborn. . . . Just two weeks ago . . . they dedicated a new piece of downtown sculpture by Mark di Suvero, an American who is one of the world's most acclaimed younger sculptors." But the installation of the work in Grand Rapids was a long time coming. In fact, it was a roller coaster of ups and downs, confusion, despair, and ultimately joy in one of the largest citizen campaigns ever mounted to budge the bureaucracy to accept a work of art.

To understand this complex story, one must first know that the city of Grand Rapids was in many ways leading the nation in terms of the installation of public art. In the late 1960s, Alexander Calder had created a monumental sculpture for the downtown center's Vandenberg Plaza. Although the work, titled *La Grande Vitesse,* drew a good amount of criticism, the citizens of Grand Rapids grew to appreciate it. Within four years of its 1969 installation, public reaction was so favorable that the city adopted its form as an official symbol, emblazoned on everything from the mayor's stationery to the municipal sanitation trucks.

In the early 1970s, just as the citizens were becoming accustomed to "their" Calder, the indefatigable Women's Committee of the Grand Rapids Art Museum organized a mind-boggling outdoor exhibition, Sculpture off the Pedestal, in downtown Grand Rapids. A number of America's leading artists

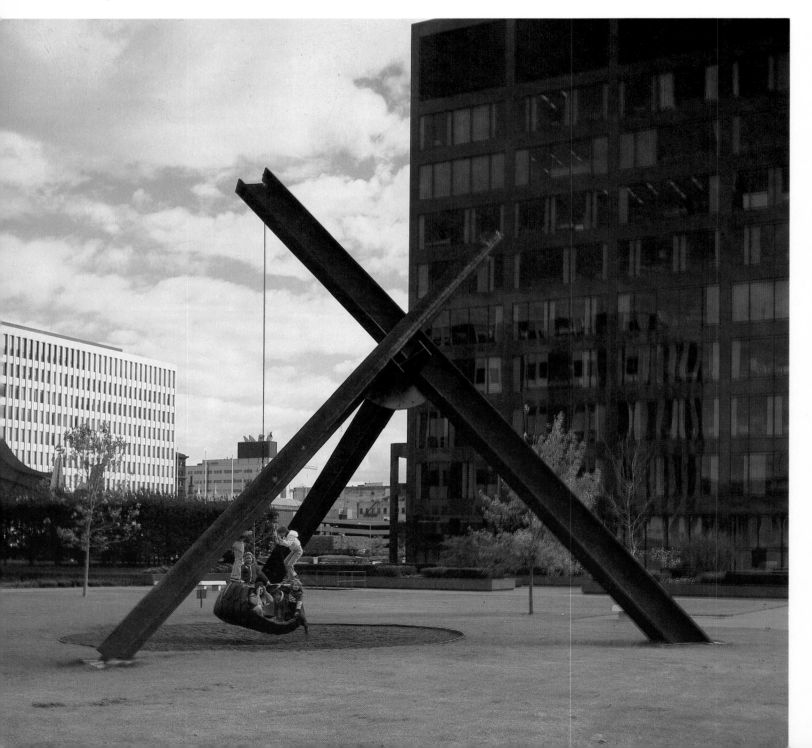

produced works for this exhibition, including Stephen Antonakos, John Mason, Lyman Kipp, William King, Robert Morris, Robert Murray, Michael Hall, and Mark di Suvero. Di Suvero's work, installed largely through the efforts of Mr. and Mrs. Miner S. Keeler of Grand Rapids, became a focal point within eyeshot of the Calder. It remained from the fall of 1973 to the spring of 1974. That same year, Calder returned to Grand Rapids to put his stamp of approval on a gigantic rooftop painting (127 feet by 127 feet) on the top of the Kent County Administration Building, which fronted on Vandenberg Center.

It was in this climate of supportiveness for avant-garde works of art that the di Suvero saga began to unfold. In 1973, purely by chance, Mary Ann Keeler saw an article in the *Detroit Free Press* that mentioned GSA's newly reactivated Fine Arts Program. In a flurry of letters to and from Representative Ford, Senator Robert P. Griffin, and GSA administrator Arthur Sampson, Mrs. Keeler succeeded in convincing the federal government that a sculpture should be commissioned for the Grand Rapids federal building and U.S. courthouse. In the process James M. Bentley, president of the architectural firm that designed the building (Kingscott and Associates, Kalamazoo), submitted a statement to GSA that such a work of art had been desired as a design necessity, and that it should be "architectonic in nature with strong structural characteristics."

In accordance with standard procedure, di Suvero was selected for the commission and accepted a contract for $40,000 in July 1974. I was surprised and pleased. The art community in Grand Rapids was ecstatic. The national art community was stunned that di Suvero would lock himself into a commission at all in those days, that GSA would have the vision to commission him, and particularly that he would accept a $40,000 contract for the "design, fabrication, and installation" of a major work when his works were

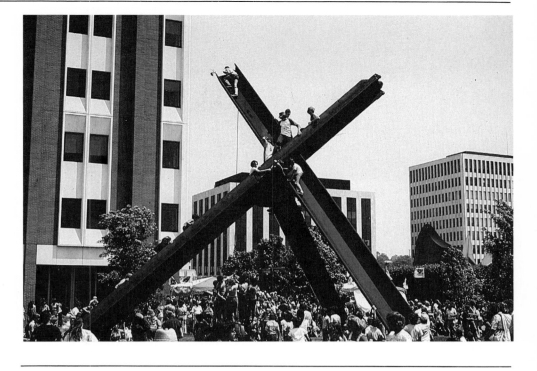

Part of the enthusiastic crowd at the dedication ceremony for Moto Viget *in June 1977. "All of us are children at heart—or were children and have forgotten it. . . . the child in us can respond to the piece," said di Suvero in his speech.*

selling for $80,000 to $100,000 and up. It was a potentially important step for Mark at the time. He'd recently returned to America from a self-imposed exile (1971–74) in Chalon-sur-Saône, France, in protest of the U.S. involvement in Vietnam. He was on the threshold of a skyrocketing career; a full-scale retrospective of his work was being planned by the Whitney Museum of American Art for the autumn of 1975, following on the heels of the first one-man exhibition ever offered a living artist in the famed Tuileries Gardens adjacent to the Louvre in Paris.

In late 1974, di Suvero submitted a maquette of his proposed sculpture to the GSA regional office in Chicago. It consisted of two tripodlike elements with extensions allowing one piece to balance on top of the other. Although the maquette was made of roughly cut steel, it was understood by all who knew anything about Mark's work (as well as by those who were involved with the contract) that the piece would be executed in I-beams. In early November, the concept was approved by the GSA panel.

★ ★ ★

Mark went to work at his sculpture ranch in Petaluma, California, at the same time preparing for his exhibitions at the Tuileries Gardens and the Whit-

ney. In May 1976, he went to Grand Rapids and there encountered an unexpected difficulty: wind velocity in Grand Rapids had been known to exceed sixty miles per hour. As Mary Ann Keeler reported, "The model he had submitted had a moving crown on a lower base. Because of the wind, this could be a problem. Any children climbing the sculpture could be severely injured at a 'pinch point.'" Paul Newhof, Mark's structural engineer in Grand Rapids, uncovered a further problem: the weight of the finished piece as originally conceived (approximately 70,000 pounds) could not be supported on the site "without significant modification to the existing structural system."

On May 28, notified that the work was nearly complete, the Chicago regional office sent Bob Stewart to inspect it. The piece he saw, reflecting the wind and weight factors, was completely different from the original— less complex, and without the upper

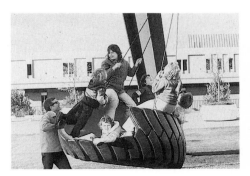

Opposite: Mark di Suvero's Moto Viget. *"The mobile element is not only visual but kinesthetic and demands experiential interaction," said the sculptor, referring to the suspended "gondola" feature of the piece. "It works on your fifth sense, the Eustachian tubes—your sense of balance."*

Right: Children playing in the gondola confirm di Suvero's view.

tripod-shaped balancing unit. When the commissioner of the Public Buildings Service, Nicholas A. Panuzio, saw photographs of this new sculpture, he was not pleased, but he deferred any further decision until his return from vacation.

Meanwhile, the people of Grand Rapids were eagerly awaiting "their" di Suvero. The *Grand Rapids Press* had run a photograph of the revised piece, praised di Suvero as the "Pied Piper of public sculpture," and reported that many citizens were so enthusiastic that they had donated materials, work space, cranes, and professional engineering consultation. By the time Commissioner Panuzio returned from his vacation, he had learned of this article and was furious, or so I was told. Apparently he was angry that the newspaper had reported the story before he'd seen the second proposal, and indeed that a second proposal existed—in completed form—without prior opportunity for review. In any case, in spite of the extraordinary level of public support, and even though the selection of di Suvero had followed a procedure tailor-made to Panuzio's specifications, he rejected the sculpture.

The Art-in-Architecture Program staff viewed this action as ill advised, and we prepared fact sheets and chronological listings of events showing that the GSA office in Chicago had known about the changes since May, as had we. We pointed out that the original work was unsafe for a number of reasons (children's hands pinched, greater load than the structure supporting the sculpture could handle, etc.) and produced documentation from the structural engineers in Grand Rapids. We also prepared position papers on the cultural climate in Grand Rapids. Mary Ann and Mike Keeler flew to Chicago to talk with the regional administrator, Frank Resnik, and the regional commissioner, William Morrison. Di Suvero himself wrote a letter "To the Committee," postmarked August 3, 1976:

> A piece of sculpture is born, interacts, changes thru the artist . . . and becomes that strange and elusive experience called "art." I cannot justify any sculpture I've done with words, and any person who judges the works without experiencing them commits the basic injustice that art suffers: philistinism.
>
> The mobile element in the sculpture for Grand Rapids [di Suvero's second proposal included a swinging "gondola" made from a tire

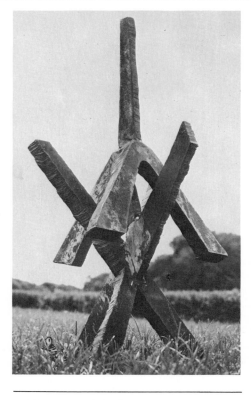

Di Suvero's original maquette for the Grand Rapids commission.

seven feet in diameter, suspended by cables from the steel members] is not only visual but kinesthetic and demands experiential interaction. For a rooftop [site of the sculpture], fifteen tons is a lot. Pier centerings was a prime consideration. Structuralism in my art required integration with architecture—not nonsensical phonemes of linguistics—and this I have done. I was nominated for the commission in Grand Rapids before the maquette came into existence; the sketch is not the finished work.

> I hope you will like the piece of sculpture: move with it! If the great Calder in Grand Rapids is female, then this piece is male. It works on your fifth sense, the Eustachian tubes—your sense of balance. Please tell me what you think of it installed.
>
> Peace be with you—and may you give happiness to others.
>
> Mark di Suvero

Commissioner Panuzio, unlike the suspended gondola of the work, was unmoved.

Discouraged but not defeated, di Suvero's supporters continued their efforts in his behalf. Mary Ann Keeler went to a great deal of trouble to have the sculpture reconstructed (it had been disassembled by this point), and a videotape made of it so that Commissioner Panuzio could see it in action. We in-

vited Karel Yasko, Panuzio's counsellor for fine arts and historic preservation, to a preliminary screening in my office. His response—that the sculpture was little more than playground equipment—was something less than encouraging. Later, when Panuzio saw the tape, he made no disparaging remarks about the sculpture; in fact, he made no remarks about the sculpture at all, commenting only that it must have cost someone a lot of money to have the video made.

At this point, the pace of events quickened considerably. The *Grand Rapids Press* headlined, "U.S. Agency Won't Buy Substitute Sculpture" (November 19, 1976), and reported, "The local group is disturbed by the turn of events, but not by the sculpture. . . . Said Myers [director of the Grand Rapids Art Museum]: 'If the piece was shoddy or ill-conceived, there might be a reason for the refusal of GSA. As it now stands, we have an excellent sculpture by an artist of stature that I consider a masterpiece.'" Ten days later in the same paper, Jan Blaich wrote in her column,

> It may be that we are on the threshold of a controversy as lively

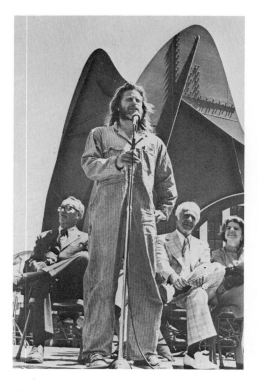

Mark di Suvero, praised by the Grand Rapids Press *as "the Pied Piper of public sculpture," addresses the crowd at the dedication of* Moto Viget *in June 1977.*

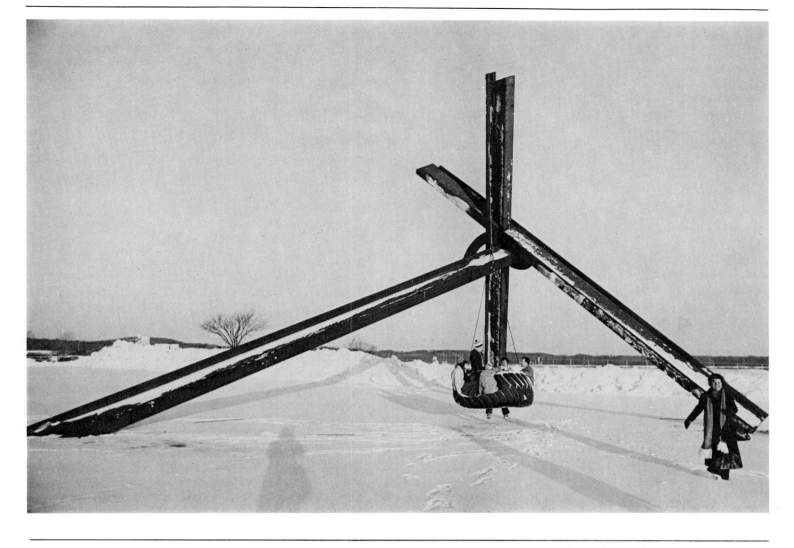

Mary Ann Keeler in the steelyard where Moto Viget *was assembled for videotaping. Upon viewing the tape, one of di Suvero's critics within GSA called the work little more than "playground equipment."*

as the one that surrounded the Calder. . . . Faith in the artist's creativity is the basis of . . . an investment. Freedom to exercise this creativity is an essential prerequisite. Such is the nature of commissions. . . . di Suvero's attempt to meet the standard of design integration could only be accomplished after he received the commission and was able to visit and become familiar with the site.

The penalty now being imposed by the GSA for this effort must be viewed as defeating the purposes of the program. It can only be hoped that the GSA will retreat from its decision, allowing Grand Rapids to significantly add to its collection of public art.

In came a wave—no, a tidal wave—of letters and petitions. Hundreds and hundreds of citizens from all walks of life—the mayor, the circuit court judge, the superintendent of schools, a judge of probate for the County Juvenile Court—all wrote urging GSA to change

its position. The result? "GSA Stands Firm: We'll Accept What We Bought," bannered the *Grand Rapids Press* (December 16, 1976), quoting Panuzio—"I am probably the first one to speak out for the artist, but in this instance, our position is firm"—and noting that Panuzio had received hundreds of letters from people who favored *any* di Suvero piece.

The onslaught of letters continued. The president, the past president, and the current director of the Grand Rapids Art Museum wrote, as did the Paulist Fathers, the Grand Valley State Colleges president, the president of the Arts Council of Greater Grand Rapids, the minister of the Fountain Street Church (who urged action from the pulpit), the West Michigan Tourist Association Advisory Board, the city's assistant planning director, and presidents and vice presidents of foundations, corporations, and executive councils. Letters came from doctors, attorneys, schoolchildren, architects, housewives, professors. The president of the Dyer/Ives Foundation combined

humor with a serious purpose, enclosing the following poem:

Now me and my girl friend, Lola
Prefer culture to steaks or granola
And the piece by di Suvero
Is simply so groovy, oh!
Please let us have our Gondola!

Some of these letters were sent to elected officials, from congressmen all the way up to President Gerald Ford, and even to President-elect Jimmy Carter. But most were addressed to Panuzio, urging him to reconsider. The citizens were angry, concerned, upset, and alarmed—recurring words in their letters. Petitions were circulated, gaining momentum with every news article.

Not everyone was pleased with the proposed sculpture. GSA did receive two or three letters critical of di Suvero's work, and a local painter, Paul Collins (who had recently completed a figurative mural on the life of President Ford for the Kent County Airport), wrote an article which was published in the *Grand Rapids Press* (December 27, 1976):

Business and government agencies have long been wary of artists and their peculiar temperaments. Many artists are presently working to alter the stereotype of unreliability. Mr. di Suvero's actions only reinforced it. For this reason, I can only applaud the recent GSA decision.

Should Mr. di Suvero be more privileged than an architect or an engineer? An engineer cannot design a bridge, receive approval and then proceed to construct a different bridge.

A rebuttal by Ronald Watson, chairman of the art department of Aquinas College in Grand Rapids, was published the following week (January 4, 1977) in the same newspaper:

We must keep in mind that this is the work of an artist, not an engineer or an architect. A sculpture is primarily for our contemplation. The work of engineers and architects has many other functions, such as providing safe river crossings and physically suitable offices, to name just two.

. . . From the businessman's point of view, di Suvero's works have appreciated in value so dramatically that financiers on Wall Street can only wish their blue chip stocks were di Suvero sculptures.

It was a standoff between the citizens of Grand Rapids and Commissioner Panuzio—an extremely ironic standoff for the staff of the Art-in-Architecture Program, for in Grand Rapids, people were signing petitions to keep a sculpture rather than angrily demanding its removal. For those caught in the middle, it was a search to find a common ground to resolve the matter. Someone suggested, as a last-ditch effort, a face-to-face meeting between Panuzio and di Suvero (both men have very engaging personalities); for various reasons, it never came off. In the meantime, Mark went so far as to send Panuzio a maquette of the second sculpture, on the theory that the finished piece would then be the "perfect imitation" that the bureaucratic mentality seemed to require. The maquette arrived shortly before Christmas, 1977. Panuzio wasn't impressed.

★　★　★

About a month later, just as the impasse seemed permanent, GSA issued a news release: "The U.S. General Services Administration today accepted a sculpture by Mark di Suvero for the plaza of the federal building-courthouse in Grand Rapids, Michigan." This dramatic volte-face took everyone by surprise. By now, of course, the country had a new president, and Panuzio was mentally preparing to leave the government—"phasing down," in his words. Perhaps this accounted for his sudden decision. But if the reasons were somewhat unclear, the explosions of joy were unmistakable.

The plaza landscaping was modified to suit the work, according to a plan worked out between di Suvero and the architect. All work was completed in time for the dedication ceremony, which coincided with the opening of the 1977 Grand Rapids Annual Arts Festival. Both Mark and his lovely architect wife, Maria Theresa, came to the dedication. As Sharon Hanks and Laurie Young reported in the *Grand Rapids Press* (June 4, 1977),

With a clash of cymbals, drums, trumpets, and tributes, the festival was dedicated to the late Alexander Calder . . . but the show stealer was the new modern art sculpture by Mark di Suvero. Hundreds of persons, from the kiddie set in blue jeans to business men in suits, dropped their inhibitions and swooped down on the sculpture. Amid laughter, they swung on the gigantic tire that hangs from the sculpture's metal beams. "It's wonderful," said a 75-year-old woman as she watched four men clad in suits and eight youngsters wiggle onto the tire. "I think they should enjoy it."

Di Suvero named the work *Moto Viget* ("strength and activity"), after the city's motto. He told the crowd at the dedication ceremony that he'd gotten the idea from his mother, who had been "Keeper of the Key to the City" that he'd received in 1973 when one of his works was installed as part of the Sculpture off the Pedestal show. "All of us are children at heart—or were children and have forgotten it. . . . the child in us can respond to the piece," said di Suvero (quoted by Bernice Mancewicz in the *Grand Rapids Press,* June 4, 1977). *Moto Viget* was formally presented to the city by GSA's regional commissioner, William Morrison, who called it "vital, abrupt, and exciting." The NEA's representative, Delores Wharton, said, "Throughout American history, the centers of art have been on the East and West Coasts. Grand Rapids has provided a showcase for the arts here and is exemplary as the 'Athens of the Midwest.'"

Mike and Mary Ann Keeler smiled; they had succeeded. Throughout the long struggle, during which they became widely known as "the Medicis for public art," they tirelessly gave of their energy, never wavering in their belief in di Suvero. The Keelers took on the federal government and set an example.

★　★　★

In a letter postmarked March 17, 1978, Mark wrote to me of his views on the entire sequence of events. He spoke of the good people of Grand Rapids:

It gladdened me to see these people unite for art. . . . these people of Grand Rapids, Michigan, took me into their homes, gave me help, faith in the work, love—and when the government said *no* to the sculpture they acted democratically, and the art community united practically unanimously.

He wrote of the GSA art program:

I think the GSA art and architecture program should be tremendously expanded in order to satisfy America's crying need for culture. This is a new age—vital, abstract, and expanding; to give the sense of art, to raise the *quality* of life, must be government's highest moment; service to the vital core of who we are; a manifold response to the "why" of our existence.

He wrote about the future of the program:

The artist needs to be into the architecture at a much earlier stage, at the building design stage. At that moment the relation between sculpture and architecture would become real; and the possibility of that great moment of the unity of a great building in dialogue with a great piece of sculpture could become real.

And finally, he wrote about any possible future relationship with GSA: "I don't think I'll ever work for the GSA if I can avoid it—don't take it personally. Good luck to you, Don!"

Some di Suvero fans scale the heights of Moto Viget to admire the view.

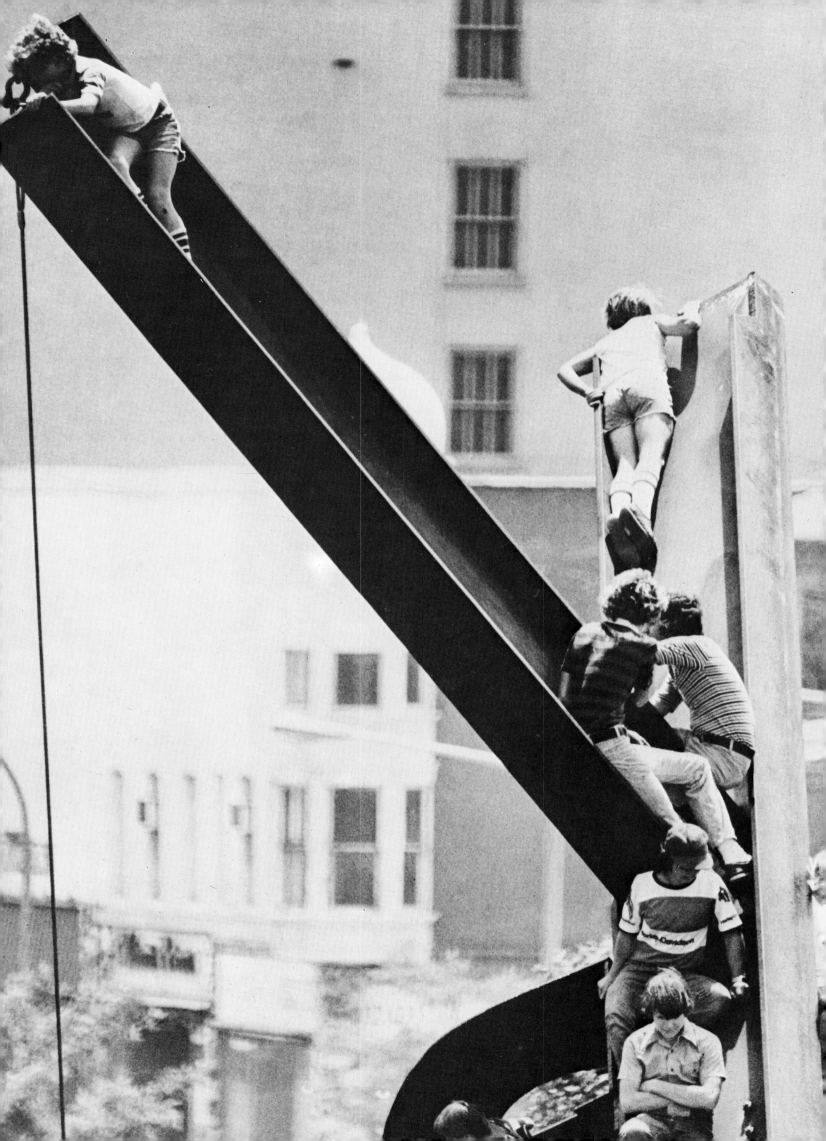

PETER VOULKOS

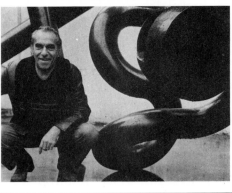

Peter Voulkos is undoubtedly one of the most influential sculptors of our generation. An artist who began working in clay, he pushed the the medium beyond previously accepted limits of scale and form. As Rose Slivka said in the definitive *Peter Voulkos: A Dialogue with Clay* (New York Graphic Society/American Crafts Council, 1978),

Until the late 1950s, pottery was pretty much what it had been for thousands of years: hollow clay forms, usually turned on a wheel and fired. Then along came Peter Voulkos. Gouging, slashing, stacking his forms, working on a monumental scale, he created a revolution in clay and became the first of a new breed of artists who cross all lines between art and craft.

If Voulkos didn't single-handedly tear down the invisible walls separating art from craft, he certainly has been a driving force and a seminal influence. "Over the last twenty years," wrote Slivka, "he has . . . taught more than ten thousand students, has had twenty one-man shows, participated in more than one hundred group shows, and has been a nucleus to which artists everywhere gravitate."

But it wasn't for a ceramic work that Voulkos was nominated by a National Endowment panel at a meeting in Honolulu during the spring of 1974. In the early 1960s, desiring to work on an ever-larger scale, Voulkos had turned his interest to cast bronze. "He wanted properties that are not inherent in the clay—the ability to move out into space with lateral movement, to explore the openness which was a part of abstract expressionist sculpture," wrote Gerald Nordland (*Peter Voulkos Bronze Sculpture*, exhibition catalogue of the San Francisco Museum of Art, October 1972–January 1973). This shift in focus made Voulkos a prime candidate to execute a sculpture for the Prince Jonah

Kuhio Kalanianaole Federal Building and U.S. Courthouse in Honolulu. For the courtyard area, the architectural firm of Belt, Lemmon and Lo had proposed "a voluptuous bronze or dark metal piece which invites one to see it from close up and dwell on it." Joe Farrell and Dave Miller, design architects from the firm, believed the work should be "serene in character," with a maximum height of five feet and a depth of four feet.

Voulkos, whose work had been included in the Whitney Museum's 1974 Sculpture Annual and the Oak-

Peter Voulkos's Barking Sands *in its first location, without base.*

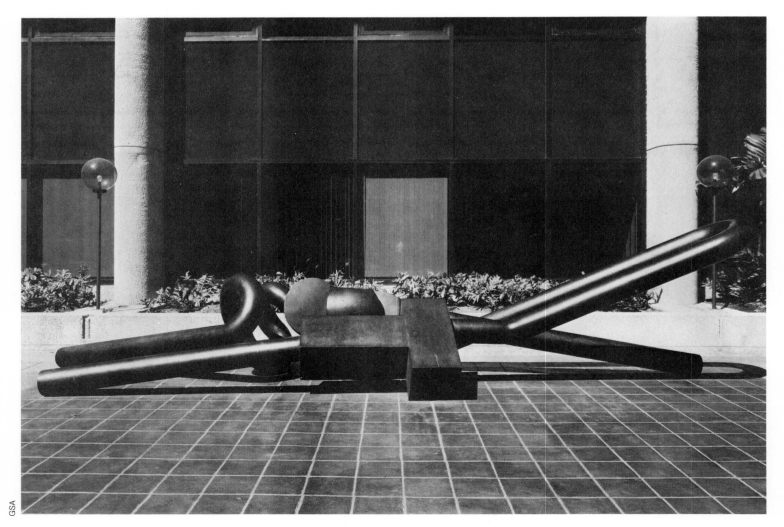

land Museum's Public Sculpture/ Urban Environment exhibition the same year, was selected by Administrator Sampson for the commission. The contract negotiations, which were held in Honolulu in January 1975, couldn't have been smoother, largely owing to Voulkos's personality. In an article on Voulkos for *Artnews* (October 1978), art critic Thomas Albright gave a perfect thumbnail sketch: "... sculptor Peter Voulkos is a man of dark, rough-hewn good looks, the type who projects a Zorba-like animal energy and raw physical strength. He is outgoing, outspoken, profane (in a booming basso profundo), intense in activity and at the same time relaxed, easygoing, with an almost fatalistic acceptance of results."

Voulkos was indeed relaxed and easygoing in his approach to the contract, and certainly very trusting if not fatalistic. He kept saying "Sure, sure" and "That's okay" to even the most complex clauses. He later wrote, "My negotiations in Honolulu were simple and pleasant. I was not asked to compete with my colleagues; rather, we were all picked for specific projects simply because of our commitments to visual information as well as our track records. I enjoyed the simplicity and respect that was accorded me."

The contract, negotiated for a fee of $40,000, was typed, xeroxed, and mailed to Voulkos in March. He signed immediately and went right to work. By mid-July, Voulkos had completed his maquette, which he photographed next to a GI Joe doll to give a sense of the intended scale. "Here are a few slides with GI Joe in the pictures," he wrote. "Looks like he's pissing on it already. Anyway I hope they suffice for the purpose."

The maquette was unanimously approved by GSA. Notified of its acceptance, Voulkos proceeded to complete the work in full scale.

... I set up a crew to help in the fabrication. As I have always cast my own bronze, the project entails the hiring of workers who are familiar not only with the procedures involved, but with how I think and feel. Most of my helpers are competent artists in their own right, so they in a sense affect me and my decision making in a quiet and subjective manner. To them, I give my many thanks.

The finished work, titled *Barking Sands*, was shipped to the site, where it awaited completion of the building before being installed and photo-

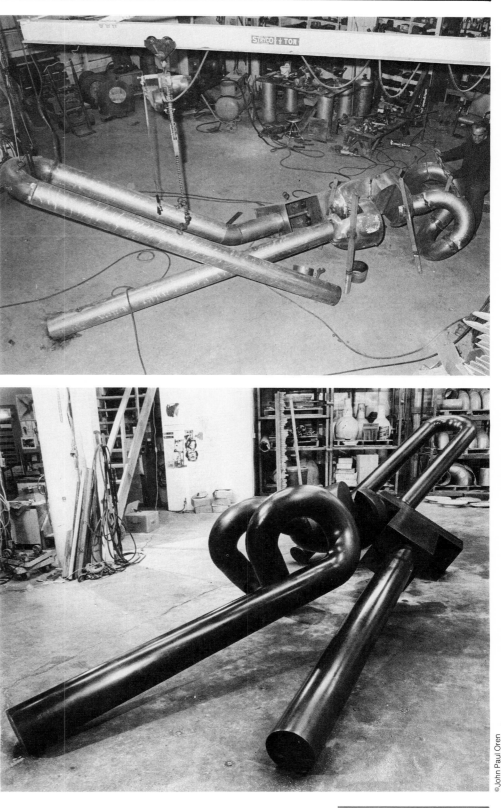

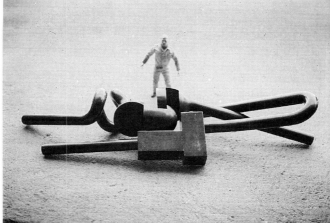

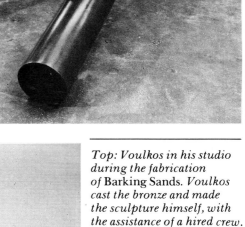

©John Paul Oren

Top: Voulkos in his studio during the fabrication of Barking Sands. *Voulkos cast the bronze and made the sculpture himself, with the assistance of a hired crew.*

Above: The fabrication process nears completion. Barking Sands *is an intriguing combination of geometric and serpentine forms. Its surface was chemically treated to induce a dark, rich patina.*

Left: GI Joe inspects Voulkos's maquette for Barking Sands.

graphed. Voulkos named his six-foot-high by five-foot-deep by twenty-five-foot-wide sculpture for an airfield where he was stationed during World War II. "It commemorates all my old buddies and the good and hard times we had together," he said.

Barking Sands was dedicated in June 1977, with First Lady Rosalynn Carter in attendance. Writing for the dedication brochure, Voulkos said:

Time frequently mellows artworks and people. Just as time will enhance the induced patina of my sculpture *Barking Sands,* so has my work changed over the years. I began my career as a painter, then I worked in clay. The transition was not difficult because both media offer an intimacy between the artist and his work.

This intimacy is not available to the sculptor working in bronze, which is one of the reasons I selected this material for my work. I felt the need to ponder my work for longer than was possible when working in clay. I also wished to work on a much larger physical scale than paint or clay allowed.

The art community in Honolulu liked everything about Voulkos's work except its location and felt that it needed a less cramped, more visible site. Accordingly, *The Cultural Climate,* newsletter of the Arts Council of Hawaii, began a crusade to have the sculpture moved. The considered views of those favoring a new site carried the day, and the piece was relocated in November 1978. Delighted with the results, *The Cultural Climate* proclaimed, ". . . the massive sculpture of Peter Voulkos has been moved from where people and elephants could trip over it to where they can see it—and wonder. It comes to rest on the mauka [inland] side of the

[building] and on a concrete base, indubitably its own."

Voulkos, who claims to find it "damn difficult" to put his thoughts into writing, conveyed his impressions of the Art-in-Architecture Program forcefully in an April 1979 letter. Calling it the most "energetic and creative venture that the United States government has [undertaken] since the WPA," he praised the program for "taking . . . valuable information out of the gallery and museum context and making it, *art,* into a viable, provocative, and stimulating question and answer for all to see. It provides intimidation and confrontation where it is needed and helpful. It is *right out there."* And, concerning the success of *Barking Sands* on his own terms, he concluded, "Do I like the work? *I love it!*"

So do the many islanders and tourists who have occasion to visit Honolulu's federal building.

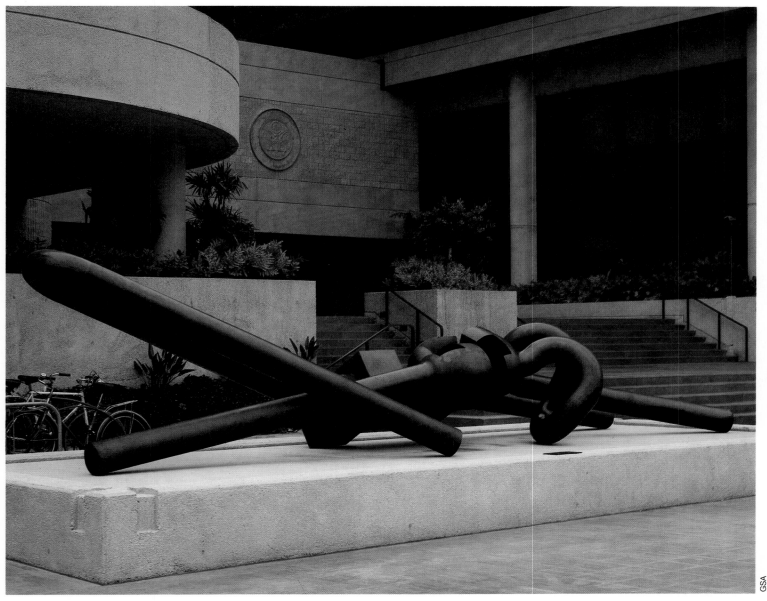

GSA

Barking Sands *on its final site on the inland side of the building. "This work was designed to be viewed from above and from eye level—a unique situation for a sculpture," said Voulkos in his statement for the dedication brochure.*

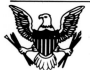

"It's a great day for the arts, with the First Lady dedicating these four exciting sculptures and fiber works. We all can be proud of these works and proud that our society is still encouraging and rewarding creativity, innovation, and experimentation," said Jay Solomon, administrator of GSA (GSA News Release 6777, June 24, 1977). It was indeed a great day for the arts, with an impressive array of dignitaries on hand for the dedication of Honolulu's Prince Jonah Kuhio Kalanianaole Federal Building and U.S. Courthouse and the artworks that had been commissioned for it.

For Sharyn Amii Mills, who had spent two years designing and executing two fiber works for the fourth-floor courtroom lobby, the dedication "was one of the most exciting, rewarding moments I have experienced"—and she deserved every moment of satisfaction she felt.

★ ★ ★

Mills was one of twenty-three artists nominated by an NEA-appointed panel

SHARYN AMII MILLS

for several different commissions associated with the federal building. She was selected by GSA administrator Sampson in November 1974, and contract negotiations were held in Honolulu in mid-January 1975. Mills agreed to a fee of $10,000 and later said that she found the negotiating experience unexpectedly interesting and pleasant.

For the next sixteen months, Mills refined her concept of the fiber sculptures, ultimately developing two separate proposals. Throughout she worked closely with the building's design architect, Joe Farrell, discussing the evolution of her work with him and making numerous visits to the site. As she later wrote,

. . . the collaboration between artist and architect is of great importance in familiarizing the artist with the planned or existing architectural environment and its special problems. It is equally important in the understanding of the aesthetic and emotional contributions the artworks could make to the spaces. . . .

Consideration was given to the total design concept of the building, to the physical space of the lobby, to

Fiber Sculpture One *(left) and* Fiber Sculpture Two, *in the fourth-floor lobby of the federal courthouse in Honolulu.*

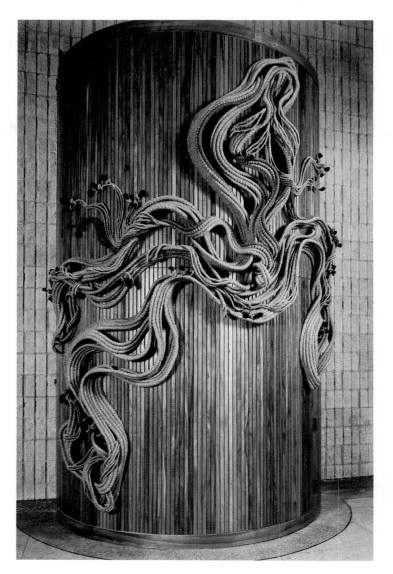

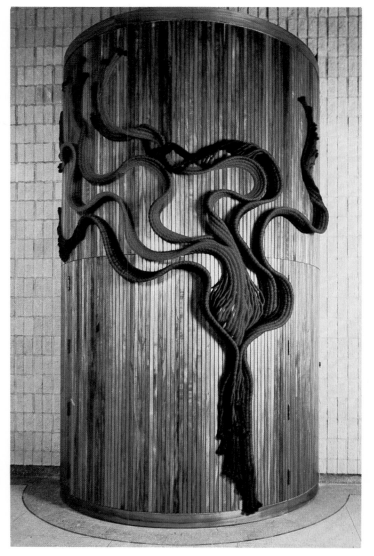

the surrounding surface textures and colors, to traffic patterns, to light, and to the location of the pieces and its effect on eye movement. These considerations and the resulting decisions regarding the pieces' general forms, materials, colors, sizes, and construction provided the framework in which my artworks were created.

Mills's final proposal, submitted in the form of sketches, was approved in May 1976. She ordered her materials and went right to work. Using a non-loom construction technique, she wrapped and coiled wool around polypropylene rope to create her organically shaped sculptures; the total effort took her the better part of a year.

A native of Hawaii, Mills was living in California at the time, and on June 10, two weeks prior to the dedication, she traveled to Honolulu to install the works. She had been assured by the GSA construction engineer that the lobby space where the work was to be placed would be ready, but it wasn't —a fact that presented her with some good news and some bad news. The bad news was that the pieces would have to be put into storage temporarily. The good news was that her works would be the only ones displayed at the dedication, because the other pieces were already in place some distance from the speakers' platform.

Two days before the dedication, the works, each measuring approximately twelve feet high by thirteen feet wide, were mounted on large wood panels. The panels were then draped, decked with colorful and fragrant flower garlands, and hoisted above the platform to await unveiling by Mrs. Carter. When the ceremonies began, the First Lady expressed her pleasure in returning to Hawaii, where she'd lived in 1949–50, and where her son, Chip, had been born. A thirty-five-foot lei had been strung across the building's main entrance, and as she pulled it down, she said, "This morning we not only dedicate a building but these fine works of art. . . . a building has to be more than just a cold place to work" (*Honolulu Star-Bulletin*, June 24, 1977).

The dedication guest list included both of Hawaii's U.S. senators (Daniel Inouye and Spark Matsunaga), Representatives Daniel Akaka and Cecil Heftel, Governor and Mrs. George R. Ariyoshi, and all of Hawaii's ranking judges. Assistant Secretary of State Patsy T. Mink and Commander in Chief of the Pacific Maurice F. Weisner

One of the sketches submitted to GSA by Sharyn Amii Mills as part of her proposal for two fiber sculptures.

both had seats of honor on the speakers' platform. The *Star-Bulletin* labeled the event "one of the most impressive building dedications in the history of Hawaii"—and Mills agreed.

The highlight of the commission was the dedication ceremony. It was so colorful, with all the beautiful tropical plants, flowers, and leis, and with the melodic sounds of the Royal Hawaiian Band and Hawaii Civic Choir. It was the height of mixed emotions—of honor and pride, of shared recognition and appreciation, of elation, and of the wonderful, warm, indescribable reciprocal feelings of Aloha and love—never, ever to be forgotten. Thank you, GSA.

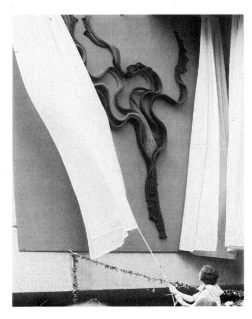

(Much of the credit for the dedication must go to GSA's longest-reigning regional administrator, Tom Hannon, who died suddenly of a heart attack shortly after the ceremonies, and whose generous labors on behalf of the Art-in-Architecture Program's objectives are sorely missed.)

Stirring as the celebrations were, it is the artists' work that remains, providing inspiration to the many who visit or work in the federal building and courthouse. Mills's *Fiber Sculpture One* and *Fiber Sculpture Two* add grace and beauty to the courtroom lobby and perhaps offer solace to those who await their day in court. As she describes the works,

These fiber pieces are meant to embellish and complement their environment and integrate themselves through color, texture, and form so as to be in "coexistence" with the architectural space, rather than be a foreign intrusion. One of my key objectives was that my artworks have their own life, yet be in healthy harmony with their surroundings. The openness of the pieces is a purposeful attempt to further integrate the wall surface with my forms.

Through my organic, nature-inspired fiber sculptures I hope to evoke warm, comfortable feelings of life and liveliness, of strength with flexibility, of movement, and of continuous growth.

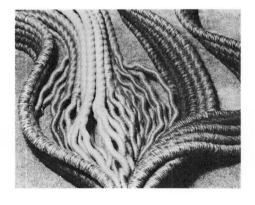

Above: A detail of Fiber Sculpture Two. *Both works consist of forms created from polypropylene rope wrapped with wool.*

Left: First Lady Rosalynn Carter unveils Fiber Sculpture Two *at the dedication of the Prince Jonah Kuhio Kalanianaole Federal Building and U.S. Courthouse. Mills was one of four artists commissioned to create various works for the building. Since the lobby space that now houses* Fiber Sculpture One *and* Fiber Sculpture Two *was not ready before the dedication, they were the only works featured at the ceremony (the others had already been installed).*

RUTHADELL ANDERSON

Ruthadell Anderson [signature]

In the spring of 1974, an NEA-appointed panel met to consider two sculpture commissions and two fiber work commissions that had been proposed for Honolulu's new federal building and U.S. courthouse by the architectural firm that designed the building (Belt, Lemmon and Lo of Honolulu). In all, the panelists nominated twenty-three artists for the four commissions, among them Ruthadell Anderson. Within three months, information and visual material on the work of the prospective artists had been assembled by the NEA staff—that is, Brian O'Doherty, director of the Visual Arts Program, and Julie Moore Jackson, his assistant. The nominations were then forwarded to GSA's Design Review Panel, which recommended Anderson for one of the fiber work commissions.

On November 27, 1974, Anderson was officially selected by Administrator Sampson. Notified of the commission by telephone, she was barely prepared (as it were) for the news. "Your telephone call . . . came early in the morning, before I was out of bed. It was particularly memorable because it lasted about forty-five minutes, and I didn't have any clothes on. The call came as a complete surprise—needless to say, I was very happy and excited about it," she wrote later.

Contract negotiations with all the selected artists were scheduled to take place in mid-January 1975, but Anderson had already planned to be in Mexico at that time. Commitments on both sides were firm, so the contract was negotiated clause by clause over the telephone. Everything went smoothly, and a fee of $15,000 was agreed upon.

Anderson worked closely with the project architect, Joe Farrell, so that she would understand the objectives of his firm's proposal for the commission. "When I toured the partially completed complex . . . Mr. Farrell expressed his preference for a large three-dimensional fiber structure," wrote Anderson. "This idea appealed to me, as I had not had

The model for Anderson's second proposal.

the opportunity to do such a piece before. The fact that the whole lobby area was to house my work alone presented still another rare opportunity."

Nine months later, Anderson submitted a proposal for a group of three large forms extending from the floor almost to the ceiling, with smaller forms incorporated as seats. She considered this design a good solution for the space, which was to serve as a gallery featuring changing exhibitions. Anderson was pleased with her concept, and the architects were more than pleased. Unfortunately, GSA's Design Review Panel was not, and they rejected it because, in the words of panelist Karel Yasko, "the weaving was used as a skin covering." The panel's "primary design interest," according to Yasko, was "to express the integrity of the medium," and "the use of props . . . to articulate the sculptural forms appeared to violate that objective."

A disappointed but optimistic Anderson then developed a second proposal, which she submitted in January 1976, and which, in her view, took into consideration the objections of the Design Review Panel. Describing it, she wrote, "The structure will consist of two continuous strips of weaving. They are hung over four short pieces of tubing which rest on two larger tubes or beams that span the entire width of the room. . . . The strips will incorporate several different weaving constructions, and they will have slotted openings in places, permitting a view through the layers."

Once again, the GSA panel rejected Anderson's design. This time, it seemed only fair that Yasko explain the panel's reasoning directly, and he called her on February 12. In a confirmation letter reiterating their conversation, Yasko said that both proposals were inadequate because they used the woven material as a covering.

In a sense it [the weaving] could have been any flexible material; emphasis was on the form created by the concealed frame or the rolls

and beam. . . . What the Design Review Panel was, and is, looking for is an expression of the material related to the lobby area and volume of the central clerestory space. The problem [needs] a solution which would recognize the high-volume space and relate it to the lower ceiling area at the first-floor level.

Anderson was understandably frustrated. "This kind of thing had never happened to me before," she said later. No quitter, she developed yet another design, this time for a work consisting of several elements. She submitted her third proposal in April 1976, and the Design Review Panel approved it in May.

From June 1976 to February 1977, Anderson and five assistants worked on the hangings. "The half-completed pieces were all over my house, and my husband and I walked over, around, and through them for six months. A stairwell was used as the assembly area for the four large tubular forms," she noted. All the work was completed by March, but the pieces had to be put in storage for three months until the building lobby was complete.

Anderson's creation, titled *Group Eleven,* consists of a large central hanging incorporating an egg-shaped form and surrounded by four woven "tubes" of varying textures. Near the outer periphery are four woven panels with wrapped elements emerging from the centers, and on each end wall are more woven panels, their weft formed by wrapped elements that create a three-dimensional vertical shape for each. The works vary in width from two and a half feet to seven feet, and in length from eleven feet to fourteen feet.

Group Eleven was installed in June 1977. Describing the process, Anderson wrote:

Two men working in a supervisory capacity for the contractor

were enlisted to help with the installation after their regular work day. Five of my assistants also helped. We prevailed on the electrician to leave us a movable scaffolding for two days, and with the help of a small hoist, we were able to complete the installation in a total of six hours. Installations are always traumatic but exciting. . . . this installation went very smoothly, and the men helping us seemed as proud as we were when it was completed.

The local press was also proud and wrote many appreciative articles about Anderson's work. The *Honolulu Star-Bulletin*, for example, praised *Group Eleven* in glowing terms and pointed out that GSA had indeed invested the taxpayers' money wisely. "The U.S. Government scored a 'steal' from Hawaii artist Ruthadell Anderson when it commissioned her to do an assembly of 11 large woven forms . . . for $15,000, compared to the $84,000 which the State paid for Anderson's tapestries for the Capitol legislative chambers" (Tomi Knaefler, "U.S. Gets Bargain in Art Forms," June 21, 1977).

On June 24, First Lady Rosalynn Carter dedicated Anderson's hangings, along with the other artworks that had been commissioned for the building. The ceremony was an impressive one, and Anderson was moved . . .

The dedication was particularly exciting because Mrs. Carter was in attendance. It was held outdoors in the courtyard of the building, and we were fortunate to be blessed with a beautiful day, clean, with light trade winds. All the artists on the platform were introduced, and I felt very proud when my turn came. I shed a few tears when all of us on the platform joined hands and sang "Hawaii Aloha" at the end of the ceremonies. . . .

and flattered. . . .

Another first was a request for my autograph later in the day.

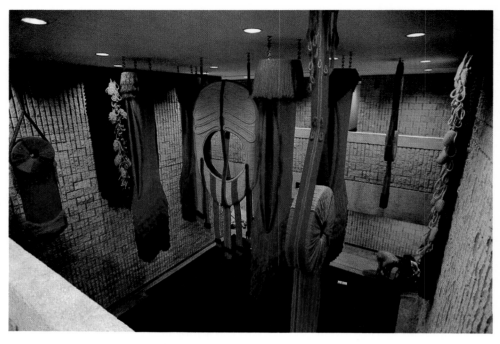

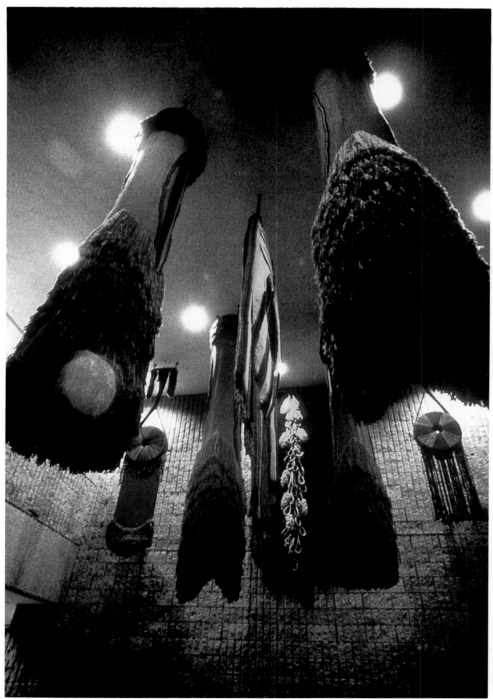

Two views of Group Eleven. *"About 700 pounds of rough textured yarn in a palette of warm colors . . . went into the pieces," wrote Tomi Knaefler. Anderson describes* Group Eleven *as "a visual summary of my experience with form and color. The various sculptural forms are united through the use of bold colors and repetitive shapes which relate to one another. More importantly, they relate to the entire environment to the two-story lobby area and . . . were designed to be viewed from both . . . floors."*

GEORGE RICKEY

Carl L. Howard

"Certainly one of the pleasantest pieces of modern art anywhere is the always-moving stainless steel sculpture George Rickey has done for the courtyard of the [Prince Jonah Kuhio Kalanianaole Federal Building and U.S. Courthouse]," editorialized the *Honolulu Star-Bulletin* on June 2, 1977. "Its main fault is that federal employees may be distracted from work as they watch in bemusement as two giant rectangular shapes slice through the air, seemingly into each other's space, without ever slicing each other."

Rickey's *Two Rectangles Excentric* is indeed a striking piece of sculpture. Not only does its movement create the illusion of two rectangles about to collide, but its placement adjacent to a ramp for the handicapped and near a wall of glass heightens the drama. If you aren't handicapped when you start up the ramp, it looks as though you may be decapitated or finely minced by the time you reach the top. But, as Rickey explained when presenting his proposal, "The rectangles are mounted on bearings about four feet from their lower ends, so that they are free to rotate around an axis forty-five degrees to the vertical. The consequent movement is through a conical path from vertical to horizontal. The rectangles never move below horizontal and are therefore always well above the pedestrian traffic."

To outward appearances, Rickey's thirty-one-foot-high sculpture displays the effortless precision of the ballet—an analogy Rickey himself draws. "The choreographer has given to him a . . . stage and the human body with its possibilities and limitations . . . and then he develops something in time and space. Well, that's very much what I do." As with a ballet performance, however, what lies behind the magical result is a lot of hard work and enormous dedication.

In the spring of 1974, Rickey was nominated for the Honolulu commission by a panel of art professionals appointed by the National Endowment for the Arts and the project architect, Joe Farrell (of Belt, Lemmon and Lo in Honolulu). He was recommended for the commission by GSA's Design Review Panel and selected by the GSA administrator on November 27. At the time, he was in West Berlin, Germany, where he spends the winter months. Since he had already planned to make a brief trip to New York in January 1975, he agreed to continue his journey to Honolulu for contract negotiations.

Rickey arrived amidst balmy weather, but my visions of negotiating on the beach under swaying palm trees disappeared as he began going through the contract word by word, noting each unacceptable clause. "Work before pleasure" became our motto; hours turned into days of indoor negotiations. It was a grueling session, during which Rickey proposed many well-thought-

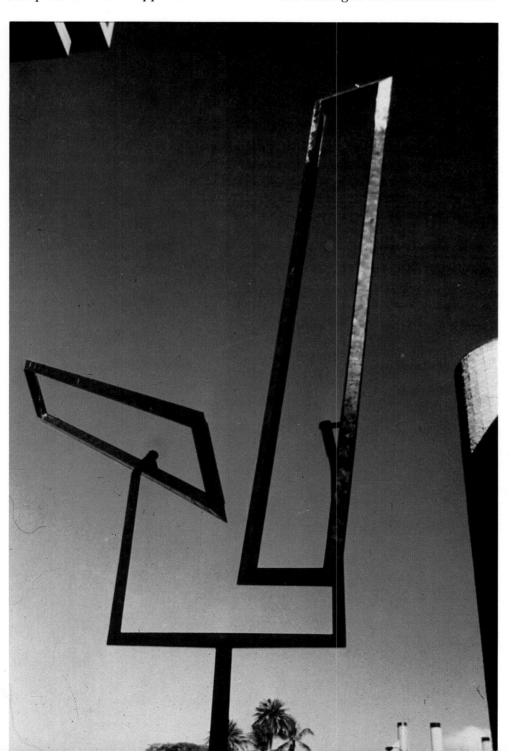

Two Rectangles Excentric, *George Rickey's dramatic thirty-foot-high stainless-steel kinetic sculpture.*

out contract modifications. As he later recalled,

> The only disharmonious moment in this project was in the discussion of the contract itself. I found it protective of the government and unheeding—not purposely—of the predicament of the artist, especially in regard to possible cancellation. . . .
>
> The final draft of the contract satisfied me and, I believe, the government. There are probably still passages where the meaning is difficult to follow. It is perhaps a pity that contracts are drawn by lawyers.

Rickey's contract was negotiated for a fee of $65,000 and was in full force by early spring. On May 13, 1975, he submitted his proposal to GSA in the form of a written statement and photo-

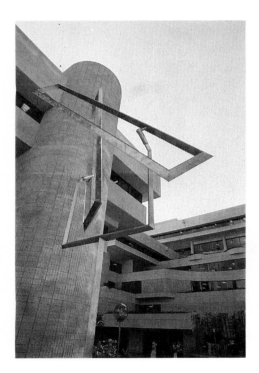

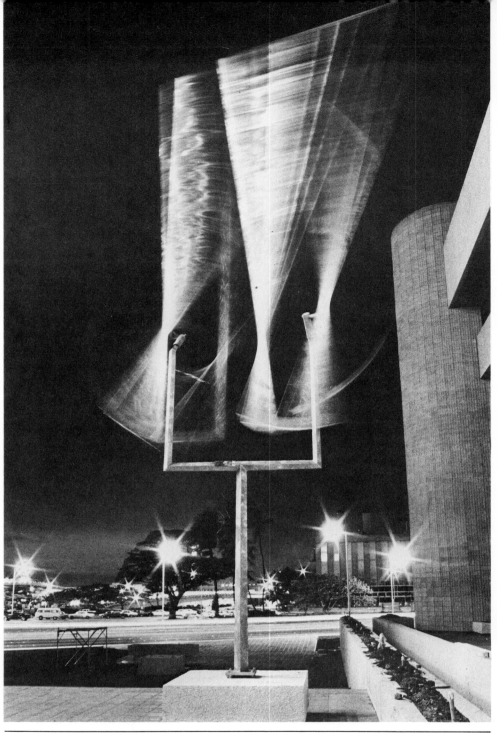

"It may be a long time before anything comes along to match the public popularity likely to attach itself to Rickey's moving steel frames," said the Honolulu Star-Bulletin *(June 2, 1977).*

Allan Miller / Honolulu Advertiser

graphs of the maquette. As Rickey described it, the piece was to consist of

> two hollow, stainless steel rectangles, each about nineteen feet six inches long by three feet six inches wide by eight inches deep, mounted on a chassis about fourteen feet high, making the total maximum height about thirty feet.
>
> The width of the sculpture at rest, in the vertical posture, is about sixteen feet; the maximum width, in the horizontal position, is about forty-four feet. This long axis will be somewhat oblique to the long axis of the promenade.

The GSA approved the proposal, and fabrication of the full-scale work

began that summer at Rickey's studio, the George Rickey Workshop, in East Chatham, New York. Writing from Berlin the following February, Rickey gave a progress report:

> One rectangle was completed before I left, and I had drawn up the chassis for my tube fabricator in Albany and the bearing mechanism for my machinist in Pittsfield. One rectangle was mounted provisionally last week. I expect the chassis to be welded up by the time I fly back to East Chatham March 15, and we will start coordinating the components.
>
> . . . I expect to have the sculpture up and swinging, virtually com-

plete, by mid-summer. I then turn to packing and shipping. . . . How is the building coming?

Rickey's question about the building was prompted by a series of construction delays that jeopardized the planned October installation of the sculpture. For one thing, it seemed that the site for the sculpture might not be ready in time; more important, if the building was still under construction, and if the building contractor was unwilling to cooperate with Rickey and his installation crew, there was the possibility of a strike that would cause further delays and skyrocketing costs.

Maintaining his tight schedule, Rickey completed the piece by mid-summer. He erected it on a hill near his

"The paths of Two Rectangles Excentric *. . . are strictly controlled and never cross," says Rickey.
"If they appear to be on a collision course, it is because of our early conditioning to movements along
a straight line. . . . The movement, in response to the breeze, is random, though the path is not."*

studio so that it could move freely in the breeze, and it was a sight to behold as the sun glistened off the gracefully swaying stainless steel rectangles. Rickey and his wife, Edith, were both there—they work well as a team. "She's been extremely supportive, extremely tolerant," he said, pausing to add, "More than supportive. She's been extremely active in what she can do that helps the whole thing go. . . . She would have been a marvelous gallery person, except she's better than what they really want."

Rickey was encouraged by GSA's contracting officer to proceed with the installation as scheduled, and he shipped the work in late August for arrival one month later in Honolulu. He had his "corps de ballet" ready and waiting in the wings and wrote optimistically,

I expect to go from the airport straight to the site to open the crates and check the contents for damage. . . . Monday I rent the staging and arc welder and arrange stage, ropes, etc. Monday night Roland Hummel

and Dennis Conners fly in, and we go to work early Tuesday morning mounting the piece. Assembly time —normally three or four hours; thereafter final welding of the shafts to the chassis, grinding the welds, cleaning—another three or four hours. So by Wednesday noon it should all be done.

True to Parkinson's Law ("Everything that can go wrong will go wrong, and it will go wrong at the worst possible time"), the various contractors and unions stepped in at this point, seemingly bent on halting the installation. Rickey, who had gone to considerable trouble to bring his crew from the mainland, was understandably dismayed. The government does not require union labor on federal projects, but he had the impression that the union was pressuring the contractor not to lend him equipment and to give him a hard time about safety regulations.

The shop steward came on next. I calmed him down and said we were almost done. But from then on

we didn't start work until the contractor finished at 3:30. Since it gets dark by 6:00, this made new difficulties. I did not dare do our own non-union welding with them around, and we literally finished in the dark with the car headlights trained on the sculpture. . . . the job was completed in a week instead of a normal three days.

Well, it's over anyhow, and it has come out all right. I am really very happy with the way it looks.

One year later, Rickey wrote to Administrator Solomon, describing his GSA commission as "an opportunity rather than a problem. GSA personnel were always sympathetic and helpful. I think they were very open-minded, trusting, and even adventurous in approving an unconventional, even unprecedented design." To which must be added that it would have been impossible not to approve *Two Rectangles Excentric,* which the *Honolulu Star-Bulletin* aptly called "a miracle of balance and symmetry."

LIN EMERY

Lionel M. Cottier, Jr.

Lin Emery had been offered a problem, which she viewed as a challenge. She had been commissioned to create a "sculptural screen" on the two-foot-wide ledge of an exterior wall thirty feet long, at a contract price not to exceed $13,500 for the "design, fabrication, and installation" of the work. The price was also to include all other costs associated with the commission—travel, shipping charges for maquettes, photography of the completed work, etc.

"If she had created the piece for a private collector, artist Emery said, she would have charged anywhere from $50,000 to $70,000. . . . the materials and the subcontracted welding work alone cost her more than the $13,500 she'll be getting from the GSA," wrote Ann Wakefield in the *Houma Daily Courier* (January 17, 1977) as Emery was preparing for the installation of her work in front of the Allen J. Ellender Federal Building and U.S. Post Office in Houma, Louisiana. Why, then, did Emery accept the contract? In her own words, "There were two main factors: the basic intent of the commission, which gives complete and sole responsibility to the artist for artistic judgment and performance, and secondly, the personal interest, understanding, and concern of your director, Donald Thalacker. This combination of freedom and encouragement gave me the impetus to achieve a major work and far outweighed the fact that the contract price was below my normal range."

Lin Emery is a serious sculptor, a hardworking professional, and a tireless activist for the cause of public art. Born in New York, she studied there and in Paris (1949–52), developing a technology for "aquamobiles" (water-driven mobiles) and "magnetmobiles." She has been commissioned to create major works for private corporations, universities, churches, and hospitals, and has been called by one art critic "a pioneer in the area of moving sculpture which was begun by Alexander Calder" (Luba Glade, the *New Orleans States-Item*, January 26, 1976). She was in every way an outstanding choice for the Houma commission, which was officially awarded to her in June 1975.

Once notified of her selection, Emery immersed herself in the project, keeping in mind a variety of factors. She explored Houma, a provincial area surrounded by sugarcane fields, whose citizens had no previous experience of contemporary art. Hoping to create a work that would win local acceptance in addition to being artistically successful, she even considered the sentiments of the area's favorite son, Allen J. Ellender, after whom the building was named. She investigated new engineering technology and materials. She studied, photographed, and pondered the site. Gradually she began to envision a design that would, as she wrote, "provide visual and psychological separation from an adjacent parking area, . . . animate the expanse of the plaza, and . . . modulate the sharp transition from traditional neighborhood to modern building."

By January 1976, Emery's concepts had been translated into form. She made a full-scale mockup of galvanized sheet metal, which she trucked to Houma from New Orleans and mounted on the wall. She worried about Houma's "penchant for tornadoes" and "how to anchor the sculpture to the wall, whose inner construction both the architect and the contractor had forgotten." She had originally planned to make the sculpture out of bronze to match the anodized bronze trim and hardware of the building, but the mockup changed her mind. "What struck me most was that the silvery color of the metal added an airiness and grace I hadn't expected," wrote Emery later.

After further revisions resulting from study of the mockup, the work was ready to be fabricated. Describing the fabrication process, Emery wrote, "Arcs were scribed on sheet metal and cut on the bandsaw. The shapes seemed to fit themselves together, curving into three-dimensional forms. All fabrication was done in the studio with the help of part-time welders and assistants, considerably reducing overall costs."

Georgia Peavler, GSA's regional fine arts officer in Fort Worth, followed Emery's progress carefully. She could barely contain her enthusiasm for the work, which she believes to be one of the most beautiful that has ever been commissioned in her region (an area including the states of Arkansas, Louisiana, New Mexico, Oklahoma, and Texas). Photographs of the Ellender Building before and after installation clearly demonstrate the visual impact of the sculpture, and in addition, there is the magic of movement. The sculpture activates the space.

Cane Dance, as the work was titled, was well received in the local press and by the artistic community. Bill Fagaly, chief curator of the New Orleans Museum of Art, summed up the reaction well when he wrote:

The artist's wish was to give animation to the space and to impart movement related to the varied, swaying rhythms of a landscape. The resulting *Cane Dance* is 28 feet long and 6½ feet high and consists of a connected series of 24 crescent forms that flutter reciprocally with the breezes. The sculpture and its title evoke images of the area, known for its sugar cane fields, Houma Indian dances and oil rig pumps. The GSA is to be congratulated for giving the space, literally and figuratively, to living American artists such as Lin Emery to share their genius with us, and the American public.

Lin Emery's Cane Dance. *The work exemplifies Emery's fascination with "natural, capricious motion rather than with unvaried, mechanical movement," in the words of William Fagaly. Describing the evolution of* Cane Dance, *Emery wrote, "Kinetic sculpture can add the dimension of time to that of space. In exploring the rhythms that seemed appropriate to the Houma site, I found a basic but infinitely variable form that I liked— and then stumbled on a way of describing its topography mathematically. I've always been charmed by the mathematician's phrase 'elegant equation.' I felt I'd found an 'elegant solution' by learning to make a direct translation (with the aid of my calculator) from math to form."*

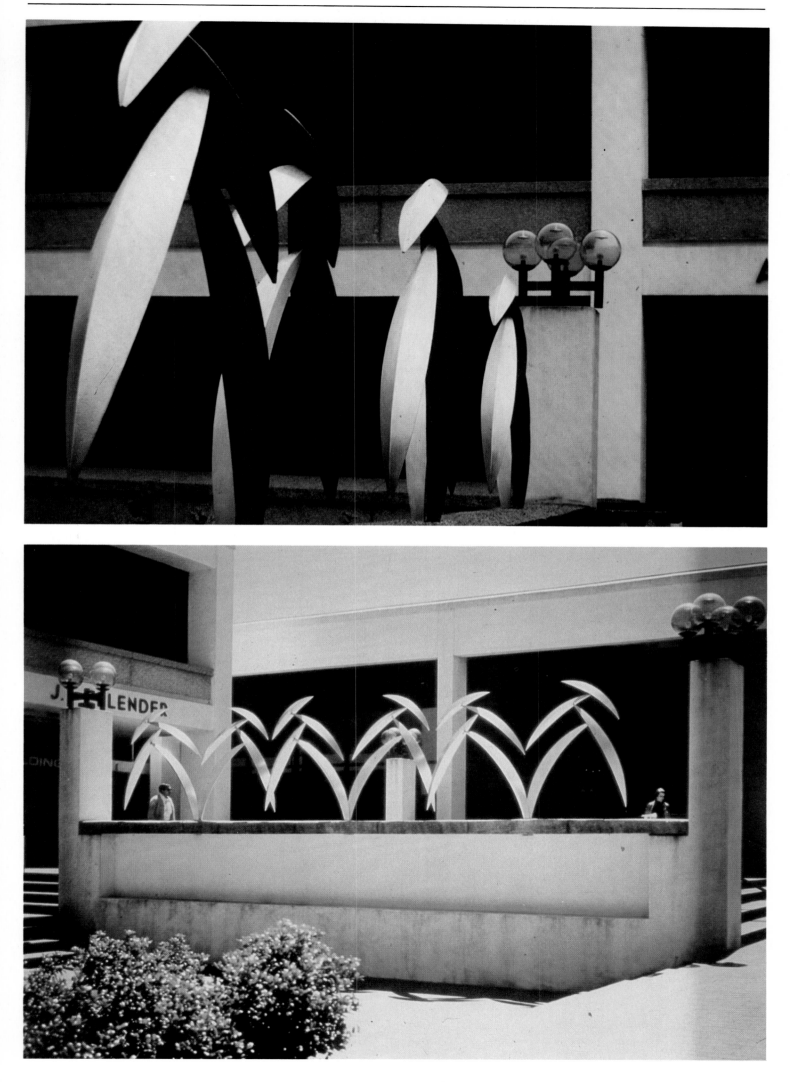

MILTON GLASER

Indianapolis was in for a colorful surprise—and, at 672 feet, one of the world's longest murals. As the new federal building was nearing completion in December 1974, internationally known designer and commercial artist Milton Glaser was going over final details with the painting contractor, Al Kite, who had to develop an entirely new system to accomplish Glaser's objectives. Faced with a design consisting of thirty-five vivid colors wrapping around the inner walls of the outdoor loggia, with each color blending into the next, the contractor found the job of mixing and applying the paint "a challenge of organization" complicated by wind, humidity, and the twenty-seven-foot height of the concrete walls. In addition, the panels of color vary in width from six to thirty-six feet, and the blending could only be done with commercial air guns.

Even as the painting was in progress, the citizens of Indianapolis were becoming more aware of and involved with the work than they might have wished. According to John H. Lyst of the *Indianapolis Star* ("Federal Building Displays Happy Face to Visitor," December 3, 1974), "several things seem to have started already. They include, workmen say, auto collisions as motorists slow and sometimes drift from their appointed lanes . . . for a better look . . . at the Federal Building mural." Lyst went on to note that the architect, Evans Woolen, wanted the artwork to make the building "cheerful, disarming, fresh, welcoming, friendly, and inviting," and that Glaser "wanted to create a mural that would express a spirit of openness and thus a new sense of government." In Lyst's opinion, their collaborative effort had succeeded, even if a few fenders were dented in the process. "Glaser's mural turns a happy face toward the artillery of the Indiana World War Memorial Plaza and evokes a mood of Godspell," he wrote.

As successful as the final result was, it took nearly a year of meetings and negotiations before Glaser was finally selected and willing to accept the proffered commission. In the summer of

Milton Glaser's mural for the loggia of the federal building in Indianapolis, Indiana. The work, one of the world's longest murals, utilizes 35 different colors in the course of its 672-foot journey around the walls and up the staircase.

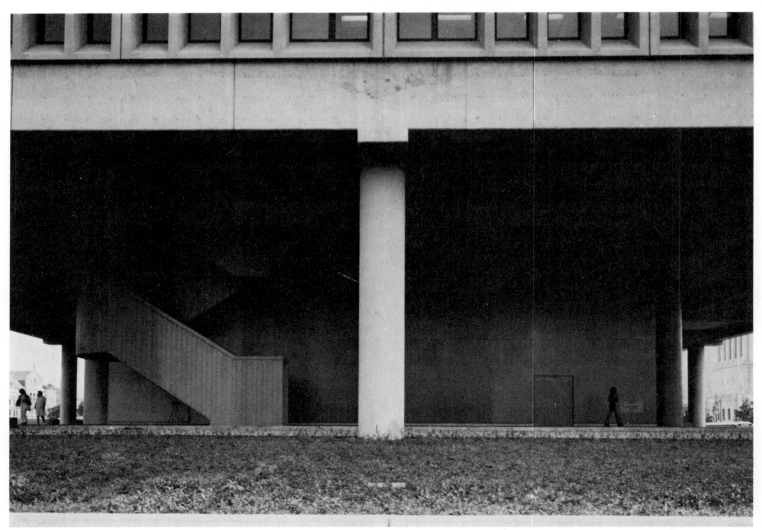

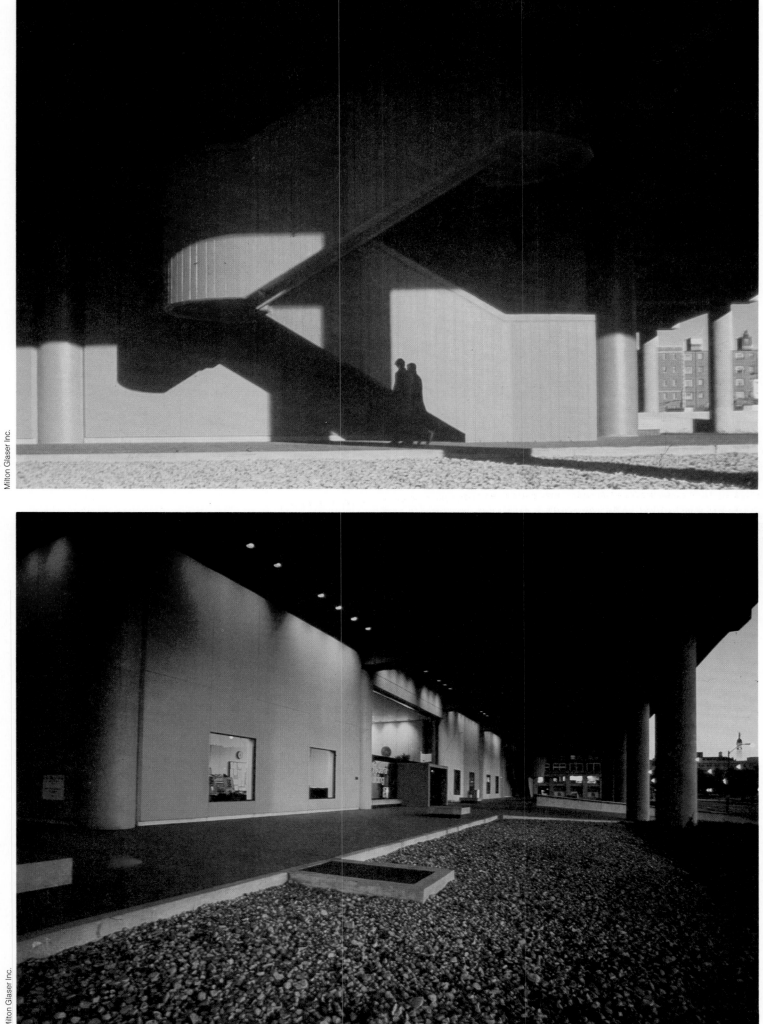

1973, an NEA-appointed panel chaired by Jan van der Marck met with architect Woolen and nominated five artists, among them Al Held. Held refused the commission because he was working only in black and white at the time, and Woolen's proposal to "breathe life and humanity into the building at the street level" specifically called for the use of color. Glaser was subsequently chosen, but since the technical problems of the project were complex, he wanted to investigate potential solutions before committing himself. The contract was negotiated in February 1974, and in April Glaser decided to accept the commission for a fee of $75,000.

Glaser's proposal was formally presented and approved in September, and work began in December. In July 1975—seven months, two coats of acrylic latex paint, and two coats of acrylic clear sealer later—the mural was complete. At Glaser's suggestion, a computerized rheostat was added to the lighting system to heighten the mural's festive mood and extend it to the evening hours. Glaser was pleased with the overall effect:

> The problem at the federal office building seemed to me to try to create a visual entity that would not conflict with the architectural statement. . . . I tried to create a nonfigurative element that would express a sort of friendly invitation to a building that is necessarily quite formal in its architecture. Actually, one of the most interesting aspects of this design is the way it appears at night, with the rheostat that alternately dims and brightens the surface of the mural so it seems to appear and disappear. The effect of fusing color was planned to be amplified at night by a lighting system . . . so that the color variation idea was expressed in time as well as on the surface itself.

Assessing his participation in the Art-in-Architecture Program, Glaser offered these thoughts in a letter to Administrator Solomon:

> . . . I found the relationship between the artist and the government a smooth one, and my expectations of any sort of bureaucratic involvement never materialized. I found the terms of my contract quite satisfactory.
>
> I really don't know enough outside of my own experience about the program itself, so it is difficult for me to suggest how it could be expanded or improved. As far as I understand the needs of American artists relating to federal art programs, the issue always seems to be the same: more money, more commissions, more encouragement, and intelligent administration.
>
> . . . my own experience was an extremely gratifying one.

A computerized rheostat illuminates Glaser's mural at night and creates the illusion of movement. As the light alternately dims and brightens, the colors seem to pulse rhythmically, brightening and then fading along the length of the loggia walls.

WILLIAM GOODMAN

Peacefully and quietly, a bright yellow steel sculpture titled *Solirio* was installed in January 1975 on the lawn area outside the recently completed federal building and U.S. courthouse in Las Cruces, New Mexico. Its creator, William Goodman, characterized it as follows: ". . . it is not descriptive of something else. It does not attempt to resemble a person from history or fiction. It does not describe a historical or imaginary incident. It is noncommemorative. . . . It is devoid of political content. Above all, it does not have to be understood in order to be enjoyed."

"Yellow Monster Guards Federal Building; Local Residents Aroused," headlined *Round Up,* the student newspaper of New Mexico State University, a bare two months later. "[*Solirio* has] been called mutilated Jolly Green Giant toilet, a giant magic mushroom, a huge goose stuck in the ground upside

William Goodman's Solirio. *These residents of Las Cruces evidently had an easier time "getting into it" than did their elders.*

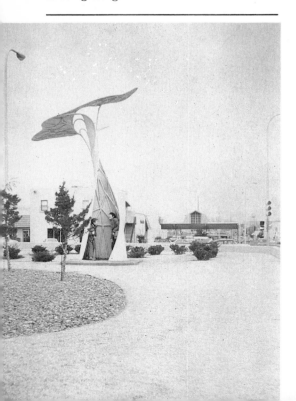

down, an airplane crash and innumerable other things," the writer of the article noted. If he had added, "Above all, it does not have to be understood in order to be hated," he would have neatly summed up the sentiments of most Las Cruces residents. *Solirio* was about as popular in Las Cruces as Helen was in Troy—and created almost as great a furor. It is hard to believe, even four years later, that a work of art could cause such a storm of protest.

★ ★ ★

Goodman, a sculptor of distinguished reputation in the Southwest, had been commissioned early in 1974 in accordance with the standard procedures then in effect. His previous work had been reviewed by qualified panelists (including the building's architect), and his design for Las Cruces had been approved by the staff of the Art-in-Architecture Program (then called the Fine Arts Program). Conscientious and hardworking, Goodman had submitted frequent reports documenting each stage of his progress from the project's inception to its completion over seven months later. No one expected any trouble when it was installed. Then all hell broke loose.

With unexampled vehemence, the press and citizenry of Las Cruces attacked the sculpture. *Round Up* complained of insensitivity to local attitudes: "This kind of modern art, while it might be great in a liberal eastern city, is not appreciated by the majority of people here" (March 17, 1975). On the same day, the *Las Cruces News* printed a letter to the editor that left little to add: "It is supposed to represent our present state of civilization for future generations. . . . It is unwieldy, without form, kind of flowing along to nothing. It is a wreck and it is yellow and utterly incomprehensible. If that isn't a perfect

picture of our present state of civilization, I ask you what is?" The next day, the *Las Cruces Sun News* prominently featured a photograph of the sculpture with an outsized price tag of $12,000 taped to it.

Letters began to flood the agency, not only from citizens of Las Cruces, but also from New Mexico's senators and representatives, who had received angry letters from their constituents. Painstakingly, the Fine Arts Program staff prepared a response that discussed the background of the program, the selection of the artist, and the cost of the project, pointing out that the $12,000 contract represented less than one-half of one percent of the construction budget. Trying to strike a conciliatory note, the response noted that abstract public art often provokes an initial reaction of outrage yielding with the passage of time to acceptance and enjoyment. We cited recent examples of this phenomenon, included supportive quotes from presidents Ford and Johnson, and concluded, "Thus, we remain optimistic that the people of Las Cruces will develop an appreciation for William Goodman's sculpture."

We didn't remain optimistic for long. On April 1, 1975, the Las Cruces Lions Club unanimously adopted a resolution bristling with *whereas*es and *therefore*s, condemning the "yellow monstrosity" as "completely out of place in Las Cruces," and requesting New Mexico's members of Congress "to strongly urge Arthur Sampson, Director of the General Services Administration, to remove . . . the monstrosity."

Karel Yasko, then counsellor to the administrator for fine arts and historic preservation, persuaded Administrator Sampson not to remove the work, pointing out that to do so would set a very damaging precedent. Yasko prepared the final draft of the response to the Lions Club, which Sampson signed and sent on June 9. He wrote, among other things:

> [Our] primary objective . . . is to give initial consideration to outstanding artists in the geographical area of the project because we believe they are sensitive to the culture and the people of the region. Highly creative artists, such as William Goodman, have a developed ability to capture the spirit of the time and the place in their work. Such perceptiveness often produces a new and unfamiliar creative expression which can have a startling

effect on the observer when first viewed in contrast to the known and traditional works which hold the observer's attention for a brief period and then are taken for granted. Seldom does any artistic effort evoke immediate universal acceptance.

The sculpture was placed at a disadvantage in being set in an unfinished environment. When the landscaping has been completed we believe it will assume its rightful place in the building's total design and become a significant part of the community's environment.

In the meantime, the press campaign against *Solirio* had continued unabated. On April 3, a coupon appeared in the *Las Cruces Bulletin* asking, "The Sculpture—Do You Want It Removed?" It did not have a "no" box. The accompanying article was tough: "Now if the city really opposes the 'burrowing whale' . . . [and] if the response were large enough, some national attention might focus on Las Cruces in its rejection of unwanted federal interference in the life style and culture of our city. . . . response-type action by the people should take place and it should be done now before we are all shamed by the sculpture's possible disfigurement or damage by vandals." A call to destroy or vandalize a work of art belonging to the federal government?

Throughout April, article after angry article appeared, and the barrage of letters to Congress and the GSA continued. In an attempt to respond directly to the criticism, William Goodman wrote an open letter to the people of Las Cruces which read in part:

Solirio is unique, and there are already people who have passed through Las Cruces who, as a result of having seen the sculpture, remember Las Cruces as more than a town not far from El Paso. I sympathize with those of you who didn't ask for a sculpture, but who awoke one morning to find one there anyway. I request that you take the time to become more familiar with it, and to watch the seasons change around it. It was built in sincerity, and I hope that its virtues be given time to become apparent.

The letter fell on deaf ears. Once again, it was up to Administrator Sampson to stand on principle, and he did. The piece remained.

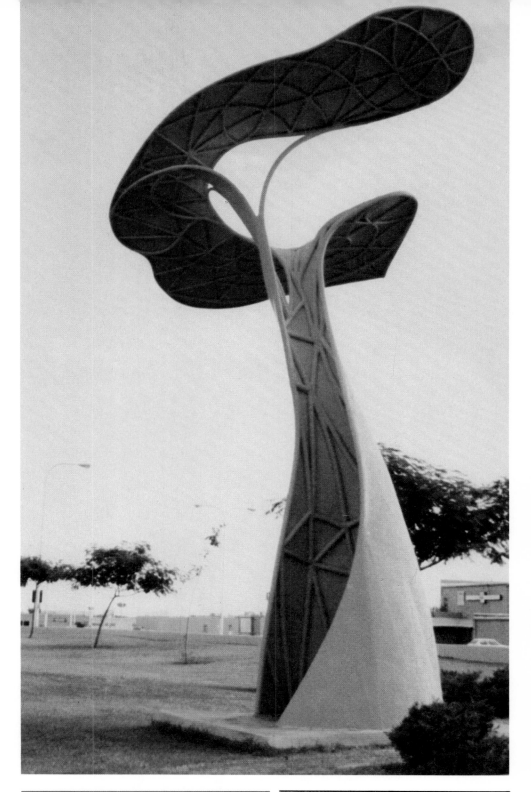

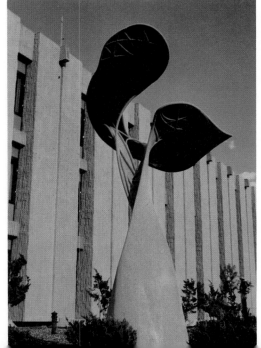

Sublimely indifferent to the storm of controversy that swirled around it, Solirio preserves its composure outside the federal building and U.S. courthouse in Las Cruces. Goodman's sculpture, which was installed in January 1975, is made of painted steel and stands seventeen feet high. "Its shape is the physical manifestation of a gesture," said the sculpture in an April 1974 letter accompanying his original proposal for the work. "This gesture suggests the opening up of a form that begins as a vertical shape and, as it opens, flattens out and becomes a horizontal one. From any position, the eye is led along curves that change from an energetic vertical to a floating horizontal, and back again. . . . Its form and its structure are as inseparable as those of a suspension bridge. . . . The shadows it casts on the ground will form a continuation of its physical shape."

It was October 18, 1974, and the nominating panel was at a standstill. The panelists had spent the entire day trying to select an artist for the interior sculpture recommended by the Leo A. Daly architectural firm for the federal building and U.S. courthouse in Lincoln, Nebraska. The work was to consist of interconnected ceiling-mounted sections cascading through openings between the mezzanine and the first floor; an additional work was proposed for the wall behind the main staircase.

Equipped with hundreds and hundreds of slides and impressive expertise, the panelists—after six hours of viewing, head-scratching, and agonizing—had nominated three artists whose work would be appropriate. But the spark of enthusiasm was missing. None of the panelists was particularly excited about the three nominees, even though they were ranked among the best artists in the country. The problem was the site, and it haunted the panelists throughout their deliberations.

Just as the meeting was about to end, Richard Koshalek, the moderator from the National Endowment for the Arts, asked everyone to try one more time—to ask themselves what would be *really* exciting for the space. A moment later, panelist Ellen Oppenheim of the Kimbell Art Museum in Fort Worth jumped out of her chair and reached into her vast collection of slides. Apolo-

CHARLES ROSS

Charles Ross

gizing that she had only brought one slide of Charles Ross's prism works, she flashed it on the screen. In spontaneous unison, the other panelists exclaimed, "That's *it!*" It was an exhilarating, electric moment.

★ ★ ★

GSA's review panel and administrator agreed with the NEA panelists, and Ross was chosen for the commission. On February 6, 1975, the contract was negotiated in Lincoln for $65,000. Ross was as apprehensive about his selection as GSA was pleased. As he later wrote, "When I first saw the Nebraska space, a long dark corridor with windows only at each end and shaded by a large exterior overhang, I thought, 'There's no light here! Why me?' I decided to take the project as a challenge."

Ross studied the space carefully. "I discovered," he said, "that long prisms suspended from the ceiling could be used to pull light from outside into the space—bars of light, absorbed and captured, responsive to the viewer's position, turning from white light to rainbow colors and back again as you walk along." Ten months after the contract negotiations, he was ready to present his proposal to GSA. He had prepared a wood model of the mezzanine and first floor, with prisms suspended from the ceiling of the mezzanine. "My first thoughts were to arrange the prisms at random, hanging at different angles in space like a frozen moment of hay blowing in the wind. But the space required something more formal," he later explained. In the version he presented, "the prisms are hung at angles which tilt slightly from the horizontal—excerpts from a tilting, irregular horizon."

As Ross learned later, during the installation process, perceptions of the horizon in Nebraska conditioned

the way people responded to the work. "Now, most of Nebraska's horizon is perfectly flat," wrote Ross. "While I was installing the work there were numerous complaints that the prisms were not 'straight.' An example of how comfortable you can get with your own horizon?" In turn, however, the piece began to affect the way people viewed the horizon. "When I returned to the building a year later," Ross said, "I had the impression that the people who worked there, who lived with the piece, had grown happily accustomed to its lack of straightness."

Ross surmounted the major obstacle posed by the site—the absence of natural light upon which the prisms rely to activate the spectra, or rainbow hues, cast on the surrounding walls and floor—in an ingenious manner. Since the original proposal for artwork included the back wall of the main staircase, he developed special spotlights aimed at the prisms suspended above the stairs. The results thus achieved were striking, as Ross himself noted.

Three spotlights and five prisms were used to generate a kind of painting in dispersed light. A number of secondary arcs of color were cast on the landing wall due to anomalies in the prisms' surfaces. These would appear or vanish when the prisms were adjusted as little as a hundredth of an inch, and considerable time was spent bringing this part of the work into focus. To my amazement, the spectrum showed up quite well on the dark brown wall, appearing to both float out of and recede into its surface. A large, bright, curved bow was cast across the landing, so that you pass through a sheet of spectrum as you climb the stairs.

The sculpture, titled *27 Prisms from the Origin of Colors,* was the first major prism piece completed by Ross

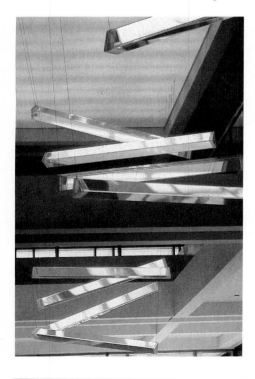

Nine of the ceiling-mounted prisms in Charles Ross's 27 Prisms from the Origin of Colors.

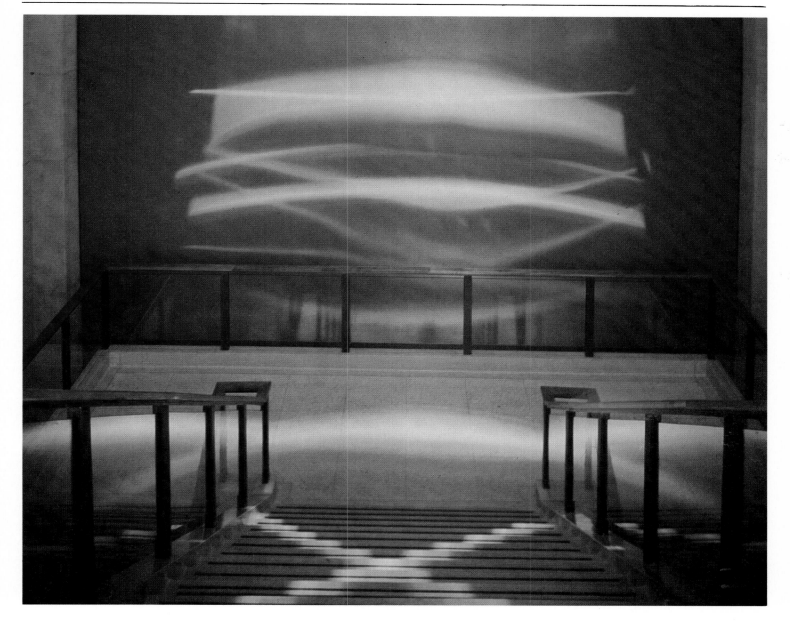

for an architectural setting. It was installed in mid-August 1976 to universal acclaim. Almost alone among GSA-commissioned projects, Ross's sculpture has occasioned not a single negative letter or news article. On the contrary, it has been one of the few works continuously lauded by both art professionals and ordinary citizens with no special interest in the contemporary visual arts. Apparently, the experience was an equally positive one for Ross, who is one of the nation's most respected young artists. In a letter to GSA's administrator, Jay Solomon, Ross evaluated the program as "excellent," commenting that he found the oft-criticized government employees he worked with "marvelous people . . . [who] put in the kind of energy necessary to make this kind of program work." He concluded, "The most important aspect of the program's success so far has been its ability to be responsive to contemporary art. It is most necessary to keep fighting the battles required to main-

tain this responsiveness."

As for GSA's responsiveness to Charles Ross, no battles are required

to maintain it. The initial spark of enthusiasm generated at the NEA nominating panel never died.

Above: The spectra cast by Charles Ross's 27 Prisms from the Origin of Colors *on the mezzanine landing of the federal building and U.S. courthouse in Lincoln, Nebraska, as viewed from the top of the main staircase. Ross's transparent geometric sculptures alter dimensions and create intriguing, colorful images through the use of refracted light. He describes his work as "cinematic in nature, seen as a sequence of spectrum images, some muted, some bright, but not all visible from any single vantage point." The triangular prisms, which he calls "excerpts from a tilting, irregular horizon," are made of acrylic. Each is filled with mineral oil and measures 104 inches long by 9 1/2 inches on each side. They rely both on natural light and on three specially designed spotlights to "generate a kind of painting in dispersed light."*

Left: Side view of the mezzanine landing, with a dominant bow of color on the floor and secondary arcs of light on the wall.

ROBERT HOWARD

"I define sculpture as the art of limiting space, and I manipulate various real materials to produce objects which focus attention to a restricted space area. I am torn between forms that come to awareness through the way light hits a surface and distributes itself over it, creating light and dark areas, and a conscious concern to articulate space-as-form, which is inherent in materials that can give varying degrees of transparency because light penetrates in and through them, and in materials of high tensile strength so that space can be surrounded or left open-ended. In making color an inherent part of the sculpture, I enhance its character in a way that can be done in no other material. Color in a truly sculptural object is extremely variable in relationship to light and dark—and in its ability to reflect itself in mysterious ways." So writes Robert Howard, creator of *Louisville Project,* a multicolored enameled aluminum sculpture that stands in the north plaza of the federal building in Louisville, Kentucky.

Howard lives and works in the Southeast and has been recognized as a major sculptor since the early 1960s. He studied in Paris (1949–50) under Ossip Zadkine, one of the recognized masters of Cubism, and has been a professor of sculpture at the University of North Carolina at Chapel Hill for more than twenty years. In 1972-73 he taught at the University of Southern California. His work has been widely reviewed, and he has had exhibitions at several museums, including the Los Angeles County Museum (1967) and the Whit-

ney Museum of American Art (1968). He is represented in the permanent collection of the North Carolina Museum of Art, among other museums, and one of his pieces was selected for exhibition at the New York World's Fair. Until 1970 he worked primarily in steel, but he has since favored fiber glass because it lends itself to repetitive modular forms (through the use of molds) and because color can be an integral part of fiber glass works. Howard is noted for sculptures such as *Louisville Project,* multiple-modular systems creating forms that not only affect the surrounding space but also call attention to positive and negative spaces of the work itself.

★ ★ ★

Although Howard's official selection was delayed for almost six months due to funding difficulties, the actual nomination and commissioning went smoothly, testifying to the viability of GSA procedures. On January 9, 1975, letters authorizing award of the contract were sent to the artist and to the GSA

regional administrator in Atlanta. Howard then developed a maquette which was approved by the GSA Design Review Panel and sent to the Lippincott company in Connecticut to be fabricated. The firm, which makes only sculpture, was swamped with work. In order to retain personal control over each project, its president, Don Lippincott, had consciously kept his "factory" from increasing in size, so Howard's piece had to wait its turn. This, together with the complex fabrication process and Lippincott's perfectionism, caused considerable delay, and Howard was granted an extension of his completion date.

The work was inspected on October 8, 1976, in its unpainted form. Already impressive, it was immensely enhanced by the subsequent exacting painting. The completed piece, consisting of unique paddle-shaped modules with flanges constructed of three-quarter-inch-thick aluminum, stands two stories high and is painted in twelve different colors—varying shades of blue, red, green, orange, and yellow. It was installed on the same day GSA dedicated Claes Oldenburg's *Batcolumn* in Chicago. (That night, Walter Cronkite concluded his broadcast with a story of the dedication, signing off with his familiar "And that's the way it is Thursday, April 14, 1977"—the eve of the deadline for paying taxes. Needless to say, the national exposure prompted some angry letters to congressmen and the agency about "frivolous" government spending.)

In Louisville, reactions to Howard's sculpture were mixed, as *Courier-Journal* art critic Sarah Lansdell noted: "Some laymen, trying to define the sculpture in terms of the metal forms visible, think the horizontal units look like airplane propellers. . . . a few

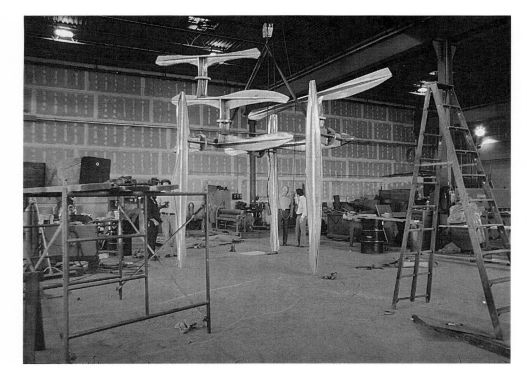

Robert Howard's Louisville Project *during fabrication at the Lippincott company. The aluminum modules were subsequently painted in twelve shades of enamel.*

Louisvillians, prompted by the propeller idea, have called it 'Flying High' or similar names. . . . the majority, finding it too unfamiliar a style to engage their affections, refer to it as 'playground equipment'" (the identical phrase reportedly used by a GSA official commenting on the di Suvero sculpture in Grand Rapids). Lansdell, however, harbored no reservations about Howard's piece: "As for me, I try to walk by it as often as I can."

The sculptor himself was undismayed by the controversy. "I'm happy to know it's controversial . . . that means it's vital. There's nothing else like it in the U.S. and in the world. . . . [People] want to keep things as they are. But I'm not interested in that. If they want the same old things, they could make them themselves." As for the project in general, Howard called his relations with the GSA "thoroughly professional and entirely pleasant," expressed his appreciation for the fine work of the Lippincott company, and compressed his experience in these "bullets" of thought:

ART . . .

is in the realm of non-logic and cannot be proven.

is an autobiographical form on the edge between feeling and rational reality.

is chance organized by intuitional necessity.

THE ARTIST . . .

laughs when he is beside himself.

wants to comprehend space.

fractures space for form by variations of time intervals.

is against impersonal death.

is for individual responsibility.

believes in Democracy—the art of retaining conflicts in equilibrium.

stabilizes and makes tangible the raw truth.

does not think of any of this stuff when he is working.

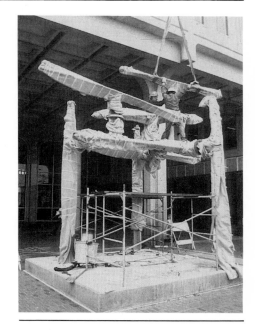

Above: Louisville Project *is installed.*

Below: The work's "spirited colors and forms . . . lend a feeling of parklike festivity to the surroundings," wrote Sarah Lansdell.

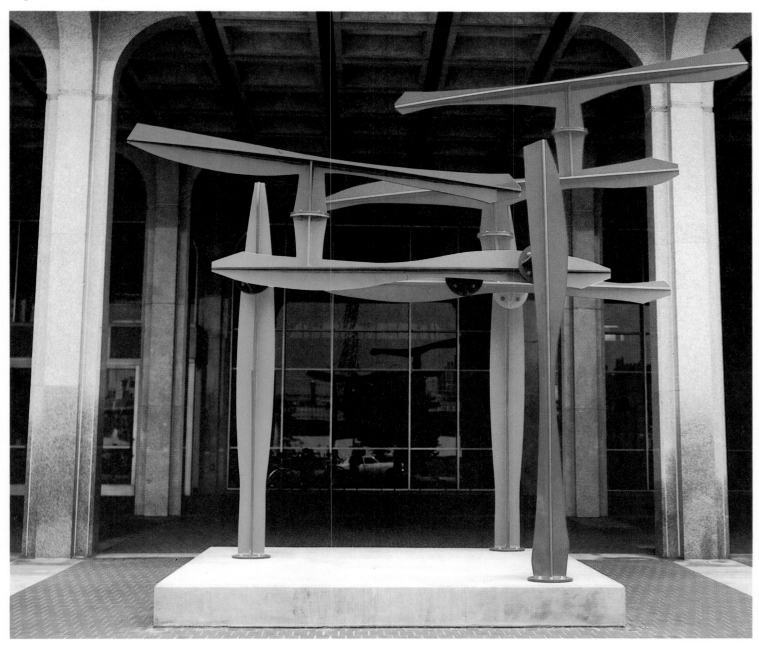

Louise Bourgeois is one of those rare individuals towards whom people instinctively gravitate, while she herself remains somewhat distant —never cold, just slightly in another world. She is vibrant, dynamic, arresting; the combined brilliance of her eyes and smile could light up a room. With such qualities, it is little wonder that she was nominated by an NEA-appointed panel for GSA's "energy conservation demonstration project," the Norris Cotton Federal Building in Manchester, New Hampshire.

In fact, of course, it was the integrity and quality of Louise Bourgeois's work that impressed the panelists. As *New York Times* art critic John Russell once said, "In a quiet way, Louise Bourgeois is one of the most distinguished artists around, and by a long way one of the most intelligent" (September 22, 1978). "Louise Bourgeois has a seething, courageous mind which continues to set up challenges which many other artists have never risked," echoed Barbara Zucher (*Artnews*, November 1978), while Peter Frank hailed her as a doyenne of the contemporary art world (*Village Voice*, October 2, 1978).

The project architects for the Norris Cotton Federal Building, Isaak and Isaak, had repeatedly urged GSA to commission a work that would deal with the theme of solar energy in an abstract way. In a November 1975 letter, for example, they wrote, ". . . a sculptural piece has always been an integral part of our design. . . . An area of the paved plaza at the southwest side of the building is set aside for this purpose, including a different paving pattern over an area approximately ten feet by twelve feet." It was to execute a sculpture for this site that the NEA panelists had nominated Bourgeois at their meeting on August 3, 1977.

On the recommendation of GSA's Design Review Panel, Administrator Solomon chose Bourgeois for the commission in October. Notified by telephone, she was pleasantly surprised. As she later said, "I had not made an application for this prize. It was decided outside my knowledge. I was simply told that I had been selected. . . . my first remark was 'Oh, how wonderful.'"

On November 30, Bourgeois took the train from New York to Boston. The following day, along with GSA representatives from Washington, she was driven to Manchester by Regional Fine Arts Officer Mike Jones of the Boston office, whose knowledge of the building design, appreciation of the

LOUISE BOURGEOIS

historical area around Manchester, and willingness to offer support wherever possible were of great assistance throughout the commission. "Before lunch, I got a look at the site. As soon as I got in touch with my site, I felt stronger," Bourgeois recalled. Her perceptive eye took in all the details of the surroundings.

> The first time I came to this town, I walked around to get a feel for the place and to see where this building would be located in the environment. I discovered that it was sitting on a hand of hills—certainly the highest point in the town. I was very aware of the orientation; I was aware of the crispness and light quality of the air, and I was aware of the sun. I was also aware of the loveliness of the town. And these impressions stayed with me as I was working on my project.

Following lunch, contract negotiations took place in a sparsely furnished room of the federal building, where Bourgeois was confronted with a formidable array of stipulations pertaining to her fee, the mode of payment, the use of minority and disabled workers, contract work hours, overtime compensation, the Safety Standards Act, etc. In her own words,

> The contract was a rather complicated affair, with thirty different clauses. . . . Having a taste for the precise, since I generally live in a rather friendly chaos, I find this tissue of protection and protective measures original, useless, and rather flattering since I am used to doing my own work and had no reason to anticipate much "labor relations."

Then the question of "Small Business" appeared. The artist was referred to as "Small Business." The artist, finding himself, for instance, in dealings with the IRS or the landlord crowd as a kind of

regrettable nonentity, suddenly was referred to as a member of the business world, if only a small one, and that pleased me to no end.

> This contract, established between the contracting officer for the U.S. of A. and myself, was signed. I was to receive $35,000, which is the smallest grant. . . . I have read this document several times, and there was nothing objectionable in it, so I signed.

<p style="text-align:center">★ ★ ★</p>

Slightly over a month later, in January 1978, Bourgeois arrived in Washington to discuss her proposal with the GSA Design Review Panel. She did not bring a completed maquette or drawings of a specific piece, as had been expected. Rather, she showed slides of her previous work and indicated preferences and directions that the sculpture might take. She later described her conceptual process, which centered on "sun and solar energy and the captivation of the sun. . . . when I talked about capturing the rays of the sun, I was always thinking about capturing birds by mirrors. . . . My first idea was to present facets—shining facets looking up to the sun and to the sky—a series of mirrors reflecting the environment at different angles."

In addition to the regular members of the Design Review Panel, Mike Jones and several other interested GSA officials were present at the meeting. Bourgeois perceived them as a kind of jury. "I was trying to convince fourteen males sitting around a table. They asked what I had in mind, and the situation brought about some tension for me," she said. She described her previous work and how it might relate to the piece for Manchester. There was some discussion about materials; orginally she had considered marble and granite, but she rejected both because of weight considerations (the piece was on a plaza

deck directly over a garage). Then someone raised the question of public safety, jokingly referring to the George Sugarman sculpture in Baltimore (which had been criticized by the federal judges there on the ground that, among other things, it would become a hiding place for criminals bent on molesting unsuspecting passersby). Bourgeois, however, took the issue quite seriously.

The first thing I did when I appeared in front of my board was to prove with slides and photographs that nobody could hide in the place and be uncivilized. . . . when I explained my reasons for avoiding this public scandal, it was met with a roar of laughter. I couldn't quite understand why—whether it was a deep concern and fascination, or whether it was my vocabulary. Well, I didn't have to find out, because from then on we really had a good time, and there was a very loose and free discussion of the thing. So I was very pleased with that, and I proved to my jurors that it was not going to be dangerous; nobody was going to slip or get hurt, and nobody was going to hide in it or commit any murder, rape, or embarrassment. So that was that.

Bourgeois returned to New York and immediately went to work. Deciding to use steel, she had the metal cut to her specifications and began welding at her studio in New York. The work went well, though not without claiming one casualty—Bourgeois's lawn. "Suddenly, there was not a blade of grass left on the place. Everything was burned by the intense heat of the welding," she lamented. Nevertheless, by early April 1978, the piece was finished and ready to be shipped.

It took to the road on a flatbed truck and was delivered in Manchester, where I found a good deal of passive resistance, and we couldn't get the damn thing off the truck. It was not the right time of the day, and no one would touch it, . . . because you make people work at the time they are not supposed to work —you know, time and a half or something. Anyway, the thing didn't leave the truck until the next day.

So it was placed on the site, and I went over to Manchester to look at it. I knew that it was a catastrophe the minute I saw it. It had been planned without a base, and it did not work. So a base . . . was made

in cement and steel. . . .

I was satisfied, . . . since we poured the cement in planks of wood. . . . It reminded me of Le Corbusier, who was my friend, . . . who used as a finish the imprint of the planks of wood in the cement. It was kind of an austere quality which I like. Now please, we are not carrying any nonsense on the subject; we are in New Hampshire and granite comes in. It is today finished in granite and it looks fine.

★ ★ ★

The piece, titled *Facets to the Sun*, is composed of thirty-six individual units varying in height from twelve to twenty-eight inches (plus base) and measuring ten feet square. Deborah Wye, assistant curator of Harvard University's Fogg Art Museum, interviewed Bourgeois about her work and about *Facets to the Sun*, reporting, "Bourgeois describes a 'human kind of radar,' in which individual units relate as people do, 'aware of each other, perceiving each other, and constantly adjusting to each other, as if by radar.' In the . . .

New Hampshire piece, Bourgeois is concerned with the sun and energy, and 'radar' takes on a broader meaning." Bourgeois herself has said, "The piece sits there today, changing with the movements of the sun, and the shadows it projects are as important as the steel itself. It gives, sometimes, the feeling of a sundial and rows of mirrors. . . . it is rather beautiful."

Indeed it is, reflecting not only the sun but the talent of a sensitive and intelligent sculptor. Awarding Bourgeois an honorary Doctor of Fine Arts in 1977, the trustees of Yale University said:

You have reminded us through your sculpture that art speaks to the human condition. You have offered us powerful symbols of our experience and of the relations between men and women.

You have not been afraid to disturb our complacency. The precision of your craftsmanship, the range of your imagination, and your fearless independence have set standards for the aspirations of others.

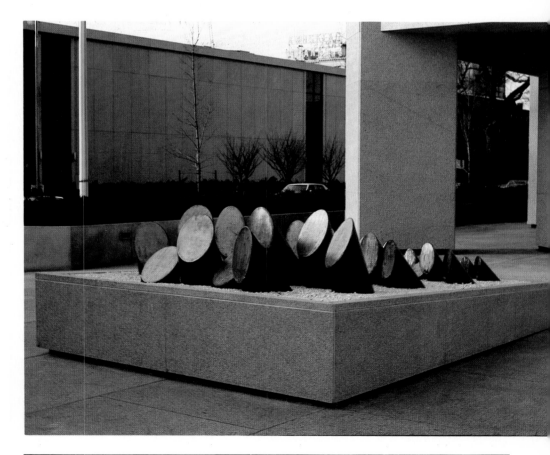

Facets to the Sun, Louise Bourgeois's sculpture for the southwest plaza of the Norris Cotton Federal Building in Manchester, New Hampshire. The piece, which consists of thirty-six individual steel units, deals with "sun and solar energy and the captivation of the sun," in the sculptor's words. As originally conceived, it was to rest directly on the paved surface of the plaza, but Bourgeois was unhappy with the effect thus achieved. As a result, Facets to the Sun *now has a cement-and-steel base finished with granite.*

ROBERTO RIOS

"Marfa, Texas, is one of the most beautiful places in the world!" said Julie Brown upon her return from a trip there as GSA's representative. It is also one of the most difficult places to get to—the closest airport is four hours away in El Paso—but it is worth the drive. Marfa is where the movie *Giant* was filmed. It is also the location of the new U.S. Border Patrol Sector Headquarters.

Brown was in Marfa to attend the meeting of an NEA-appointed panel on March 2, 1978. The project architect for the Border Patrol building, Joe Federico, Jr., of Dallas, had recommended that a painting be commissioned for the interior entrance wall. As Federico conceived it, the panelists' task was to nominate appropriate artists to "depict this particular region's western historical background, i.e., Ft. Russell, U.S. Cavalry, Mexican and Indian folklore."

Five months earlier, the Houston Contemporary Arts Museum had organized an exhibition of Chicano art. Its director, James Harithas, was on the panel, and he was quick to nominate Roberto Rios, a gifted San Antonio painter whose work had been featured in the exhibition. The other panelists unanimously agreed, and Administrator Jay Solomon selected Rios for the

Mexican Immigrant *(above) and* The Marfa Sector, *two murals planned by Roberto Rios for Border Patrol Sector Headquarters in Marfa, Texas.* Mexican Immigrant *was eventually rejected by GSA, not on aesthetic grounds, but because of misgivings in certain quarters about its content.* The Marfa Sector *hangs in the building lobby.*

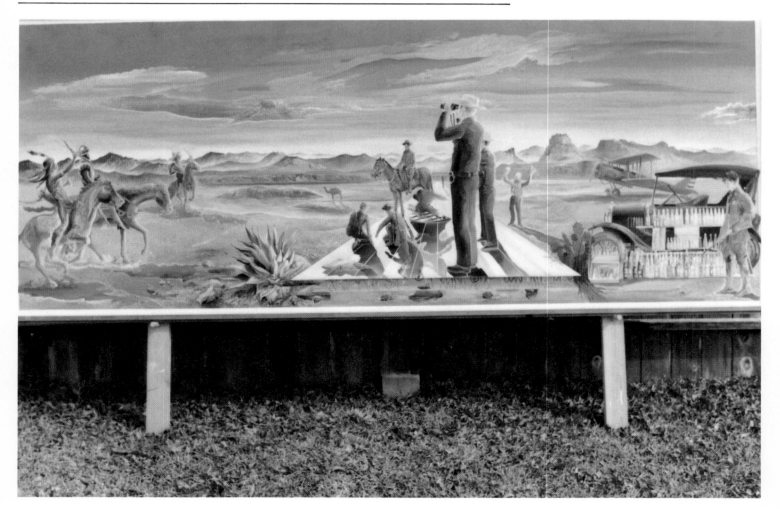

commission on April 25. Rios, now in his mid-thirties, began painting as a teenager, creating many church murals and working as an illustrator. In addition to his inclusion in the Contemporary Arts Museum show, he was commissioned in 1978 to create three murals for the city of Miami.

In mid-May, Brown traveled to Marfa from Washington, D.C., to negotiate the contract. The negotiations went smoothly, and a contract fee of $6,500 was agreed upon. "Rios was very attentive," Brown recalled, adding, "He agreed to accept the contract on the spot."

According to Rios, "I did not know anything about Marfa or the Border Patrol until I received the commission to paint a mural." Shortly after he learned of his selection, he went to Marfa to familiarize himself with the site. He began to research the history of the Border Patrol in Texas and the Marfa–Big Bend area and spent many hours in the public library. He established a rapport with the Border Patrol employees, who expressed their interest in the project and talked extensively about Marfa and its environs. "All my ideas and impressions were incorporated to produce a small-scale color rendering of the mural," he said.

In mid-June, Rios sent GSA a black-and-white sketch representing his proposal for the mural, which was to hang in the building's detention area. He also said that he was planning a smaller mural for the lobby.

Enclosed is a copy of the preliminary drawing I have made for the mural at Marfa, Texas. I am working on the color rendering, but I wanted to know what you thought of it. It is entitled *Mexican Immigrant*. It has a lot of symbolism, but it explains life on both sides of the border. Briefly, it begins with a poor Mexican family seeking a better way of life, which to them awaits across the river in the United States. . . . The idea is basically the same for immigrants from other countries, but the Mexican will be able to identify with it. It is going to be a very colorful and powerful painting. I am very pleased with it.

For the smaller wall, I plan to do the history of the Border Patrol specifically as related to the Marfa area.

The artist at work on The Marfa Sector, *a symbolic depiction of past and present Border Patrol activities. Rios executed the mural in acrylic on a birchwood panel.*

Six weeks later, Rios finished both color renderings and sent them to GSA, noting, "The renderings are not as detailed as the actual paintings will be, but they will give you an idea of the colors I plan to use. . . . Please call me if there are any questions."

There were indeed some questions. L. N. Stewart, GSA's regional commissioner (PBS) in the Ft. Worth office, had seen the preliminary drawings and was concerned about *Mexican Immigrant*. In a memo to the Washington office, he wrote:

Considering that one of the functions of the Border Patrol at Marfa is control of illegal alien activity, we do not feel that the proposed mural and explanation as submitted by Mr. Rios are very appropriate for this Station. Our thinking is two-fold in that the mural could be interpreted as encouraging migration from Mexico to the United States, which does not seem to enhance Mexican-American relations; and further, the illegal alien control problem at Marfa could be made more difficult since the mural could possibly encourage such illegal migration.

Alerted by Stewart, GSA's Design Review Panel raised the issue of how the patrol personnel and the Immigration and Naturalization Service might react; they also wondered about possible international repercussions. The proposed work was shown to Administrator Solomon. Like the panelists, Solomon found it aesthetically interesting, but he also believed it could cause problems. Finally, the agency decided to approve only the smaller mural, titled *The Marfa Sector*.

★ ★ ★

Rios started to paint the full-scale work shortly after being notified of GSA's decision. Addressing the progress and subject matter of the mural, he wrote:

I used symbols in the mural to represent various events in the history of the Border Patrol and the Marfa area. As a result the mural is surrealistic, but the viewer will be able to interpret the images. It includes Indians who were the first inhabitants, and Spaniards who explored and settled the area. Also depicted are the various activities of the Border Patrol in the past and the present, such as keeping bandits from coming across the border to terrorize the settlers; the curtailing of liquor smuggling during Prohibition to the present, and the major task of preventing illegal entry and drug smuggling into the country through electronic, ground, and air surveillance.

I painted the entire mural by myself just as I have painted the other murals I have been commissioned to do.

The Marfa Sector is four feet high by ten feet wide and is painted on a specially built panel of birchwood. It has a frame and is mounted on the wall with metal braces. Final inspection of the mural was made in January 1979 by Regional Fine Arts Officer Georgia Peavler, who called it "terrific" and said that it "makes a handsome addition to the lobby of the Border Patrol Sector Headquarters." As for Rios, he praised GSA's program for providing "opportunities for artists from throughout the country to have their artwork [or some of it, he might have added] on permanent display at various federal buildings maintained by GSA."

LEONARD BASKIN

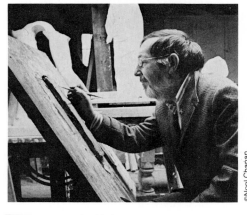

©Noel Chanan

Leonard Baskin's commission for the lobby of the courthouse and federal building annex in Nashville—a bas-relief depicting Tennessee's three United States presidents—was GSA's single experience with a phantasmal artist. Periodically, Baskin's voice would emanate from a telephone receiver (originating either in Devon, England, where he winters, or in Little Deer Isle, Maine, where he summers), his written word would emerge from the labyrinth of the postal system, but he himself never materialized. To this day, no one in GSA has met him.

★　★　★

Baskin, a draftsman, printmaker, painter, and sculptor, is one of the modern masters of representational art. Art historian Dr. Alfred Werner has written of him, "In Baskin, we have an individual with a nimble mind, preoccupied with the theme of mortality, and unconcerned with all that is purely decorative, predominantly private. . . . he is eager to employ his most precious possession, his brain, to direct, with love, the work of his indefatigable hands." His art centers around the human figure, and he was both an obvious and unanimous first choice of the NEA-appointed panel at its meeting in Nashville on September 17, 1974. GSA's Design Review Panel recommended him without hesitation, and Administrator Sampson approved his selection three months later. Given the theme, one couldn't help wondering what Baskin would do.

In January 1975 he was offered the commission by transatlantic telephone. He was far from eager to accept and expressed disappointment with the available amount of money ($30,000). When he learned that he would have to go to Nashville to see the site before developing his concept and that he would also have to install the work and have it photographed, his reluctance increased. Nonetheless, he agreed to listen to an explanation of the terms and conditions of the contract, and in the end he decided to take the commission.

Leonard Baskin's proposal for The Three Presidents from Tennessee, *submitted in the form of pencil sketches. Left to right: Andrew Johnson, Andrew Jackson, and James K. Polk.*

The following August, three pencil sketches arrived by mail for GSA's review, and Baskin augmented them with the following statement:

The three sketches I sent you last week do not even adumbrate the feeling, quality and character of the realized bronze reliefs. It is axiomatic to say that three pencil drawings cannot evince the specific richness of patinated bronze. Nor can they convey the life of the hand in the mastic and malleable clay that yields the works' particularity. It is my usual practice, for the above reasons, never to submit "sketches";

I prefer to present the finished work for consideration.

Baskin's proposal was accepted, and the works were cast in bronze by the Bedi-Maky Foundry in Brooklyn, where they were inspected and approved in October 1975. Baskin made arrangements with the building's architect, Bruce Crabtree (of Taylor and Crabtree in Nashville), for the installation, which was accomplished in April 1976. GSA received very few negative letters about the works, and Joan Mondale made a special trip to see them a year later while in Nashville. She was so enthusiastic that GSA held a belated

GSA

dedication ceremony in an effort to increase community awareness of Nashville's latest cultural acquisition.

Commenting on the work in a letter to Administrator Solomon (October 21, 1977), Baskin wrote, "The essential problem was to somehow make an artistic statement about the quintessential dullness of Presidents Polk and Johnson. Jackson of course was an inspired President and spurred one on to create a sculpture somehow evocative of his qualities. The blandness of the other two remains a problem." Of his experience with the Art-in-Architecture Program he said,

[The] relationship between government and artist seemed happy, harmonious and easy. The terms of the contract were satisfactory, but the amount of money provided struck me as somewhat paltry. I would simply urge you to extend the programme in any way you can, making sure that every federal building is amply adorned with works of art. The needs of American artists are simply to be commissioned as often as possible with a programme of largesse inviting them to make a real contribution to the arts in America.

GSA

GSA

The Three Presidents from Tennessee, *Leonard Baskin's two-foot-high bronze bas-reliefs for the lobby of the courthouse and federal building annex in Nashville. Baskin, who divides his time between Maine and Devon, England, has had numerous one-man exhibitions in the United States and abroad. Long recognized for his masterful woodcuts and pen-and-ink drawings, he has recently become known for his sculpture as well. In all his work, he preserves a comprehensive relationship to the art of the past while asserting a contemporary point of view. Despite prevailing artistic tenets and the dominance of abstraction in American art, Baskin's work shows that the human face and figure can still be a vehicle of deep emotion and profound thought. As noted art historian Alfred Werner has written, "His genius as a draftsman and his understanding of the media (both relief and intaglio) have placed his graphic work on a level with the great woodcutters of the 15th century. The expressive power of Baskin's line . . . and the force of movement in his designs combine to create disturbing explorations into man's social, moral and psychic realms."*

JAMES SURLS

James Surls [signature]

GSA has sometimes been criticized by local art groups for commissioning only the internationally acclaimed giants of the art world—a perception that is inaccurate but understandable, since most media coverage of the Art-in-Architecture Program mentions only those artists whose names have "recognition value." In fact, between forty and fifty percent of GSA artists are commissioned on the basis of local reputation and are often selected for projects outside their regions, thus fostering a more widespread recognition of their work.

Today James Surls, who lives in Splendora, Texas, is a nationally recognized artist. Some years ago he was referred to as "the best of Texas regional artists" (Janet Kutner, catalogue essay for the Tyler Museum of Art, 1974), and though his reputation was gradually expanding, it wasn't until 1977—the year GSA commissioned him to create a sculpture for the Hastings Keith Federal Building in New Bedford, Massachusetts—that Surls became widely known on the East Coast. That same year, he was featured in the Guggenheim Museum's Nine Artists: Theodoron Awards exhibition, and in 1979 he was included in the Whitney Museum's Biennial.

Surls was nominated by the National Endowment panelists in the summer of 1977, and GSA awarded him the commission in October. Notified of his selection, he flew from Splendora to New Bedford in December for contract negotiations. He liked the historic town, with its whaling traditions and picturesque New England architecture. "My first trip to New Bedford was good. The people were nice, and I felt good about it all," he wrote. The contract was negotiated for $9,000—the maximum allowance for this particular project. Since the fee was to cover the design, execution, shipment, and installation of a monumentally scaled exterior sculpture, there was little, if any, prospect of profit, but Surls accepted the contract and signed it on the spot.

Both in manner and in physical presence, the thirty-three-year-old Surls is an impressive and unconventional individual. His energy seems boundless, and he combines a savvy, dry wit with down-home earthiness. Towering above six feet, he cuts quite a figure with his single earring, full beard, and thick hair pulled back into a ponytail. At this juncture in his career, his spirits were soaring even though his pockets were empty. "I had to pay my way [to New Bedford], and that was strange to me,

because by the time I got home I was a little over $400 into a project I didn't know if I was going to get or not—and I had to borrow the $400 from a friend," he said.

In January 1978, Surls presented drawings of his proposal to the GSA Design Review Panel in Washington, D.C. Easygoing and confident, he described the piece, which was to be made of southern pine logs roughhewn from stripped tree trunks—giant spikes set in steel collars welded to a central horizontal core. He was still low on money and noted that once again he had had to pay his own way. "I am now $800 into a $9,000 contract that I may or may not get." In fact he had gotten the contract, but the first payment depended on the approval of his proposal, which was immediate.

Seaflower, as Surls titled his sculpture, measures seventeen feet high by fifteen feet deep by twenty-eight feet

long. In its rough texture and use of wood, it evokes New Bedford's connection with the sea. "There are thousands of sea flowers, and *Seaflower* is very similar to some of them," said Surls, also noting that "the initial letter 'cee' [of the first name of his wife-to-be, Charmaine Locke] adds a romantic connection" (Don Glickstein, "Sculptor Says City Deserves 'Seaflower,'" *New Bedford Standard-Times,* May 27, 1978).

The completed work was ready to be trucked from Splendora to New Bedford in April 1978. According to Surls,

... it was the longest and hardest trip I have ever taken. The truck was so slow and the gas tank so small that we were averaging twenty-seven miles per hour—when we were moving—and we moved less than not.

... between Little Rock and Memphis, the trailer with *Seaflower* mounted to it went arcing off the

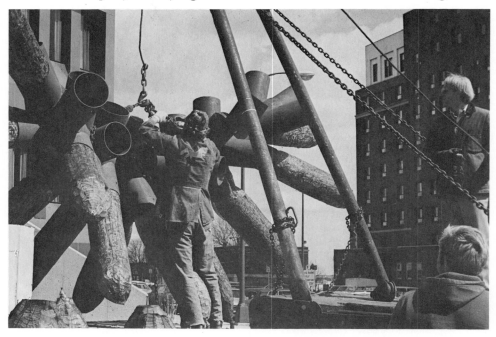

Seaflower, *James Surls's sculpture for the Hastings Keith Federal Building in New Bedford, Massachusetts, during installation in April 1978. The wood-and-steel work was installed by Surls himself, with the assistance of several friends, who also helped him truck it to New Bedford all the way from his home in Splendora, Texas.*

interstate and ended up in a ditch. Charmaine was driving at the time, and you should have seen her face; from the mirrors she saw "art to the right, truck to the left." . . .

Six days after we left home, we were in Washington, D.C., lost at four in the morning, trying our very best to get on a highway to Philadelphia. We did but broke down in a toll booth in Delaware. . . . We got towed off. We got fixed. We got on the road again, but with no sleep for over thirty-six hours, and now, no money. No money. We spent it all but twenty-five cents. . . .

. . . We enter Philadelphia . . . I sell a piece of art to a friend; we have cash. Two days later, we are on the road . . . [four] days later we install the art. It is done, and I am pleased. Art is for us all. I love it for sure.

Though Surls was pleased with *Seaflower,* his was a minority view. In fact, the official tally in a poll conducted by the *Standard-Times* (May 6, 1978) was 332 against the sculpture and 54 in favor. Articles and letters debating the merits of the work appeared nearly every day for over a month, with descriptions ranging from "giant bug coming out of the building," "frightened caterpillar," and "crippled sea urchin" to "impression of nimble ballet dancers," "extremely energetic expression," and "really beautiful." As the newspaper said, *Seaflower* had "'blossomed' in front of the Hastings Keith Federal Building in downtown New Bedford" and "evoked a torrent of comment." One reader saw a certain value in the controversy and wrote to the paper, "I may be weird but I think that sculpture in front of the federal building is just great. I think of it as the burr in the pants of our city. Anything that gets as much reaction as that can't be all bad."

Back home in Splendora, Surls reflected on his experience with the Art-in-Architecture Program.

The $8,200 is eaten by pipe, timbers, welders, labor, trucks, cranes and motels. I got home owing money. It is hard on your psyche . . . to take a job knowing there will be no profit. I did it. I learned. And again my reward is satisfaction and knowing there is a *Seaflower.* . . . I smile and say life goes on, and in time all points meet, and things are as they are.

If I sit in this place and look back 'cross time, I see a wooden city, washed in place, like the drift in the

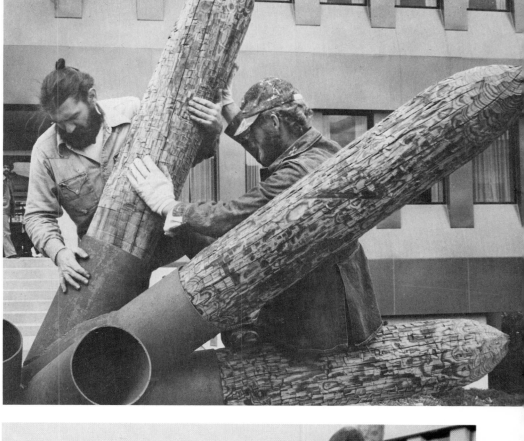

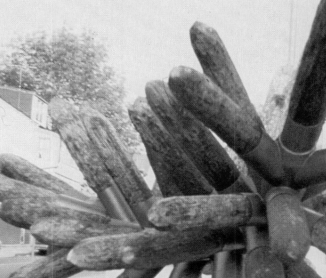

crook of the bay. New Bedford. I see walls made of timbers, laid flat like bridges. The walk between the land and sea.

So *Seaflower* was born. A gift to the people who made New Bedford New Bedford.

Above: The installation continues as Surls and a friend, Billy Holden, fit the roughhewn logs into their steel collars.

Top: Seaflower *on its site in front of the federal building, where it "evoked a torrent of comment," in the words of a local newspaper.*

HALE BOGGS FEDERAL BUILDING

 The artworks in and around the Hale Boggs Federal Building and U.S. Courthouse in New Orleans represented several "firsts" for the GSA Art-in-Architecture Program. Never before had GSA purchased existing works of art directly instead of commissioning artists for specific sites. In addition, the NEA-appointed panel that selected the artworks gave an expanded role to community residents; all the panelists were from New Orleans, and the meeting was opened to local art patrons, art groups, and individual artists, and to representatives of the mayor's office and the State Arts Council. Finally, the program was operating with a reduced budget of three eighths of a percent of the construction cost of the building rather than with the previous allowance of half a percent.

★ ★ ★

The federal building and U.S. courthouse under construction in New Orleans in 1973 was among the first projects singled out for fine arts commissions after the 1972 reactivation of the Art-in-Architecture Program. However, money for artwork had never been set aside, and the project's status—"Funds Not Immediately Available"—remained unchanged for several years. Then, in October 1975, District Judge Alvin Rubin got the ball rolling with a letter to U.S. Representative Lindy Boggs, widow of Hale Boggs (for whom the building had recently been named). "It had been my impression that there were some funds available for the purchase of some kind of artwork [but I am informed that] all building funds have been expended," wrote Judge Rubin. "This seems to me to be most unfortunate, both from the standpoint of the building as a continuing monument to Hale, and with respect to all of our efforts to perpetuate New Orleans' cultural and artistic traditions."

Less than a week later, Lindy Boggs wrote GSA to express her concern, attaching a copy of Judge Rubin's letter. "I am hopeful that additional funds can be located . . . and would appreciate hearing from you with respect to the prospects," she said in part. "In addition to my own personal feelings in the matter, I can assure you that there is considerable enthusiasm in our City

. . . for the inclusion of appropriate fine arts." Within two months, by letter dated February 13, 1976, GSA had responded to Mrs. Boggs: "We are pleased to inform you that funding in the amount of $105,000 is being made available . . . for the Hale Boggs Federal Building in accordance with our fine arts policy."

Immediately thereafter, the staff of the Art-in-Architecture Program began assembling the necessary material for an artist nominating panel to be appointed by the National Endowment for the Arts. However, the letter asking the NEA to convene the panel was never sent because GSA administrator Eckerd had all but suspended the program's activities pending an NEA review of the commissioning process. Eckerd was distressed by adverse local reaction to several recently installed works, and he wanted the NEA to recommend changes that would avert such responses.

From the standpoint of the New Orleans project, the delay was critical, because the federal building had a "purchase contract funding collapse date." All work on the building, including the fine arts, had to be completed by September 1, 1976, or the money would no longer be available, and GSA would be forced to renege on its commitment.

On May 20, with time running out, Administrator Eckerd signed the letter requesting that the NEA appoint a panel to nominate artists for the New Orleans project. The panel was to operate under revised guidelines designed to insure greater community participation in the selection process and to engender local support for specific GSA-commissioned artworks. Eckerd believed that the Hale Boggs Federal Building would be a kind of "test case" for the new guidelines, which were expected to "make a contribution toward improving community reaction to new arts projects in the future," as he said in his letter to the NEA.

Needless to say, a lot of fancy footwork was necessary during the remaining three months in order to satisfy the community-involvement requirements and still have the artwork in place by September 1. As the normal commissioning process usually takes at least a year from nominations to finished work (and often much longer), it was apparent that the only way to meet the deadline was by the direct purchase of existing works.

A flurry of letters and notices, telephone calls and news interviews, kept art administrators, museum curators, artists, art critics, and GSA staff members hopping right up until the date of the panel meetings, which took place on June 30 and July 1. The panelists, all from New Orleans, included art critic Luba Glade, Chief Curator William Fagaly of the New Orleans Art Museum, Greater New Orleans Arts Council director Geoffrey Platt, Jr., and architect James W. Rivers (who is also a weaver). In addition, the panel was officially advised by a representative of the mayor's office, civic leaders, and others. Officials from GSA's regional office in Ft. Worth were on hand for the occasion, and artists and dealers came too. Nicholas Panuzio, commissioner of GSA's Public Buildings Service in Washington, attended the final session.

The panel's deliberations went quite well (certainly far better than anyone believed possible under the circumstances), though at least one participant found the sessions a bit chaotic. "The labyrinthian selection processes and convoluted machinations both of individuals and well-meaning bureaucrats culminated in a two-day session . . . which sometimes resembled a tea party given by the Mad Hatter," reported Luba Glade in an article recounting the entire story of the New Orleans project ("Art Politics at the Hale Boggs Federal Building," *New Orleans States-Item*, July 17, 1976). Controlling the three-ring circus for the NEA was the unflappable Richard Koshalek, then director of the Ft. Worth Art Museum.

After reviewing visual material on over three hundred artworks, the panelists chose four tapestries, two fiber sculptures, a painted sculptural canvas, and two exterior sculptures. Commissioner Panuzio was pleased with the selections, and in a July 8 memo to Administrator Eckerd recommending approval of the works, he described them as "compatible with the architectural design and of a high level of quality." He noted that the combined cost of all the works would be $80,150—an amount that was well within the new three-eighths-of-one-percent budget. "Since we had originally planned to spend a total of $105,000, the newly anticipated expenditure represents a savings of approximately $25,000," he added with evident satisfaction. Eco-

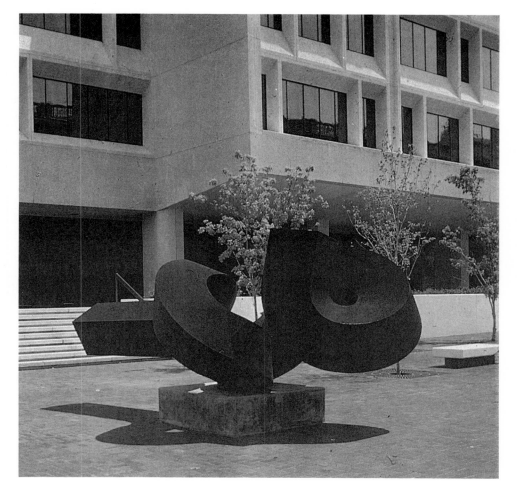

nomics aside, GSA concurred with the judgment of panelist William Fagaly, who wrote GSA on July 2:

> I am happy with the way the New Orleans meetings were conducted, and I am extremely pleased with the works which we were able to recommend. I feel that these works will be an important addition to the city and represent a quantum jump in the number of large-scale works in public places in the Crescent City.

★ CLEMENT MEADMORE ★

The major purchases for the Hale Boggs Federal Building were two exterior sculptures, one by Clement Meadmore and one by Lucas Samaras. Meadmore's sculpture, titled *Out of There*, had been on display in New Orleans since early spring, when it had been temporarily placed near the International Trade Mart in connection with the International Sculpture Conference. Described as a "long black quadrilateral tube [that] curls around itself and then dissolves into space" (*Art/Works*, Spring 1976), the painted steel piece measures sixteen feet wide by nine feet eight inches deep by six feet six inches high. It was purchased for $35,000 and is located on the building's southwest entrance plaza off Camp Street.

Above: Sculptor Clement Meadmore.

Right: Two views of Meadmore's Out of There, *on the southwest plaza of the Hale Boggs Federal Building and U.S. Courthouse in New Orleans, Louisiana. "Like jazz, which is improvised on a strict set of chords for each tune, my own work is improvised using a strictly geometric set of quarter-circle and straight elements,"* says Meadmore.

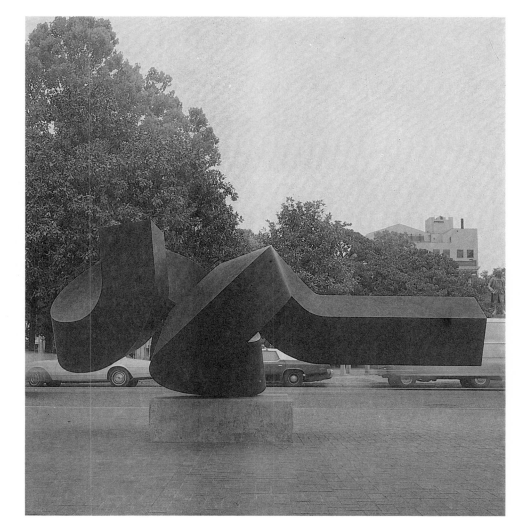

Philip Tsiaras/Pace Gallery

Meadmore was pleased that his sculpture had been selected. In his own words,

> *Out of There* is the final piece in a ten-year series and is not only the culmination of that series but also the most baroque. As a result, it seems appropriate that it should have found a home in New Orleans, one of my favorite cities, and the birthplace of the music I have collected all my life.
>
> Like jazz, which is improvised on a strict set of chords for each tune, my own work is improvised using a strictly geometric set of quarter-circle and straight elements. These elements reflect the curve of the Mississippi, on which the Crescent City was built, and, in combination, the elaborate curvilinear designs of traditional New Orleans architecture.

★ LUCAS SAMARAS ★

At the entrance to the plaza that separates the office building from the courthouse is a Cor-ten steel sculpture by Lucas Samaras, fabricated in the early 1970s by the Lippincott company of North Haven, Connecticut. Measuring nine feet high by six feet wide by thirteen inches deep, it gives the impression of a sunburst radiating geometry. It is the largest of Samaras's outdoor steel sculptures to date, and the only one to be on public display. It was purchased and installed for $33,000.

According to Samaras, the piece had its genesis in a "reawakening—elements from my past or from the art historical past." In particular, with its

Above: Sculptor Lucas Samaras.

Right: Two views of Silent Struggle.

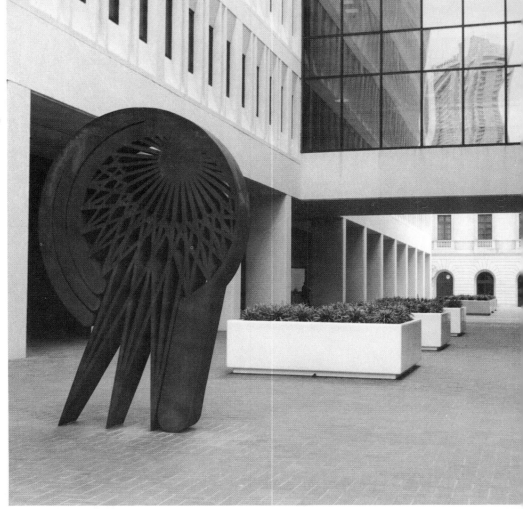

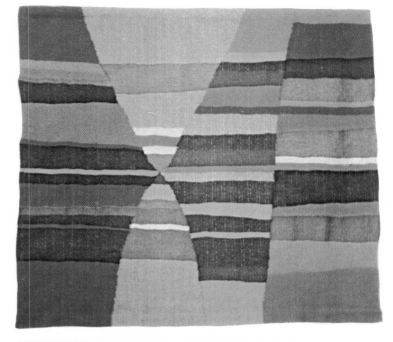

"intricate juxtaposition of light/dark and compactness of lines," it makes reference to such diverse influences as Louis Sullivan and Islamic art. Samaras titled his sculpture *Silent Struggle*. It reflects, he said, "a period in the late 1960s when I did a number of cut-paper drawings . . . derived partly from Oriental art, partly [from] the idea of the doily, . . . so when you held them up, [their structure] was a very delicate kind of thing. . . . Then, when I started making the Cor-ten steel pieces, I continued that idea, only I geometricized a little bit the form."

★ ★ ★

The other purchases were interior works, all located in the courthouse lobby, which is faced in black polished marble. In selecting them, the panelists were looking not only for artistic quality but also for pieces that would work well both individually and together. The success of their efforts was praised by art critic Alberta Collier, who wrote, "In my opinion, the committee charged with the selection did an excellent job. . . . The wall hangings . . . are all excellent in themselves and break the monotony of the dark polished walls" (*New Orleans Times-Picayune*, August 17, 1976).

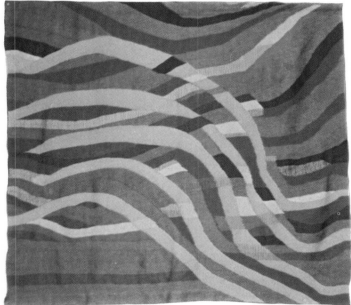

★ **SILVIA HEYDEN** ★

Three tapestries created by Silvia Heyden of Durham, North Carolina, grace the lobby walls. Two, *Intervals* and an untitled work, hang in proximity to one another on the southwest wall, and the third, *Orientalisch*, hangs on the northeast wall. Their strong abstract designs are woven in fibers "whose rich hues rival Joseph's coat" (Collier, *Times-Picayune*, August 17, 1976). The three works, each approximately five feet square, were made in 1974 and 1975 and were purchased at a total cost of $4,650.

Heyden, who is also a violinist, regards her tapestry designs as obeying rhythms similar to those in music, their creation proceeding from measure to measure in a way similar to musical development. As she says,

> I realize more and more that a design on paper is contrary to the basic principle of the loom. A tapestry originates with the vertical and horizontal crossing of warp and weft. Similar to the sound of the violin between strings and bow, a tapestry has to be built up like a stone wall, one weft thread relating to the preceding one.

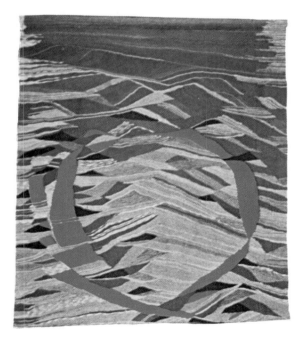

Top to bottom: Intervals, *an untitled work, and* Orientalisch, *three colorful abstract tapestries designed by Silvia Heyden.*

★ CAROL SHINN ★

Carol Shinn's *Two Columns* combines linen and jute in a six-and-a-half-foot-high by forty-five-inch-wide fiber sculpture located on the lobby's southwest wall. The work consists of two woven panels whose inside edges are faced with a heavy vertical shag. The panels are connected by regularly spaced coarser fibers that run horizontally through both. Describing her work, Shinn wrote:

What is important to me are the aspects that set weaving apart from other media. Weaving is making fabric, and it is the qualities of fabric with which I deal, its density, rigidity, pliability, and texture. Uses of tension and drapery are often employed to make these qualities apparent.

In the piece *Two Columns*, the contrast of draping the connecting cords emphasizes the rigidity of the fabric in the two panels. To reproduce imagery is not to make fabric; it is to impose upon it. For this reason my work aims at simplicity of overall form with the primary emphasis on structure and underlying order. Yet the inherent surface qualities of the materials are not denied but are incorporated as determining elements in the very structure of each piece.

Shinn, a resident of New Orleans at the time her work was selected, now lives in Arizona.

Carol Shinn's Two Columns, *a linen-and-jute fiber sculpture.*

★ ANNETTE KAPLAN ★

The largest of the woven tapestries, a black-and-white work of bold graphic design, hangs on the northwest wall of the lobby. Titled *Journey Two,* it was created by Annette Kaplan of Oakland, California, who wove it on a jacquard loom in 1974. It measures seventy-three inches wide by one hundred thirty-eight inches high and was purchased for $1,700.

The concept of "outside-inside" is a major concern of Kaplan's, and all her works are designed to be viewed from both sides. *Journey Two,* an abstract geometric composition, appears to be inspired by Indian art but is in fact more akin to computer technology. As Kaplan explained,

In 1974 I began to use a jacquard loom, which functions very much like a player piano. Prior to weaving, the designs are completely programmed into the loom using a series of hand-punched cards. These cards rotate around a cylinder, calling forth the designated threads upon their turn. (The textile industry utilizes mechanized jacquards to produce large quantities and multiples.) During this period, I was working in related series of one-of-a-kind tapestries that utilized multiple-repeat patterns. I was concerned with pattern fields, multiples, inversions, geometrics, and optical illusions.

★ ANN MITCHELL ★

Across from *Journey Two* is *Cumulus,* a sculptural needle weaving created by Ann Mitchell of Houston, Texas. Mitchell began learning the techniques

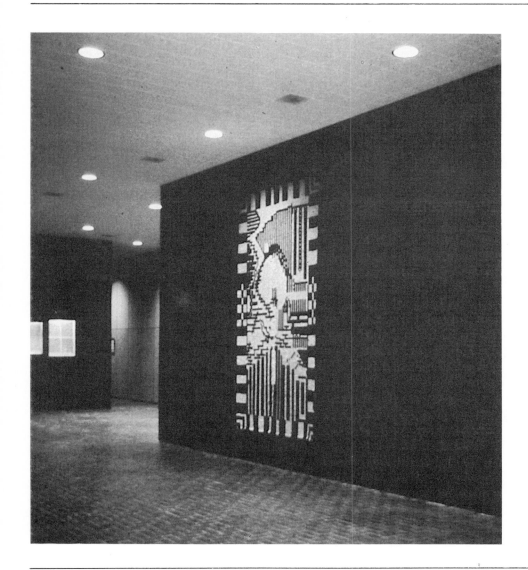

of off- and on-the-loom weaving in 1967, and she won the Pi Phi Scholarship in Gatlinburg, Tennessee, in 1973. As its title suggests, *Cumulus* symbolizes cloud formations. Measuring ninety-six inches wide and thirty inches high, it was purchased for $750 and installed on the northeast wall of the lobby.

★ **TERRY WELDON** ★

On the southeast wall of the lobby hangs a three-dimensional painted sculptural canvas titled *Water Holes,* by Terry Weldon of New Orleans. Weldon, whose works have been exhibited widely throughout the United States, France, Germany, and Iran, says he is interested in "exploring and creating new surfaces, textural surfaces which express their 'differences of quality.'" *Water Holes* was acquired for $4,200 and measures twelve feet wide by seven feet six inches high. In designing it, Weldon anticipated an interaction between the work and the viewer.

Left: Journey Two, *Annette Kaplan's loom-woven black-and-white tapestry.*

Below: Ann Mitchell's Cumulus, *a sculptural needle weaving.*

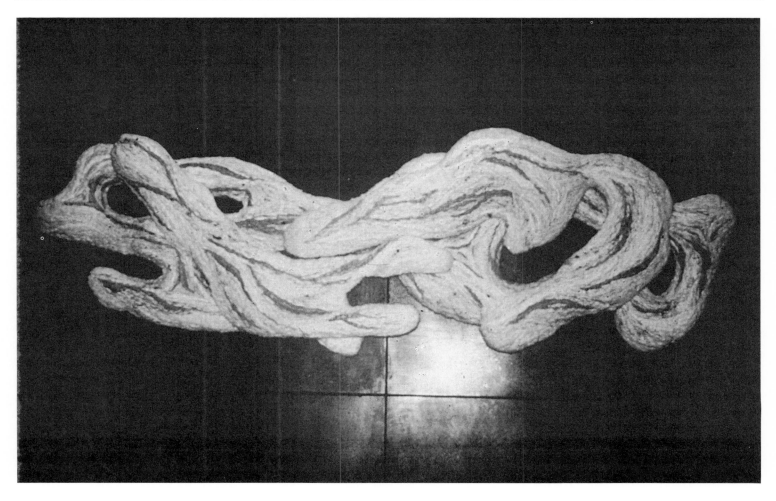

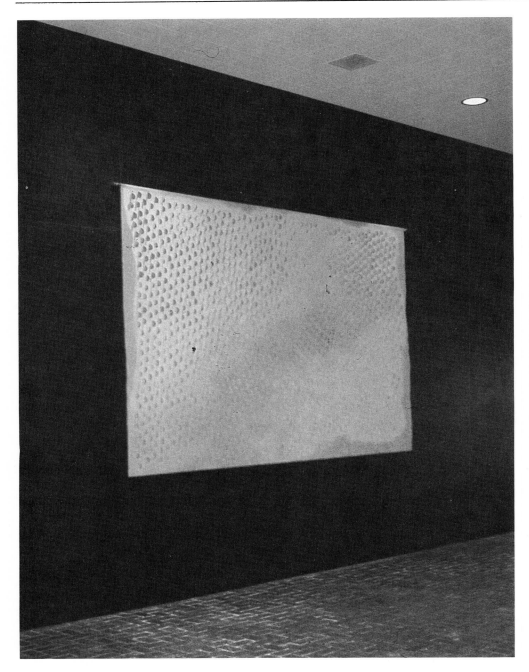

Currently I have been involved in creating tactile surfaces in order to allow the person looking at them to feel tempted to participate with the piece by touching it as well as looking at it. I want all my work to stimulate all the senses. I want the work to intrigue, stimulate, and play with the participant and his imagination.

★ ★ ★

Both individually and in their total effect, the artworks at the Hale Boggs Federal Building were favorably received by art professionals and the public alike. There was, however, a certain amount of the sort of criticism that often attends GSA installations—art in federal buildings is a "waste" of tax dollars, spending money on "frills" is ridiculous when there are so many other, more pressing needs, etc. In a letter to the editor of the *Times-Picayune* (August 17, 1976), William Fagaly responded forcefully to such complaints:

> In comparison with other free-world countries, our government has a poor record of support for its strong and national artistic and cultural heritage. It spends twenty-nine cents per capita on the arts and humanities (including dance, literature, museums, music, public media, theater, visual arts, architecture, folk arts, art education, community cultural centers, etc.) in comparison to $380 per capita for defense, $110 for health, $50 for education, and $4 for public transportation.
>
> In this year of reflection on our country's achievements, I applaud the GSA and NEA's joint program to help beautify our country, and at the same time to support its own valuable national asset and resource—its artistic citizens.

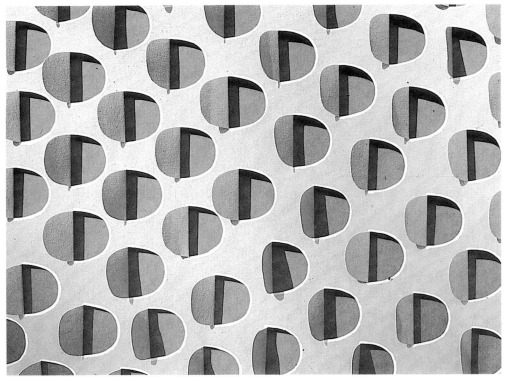

Top: Terry Weldon's Water Holes, *a three-dimensional painted canvas.*

Left and above: Two details of Water Holes.

ALFRED P. MURRAH FEDERAL BUILDING

With the installation of thirty-two works of art, including some traditionally considered crafts, in the Alfred P. Murrah Federal Building in Oklahoma City, the Art-in-Architecture Program broke new ground in several respects. For the first time, GSA acquired works of photography; ceramic sculpture, finger weaving, and a quilt were procured; there was an emphasis on selecting works by regional artists and craftsmen; and the pieces were placed throughout the building rather than being clustered in one or two locations.

Until Jay Solomon took over as GSA administrator, it was the agency's policy to commission only major works. Solomon encouraged an expansion of the program to include a greater variety of media and incorporate artworks in a number of building areas instead of concentrating on one or two main commissions for the lobby or plaza. His philosophy meshed perfectly with that of Bill Shaw, design architect for the Murrah Building (from the joint-venture firm Shaw Associates/Locke Wright Foster). From the very beginning, Shaw had envisioned the building with multiple works of different types. Since the cost of purchasing existing works is generally much less than the cost of commissioning new ones, GSA decided to acquire directly all but the major fiber sculpture for the main entrance lobby. With such a large number of works involved, there was no other way to fulfill the architect's proposal within the overall budget of $80,000.

Responding to Administrator Solomon's request for artist and artwork nominations, an NEA-appointed panel met with the architect in Oklahoma City on August 23, 1977. The panelists, representing both geographical sensitivity and professional diversity, included museum directors Ronald Hickman (Phoenix Art Museum) and Norman Geske (Sheldon Memorial Art Gallery, Lincoln, Nebraska), noted weaver Alice Parrott (New Mexico), and the associate director of the Oklahoma Indian Affairs Commission, Dr. Joy Reed. Awaiting them were craftworks and artworks by the hundreds, shipped and hand-carried from all over the Southwest for their evaluation. The large double room in the new federal building was wall to wall, floor to ceiling, with sculptures, ceramics, paint-

ings, and much more; and each panelist brought carousels filled with slides of additional works.

The task seemed impossible to complete in one day and in fact could never have been accomplished without the determination and diplomacy of the NEA crafts coordinator, Elena Canavier (now art advisor to Joan Mondale). As the Oklahoma project was of special importance to Administrator Solomon, he asked his observant and always tactful "right hand," Jean Allen, to attend the proceedings; she was visibly impressed. Beginning before 9:00 A.M., the panelists worked through the day and night and finished after 2:00 A.M. the

following morning, exhausted from their labors. For the main commission, they nominated Gerhardt Knodel; their other recommendations, subsequently adopted by GSA, appear below.

Of the thirty-two works, only Gerhardt Knodel's fiber sculpture was commissioned under the Art-in-Architecture Program's existing guidelines. Technically speaking, however, Terrie Mangat's quilt and William Scott's sculpture were also commissioned, in the sense that both were modified for the Murrah Building. The quilt selected by the panelists had a giraffe motif, and Administrator Solomon believed that a

ARTWORKS IN THE ALFRED P. MURRAH FEDERAL BUILDING

ARTIST	TYPE OF WORK	TITLE OF WORK	COST
Michael Anderson	Stainless steel and wood sculpture	Stellar Wheel	$1,000
Sally Anderson	Fiber work	31 Flavors	3,000
Anna K. Burgess	Fiber work	Carnival	650
	Fiber work	Through the Looking Glass	950
Karen Chapnick	Fiber work	Soaring Currents	1,400
Curt Clyne	Photograph	Cowboy in Coffee Shop	200
	Photograph	Winter Scene	200
Richard Davis	Bronze sculpture	Storm	3,200
Albert Edgar	Photograph	Columbines at Cascade Canyon	200
	Photograph	North of Cunningham's	200
Fred Eversley	Plexiglas sculpture	Untitled	4,200
David Halpern	Photograph	Morning Mist	200
	Photograph	Charon's Sentinels	175
Betty Jo Kidson	Fabric work	Morning at Taos	450
Jane Knight	Fiber work	Double Layers	700
Jerry McMillan	Brass sculpture	Palm Tree Coil	2,800
Dena Madole	Fiber work	Synthetic Fibers	400
Terrie H. Mangat	Quilt	Oklahoma Quilt	1,500
Joyce Pardington	Fiber work	Canyon Wall Number Two	400
	Feather and fiber work	October	200
Charles Pebworth	Marble sculpture	Lookout from San Bois	6,500
Rebecca Petree	Fur and painted canvas	Fur Piece	800
Charles Pratt	Wood and metal sculpture	Cowboy Hat	700
William Scott	Kinetic stainless steel sculpture	Vigil	13,000
Franklin Simons	Ceramic sculpture	Monolith	300
Grant Speed	Bronze sculpture	Rider in the Distance	4,000
Bud Stalnaker	Fiber work	Precise Notations	750
James Strickland	Wood relief	A Fallen Oak Tree	2,100
Melanie Vandenbos	Finger weaving	Sunburst	600
Carol Whitney	Ceramic relief Indian figures (2)	Untitled	250

regional theme would be more appropriate. Mangat agreed, and she designed and executed a different quilt specifically for the Oklahoma project. Similarly, Scott's exterior sculpture, which originally had a single moving element, was expanded for the Oklahoma site and now consists of three identical moving parts.

★ GERHARDT KNODEL ★

Gerhardt Knodel was selected to design a sculpture for the Murrah Building's two-story entrance lobby, which has a main staircase descending to the floor below. Knodel, widely known and respected for his handwoven, beautifully crafted fabric sculptures, is one of the most sought-after artists in his field. His space-modifying works are in great demand, and GSA was concerned that his heavy schedule might prevent him from undertaking the commission. On November 9, 1977, contract negotiations were held in Oklahoma City, and Knodel flew in from his home base at the Cranbrook Academy of Art in Bloomfield Hills, Michigan. The terms of the contract were discussed

thoroughly, and to everyone's delight, Knodel agreed to accept the commission at a fee of $28,500.

In January 1978, Knodel presented a complete model and samples of fabric to GSA, explaining that he had developed his concept after extensive research. Aware that Oklahoma has a large population of Indians, he spent a great deal of time studying Indian culture, drawing heavily on Cranbrook's large collection of artifacts, art objects, and historical materials. Knodel discovered that ribbons, which were in abundant supply in nineteenth-century Europe, were exported to the United States in great quantities and

were used by settlers to barter with the Indians. Taking off on this theme, he designed a work consisting of 161 fabric strips of various lengths, suspended to create a sense of volume—"a canopy opening up, . . . a landscape of fabric, . . . an experience of moving through space."

Knodel titled his piece *Sky Ribbons: An Oklahoma Tribute.* After it was installed, he elaborated further upon its symbolism:

Ribbons are a means of visual joy. Native American Indians celebrated their lives by decorating their clothing with ribbons. Nineteenth-century settlers came with ribbons that served as symbols of refinement and elegance in a dusty place. Blue ribbons became signs of ultimate victory or reward for the rancher, the bronc buster, and the farmer. The military decorated their best with strips of colored cloth. . . .

Sky Ribbons is a three-dimensional work which communicates its fullest meaning when one experiences every accessible point of view. The work was conceived as existing in a dialogue with the architecture. Like the architecture, it

Gerhardt Knodel's Sky Ribbons. *"It is a landscape and a skyscape that celebrates all the best we have been. Like the American flag, it symbolizes and commemorates our origins and history, and in its color, light, life, and order, it recognizes elements that are fundamental to all people,'' says Knodel.*

is intended to expressively accompany, not dominate, the activity of people who use the building.

The Alfred P. Murrah Federal Building and all the artworks were dedicated on June 7, 1978. Joan Mondale, who spoke at the ceremony, called the overall effort "a model for other governmental agencies—and for the private sector—of what can be done when good architecture and art are combined in a truly human environment." With characteristic forcefulness, Mrs. Mondale talked about the importance of art in our everyday lives: "Art is more than frills afforded by the 'good life.' It is more than decoration of a public place. It is not just the icing —it's the essence, and it's the education. . . . Art re-educates and sharpens our perception."

Another view of Sky Ribbons *(left, 11'7"h x 14'7"w x 8'2"d), commissioned for the building lobby. Sally Anderson's* 31 Flavors *(below, 48"h x 70"w x 11"d) and the thirty other works that appear on the following pages were purchased directly.*

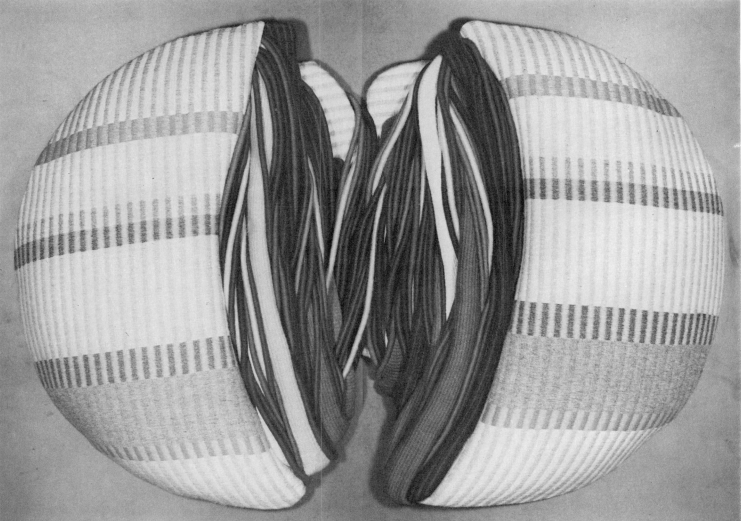

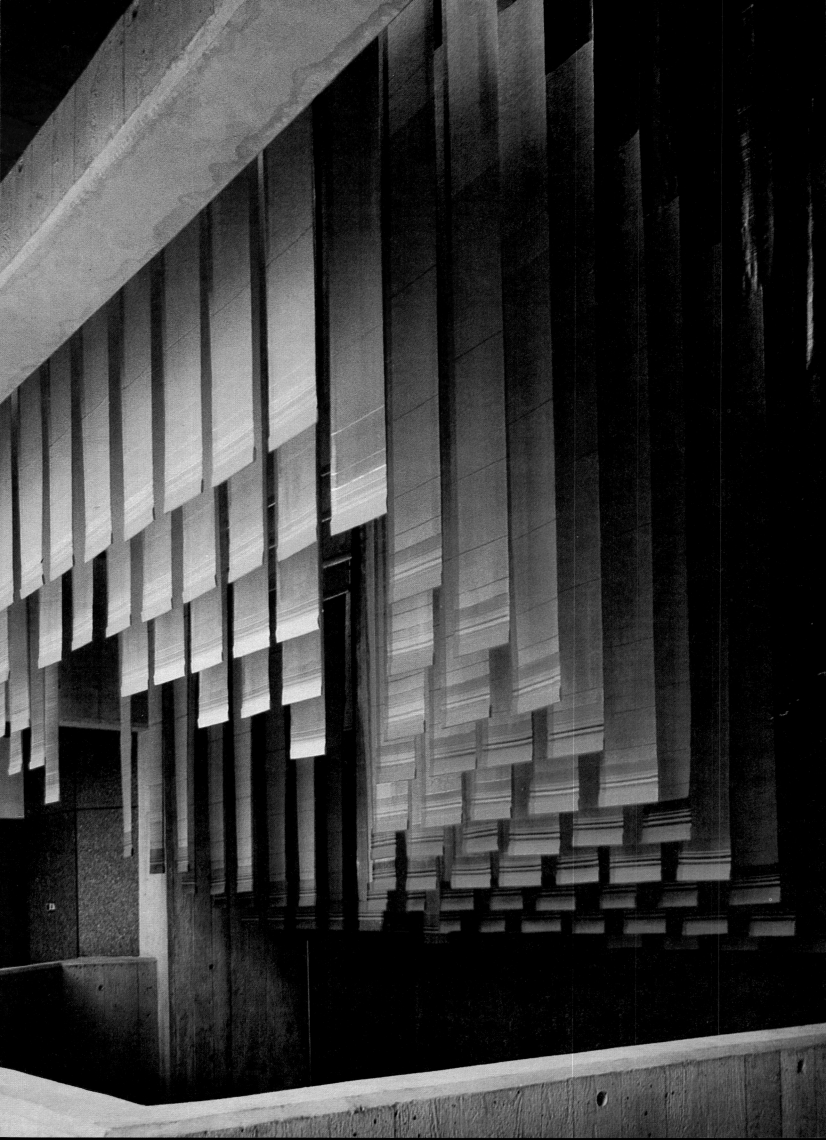

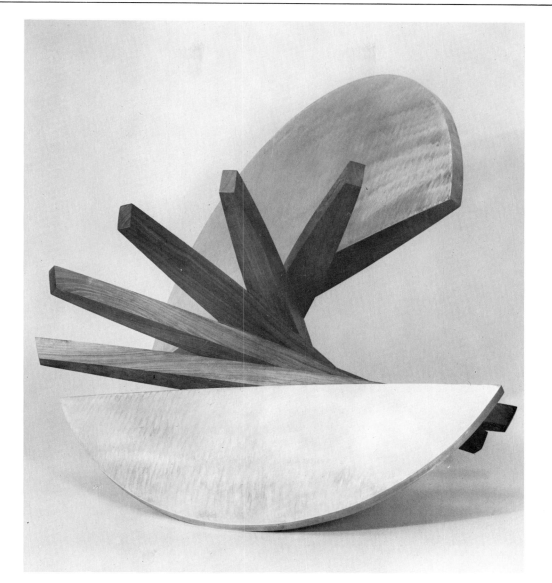

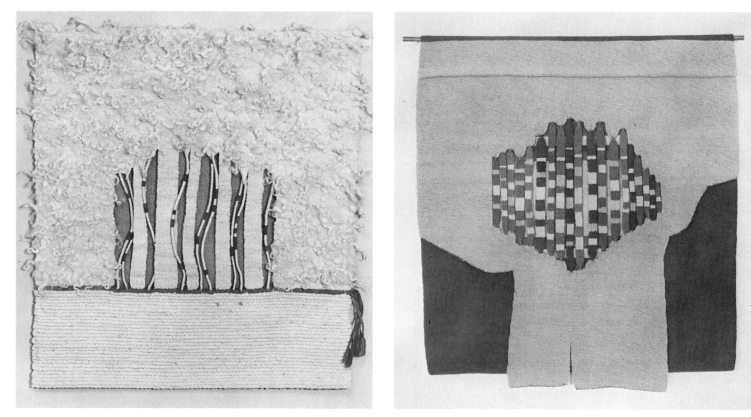

Top: Michael Anderson's Stellar Wheel *(29″h x 30″w).*

Above: Carnival *(left, 36″h x 30″w) and* Through the Looking Glass *(40″ x 40″), by Anna K. Burgess.*

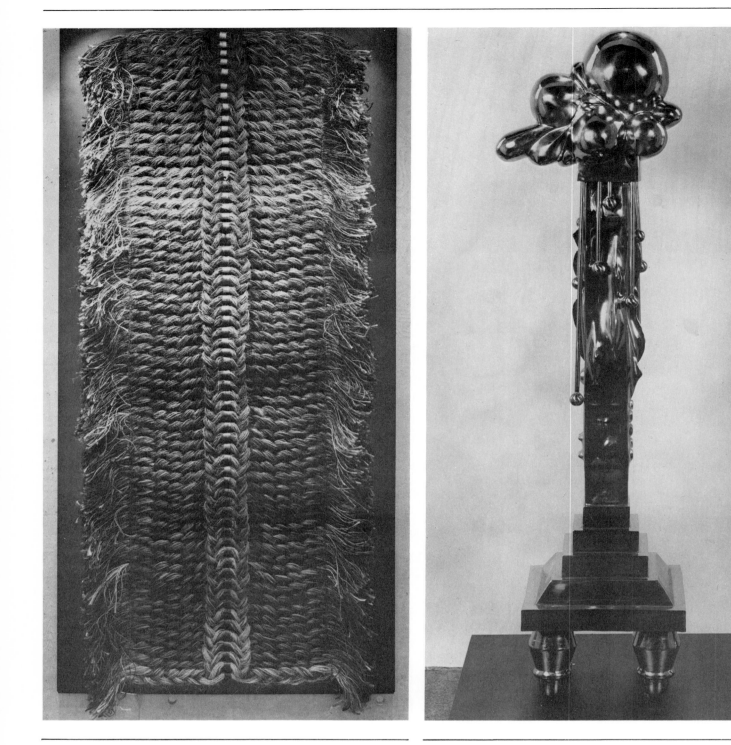

Karen Chapnick's Soaring Currents *(94″h x 42″w).* Storm, *by Richard Davis (69″h x 16½″w).*

Winter Scene (above, 13"h x 17"w) and Cowboy in Coffee Shop *(7½"h x 11"w), by Curt Clyne.*

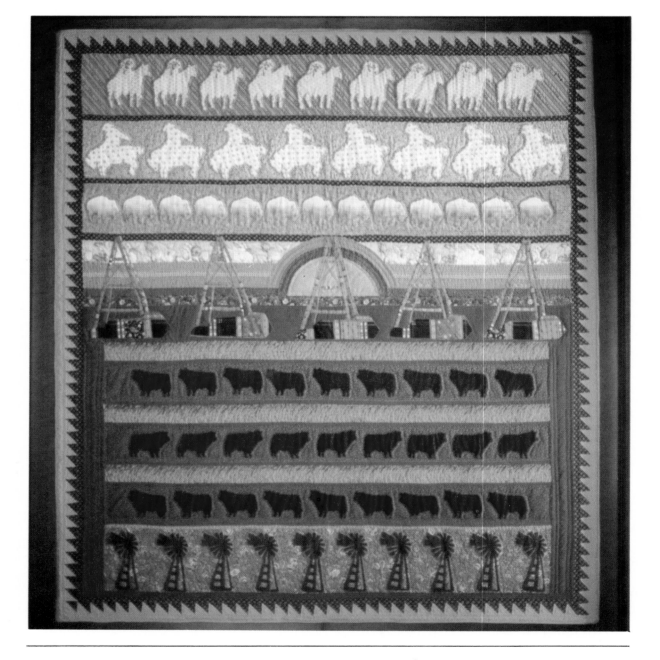

Opposite: William Scott's Vigil *(each element 120"h x 33"w x 8"d).*

Above: Terrie H. Mangat's Oklahoma Quilt *(87"h x 79"w). "In designing* Oklahoma Quilt, *I tried to capture some of my feelings about the land and spirit of Oklahoma," wrote Mangat. "In the quilt I pictured a land that is half sky, half earth, with the all-important Sun setting on the horizon. On the earth are the symbols for man's work: oil derricks, wheat, and beef cattle. There is a row of windmills to represent the ever-present wind, and a fleeting section of foliage at the horizon. The sky holds the spirit of Oklahoma. In the form of clouds I put the Indian, the Cowboy, and the Buffalo. All of these images were achieved through reverse appliqué, a technique I find useful in making intricate shapes and in putting strong colored and printed fabrics together. The undersides of the buffalo clouds are airbrushed to reflect the setting sun.*

Opposite: Charon's Sentinels
(top, 14"h x 19"w) and Morning Mist
(14"h x 19"w), by David Halpern.

Left: Monolith *(48"h x 24"w), by Franklin Simons.*

Below: A Fallen Oak Tree *(73" x 73"), by James Strickland.*

North of Cunningham's *(15½″h x 23¼″w)* and Columbines at Cascade Canyon *(opposite, 15¼″h x 19½″w).*

An untitled Plexiglas sculpture by Fred Eversley (19½″h x 18″w).

Top: Rider in the Distance *(17"h x 39"w x 8"d), by Grant Speed.*

Above: Dena Madole's Synthetic Fibers *(left, 60"h x 24"w) and Jane Knight's* Double Layers *(40" x 40").*

Morning at Taos *(40″ x 40″), by Betty Jo Kidson.*

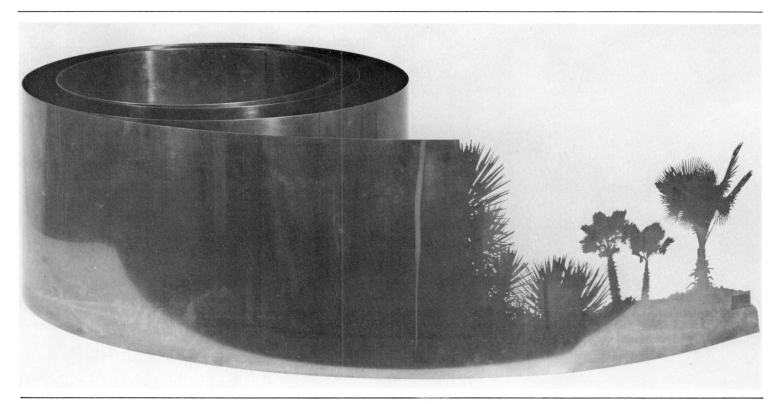

Palm Tree Coil *(12″h x 20″w), by Jerry McMillan.*

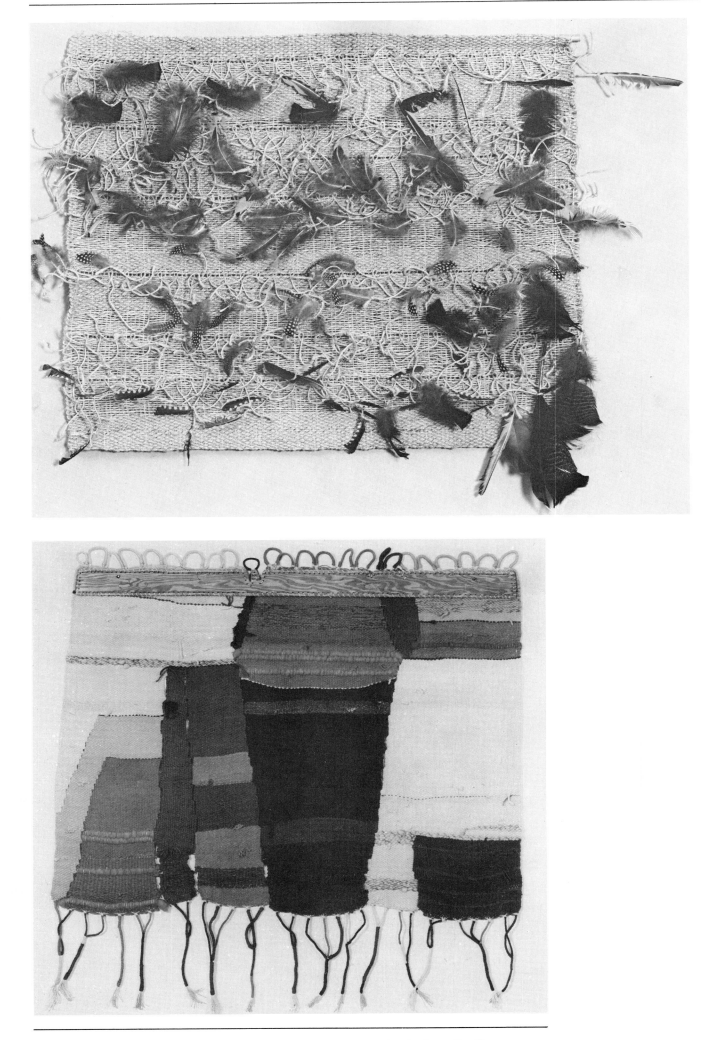

October *(top, 24"h x 30"w) and* Canyon Wall Number Two *(62" x 62"), by Joyce Pardington.*

Cowboy Hat *(18"h x 16"w), by Charles Pratt.*

Lookout from San Bois, *(49"h x 30"w x 16"d), by Charles Pebworth.*

Fur Piece *(38"h x 32"w), by Rebecca Petree.*

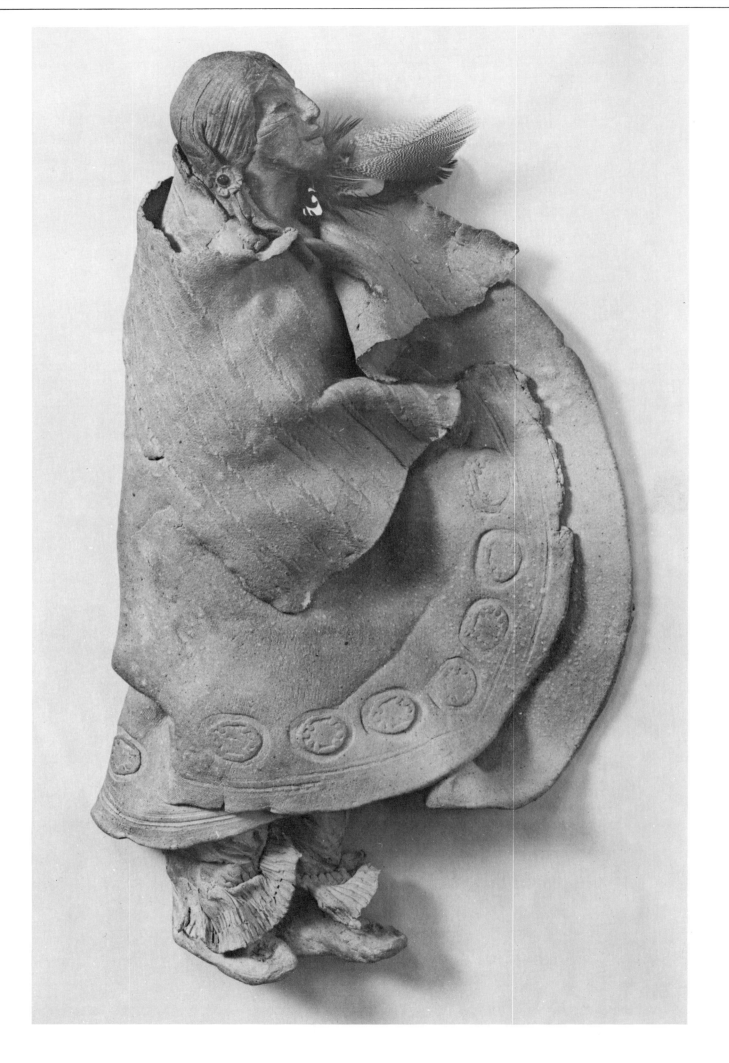

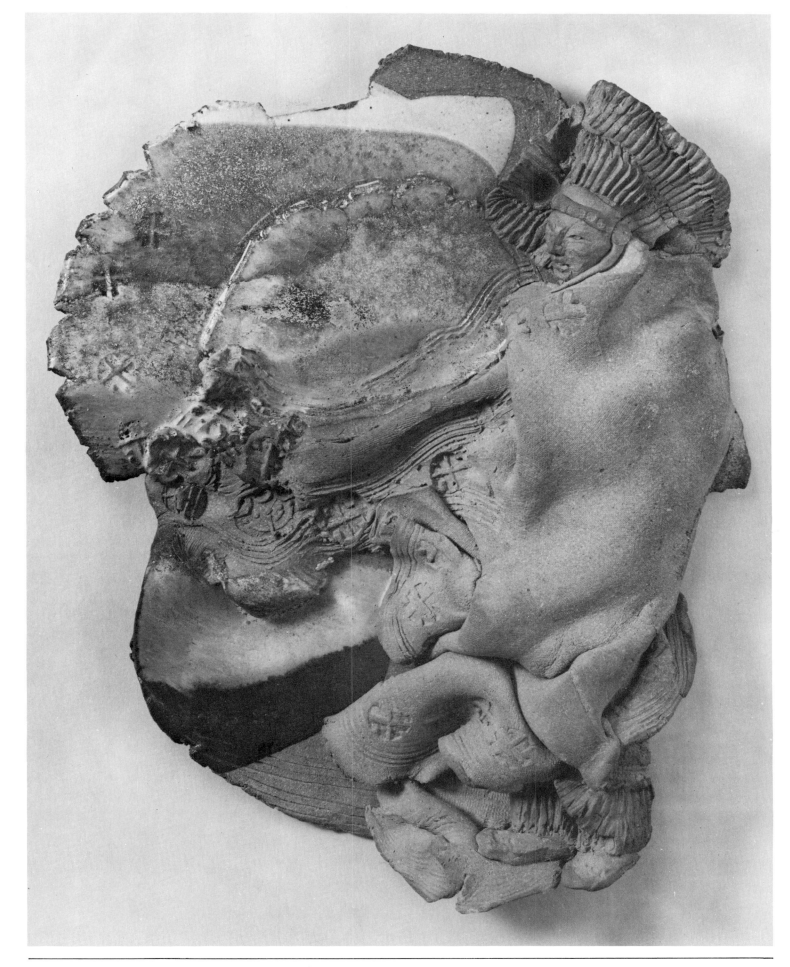

Opposite and above: Two ceramic relief Indian figures by Carol Whitney (17½"h x 9"w, 17"h x 13½"w).

Precise Notations *(80"h x 36"w), by Bud Stalnaker.*

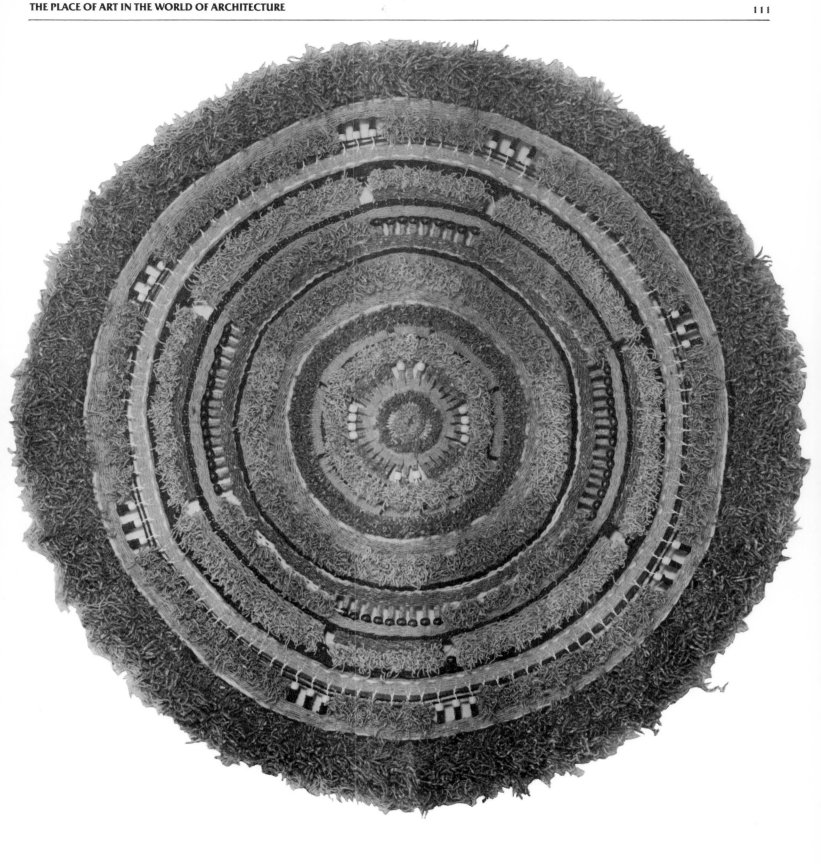

Sunburst (42″ diameter), by Melanie Vandenbos.

"On Friday it was a simple, unobtrusive, circular fountain, half-filled with green stagnant water and surrounded by a short brick ledge in front of the federal building at 80 N. Hughey Ave. . . . By Monday, however, the fountain had become the base of a big, shiny, silver monolith that caused heads to turn and people to talk." So began an article by Judy Doyle in the *Orlando Sentinel Star* on February 7, 1978 ("Steel Sculpture Lifts Eyebrows, Poses Questions"). Doyle then proceeded to relate some of the sidewalk commentary: "'It looks like a giant cookie cutter,' said one observer. Another said it looked like the ragged edge of a key. . . . 'It has one redeeming social value: it will keep the drunks from bathing in the fountain,' said another. One woman thought it was the cover of the sculpture."

Eleven days later, First Lady Rosalynn Carter traveled to Orlando, Florida, to dedicate Geoffrey Naylor's fountain sculpture, and her views were considerably more positive. Speaking to the large and enthusiastic crowd that was on hand for the ceremony, she said, "Most of us grew up thinking that government buildings were dreary places with little to lighten the heart or spirit. But here today we see exactly the opposite: buildings that please us; a work of art that captures our imagination. We need beauty in our daily lives. Everyone needs—and deserves—a humane environment." As Mrs. Carter concluded her remarks, the skies filled with helium ballons, and she and Naylor ceremoniously pulled a switch to activate the water.

GSA administrator Jay Solomon, master of ceremonies for the occasion, was clearly delighted that the First Lady had accepted his invitation to be the keynote speaker. And Naylor, who had worked frantically to install the work on time for the dedication, was the picture of calm even though he'd been besieged by TV cameramen and journalists for the preceding twenty-four hours. It was truly a "media event," and Naylor was ready. He later described the developments that led to that proud moment.

The work on the sculpture was moving along smoothly when, about six weeks before my planned installation day, I had a call from [GSA] asking if I could move up the installation two weeks, since the President's wife, Rosalynn Car-

GEOFFREY NAYLOR

ter, was willing to be present for the dedication of the sculpture. At first I said no but changed my mind when I realized it was important to a number of other people who were connected with the sculpture's completion. It required an effort to finish two weeks early, but looking back, I believe it was worthwhile. To have present on the day of the dedication a Marine band, Mrs. Carter, Senator Stone, and Congressman Kelly, plus many other people, was, to say the least, unusual and unexpected.

On August 1, 1975, Naylor had been nominated by NEA-appointed panelists to execute a sculpture for the U.S. courthouse and federal building in Orlando. Such a commission had originally been suggested by the joint-venture firm that designed the building (Smith and Swilley, Architects/Davy Powergass, Inc./Schweizer Associates Architects, Inc., of Lakeland, Florida). Writing on its behalf, architect Warren H. Smith stated, "We propose a major metal sculptural feature to be placed in the sculpture pool. . . . This sculpture . . . should rise out of, or 'float' above, the sculptural pool [and] create an 'interest linkage' between the main building entrance . . . and the rather overwhelming adjacent street scene." Smith's diplomatic choice of words understated the site conditions drastically. The "rather overwhelming adjacent street scene" in fact consisted of an overhead freeway, acres of asphalt parking lots, and an accompanying sea of parking meters. It was an open question whether the proposed sculpture could survive the competition.

For awhile there seemed to be no need for concern on this score, for in early 1976 the Orlando project was suspended—along with all other contract awards—by GSA administrator Jack Eckerd (himself a native of Florida) and Public Buildings Service commissioner Nicholas Panuzio. The administrator was apparently upset by the controversy surrounding certain GSA commissions and wanted the selection procedures revised to ensure a broad range of community support for future works of art. No additional projects were to be undertaken until the new procedures were developed and approved.

In April 1976, after meeting with Administrator Eckerd and studying the GSA arts program, the NEA came up with a number of recommendations, all designed to involve local officials, civic groups, art experts, journalists, and residents in the commissioning process. Towards the end of May, Eckerd directed that the recommendations be adopted; draft after draft of revised procedures was prepared and then reviewed by Commissioner Panuzio. By July the proposed changes were being circulated for the necessary GSA clearances, but it took another eight months before the GSA order implementing them was signed. Finally, on March 25, 1977, Panuzio officially approved Naylor's selection, and the contract, previously negotiated for $30,000, went into effect. The adjacent street scene was soon to meet its match.

Not surprisingly, Naylor had serious reservations about the site. As he later wrote, ". . . it was obvious that my sculpture would have to struggle for its identity, positioned as it would be between a large block of a building and an elevated interstate highway. Anything understated or subtle would not stand a chance, in my opinion. A secondary thought was how the dere-

licts associated with a nearby bus station might treat the sculpture." With these considerations in mind, Naylor developed a maquette that he presented for GSA's review on June 8, by which time both Eckerd and Panuzio had departed the agency. The maquette was executed in stainless steel and rested on a base with a mirror representing the water of the pool. When it was approved, Naylor immediately went to work on the fabrication, completing it nearly single-handedly. His only assistance came from his students at the University of Florida. As he later noted, the contract fee would not have been adequate to cover the cost of outside fabrication.

★ ★ ★

Aritfact, as the sculpture is titled, is made of stainless steel. Describing it, Naylor wrote,

> Since I have usually used stainless steel for outdoor sculpture, it was an obvious choice for its durability, cost, etc. . . . The concept comes directly out of the nature of the material, the technique used, and the structure necessary to hold up in eighty-mile-per-hour winds. . . .
>
> The source for the aesthetic elements, if there is one that can be cited, is from ancient monuments —Neolithic, Roman, Mayan, and

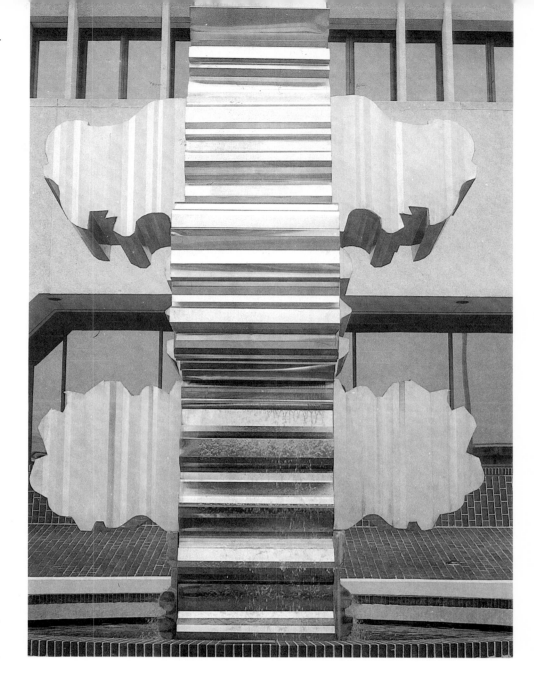

baroque. The intention is to stack up and elaborate a series of forms to which the viewer will respond. The meaning or explanation of the piece is implicit in the formal and emotional response of the viewer to the scale and complexity of the shapes, and a long intellectual explanation is unnecessary.

Explanation may have been unnecessary, but persuasion was not, for a number of residents of Orlando were less than captivated by Naylor's piece. Shortly after its installation, however, *Artifact* received a boost from an unexpected quarter when local gossip columnist Susie Hupp devoted over three hundred words of her *Sentinel Star* column (February 21, 1978) to singing its praises. Under the headline "Sculpture Still Controversial," Hupp exhorted her readers to applaud Naylor's efforts, quoting admirer after admirer: ". . . likes the effect of the ripples and sur-

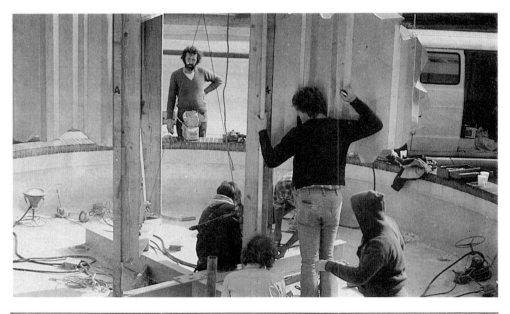

Top: Artifact, *Geoffrey Naylor's stainless-steel fountain sculpture for the federal building and U.S. courthouse in Orlando, Florida. The piece measures twenty-one feet high, twelve feet deep, and twelve feet wide; it stands in a pool twenty-one feet in diameter. It was commissioned in the spring of 1977 and installed the following February.*

Above: Naylor looks on reflectively as the installation begins.

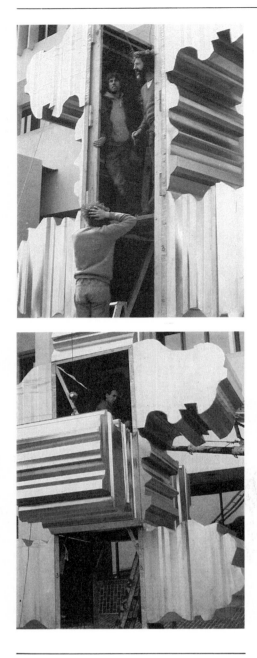

faces," ". . . has a wonderful water-like quality," ". . . marvelous reflections." Hupp concluded with a Naylor quote: "Children have less trouble accepting it than adults do."

If some Orlando citizens were having difficulty with *Artifact,* art professionals in the Southeast were not. Among the more respected, Ted Potter, director of the Southeastern Center for Contemporary Art, went on record as follows: "Geoffrey Naylor is one of the South's outstanding sculptors. Naylor's special use of water as a primary element in this particular commission is a fine example of a contemporary approach to classical outdoor sculpture." Naylor, too, was satisfied with the work. Writing for the dedication brochure,

he expressed his visions of its meaning and impact:

It is my intent that this piece have a universal, democratic appeal, as the sculpture is a public rather than a private commission. An attempt, I believe, has to be made to reach the public with sculptural values. It is my hope that this sculpture will enliven the area where it is placed, that people on the interstate will express surprise at its presence as they pass by, that at night it will glisten out its visual message. That the splatter of water, the movement of the shapes will also add a new dimension in the lives of people who come in contact with it.

Above: Artifact *during installation. Naylor and his assistants get an "insider's view" of the sculpture as they assemble its stainless-steel sections.*

Right: The installation completed. According to Naylor, his conception for Artifact *was influenced by Neolithic, Roman, Mayan, and baroque monuments. Writing for the dedication brochure, he commented on his choice of materials and its influence on the piece: "The need for durable material and for a strong visual statement sets two limitations. A third is what the material will do once the sculptor starts to manipulate it. These restrictions provide a very strict discipline, and in some ways this sculpture goes to the extremes of what the material permits. In this work, the maximum plastic effect of stainless steel (i.e., movement, change) has been used: bizarre shapes rather than standard shapes, variety of angles rather than ninety-degree angles, curves rather than straight lines."*

Opposite: Artifact *with its fountain mechanism in operation. During the day, the water reflects sunlight, imparting a burnished quality to the undulating forms.*

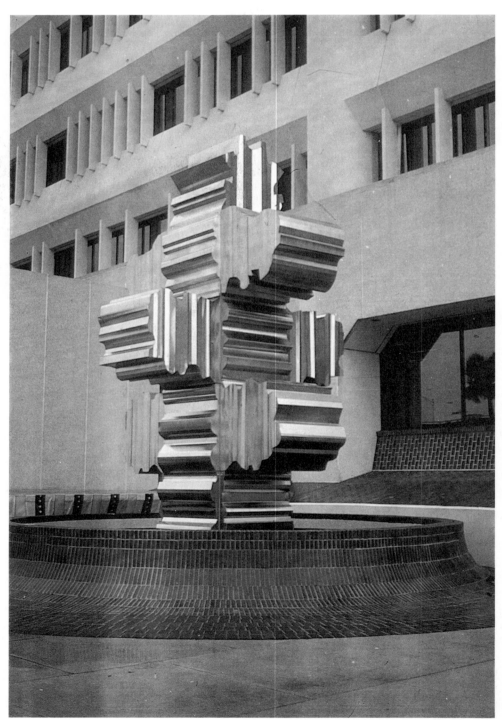

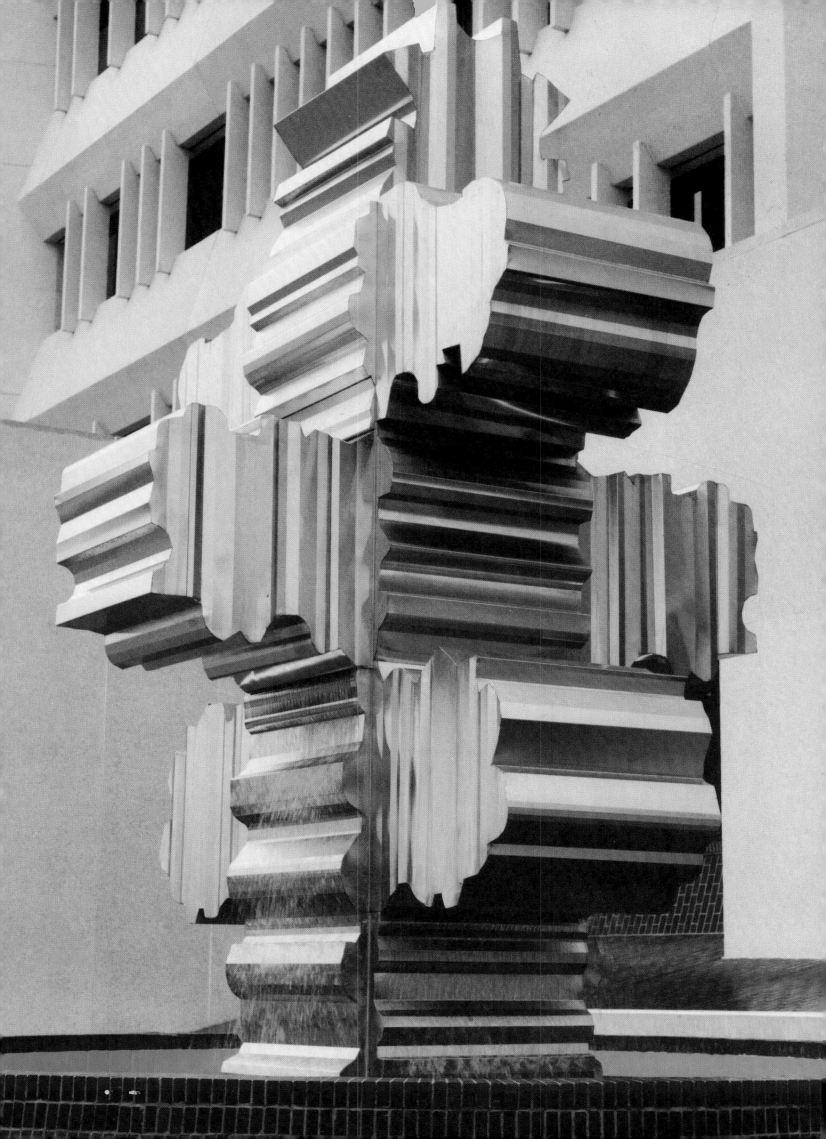

AL HELD

Before Al Held could begin the monumental task that faced him, weavers in Belgium had to complete theirs. The internationally acclaimed painter needed two continuous canvases, each measuring almost twelve hundred square feet, and the weavers worked for three months to fill his order. "I got the canvas in Belgium simply because that's the only place I could get that size canvas," said Held. "I wanted one piece; I wanted to duplicate that wall."

The wall in question was actually two walls in the lobby of the Social Security Administration's Mid-Atlantic Program Center in Philadelphia. Murals for this prominent site, which is visible through the expanse of glass on the building's first-floor facade, had been proposed by the project architect, Frank Knoble (of Deeter, Ritchey, Sippel Associates in Pittsburgh). In August 1974 an NEA-appointed panel met in Philadelphia to consider Knoble's recommendation. Panelist Dianne Vanderlip, then director of Moore College of Art in Philadelphia (now curator of contemporary art at the Denver Art Museum) quickly realized the potential of the site, and it wasn't long before Held's nomination was secure. He was selected for the commission two months later by Administrator Sampson, acting on the advice of GSA's Design Review Panel.

Held wasn't kidding when he said that he wanted to duplicate the wall. Shortly after the contract was negotiated for $126,000, he hit the pavement looking for a space large enough to accommodate both canvases in an un-broken linear extension of nearly two hundred feet. "The ideal thing would have been to paint it in the lobby, but I decided that I couldn't live in Philadelphia. I'd destroy my marriage," Held said. "So I thought that the next best thing would be to find a space in New York where I could build the walls just the way they were on the site." After three months of exploring, Held finally found a gigantic warehouse on the Brooklyn waterfront—an area familiar from his childhood days. The space was exactly the right size and had continuous windows on one side, just as in the lobby.

While the Belgian weavers labored on, Held brought carpenters to his newly leased Brooklyn studio to begin building walls identical to those at the site. Throughout he insisted on perfection—the same standard he applies to his paintings. He was determined to recreate the physical characteristics of the Philadelphia space, to mentally transport himself there. As he later wrote,

I could have done that commission here in my [Manhattan] studio by setting up separate panels, working from a large drawing, and simply rendering it. What I had in mind to do . . . was to set it up as though I was painting *there*, on the site . . . so that I could experience all the perceptual phenomena. . . .

The real trip was to decide that I wanted to paint this thing in full scale, that I wanted to paint this thing directly and not as a blowup of a small sketch or in sections.

Before long, Held was referring to the work not as "this thing" but as "that albatross."

★ ★ ★

Held presented a small sketch and a somewhat larger pencil drawing of his proposed work to GSA in May 1975. In an accompanying letter he explained that he intended to use only two colors, black and white, and listed his options: two white paintings with black lines, two black paintings with white lines, or one of each. "As it stands now, I conceive the paintings as white with black lines, as the sketches imply. But I would very much like to leave those decisions to the creative process," he concluded. The GSA panel, respecting Held's artistic judgment and seriousness of purpose, approved the proposal without cavil.

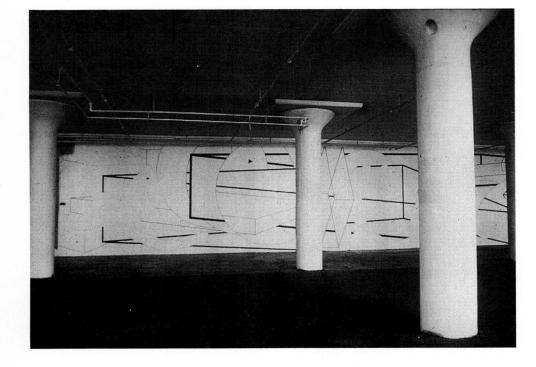

Left: One of the two murals comprising Al Held's Order / Disorder / Ascension / Descension, *in the artist's Brooklyn studio. Held rented the studio especially for this commission and built actual replicas of the site walls.*

Opposite: An exterior view of the other mural, after installation in the lobby of the Social Security Administration Mid-Atlantic Program Center in Philadelphia.

Tom Crane/GSA

Held went immediately to work, returning to the Philadelphia site from time to time during the construction of the building, which was moving swiftly to completion. By chance, he was making one of his periodic visits just as the plaster job for his walls was being inspected. Held, who had been his own construction engineer for the walls in his studio, was horrified by what he saw. "They undulate like a damn accordian!" he lamented, urging GSA to reject them. The walls were complete and in fact had just been approved—but Held doesn't give up easily. Soon GSA's Karel Yasko was en route to Philadelphia to examine the walls, which he too judged to be in "unsatisfactory condition."

Meanwhile, Held was investigating methods of mounting the mammoth murals. After several months of research and consultations with conservators, restorers, museum professionals, and countless others, he discovered that it would be inadvisable to mount the paintings directly on the walls in any case, even if the latter could be made perfect. This was so for a variety of reasons, among them the existence of a cafeteria kitchen on the other

side of the walls. The conservators fretted about the possible effect of the steam tables and the moisture that might seep through the walls, leaving Held to conclude that the proximity of the kitchen "would in five years make a mess out of the murals." Moreover, if the canvas was glued directly to the walls, it would be torn by their movement when the building settled. Held also pointed out that it would be impossible to restore the murals if they were vandalized or damaged, because "the restoration fee would be far in excess of the original cost of the mural."

Held wanted to see his work survive. "Knowing the typical life of a building, if I painted it on the wall, it would simply disappear, like most of the WPA projects," he said. Accordingly, he decided that the only solution was "to rebuild the whole wall"— neither a modest nor an inexpensive undertaking. He was willing to underwrite half of the expense if GSA would cover the other half; GSA agreed. "We started with two-by-fours bolted right through the wall, then attached three-quarter-inch plywood to the whole wall . . . 180 feet. And then we fabricated a skin of three layers of fiber glass."

The reconstruction of the walls and the mounting of the murals cost an additional $30,000, but for Held it was money well spent.

It was real growth. I still refer to that mural as a "mark." The paintings that came after it were directly affected by the experience.

I have been able since then to paint paintings that have a kind of unfolding in time . . . a kind of time release. I had to make a painting that one walked by—that one had to experience by walking through. . . . That was the central thing: the introduction of that aspect of time— real and abstract time.

I became the prototype spectator. I kept moving through that space looking at that painting, seeing what was really happening, and keeping that spectator constantly in mind. The mural got changed, and got changed again and again and again, in the process.

The murals were finally completed in the early summer of 1976, and Held threw open the doors of his studio to a throng of artists, critics, and friends. Everyone was stunned by the scale, the

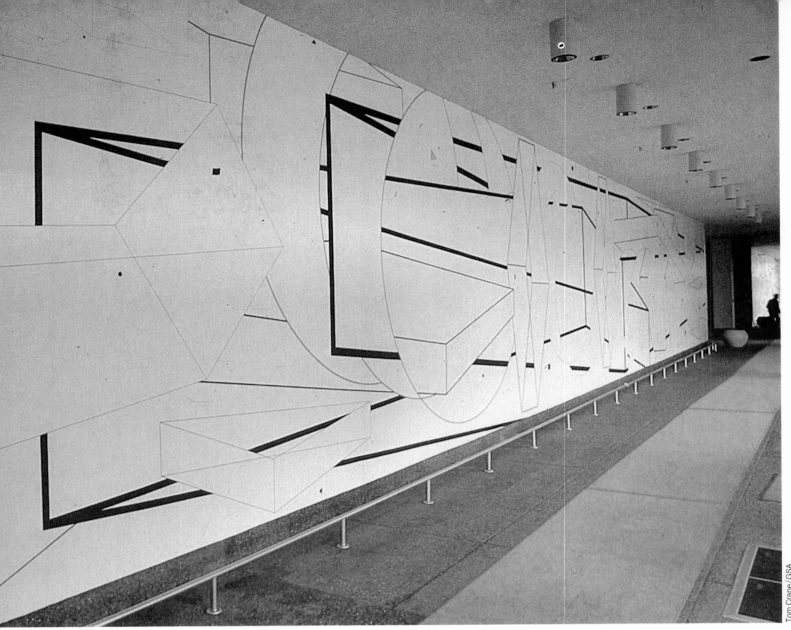

depth, the vigor, and the refinement of Held's most ambitious work to date. Hundreds of people moved back and forth in front of the murals, awed by the result of his year-long sacrifice.

Held, who was deservedly basking in critical acclaim for his achievement, still faced one final task: the installation. In March 1977, Held and a crew of eight men took the canvases to their permanent home in Philadelphia. With mixed feelings of fear and exuberance, they unrolled the paintings on the floor, established a center line along their length, and measured up and down to get a top line. Then they did the same thing to the wall. Using the two top lines, one on the back of the canvases and one on the wall, they carefully mounted the murals. "We had to follow this line and have faith that it was going to come out right at the end," said Held. "To make a long story short, we also had to do it in one shot. It was a twenty-four-hour job with eight men who worked right through the day and night.

You couldn't stop in the middle. . . . It had to *all* be done." The work proceeded flawlessly, in typical Held style.

Once the murals were up, Held trimmed the top and bottom edges, leaving a thin line between the ceiling and the wall. Minute though it was, this crack bothered Held. He considered putting a very small piece of molding at the top to seal it but rejected the idea because the mural contains lines as fine as one sixty-fourth of an inch, "so every mark becomes clear and pertinent." The line formed by the molding strip would be too prominent by contrast—"heavier than half the lines in the painting." The only acceptable solution was a painstaking one. Working with an assistant on a scaffold, Held spent three weeks obliterating the 180-foot-long crack with paste. "Three weeks up on the scaffold, filling in just that crack, then extending all the lines to the ceiling so it would be absolutely right into the ceiling and right down to the edge of the floor—and that's just one

small detail!"

★ ★ ★

Held's exacting efforts, not to mention his considerable talent and determination, produced one of the most spectacular marriages of art and architecture in the country. The otherwise straightforward building has become a showplace of sorts since the installation of *Order/Disorder/Ascension/Descension,* as the murals are called.

With the assistance of local arts groups, art schools, private citizens, city government, and corporations in Philadelphia, a day-long festival titled "Celebration: Buildings, Art and People" was held on June 6 to dedicate Held's murals and two other GSA-commissioned artworks, a mural by Charles Searles and a fountain sculpture by David von Schlegell. Amidst helium-filled balloons and the blare of trumpets, Joan Mondale joined Administrator Jay Solomon and the artists for the

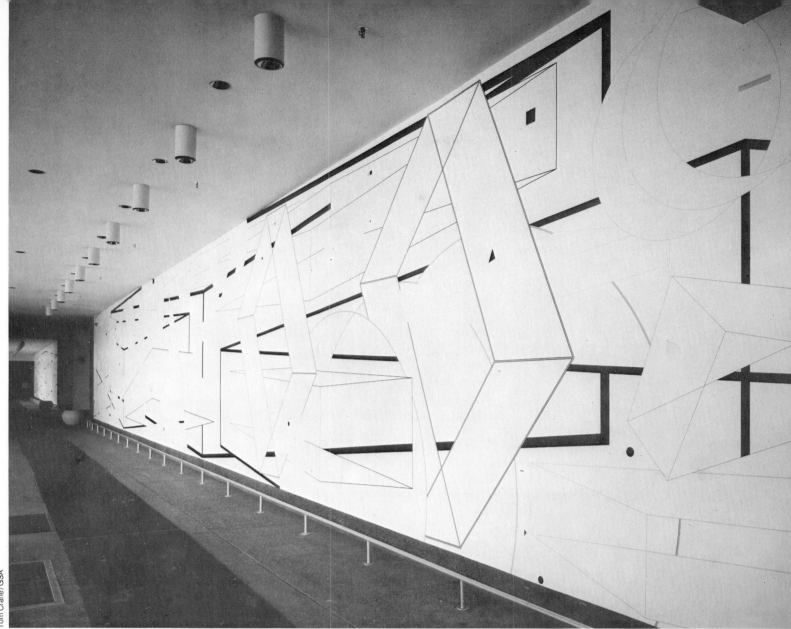

Tom Crane/GSA

occasion. In her remarks, the ever-gracious Mrs. Mondale said:

Today, thanks to the Art-in-Architecture Program of the General Services Administration, we are seeing exactly how the arts can enrich the everyday lives of all of us. One of the reasons this particular federal program is a favorite of mine is because it proves over and over again, with each new addition to our government buildings, that the people —not just the intellectuals, but all of us—can appreciate the very best in contemporary art.

"Three New Works of Distinction and Merit in City," headlined the *Philadelphia Inquirer* the following day in an article by art critic Victoria Donohoe. Clearly impressed with Held's murals, Donohoe called them "formidable but accessible paintings" and continued, "Held's art is an art of movement and change—a truly urban art that does something monumental with the rec-tangular patterns of the city. His magnificent new murals seem to float as we move back and forth in front of them —and . . . we feel we are lifted up too."

From Held's perspective, the experience was as rewarding as the task had been formidable. "It was more than worth it to me," he said. "It was a life experience." Of the GSA Art-in-Architecture Program, Held wrote, "I think it is phenomenal. . . . it's been handled beautifully in the sense that I haven't heard one hint of scandal, which is fantastic in itself. . . . it's something that's long overdue, and the timing is very good in that art in America today is at a point where the work GSA will be getting is first-rank work. And I think that is terrific!" And in one of his final letters to the contracting officer's authorized representative, Ray Jones, with whom he was in frequent contact, Held said (the albatross having evidently returned to its previous incarnation by this time), "Free, free at last. I have just finished this thing. . . . It has been fun."

Above and opposite: Two views of Order / Disorder / Ascension / Descension. *Writing for the dedication brochure, Anne d'Harnoncourt said: "Of the three commissions now being dedicated in Philadelphia [the other two being Charles Searles's mural and David von Schlegell's fountain sculpture] it seems particularly appropriate that two should be large-scale murals, a public art form not widely pursued in recent years but here taken up with energy and innovation. Al Held's vast abstract paintings make extraordinary use of perspective, and the interplay of line and apparent volume holds our interest along a building-wide corridor." The murals are indeed vast, each measuring thirteen feet high by ninety feet wide. "The manner in which the body, the mind, and the eye relate to painted forms on a flat surface has been a long-standing concern of mine," said Held. "Working on a mural of this scale and for a specific space forced heightened awareness of these perceptual problems. It is my hope that the experience of walking through, into, and around a space of this scale will also enrich the perceptions of the observer, projecting them into a state beyond the visual experience."*

LOUISE NEVELSON

©Lynn Gilbert, courtesy Pace Gallery

Louise Nevelson

My search in life has been for a new seeing, a new image, a new insight, a new consciousness. This search includes the object as well as the in-between places—the dawns and the dusks, the objective world, the heavenly spheres, the places between the land and the sea. . . . Man's creations arrest the secret images that can be found in nature.

Bicentennial Dawn is a place, an environment that exists between night and day—solid and liquid—temporal and eternal substances. It can be experienced as a monument to the past as well as the spores of the future. Contemplation is the means by which we extend our awareness. *Bicentennial Dawn* is a contemplative experience in search of awarenesses that already exist in the human mind. The inner and the outer equal one.

With this statement, Louise Nevelson summed up her artistic views and described the ninety-foot-long sculpture she had executed for the main entrance foyer of the James A. Byrne Federal Courthouse in Philadelphia.

The work was installed and dedicated in January 1976, the "dawning" of the Bicentennial (hence the title), and it brought an extraordinary outpouring of praise from the art press and politicians alike. First Lady Betty Ford, who joined Nevelson in dedicating *Bicentennial Dawn*, called it "magnificent," and even Philadelphia mayor Frank L. Rizzo was enthusiastic, exclaiming, "Beautiful, beautiful." The venerable art critic Emily Genauer declared in the *New York Post* (January 17, 1976), "I know of no single public sculpture anywhere in the country more beautiful than this newest Nevelson—and I am not excluding Picasso's steel

sculpture in Chicago, or any of the several handsome and major works by Henry Moore and Alexander Calder." In her article, Genauer also commented on the dedication, which was a dazzling production such as has seldom been attempted by GSA before or since: "For what has to have been the most exhilarating art event this week not in New York but in the whole country, I nominate the dedication . . . in the lobby of a new Philadelphia federal courthouse . . . of an enormous white-wood sculpture by Louise Nevelson."

The dedication was truly an impressive affair, and it had a dual purpose. First, it honored Nevelson and her sculpture, which in scale and complexity was her most ambitious permanent work up to that time. Second, it provided an opportunity for GSA's new administrator, Jack Eckerd, to see firsthand the art community's vigorous endorsement of *Bicentennial Dawn* and of the Art-in-Architecture Program's activities. It was crucial that Eckerd be exposed to such a dynamic display of support lest, besieged by complaints from taxpayers and congressmen about other GSA-commissioned artworks, he cancel the program.

Accordingly, all the stops were

pulled out. With community contributions, both financial and spiritual, an extravagant setting was created. The lobby became a palm garden filled with gigantic plants; uniformed waiters and waitresses served drinks and exotic hors d'oeuvres; and a forty-two piece orchestra played sonorously—in all, a most seductive atmosphere. Tuxedoes and long gowns were the prescribed dress—even Brian O'Doherty, director of NEA's Visual Arts Program, shed his customary Levis and kerchief for the evening's elegance.

Exactly on schedule, the guests moved toward the lobby area adjacent to the foyer as Nevelson, Mrs. Ford, and high officials from all levels of government appeared on the platform. Like clockwork, the ceremony proceeded with speeches carefully calculated to give credit to Nevelson *and* to encourage Jack Eckerd's support for the Art-in-Architecture Program. Betty Ford and Louise Nevelson together pulled the handle of a large ceremonial switch, and the orchestra sounded the dramatic opening notes of Strauss's *Also Sprach Zarathustra. Bicentennial Dawn*, separated from the guests by a floor-to-ceiling glass wall, was in total darkness as the music began. One by one, its

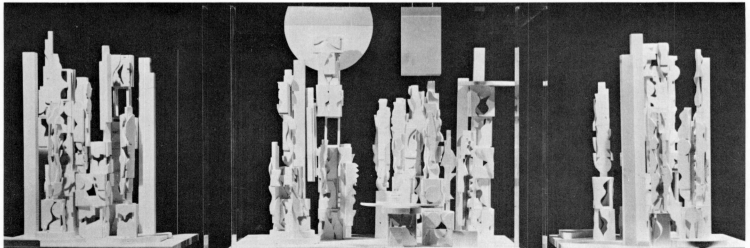

Al Mozell/Pace Gallery

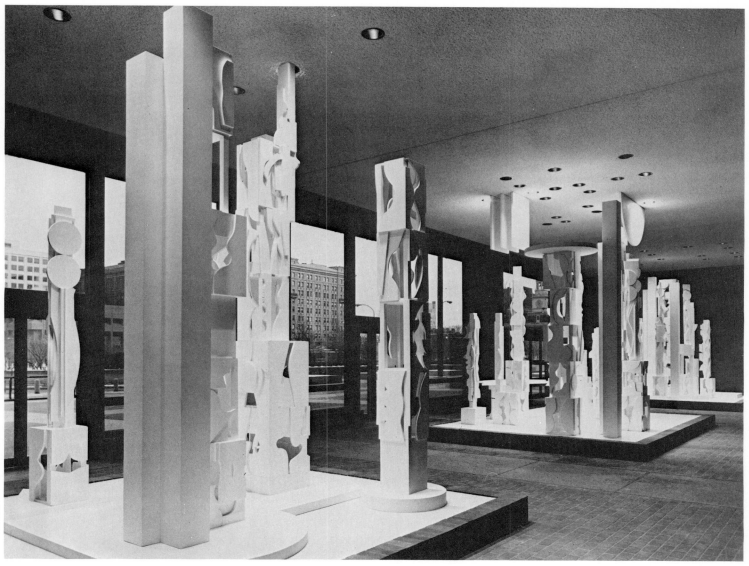

Tom Crane / GSA

Opposite: Louise Nevelson's maquette for Bicentennial Dawn—*a work of art in its own right.*

Above: Bicentennial Dawn *in the main entrance foyer of the James A. Byrne Federal Courthouse in Philadelphia. Nevelson accepted the commission in January 1975, and the work was dedicated one year later, almost to the day, at an impressive ceremony attended by government officials, art professionals, and other dignitaries. Nevelson's striking sculptural environment consists of twenty-nine painted wood columns arranged into three groupings that divide the lobby space "so that people are encompassed," as Nevelson puts it. As a whole, the work measures fifteen feet high by ninety feet long by thirty feet deep. "But for all its monumentality," wrote art critic Emily Genauer (New York Post, January 17, 1976), "*Bicentennial Dawn is shaped with unusual delicacy, even for Nevelson. It is cut away in curves and delicate hollows, the spaces between the collage-columns working with the shadows thrown by all the separate elements to make rhythms as lyrical as they are complex.... The work is totally abstract, ... its fragments of white wood attached to each other in the architectural collage which is typically Nevelson.*"*

twenty-nine columns were slowly illuminated until the entire sculpture was a blinding white. At that precise moment, the music reached a crescendo and fireworks exploded over Independence Mall in the background. The guests oohed and aahed in unison as an emotional current swept through the room.

★ ★ ★

The story behind the commission was often as dramatic as the dedication itself, although only a handful of those present knew the details. Nevelson had been nominated on September 19, 1974, by NEA-appointed panelists who, in the words of architect J. Roy Carroll (writing on behalf of the three joint-venture architects who designed the Byrne Federal Courthouse), "behaved exactly the way those who have conceived this program have intended. They were most attentive to the wishes of the architects . . . and were patient in listening to the specific proposals

we made regarding certain artists."

Nevelson was selected by Administrator Sampson on December 10, 1974, and on an inclement January 8, she donned her chinchilla-lined raincoat and was chauffered from New York City to Philadelphia in a black limousine. She inspected the proposed and alternate sites and agreed that the foyer area originally designated by the architects was the most appropriate. Afterwards, at a spirited luncheon hosted by two of the architects, Ted Bartley and Alfred Clauss, at Philadelphia's famed Bookbinders Restaurant, Nevelson reigned like the queen of sculpture she is. Then contract negotiations began, proceeding smoothly under the watchful eyes of Arnold Glimcher, Nevelson's dealer from the Pace Gallery, and Joyce Schwartz, the gallery's director of commissions.

The agreed contract fee of $175,000 represented a mere eleven hundredths of one percent of the construction cost of the building, but at least one key GSA official considered it too high. Admittedly, $175,000 is a substantial sum,

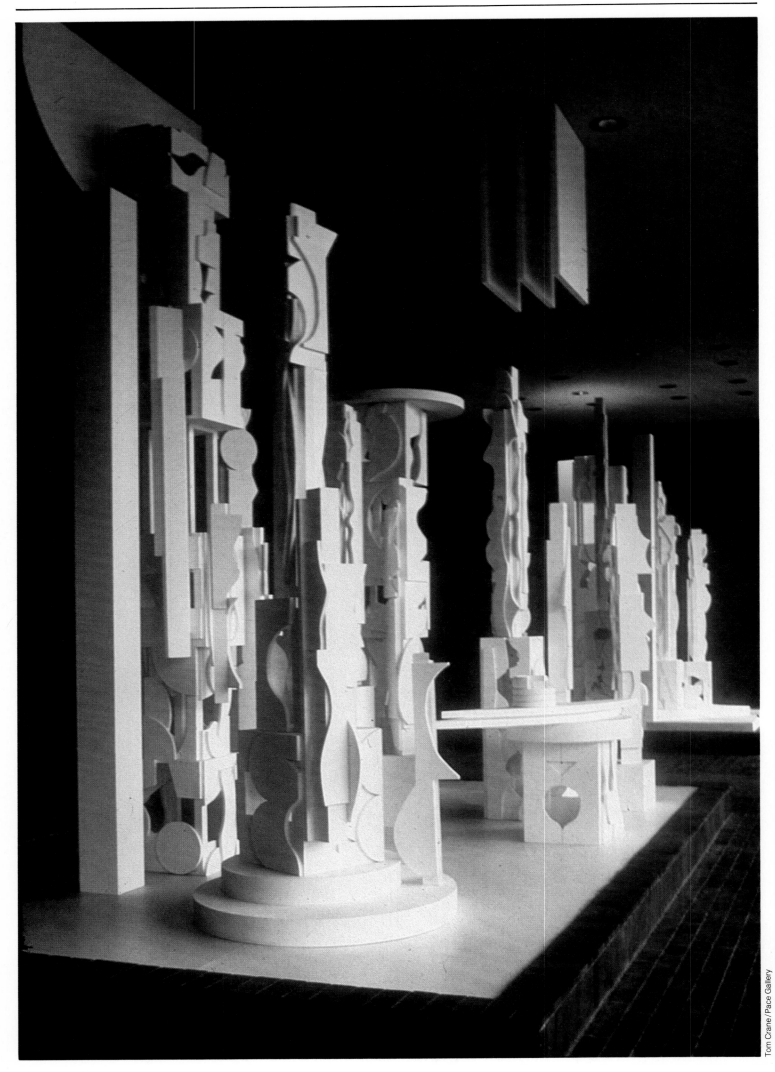

but in this case it needs a modifier—$175,000 for a work of art. If the government paid $175,000 for the Mona Lisa, everyone would regard the amount as a pittance. Moreover, since Nevelson sells her columns for $30,000 each, and since there are almost thirty columns in *Bicentennial Dawn*, simple mathematics reveals that GSA paid less than ten percent of the fair market value of the work. Finally, Nevelson was responsible for the installation, including lighting and specially designed bases using the same kind of terra cotta pavers that had been specified for the floor of the foyer. The complete sculptural environment is easily worth over a million dollars. In context, therefore, it is evident that GSA was quite thrifty with the taxpayers' money.

Four months after the contract was signed, Nevelson shipped her maquette

Two views of Bicentennial Dawn. *"Nevelson's sculptures are phantom architecture, alluding to no single time or place,"* writes Martin Friedman, director of the Walker Art Center.

(which, by the way, is itself an important and valuable work of art) to Washington, D.C., for presentation to GSA's Design Review Panel. For the occasion, the project architects shuttled in from Philadelphia, and Arnold Glimcher and Joyce Schwartz of the Pace Gallery were also on hand. The meeting began as a closed session involving only the panel members and the architects. Actually, "session" is hardly the word; "shouting match" captures the flavor of the gathering much more accurately.

With his voice rising, panelist Karel Yasko attacked the piece on several grounds: that it would be a fire hazard, that it would present a maintenance problem, that it would be an obstacle course for the handicapped—and others, for that matter—forcing them to zigzag around the work upon entering or leaving the building through the foyer. "In fact," recalled program assistant Dee Dee Brostoff, "Mr. Yasko seemed adamantly opposed to everything about the sculpture." Everyone took issue with Yasko, who focused particularly on the "obstacle

course" objection and urged that at least the sculpture bases be removed. Arnold Glimcher answered on behalf of Nevelson: "Without the base, the piece doesn't work—the base is a unifying factor. If the bases are to be removed, the entire work will have to be redone." It was an unsettling moment, but in the end the panel accepted Nevelson's design over Yasko's protestations, and the integrity of her concept was preserved; she had designed the sculpture to require the viewer's participation. "I didn't want people to come right through the doors, back and forth," she was quoted as saying (*Philadelphia Inquirer,* January 14, 1976). "I deliberately divided the spaces so that people are encompassed . . . and cannot avoid being exposed to creativity."

In the years since its installation, no one has accused *Bicentennial Dawn* of obstructing traffic. It might more appropriately be charged with obstructing justice insofar as the employees of the federal court like to linger in the foyer to admire it. Just as Nevelson intended, those who pass through the

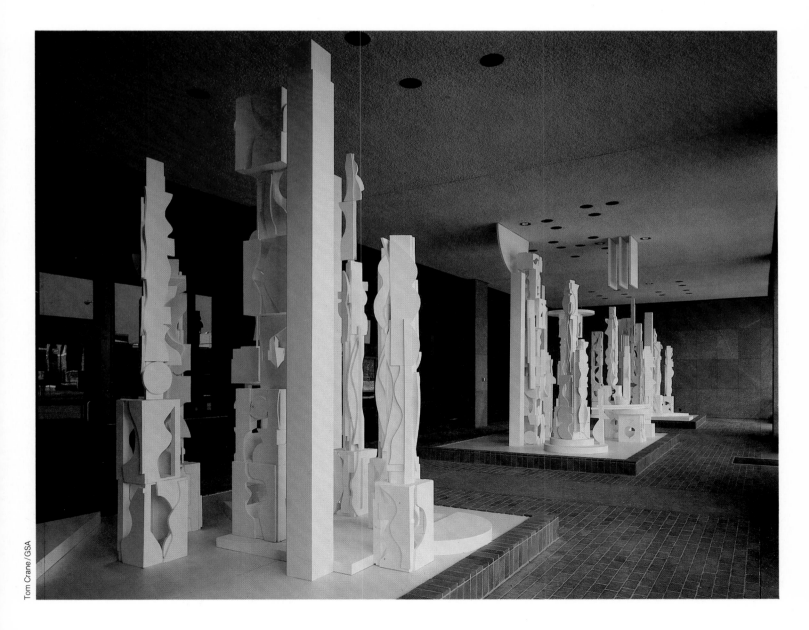

Tom Crane/GSA

building are captivated and immediately engaged by the sculpture, and most would agree that it is a close encounter of the best kind.

Reflecting on her experience with GSA in a letter to Administrator Solomon (August 23, 1977), Nevelson wrote:

The GSA Art-in-Architecture Program allowed me to fulfill one of my major ambitions—the creation of my only major interior environmental sculptures in America. . . . I am also aware that the many artists involved with your GSA program share my feeling that it is the most important project that the government has undertaken in the fine arts. . . .

. . . Meeting with the architects and engineers and visiting the site went well, but I would have preferred meeting with the architects before plans were finalized on the building. This would have allowed a greater collaboration and result. It pleased me to realize that professionalism was respected from the moment of selection through all

Above: Louise Nevelson and Betty Ford at the dedication of Bicentennial Dawn.

Below, opposite: Another view of the work, and a close-up of the central grouping.

phases of fabrication and installation.

. . . the federal government is the ideal agency to establish the highest standards in art and architecture. Commercial interests are too often hindered by narrow profit motives. The percentage designated for art in new construction, one half of one percent, is probably minimal if our country is to develop an aesthetic awareness comparable to other civilizations.

. . . I know of cases where prominent artists, rather than create a lesser artwork, and unable to bear the costs themselves, do not accept government contracts or, if they do, go into debt. Fortunately, I have lived long enough to enjoy my life as an artist, but there were many difficult years that a young artist could do without.

. . . Americans travel in huge numbers to Europe and the Far East to see centuries of aesthetic achievement; let us hope that Europeans will come to us to see the results of the GSA program.

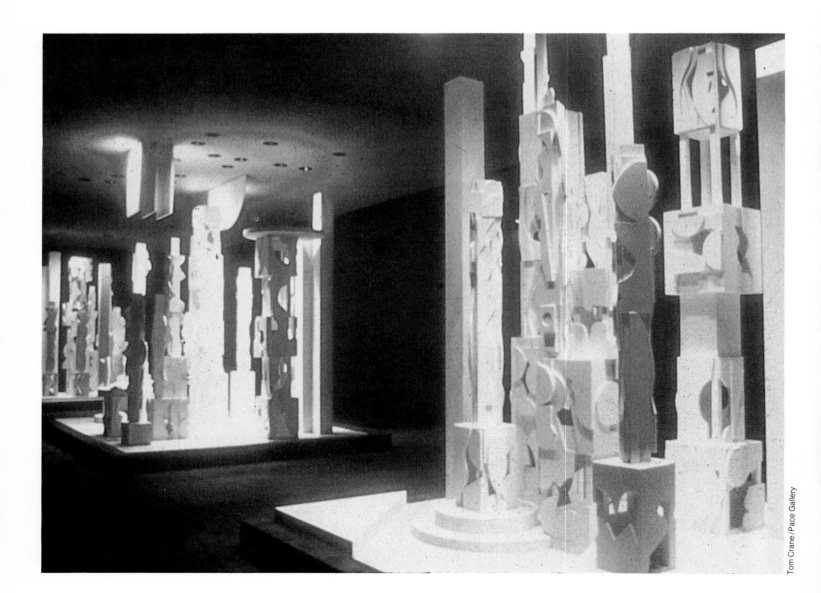

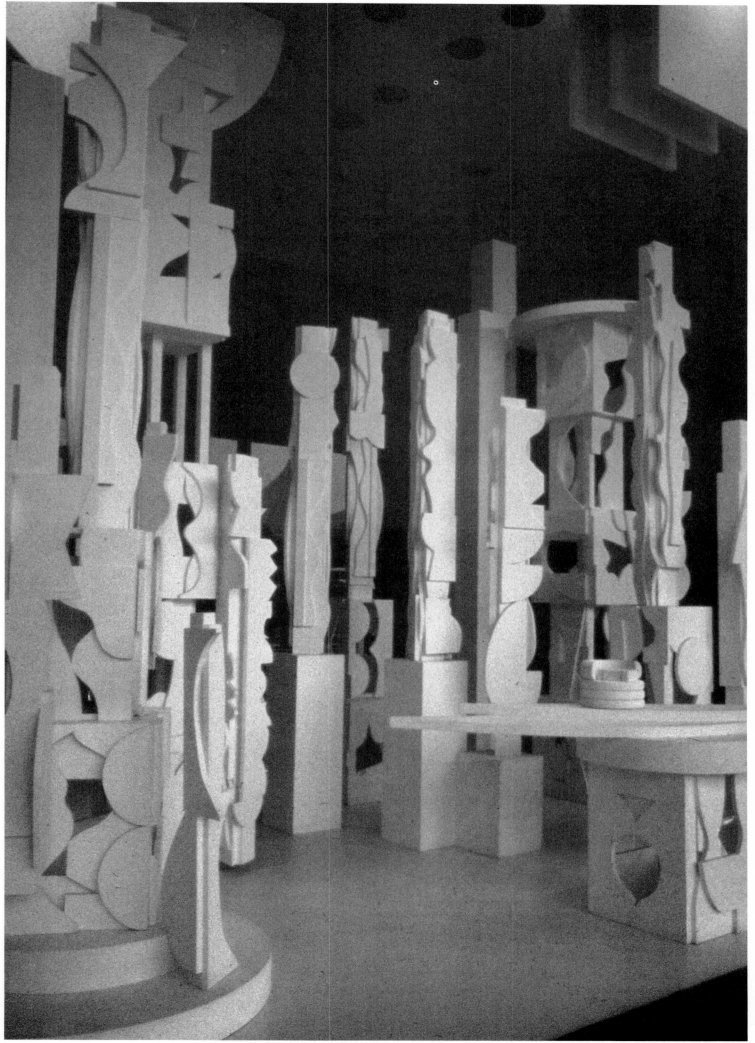

CHARLES SEARLES

The federal government rolled out the welcome mat today, and nearly 2,000 Philadelphians caught a glimpse of the city's four newest conversation pieces. Joan Mondale, wife of the Vice President of the United States, and Jay Solomon, Administrator of General Services, headed the list of federal, state, and local officials attending "Celebration: Buildings, Art and People," the dedication of three murals and a large sculpture fountain at three downtown buildings. [GSA News Release 6765, June 6, 1977]

Celebration, a mural by Charles Searles for the William J. Green, Jr., Federal Building, was among the works dedicated on this happy occasion; indeed, it inspired the theme of the festivities.

Searles was nominated for the commission in September 1974 and was selected by the GSA administrator in December. Funding for the project was uncertain, however, and Searles was not officially awarded the contract until June 1975. Within four months, he had developed his proposal and presented it to GSA. The painter was excited about his preliminary submission, and the agency responded in kind, approving it without delay. Searles later described the genesis of *Celebration*.

The first idea of *Celebration* came to me in 1970 while I was participating in a street festival in North Philadelphia. The scene was joyous. Dancers and drummers per-

formed on a portable stage while children played and adults stood around watching. The afternoon was warm and sunny, and the small, crowded street was barricaded at both ends. As I stood there watching, I had a wonderful thought. Why not do a painting of this festival event? I began taking photographs for future reference.

In 1972 I went to Africa, where my concepts grew. I did many paintings with African themes, especially street trading, and the festival idea stayed with me throughout this development.

When I was commissioned by the General Services Administration to execute a mural for the federal complex in Philadelphia, I took the opportunity to recreate the original Philadelphia festival for the city of its conception. Then, because of the joyous nature of the original event, I thought, why not call the work *Celebration*?

★ ★ ★

Searles put the finishing touches

on his mural in the spring of 1976, and it was ready for installation in June. At the time, however, administrative support for the Art-in-Architecture Program was waning. The dedication had to wait for a new GSA administrator, who arrived in the person of Jay Solomon, a strong advocate of public art. Within one month of his taking office—and one year after *Celebration* was permanently hung—the ceremony was held (in fact, seven other artworks were dedicated during the same month).

Writing for the dedication brochure, noted art historian and Philadelphia Museum of Art curator Anne d'Harnoncourt described the impact of the Searles mural and other recent installations (Al Held's murals and David von Schlegell's fountain sculpture).

With the welcome appearance of three new works of art in federal buildings in Philadelphia—following hard upon the dedication of the Louise Nevelson sculpture in 1976—the General Services Administration has once again contributed to the culture . . . of this region.

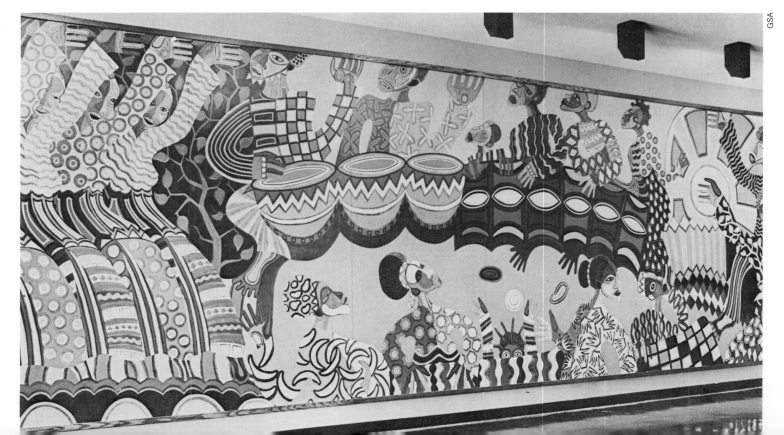

GSA

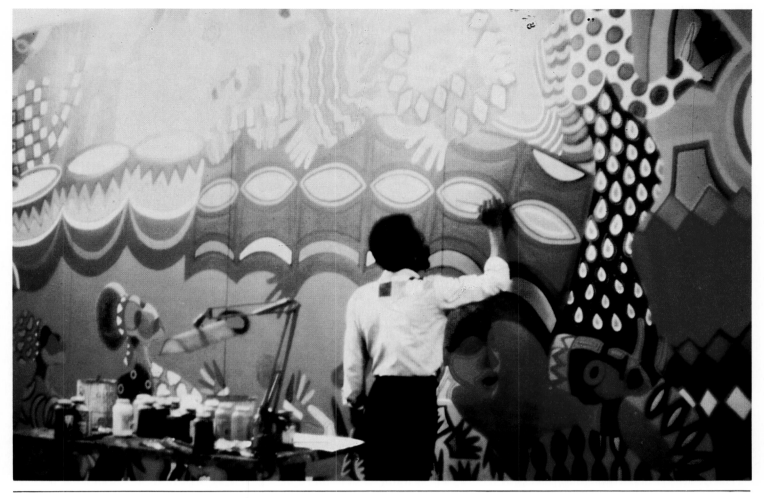

Opposite: Charles Searles's Celebration, *for Philadelphia's William J. Green, Jr., Federal Building.*

Above and below: The artist at work. Describing his mural, Searles said, "An oval composition within a rectangular format is the basic overall design. My plan was to have people visually enter the painting from either end and move their eyes across, down, and back again in an oval movement."

. . . Of the three commissions now being dedicated in Philadelphia, it seems particularly appropriate that two should be large-scale murals, a public art form not widely pursued in recent years but here taken up with energy and innovation. . . .

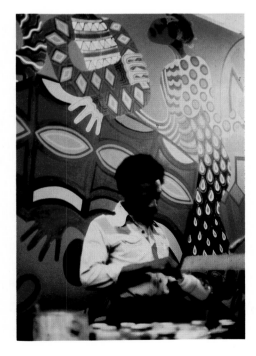

The vivid colors and interlocking patterns of Charles Searles' dancers and drummers bring a utilitarian space alive.

Searles's mural, measuring nine feet high by twenty-seven feet wide, provides a daily experience of art to the visitors and workers in the federal building; it is located in the entrance lobby to the cafeteria, thereby insuring that the noontime crowd has a recurring opportunity to study it. As Joan Mondale said in the dedication brochure, ". . . the inclusion of art in a public building extends the function of the structure beyond the mundane, bringing a spiritual satisfaction to many people who might otherwise be deprived of art in their daily lives."

Celebration has been very well received, perhaps in part due to the effort of major newspapers to inform Philadelphia residents about the artist, his work, his views, and the specific problems inherent in the commission. One such article, Nels Nelson's column in the *Philadelphia Daily News* ("Searles: Portrait of an Artist," August 3, 1976),

traced the artist's professional career as it has paralleled his personal life. Nelson pointed out that after his year-long effort, Searles was left with only a few thousand dollars out of the $30,000 commission. Nevertheless, he reported, ". . . the work that Searles regards as the culmination of his life in art up to now is *Celebration.*"

In March 1978, Searles wrote to Administrator Solomon, offering comments on the program and on his participation in it. He said that he "found the working relationship to be very good." He suggested that sketches and other developmental material for GSA commissions should remain the property of the artist to offset financial loss during the lengthy execution period, which would otherwise be spent in the more profitable activity of creating smaller works. Money aside (as it usually is for artists who undertake government commissions), Searles found his GSA experience rewarding and concluded, "Mr. Solomon, I want to thank you and GSA for the wonderful opportunity and challenge that I had with the commission."

DAVID VON SCHLEGELL

Less than two weeks after David von Schlegell was officially notified of his selection for a fountain sculpture commission on the plaza of the new federal building and courthouse in Philadelphia, he wrote from his home in Guilford, Connecticut, "My dealers and my family are saying, 'Don't spend it all—make some money this time.' Well, that's not the point. The point is that this contract allows me to make a piece with *no* compromises, for once. I can and will make the very *best* possible sculpture. . . . I am going to Philadelphia next week, but already ideas are forming, and I feel good about the possibilities. . . . Maybe the piece will be so obviously good that even the congenital complainers and idiots will stay off your backs."

★ ★ ★

The formal announcement of von Schlegell's selection was a long time coming due to uncertainty about funds for the project, which come from the construction budget. Nominated by NEA-appointed panelists and the building's architects (from the joint-venture firms of J. Roy Carroll, Jr., and Partners/Bartley, Long, Mirenda and Reynolds/Bellante, Clauss, Miller and Noland) in September 1974, and selected by the GSA administrator in December, von Schlegell did not receive a contract until the following June, when the final fiscal-year tabulations indicated that the money was available. (As usual, funding for art projects is the last to be allocated—and the first to be cut when budgets are tight.) With only days left in the fiscal year, the go-

ahead was given, and the contract was awarded with lightning speed.

By September 1975, von Schlegell was ready to present his proposal. An utter perfectionist, he arrived in Washington, D.C., with renderings of the fountain sculpture showing its relationship to the site, along with a meticulously crafted maquette in stainless steel, the material to be used in the finished piece. As is always the case with his work, von Schlegell had developed the concept in relationship to the site. As he later said,

> . . . My intention is to heighten the experience of the whole place . . . so the object mediates between the person and the place and isn't just a thing, an end in itself.
>
> I started going to Philadelphia. . . . It seemed to me that basically what was called for was something fairly small, because there's no point in trying to deal with those buildings through scale. [We needed] something that would come down and be more to the scale of the people in the plaza, [and] something with a lot of diagonal lines to counteract the verticality of the building. And it seemed to me we needed a brightness, because it's a very dark place . . . something dramatic—quite dramatic.

The sculpture itself had to be a centering device. . . .

So, with all those things flowing through my mind, somehow I came up with this form, and the water entered into it—and the water became actually a formal element in the sculpture. . . .

However, in the wintertime, when you can't have water—because it freezes—I also wanted a piece of sculpture that would . . . stand up by itself, without the water. So it was a very complicated problem. All those things went through my head as I was trying to come up with a conception. Once the conception was arrived at, it was simply an engineering problem from there on.

The only flaw in this admirable description of the conceptual process was the characterization of its translation into reality as "*simply* an engineering problem." The problem was far from simple, as von Schlegell later acknowledged. In fact, the construction and installation of the piece took more than a year. "We had to call in hydraulic engineers . . . we had to do a great deal of experimenting. . . . I had an idea of what I wanted the water to look like, so we started from there. [Something] I'd seen water do that seemed quite interesting to me was the way it flows over the top of a dam. It's very thin—a translucent sheet. So we tried to achieve that in one part of the sculpture. And in the other part, we tried to get something that was more exciting . . . to achieve the feeling that you get when the bow-wave of a boat cuts through . . . the ocean. We did that by throwing water against a curved plane—three strong jets of water. Again, we had to experiment a good deal, and it came out as we'd hoped it would."

The piece was fabricated at the Lippincott company in North Haven, Connecticut. Since he teaches at Yale, in nearby New Haven, von Schlegell was able to keep constant watch over

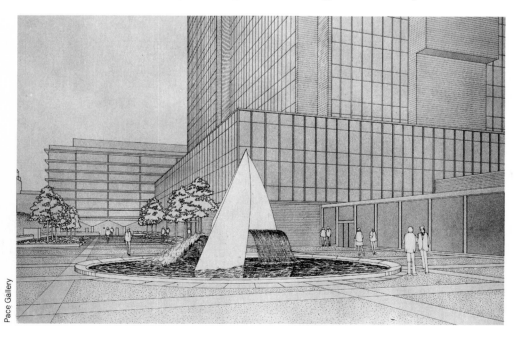

Pace Gallery

A line rendering of Voyage of Ulysses, *submitted as part of von Schlegell's proposal.*

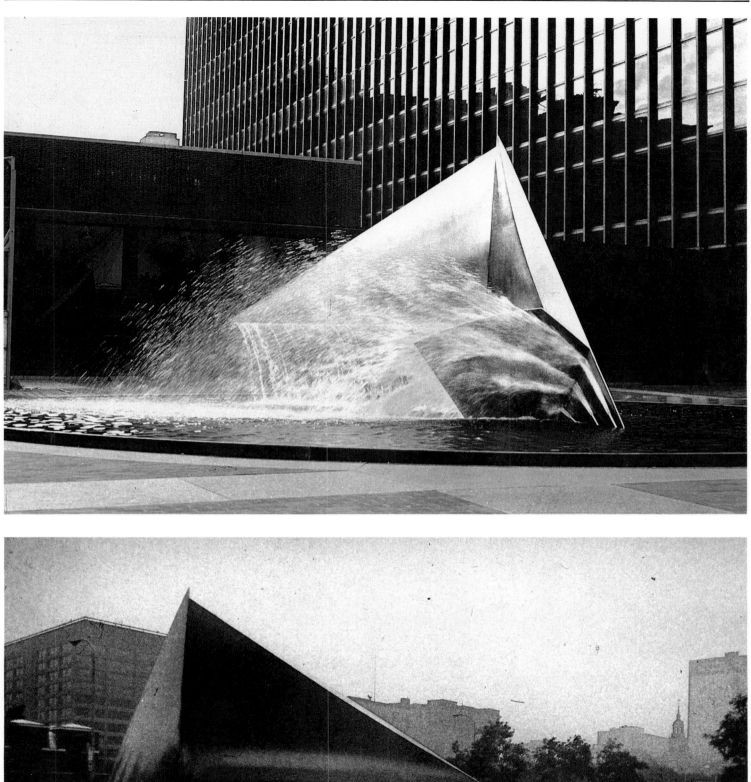

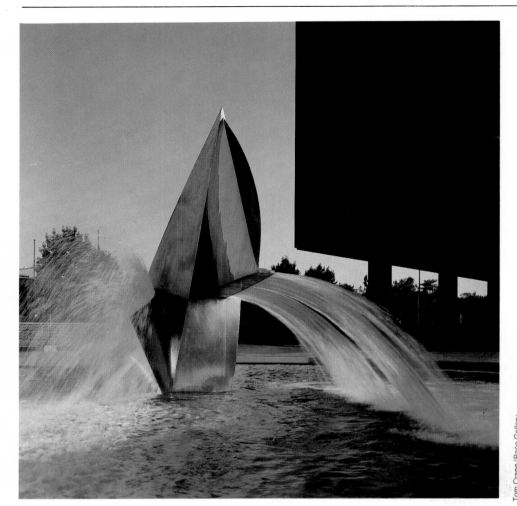

Voyage of Ulysses, *David von Schlegell's stainless-steel fountain sculpture for the plaza of the federal building and U.S. courthouse in Philadelphia. The piece measures sixteen feet high by twenty-eight feet four inches wide by six and a half feet deep and stands in a pool sixty feet in diameter.* "In naming this sculpture Voyage of Ulysses, *I am thinking of great emotions and events recalled much later and in tranquility,*" *wrote von Schlegell.* "Time—its essence and flow—becomes fused with the story of that great voyage. In the sculpture there is a duality of stillness and motion. The quiet object and the steady flow of water becomes a metaphor for the Odyssey as charted by Homer and seen by us as a glowing symbol of man's driving toward the unknown—a universal force basic to the later exploratory drive . . . that resulted in the discovery of a new world."

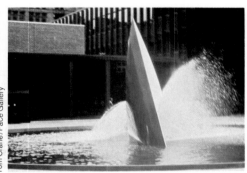

Tom Crane/Pace Gallery

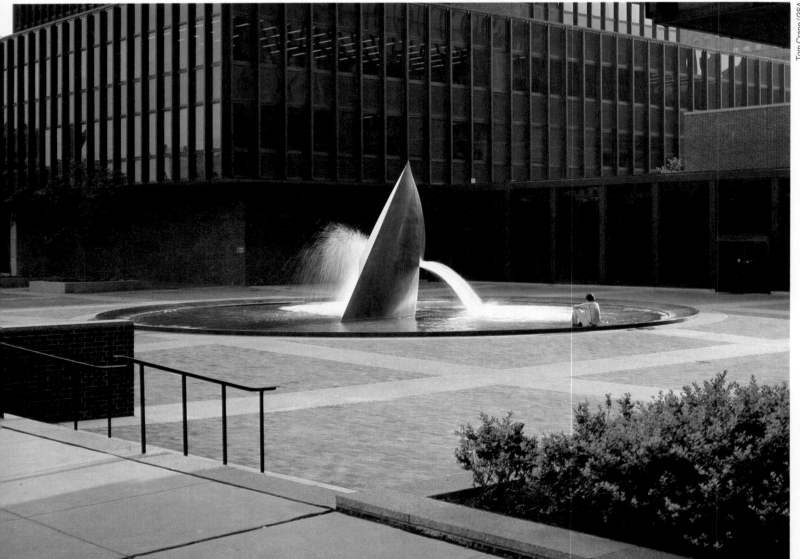

Tom Crane/GSA

the process. His insistence on perfection was fully shared by the small and sensitive crew at Lippincott, where, with Don Lippincott at the helm, perfection is just barely good enough. Their painstaking efforts paid great artistic dividends, though the complexity and duration of the fabrication left von Schlegell without a dime of profit. As he later observed, "All sorts of people made their living making that sculpture: metalworkers, engineers, plumbers, electricians, hydraulic engineers, the companies that produced the materials—[the money] went into the economy."

★ ★ ★

Voyage of Ulysses was dedicated by Joan Mondale and Jay Solomon on June 6, 1977. Despite the constant threat of rain, media coverage was extensive, and helium balloons filled the skies as the ceremonial switch was thrown to activate the water. Mrs. Mondale, "a friend of the arts in rain or shine" (*Philadelphia Inquirer*, June 7, 1977), captivated the press with her sincere enthusiasm. "The arts, in all their manifestations, offer us the quality we so much desire," she said. Administrator Solomon concurred. "We are a wealthy nation," he said, "and part of that wealth can be measured by our contributions to the arts. In a country as rich and creative as ours, it's appropriate that we set aside part of that wealth to finance fine arts projects. I hope that the success of our program will encourage others—private industry and state and local governments—to fund similar art-in-architecture programs." The *Philadelphia Daily News* headlined its story of the dedication "2d Lady Exhibits Art of Diplomacy," and Sarah Booth Conroy, the *Washington Post*'s distinguished critic, wrote approvingly, "David von Schlegell's *Voyage of Ulysses* . . . is the fourth recent major art work for Philadelphia from the GSA art-in-architecture program."

Explaining the title of the work, von Schlegell wrote for the dedication brochure, "The voyage of Ulysses is a great event from the deep past. But history is part of our present. And the still image (vaguely heroic and nautical), surrounded by water continually flowing just as time flows, can form a metaphor for the continuing presence of the past—of this ancient voyage—in the present." Like Penelope when her legendary sailor returned at last, the

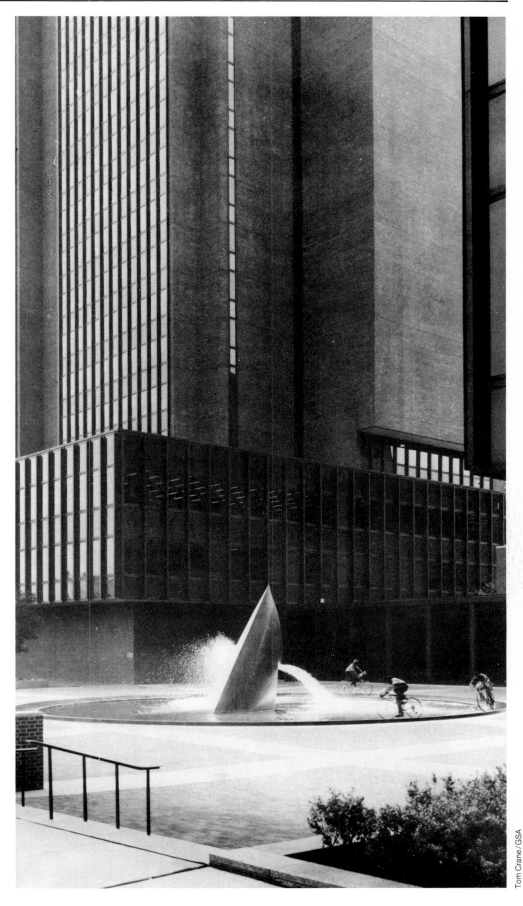

Tom Crane/GSA

people of Philadelphia have embraced von Schlegell's sculpture with open arms. It has become part of their landscape. As von Schlegell himself said of the installed work, "Imagine this place without the sculpture . . . and see the difference. See how the place *has* changed now that the sculpture is here."

"A public sculpture should be an unprecedented object, new and surprising," says von Schlegell. *"It should enhance and become one with its site while remaining within the historical context of older sculpture. The quality 'presence' . . . underlies formal invention and suggests meaning. Through formal spareness, abstract sculpture can attain this presence, intuitively sensed by the viewer."*

JACK YOUNGERMAN

Some years ago, Jack Youngerman was asked by architect Gordon Bunshaft, of Skidmore, Owings and Merrill in New York, to create a large painting for one of the firm's projects. Youngerman worked out his design and showed it to Bunshaft, who said that he was very disappointed. According to Youngerman, "He felt that it wasn't a good idea to commission works from artists, that one should just buy one of the artist's works that fits the space. I asked him why, and he said, referring to my design—and in general —that artists became uptight when they had a commission and frequently produced works that were not up to their best. . . . I don't think he's right." Neither did GSA.

In October 1974, an NEA-appointed panel nominated Youngerman to design a tapestry for the Portland Federal Building—which, ironically, was also designed by Skidmore, Owings and Merrill. Youngerman, who has executed a number of important commissions, is highly regarded by art professionals. He is known primarily as a painter, but in recent years he has also been working as a sculptor. Initially he was not very enthusiastic about the proposed tapestry—"Why not a painting?" he asked. In addition, he was swamped with work when the commission was offered to him in the spring of 1975. He nonetheless decided to accept the job, and the contract was negotiated for a fee of $33,000.

Youngerman had been involved with tapestries before, notably working with Gloria F. Ross, a successful artist in her own right. In fact, one of her first commissions had been to translate a Youngerman design into a tapestry for another Skidmore, Owings and Merrill building in Chicago. Gene Baro, former *Washington Post* art critic, once described her tapestries as "unexcelled for fidelity to the spirit and letter of the models" (*Washington Post,* February 8, 1972)—an assessment with which Youngerman agreed. "I think Gloria is very conscientious and faithful to the original design," he said. Youngerman and Ross decided to collaborate again on the Portland project.

By November 1975, prior commitments and interruptions notwithstanding, the design was well on its way to completion, and Youngerman was pleased. "The tapestry will be a jewel in your crown," he wrote GSA. On January 21, 1976, Youngerman and Ross presented their proposal to GSA in Washington, D.C. The design—a

swirling central shape in chrome yellow, set against a rich blue background and surrounded by whirling shapes in vermilion red, with green shapes at the corners—was to be fabricated in wool and would measure fourteen feet square. It was titled *Rumi's Dance.*

Youngerman had been intrigued with Rumi, a thirteenth-century Persian poet and mystic, since the mid-1950s. At that time, during a trip to the Middle East, he had been given a small volume of Rumi's quatrains, or four-line poems, translated into English. "They remain my favorite poetry," says Youngerman.

> They are very limpid, beautiful, sensual-mystical. . . . They're about ecstatic states, either drug-induced or erotically induced or induced by the dance.
>
> Rumi was the founder of the Whirling Dervishes. When the Dervishes dance, the group of dancers always represents Rumi. He's the one who takes the center, and the other dancers turn around him— slowly, as a matter of fact, not rapidly like everyone thinks—wearing these extraordinary bell-shaped

skirts that come out as they turn. . . . They turn around and around, turning on themselves and then turning on this central figure—the guru, if you wish—like the planets around the sun.

This tapestry design—with a large, predominant, bright shape in the middle, surrounded by turning shapes—for me relates to the Dervish dance pattern, and that's basically the reason for the name.

★ ★ ★

By June 1976, Gloria Ross had translated Youngerman's design into a lush, intricately woven, woolen reality. Spread out on the floor of Youngerman's New York loft for GSA's inspection, the tapestry was the very embodiment of vibrant color. "Come, sit on it!" Jack and Gloria said, slipping off their shoes and sinking into the thick pile. Unthinkable, thought I, but to see the tapestry is to want to feel it, and before long I had joined them. Even today, it's hard to forget the sensation.

Rumi's Dance was shipped to Portland for installation almost immediate-

Opposite: Rumi's Dance, *a wool tapestry designed by Jack Youngerman and woven by Gloria Ross.*

Above (left to right): Joyce Schwartz of the Pace Gallery, Don Thalacker, Gloria Ross, and Jack Youngerman give Rumi's Dance *a final inspection in Youngerman's New York loft.*

ly after final approval, and GSA wasted no time in issuing an enthusiastic press release about the colorful work. Youngerman was also happy: "The tapestry installation in Portland went very well, and it's beautiful! (Everyone agrees, I think.)" He was right. GSA, in this case highly vulnerable to the charge of woolgathering in the federal bureaucracy, received few complaints about *Rumi's Dance,* which was praised by the public and art professionals alike.

After the work had been installed, Youngerman spoke further about it:

... there wasn't too much space in front of it, which is one reason I have quite a bit of detail.... you can see it from outside.... At night you can see it from two blocks away, and it's quite effective as you pass by the building—in a car, even.

If an artist has enough time to develop the work, then it's to everyone's benefit. I feel I did have enough time with the tapestry, and I'm completely satisfied with it. If I had ten more years, it wouldn't have been any better.

In retrospect, he was even glad that it had been a tapestry commission. "You start with something that you don't like, and then it forces you into things you wouldn't have done otherwise," he said.

As for the experience of working on a commission for the federal government, Youngerman summed up his feelings in a handwritten note to Administrator Solomon (August 24, 1977): "There was a *very* good relationship with the government.... The contract terms, etc., were generally satisfactory. I hope the program will (continue to?) use imagination in seeking out artists. Good artists need only an opportunity to show what they can do."

DIMITRI HADZI

Though it is the unwritten policy of GSA's Art-in-Architecture Program to award only one commission per artist, three artists have received two commissions apiece. In each case, the first commission was awarded during the 1962–66 era, when artists were nominated by the project architect, and the second came after the 1972 reactivation of the program, when nominations were made by NEA-appointed panels.

Dimitri Hadzi stands alone, however, as the only artist to receive two major commissions. His first work, a bronze exterior sculpture in front of the JFK Federal Building in Boston, was commissioned at a fee of $66,000 and completed in 1968 (the other two artists, Philip McCracken and Harold Balazs, received their first commissions for substantially less—$2,500 and $6,000 respectively). Hadzi's second work, a carved basalt sculpture, was created for the east terrace of the federal building in Portland, Oregon, at a contract fee of $65,000. It is one of two works fulfilling the architect's art-in-architecture proposal (the other is a tapestry designed by Jack Youngerman for the lobby).

Hadzi became interested in basalt in 1974 when, as a participant in an international sculpture symposium in Eugene, Oregon, he used it to create a large work, with the help of young apprentices. Selected for the Portland commission in the spring of 1975, Hadzi decided to use the native Oregonian rock again. "I felt there is so much sculpture in Cor-ten steel or bronze that stone would be a welcome change," he said.

About one year later, in April 1976, Hadzi sent a wax maquette to Washington, D.C., for GSA's inspection. The Design Review Panel approved the proposal, although a memo in the Portland file records the reaction of program assistant Dee Dee Brostoff as follows: "At this juncture, Dee Dee wishes to go on record as saying, 'Frankly, to me, this piece is disturbingly phallic.'" Hadzi had a somewhat different interpretation of the work's symbolism (though not necessarily a contradictory one—when told of Brostoff's response, he said he was glad that someone, at least, got the message): "[On] a geological trip to the Columbia River Gorge . . . the natural formations, the wilderness, and . . . the memory of the exploratory spirit of adventurers such as Lewis and Clark inspired me to express man's power over nature in his expansion over, and taming of, the wilderness," he wrote to Regional Fine Arts Officer Earl Morris. In another letter to GSA, he amplified upon his inspiration: "I was particularly interested in the Legend of the Bridge, which gave me, I believe, the 'archlike' image of the final sculpture."

★ ★ ★

River Legend, as the work was titled, experienced a number of metamorphoses before emerging in its completed form. As Hadzi described the process later, it was first a wax maquette about two inches high, then a ten-inch model, also in wax (the one the Design Review Panel received). As a three-foot plaster model, it was shipped from Hadzi's East Coast studio to Oregon, where it was further modified. In Oregon, *River Legend* finally achieved its actual size, though it was still made of plaster. With this model, Hadzi ironed out the remaining problems in the design, using it to "visualize the scale and to pick the final blocks of basalt, as well as to determine the angle of joining the blocks. We were relieved and delighted when the engineer who checked it out reported that it could not be improved upon!"

With another small wax model as their final guide, Hadzi and his assistants did most of the work of carving and fitting in Eugene, Oregon. *River Legend* was then dismantled and shipped to Portland in August 1976 to be reassembled at the site. There, the pieces were put together with pins and joints, and the sculpture, which at last could be seen as a monolith, was ready—literally—for the "finishing" touches. It was ground and polished, and "the rough chisel-point surfaces were made to contrast with the velvety smooth hand-polished surfaces." Hadzi described the last stages of the installation as follows:

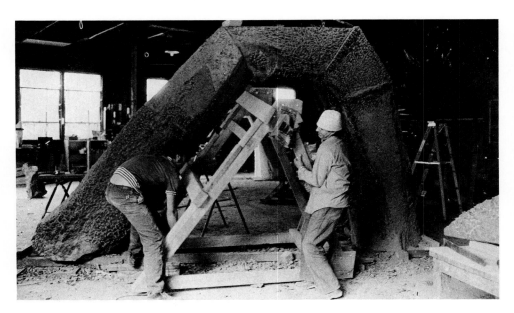

For the final ten days or so the public watched and participated. Indeed, a great deal of support was gained from the onlookers, and the public was particularly fascinated that the local stone, which was usually seen as gravel and building material, could be transformed and worked in such a way as to be used effectively as an art expression.

This is where I feel the work was successful in uniting art with the environment. The sculpture brought together a happy mingling of local material in the form of Oregonian basalt, the participatory interest of the public as the work was being brought to completion on the site, and the active participation of some half-dozen dedicated young people (whose efforts I recognized by having them carve their initials by my name). Finally, the very theme was inspired by the nature and landforms of the state for which the sculpture was created.

Not only did *River Legend* have several incarnations, but it also spawned numerous progeny. During the construction and carving, Hadzi saved a considerable quantity of basalt chips, thinking that he "might 'recycle' them somehow." He eventually created fifty small sculpture "sketches" by carving and polishing the chips, which he donated to Harvard University's Carpenter Center for the Visual Arts. They sold out on opening night.

★ ★ ★

River Legend is ten feet high by thirteen feet wide and weighs slightly more than seven tons. Evidently its associations are not only Freudian and/ or nature-derived, but economic as well. Writing for an exhibition catalogue accompanying a showing of Hadzi's recent sculptures at the Gruenebaum Gallery in New York (September 9– October 7, 1978), Professor Albert E. Elsen of Stanford University's art history department said, "Polishing old stone into new life for *River Legend* Hadzi equates with the work he did as a kid shining old shoes during the Depression, bringing their shapes 'back to life.'"

Opposite, left: Dimitri Hadzi oversees the quarrying of the basalt used in River Legend, *which came from Bond Butte, Oregon.*

Opposite, right: River Legend *during fabrication, partially carved and assembled.*

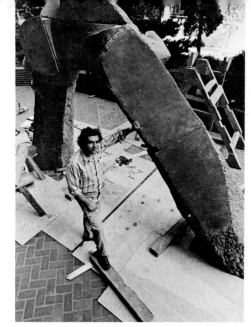

Left: Hadzi and River Legend *during the sculpture's installation on the east plaza of the Portland Federal Building.*

Bottom: Using a crane, workmen carefully lower one of River Legend's *heavy basalt sections into place.*

Below: River Legend *after installation and final polishing. The sculpture's surface, alternately rough and smooth, presents an intriguing visual and tactile contrast. "Hadzi's sculpture pays tribute to the great beauty of the environment through the use of natural materials like basalt. This is especially appropriate in the Pacific Northwest, which is so often associated with the outdoors," said Commissioner Nicholas A. Panuzio of GSA's Public Buildings Service.*

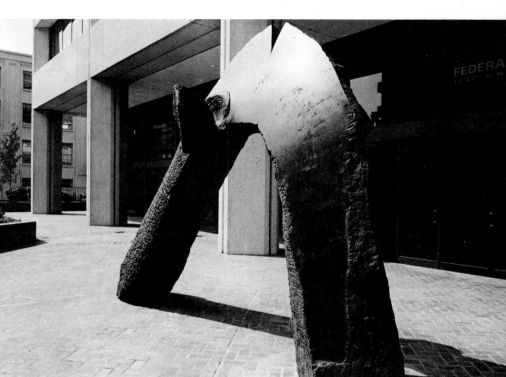

GSA

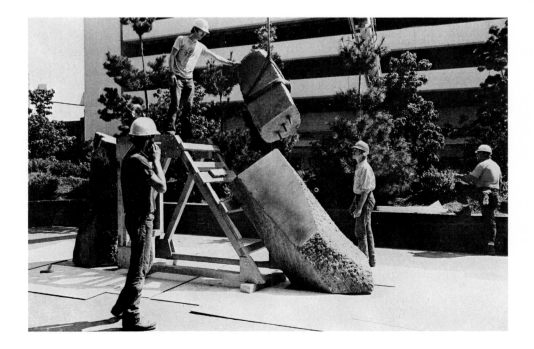

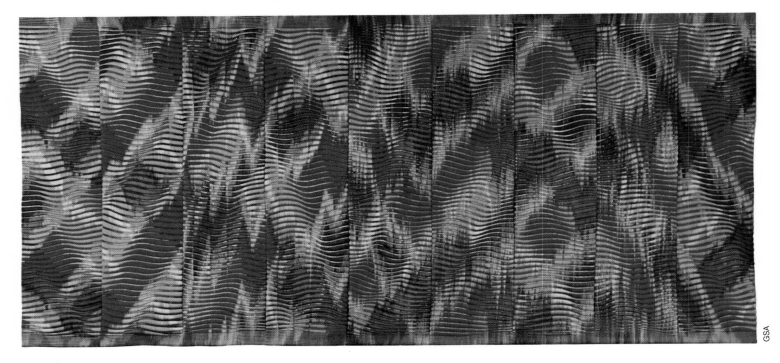

GSA

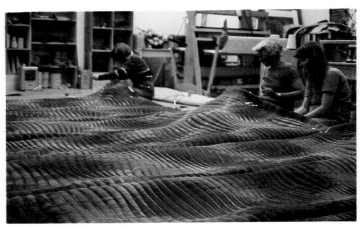

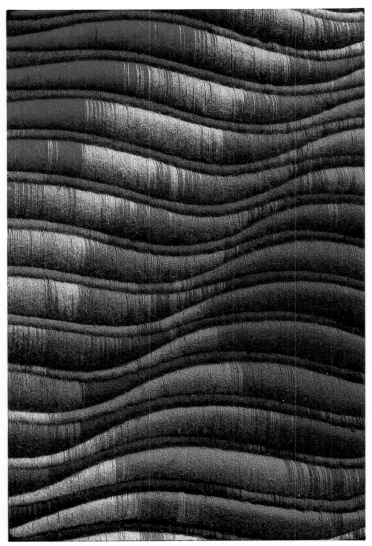

Top: Lia Cook's Spacial Ikat III, *in the lobby of the Social Security Administration Western Program Center in Richmond, California. The tapestry measures nine feet high by twenty feet long.*

Left: One of the tapestry's nine panels on the loom.

Above left: Spacial Ikat III *nears completion. After weaving, the panels were bound together and finished by hand.*

Above: A detail of Spacial Ikat III.

LIA COOK

Architect Robert D. Peterson knew whereof he spoke when he submitted the name of Lia Cook to an NEA-appointed panel considering commissions for the new Social Security Administration (SSA) Western Program Center in Richmond, California. Peterson had been introduced to Cook's work by Louise Allrich, one of the most knowledgeable dealers in the field of textile arts. Allrich, in turn, first became aware of Cook's fine constructivist tapestries in 1973, when one was featured in the Sixth Biennale Internationale de la Tapisserie in Lausanne, Switzerland—the world's most prestigious tapestry exhibition. Subsequently, Cook's work appeared in the Seventh and Eighth Biennales, and she has also received several NEA grants and fellowships. Her tapestries have been exhibited in highly respected museums and galleries both in the United States and abroad.

Writing on behalf of Pereira/Bentley/Tudor in San Francisco, the architectural firm that designed the building, Peterson said,

> [Cook's] work exemplifies constant progress toward dimensional weaving both in a technical and optical sense, well suited owing to its dense, exposed warp face to public exposure. [Her] work currently in progress would be most effective in a "corridor" location, changing in aspect as people see it at various angles when passing. [Letter to GSA, January 15, 1975]

The NEA panelists agreed, and Cook was officially nominated in May 1975. She was recommended for the commission by GSA's Design Review Panel, and Administrator Sampson selected her in late summer. Contacted by phone immediately thereafter, Cook expressed her pleasure at receiving a GSA commission.

Contract negotiations were held in San Francisco in November, after Cook had visited the site in Richmond. She was not particularly happy with the contract fee, which was ultimately negotiated at $27,000. Because of the complex labor involved in her work, and in light of the prices she was getting on the established market, she felt it should be considerably higher. Nonetheless, her overall reaction was a favorable one.

> The contract negotiations were professionally handled. I feel that I received most of the items that were important to me (i.e., time to complete the work and payment schedules) except the price, and I was able to modify the work to make the price reasonable. There was no flexibility in the structure or format of the contract itself, and I later learned that the contract only provided protection for the U.S. government and not for the artist. In any case, at the time of the negotiations I felt very positive about the process.

★ ★ ★

Cook developed her proposal and submitted it in the summer of 1976, along with a description of her working method. "The planning of the color and the setting up of the loom before construction begins is a very intricate process," she noted, explaining that the tapestry would be woven on the loom in panels, then bound together by hand to produce the effect of a relief. The warp yarn, imported English wool, would be custom-dyed to Cook's specifications using the "space-dyeing" technique (so called because the yarn changes color at intervals). The weft would be much more heterogeneous, including "wool, jute, cotton, and polyurethane foam (meets the federal fire safety regulation F.A.R. 25.853)."

The GSA panelists were duly impressed and gave their unanimous approval to Cook's concept. Cook was also impressed and later wrote, "Producing the proposal was exciting in that the artist had complete freedom to design what she felt best for the space. This sense of confidence in the artist's judgment is truly a supportive and professional attitude."

No sooner had Cook received the go-ahead than disaster struck. According to the legislation that enabled construction of the building and funded the fine arts commissions associated with it, all work had to be completed by December 31, 1976. The staff of the Art-in-Architecture Program had been unaware of this stipulation and was as stunned to learn of it as was Lia Cook. Such a situation had never arisen before—nor has it since. "My biggest disappointment was that the working time was unexpectedly and unilaterally shortened from a full year, leaving only a few months to complete a large-scale piece," Cook wrote. "[The] shortened deadline raised costs considerably. No compensation was provided. My schedule was disrupted, and this action on the part of the government gave me the impression that it was not serious about its commitment to provide good artwork and to support the artist in getting the job done."

By dint of a heroic effort, Cook completed the work on time. Titled *Spacial Ikat III*, it is optically dazzling, executed to perfection in yarns so sensuous that the impulse to touch the undulating forms is all but irresistible. Apparently the building employees agreed, for they greeted the work with enthusiasm and even helped with the installation. "It is always very exciting to see a piece installed in its space in a building. I felt that my piece worked well, and although most of the public employees were unfamiliar with my art form, they began to respond immediately," Cook wrote.

The lasting value of any commission is, of course, the artwork itself. Significant works, such as Lia Cook's, originate with their creator—and GSA by and large honors this fact. Despite the problems associated with her commission, Cook recognized this aspect of the Art-in-Architecture Program and stressed its importance. "I feel that the strongest part of the [program] is the freedom of design allowed the artist. I feel that this point of view will ultimately produce the best-quality work," she said in summing up her experience.

RICHARD HUNT

Reynolds Metal Company

Richard Hunt [signature]

"Four major artworks will be installed by the end of December at the new Social Security Administration (SSA) building in Richmond, California. As part of the U.S. General Services Administration's Art-in-Architecture Program, Richard Hunt created a sculpture for the courtyard. . . ." So began a GSA news release issued on December 7, 1976. A few weeks later, Ted Reid, a GSA architect and regional fine arts officer from the San Francisco office, wrote GSA's Washington, D.C., office as follows:

> Just to let you know that our fine arts are all installed in the Richmond Social Security Payment Center and, in my estimation, are an unqualified success.
>
> Richard Hunt's work, in particular, is a revelation. I was least convinced of his conceptual submittal. But it is hard to imagine a form more appropriate to the space. The scale and patina of *Richmond Cycle* are striking.
>
> My hat off to those of you who were perceptive enough to identify with and have faith in a talent.

Reid had had the rewarding experience of developing an appreciation for an artwork that he initially viewed with skepticism. And, as events unfolded, it became apparent that Reid wasn't alone in his uncertainty.

★ ★ ★

In October 1974, three NEA-appointed panelists met with architect Robert D. Peterson (of Pereira/Bentley/Tudor) to nominate artists for commissions fulfilling the architect's fine arts proposal for the Richmond building. The panelists nominated Hunt, among others, for two proposed sculpture commissions, but they thought that the tapestries Peterson had suggested would not be economically feasible within a total budget of $135,000. They advised that photomurals be commissioned instead. Peterson seemed to accept their judgment at the time, but he later researched the costs of tapestries and fiber works, concluding that the budget was indeed adequate. In a January letter to all the panelists and GSA, Peterson reiterated his recommendation for tapestries as part of the total proposal. The panelists then agreed upon appropriate fiber artists, and GSA received the complete list of nominations in May 1975.

The final selection of artists was further delayed when GSA's Design Review Panel met shortly thereafter, recommending Hunt but rejecting Peterson's proposal for two sculptures because, in their opinion, the site for the second sculpture was not suitable. Upon hearing the news, Peterson wrote GSA, enclosing slides of the proposed site and requesting that the panel review its decision. Reconvening in August, the panelists considered the matter and, in a formal memo dated August 12, reaffirmed their initial conclusion as to the wisdom of "deleting the proposed site location."

At last the Design Review Panel's recommendations could be forwarded to Administrator Sampson, who selected Hunt and three fiber artists on August 21. Hunt was notified by a telephone call to his Chicago studio, and he later recalled the conversation. "I felt again those contradictory feelings I usually have when awarded an important commission. Happy to be chosen, deserving and all that, but concerned, worried—will it be all I and they hope it will be?"

Contract negotiations with all the artists were held in San Francisco during the first week in November. Hunt agreed to a fee of $70,000 and took the complex clauses in stride; he'd visited the site, liked what he saw, and was ready to go.

> . . . I was very impressed with the building and felt that the site provided me a great opportunity to work out some sculptural ideas I had been toying with for some time. I was anxious to sign on the dotted line and get started.
>
> I saw the sculpture as a means to recall something of the landscape and sense of place of the area. The open-walled patio allowed me to think about a scale that was large enough to have a presence but rather intimate and approachable at the same time.

Hunt presented his maquette to the Design Review Panel in June 1976. The Art-in-Architecture staff was a bit nervous, considering the apparent lack of support within the agency for the program's operations (among other things, Sugarman had been told to stop work on his controversial Baltimore sculpture, and GSA had refused to dedicate Segal's *Restaurant*, assuming the Buffalo residents wouldn't appreciate the sculpture, and therefore not wishing to call attention to it). At the request of Administrator Eckerd, his special assistant, Robert T. Griffin, had prepared a report (dated May 10, 1976) recommending sweeping changes in the program, such as "non-art type representation" on the artist nominating panels, a philosophical shift from viewing the integration of art and architecture as desirable to incorporating art only "when appropriate" ("Advantage: This option will significantly reduce the number of projects requiring fine arts and its attendant adverse criticism"), contributions from the local community to help fund the artworks, a reduction in the fine arts budget allowance, and so on. In all, the climate hardly seemed favorable.

Hunt, too, was nervous, but for entirely different reasons. The idea of presenting his concept to the GSA panel made him uneasy, for he feared that it might bind him to a preliminary formulation and prevent him from modifying his design later.

> . . . the model is not a completed sculptural idea that only remains to be blown up, but an indication of the direction the sculptural process will take. The basics are there in the scale model—material, height, width, etc., but my working method implies fleshing out and detailing

Richard Hunt's Richmond Cycle, *which spans some fifty-feet and is ten feet ten inches high by eight feet nine inches deep.*

the work more fully as I go.

At the meeting many of the questions assumed that the sculpture was completed before it was started. For my part I felt it was necessary to assure the GSA that I knew where I was going with the sculpture even though the model could not show every step of the way.

I suppose they received enough assurance, because they gave me the go-ahead.

Because of the timing of Hunt's submission—at the height of GSA preoccupation with negative community response to artworks—"enough assurance" meant a good deal more assurance than usual. Before Hunt received the official green light, architect Peterson was contacted to find out if the artwork was *really* necessary. Yes, he replied in a letter dated June 14: ". . . the sculpture seems even more necessary now after having experienced the space. The geometry of the building, the people flow from the cafeteria and overflow from the auditorium, forms a key focal point for experiencing Richard Hunt's work."

Photographs of the maquette were sent to the three NEA panelists for their inspection, and all endorsed it vigorously. "I think the curvilinear forms of the sculpture will comprise a pleasing complement to the hard-edge exterior of that building. Certainly the piece represents Hunt's work at its best, and will be a more than fitting addition to the environment of Northern California," wrote Brenda Richardson, curator

of painting and sculpture for the Baltimore Museum of Art. "This letter is in support and confirmation of the sculpture by Richard Hunt. . . . The piece . . . will, I think, provide an interesting visual break for the interior courtyard," said Jan Butterfield, art critic and contributing editor of *Arts* magazine. Perhaps the strongest statement came from William C. Agee, director of the Museum of Fine Arts in Houston:

I have looked at the photograph carefully, and based on long knowledge of Mr. Hunt's work, it appears that he may have produced one of his very finest achievements as an artist. It has a weight and authority, as well as a grace and movement, that will be a superb enhancement of the Richmond building. It seems to me that the piece is something that everyone can be proud of, and is a great credit to all concerned. I couldn't be more pleased.

With the architect's affirmation that the work was necessary, a report from the structural engineers stating that the sculpture's weight could be safely supported by the plaza, and the endorsements of the NEA panelists, the Design Review Panel granted its approval.

Hunt began fabricating the work in the summer of 1976. "Construction . . . went rather well," he wrote. "The problems were at the beginning and the end. First the large sheets of bronze had to be ordered direct from the mill, and delivery took forever. Then, halfway through the construction period, I got

a hurry-up from GSA. They wanted the sculpture in place before the end of the year instead of the March following." The "hurry-up" Hunt received arose from a situation that affected all the artists commissioned for the Richmond project: all work had to be completed and installed by December 31, when the funding would "collapse." Unfortunately and inexplicably, this stipulation had not been made known to the Art-in-Architecture Program staff until the end of July 1976. Needless to say, Hunt wasn't pleased. As he later recalled, the accelerated pace "caused me a few gray hairs and resulted in a good deal of overtime for my helpers, but we got the work finished and installed in time for Christmas."

The installation of the sculpture was probably as easy as anything about the project. I had worked out the design with the architect and the engineers so that the sculpture could be set in place without anchors that might have disturbed the plaza, which was also a roof. The biggest job was for the crane operator and his helper, who had to rig and set the pieces very carefully. It was a long way up and over [the walls surrounding the plaza] from the street to the site.

Hunt titled his work *Richmond Cycle*. Administrative jitters notwithstanding, it was well received by art professionals and the public alike. It is indeed, as Ted Reid wrote after his final inspection, "an unqualified success."

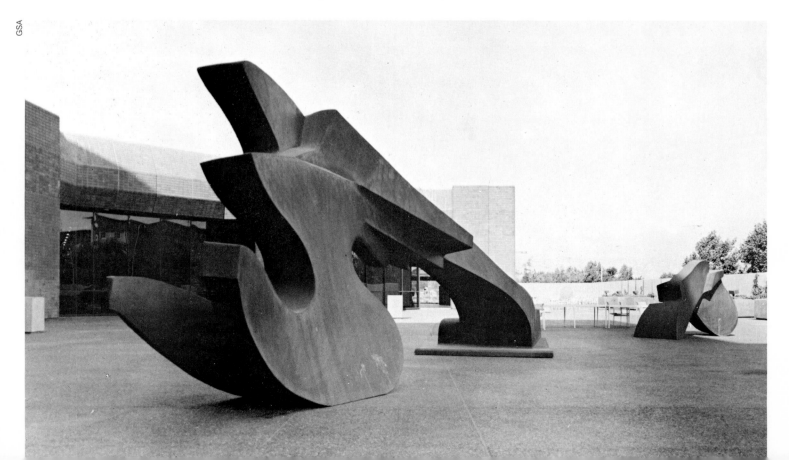

GSA

JANET KUEMMERLEIN

Visitors entering the main lobby of the Social Security Administration (SSA) Western Program Center in Richmond, California, are immediately confronted by a guard to ascertain whether they have proper credentials or are on official business. Since the center houses the machinery and records for SSA operations in the West, the tight security is understandable, if regrettable. Happily, a large and colorful fiber relief sculpture by Janet Kuemmerlein is visible even to those who are denied access to the building; her thirty-foot-wide, five-foot-high, ten-inch-deep work is mounted on the wall facing the glass entrance doors and therefore can be seen from the outside.

Kuemmerlein, who lives in Kansas, has received a number of commissions from banks, corporations, schools, and churches throughout the country. Her work has been exhibited in New York, San Diego, and points in between (including the Chicago Art Institute, the Sheldon Memorial Gallery in Lincoln, Nebraska, and the Dallas Museum of Fine Art), as well as in international exhibitions. In the spring of 1975, Kuemmerlein was nominated for the Richmond commission by NEA-appointed panelists and the design architect for the project, Robert D. Peterson (of Pereira/Bentley/Tudor), following a protracted search for and evaluation of fiber artists. The following summer, GSA's Design Review Panel recommended that Kuemmerlein execute one of three proposed fiber works. Administrator Sampson approved the panel's recommendation, and the contract was sealed in November after a marathon week of negotiations with Kuemmerlein and the other artists selected for commissions associated with the SSA building.

The Richmond project was GSA's second effort to incorporate textile arts into the design of a federal facility (the first was in Honolulu with Hawaiian fiber artists). For the NEA panelists and for program administrators from NEA and GSA, the experience was an educational one, particularly as concerns the cost of large-scale fiber works. Some panelists thought that commissioning major textile works was prohibitively expensive—in the range of the $1,000 per square foot associated with the Aubusson weavings in France; others believed that large-scale works (pieces measuring approximately two hundred square feet) could be made for $15,000 or less. In fact, such works often cost considerably more than $100 per square foot—and considerably less than an Aubusson tapestry.

Even Janet Kuemmerlein, with years of experience creating architecturally scaled works, was surprised—and disappointed—at the overall expense of designing, executing, and installing her GSA-commissioned work. "I am still aglow from my week in San Francisco," she wrote on November 8, 1975, following the negotiation of her contract for a fee of $18,000. "I am planning, as I'm sure the others are, to do the finest piece ever." After completing the piece, however, she lamented, "More time should be allowed the artists to determine the costs of the project and to negotiate from a more knowledgeable position, because it was a very expensive [piece] for me to produce—and when I realized it, I was already locked into a price."

Kuemmerlein submitted her proposal on June 30, 1976, in the form of a large color rendering and photographs of detail work, accompanied by a brief written description of her intended materials and methods:

The technique used shall be machine- and hand-stitched and braided yarn, fabric, and manila rope wrapped with wool yarn, to

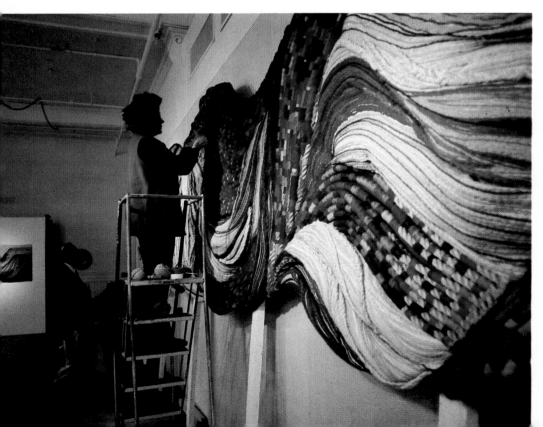

Right: Odyssey, *Janet Kuemmerlein's free-form fiber relief sculpture.*

Left and opposite, top: The artist at work.

Above: A detail of Odyssey. *Wrapped manila rope and stitched padded areas combine to create the undulating surface of the vibrant work, which mixes neutral earth tones with colors modulating from yellow, gold, and green to red, purple, and blue.*

be stuffed with fiberfill and mounted against five-eighths-inch plywood. This will be divided into five sections and fitted with metal brackets . . . suitable for mounting. The sections will stand approximately ten inches from the wall.

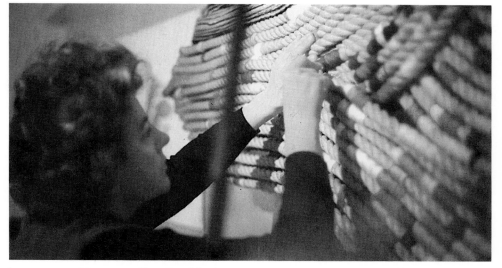

Although Kuemmerlein's proposal was approved, her work—along with all other projects then in progress—was undergoing evaluation by the commissioner of the Public Buildings Service. The commissioner and other GSA officials, responding to critics in Congress (and, no doubt, to their own uncertainty about the aesthetic value and/or appropriateness of some GSA-commissioned works), wanted a complete review of the Art-in-Architecture Program. In the meantime, most of the program's activities were in a state of suspended animation. For example, the commissioner had recently ordered a halt to George Sugarman's work for the federal building and U.S. courthouse in Baltimore due to complaints from the federal judges who would be working there. Everybody was nervous. All new projects for which artists had not yet been chosen were being held in abeyance while new selection procedures were developed, and the architects for ongoing projects were contacted to find out if proposed artworks were "really necessary and desirable." In the case of the Richmond building, as in every other case, the architects responded affirmatively.

Thus, Kuemmerlein began to make her proposal into a reality. By this time, however, the period allotted for the completion of all the Richmond artworks had been reduced by approximately three months. Unbeknownst to the staff of the Art-in-Architecture Program, the project had a funding "collapse" date that would go into effect in less than six months. If the work was not finished by December 31, 1976, the funds would no longer be available. Although this unexpected deadline caused "some strain and additional expenses" for Kuemmerlein, her piece was ready for installation in December, as required.

Kuemmerlein, who titled the work *Odyssey*, describes it as follows:

It is designed to move the observer's eye along from vivid color changes to neutral areas of stitched and wrapped fiber, thus depicting a journey or adventure through which one passes as in the case of the classic tale *The Odyssey.* . . . It enhances the environment by engaging the viewer in visual and intellectual participation in an aesthetic journey.

Assessing her experience with the Art-in-Architecture Program, Kuemmerlein wrote Administrator Solomon on March 5, 1978. "I found my relationship with everyone involved in the project to be cordial and enjoyable. They were all very helpful and considerate. . . . In conclusion, I found the project personally gratifying . . . but financially devastating." Shortly thereafter, in response to an article in *Art Voices/South* magazine (March–April 1978) that touched upon artists' desire to create major works even when the financial rewards are limited, Kuemmerlein wrote, ". . . it was very funny to me to read about the many artists who overproduce. I guess it is an occupational hazard. We are a funny bunch."

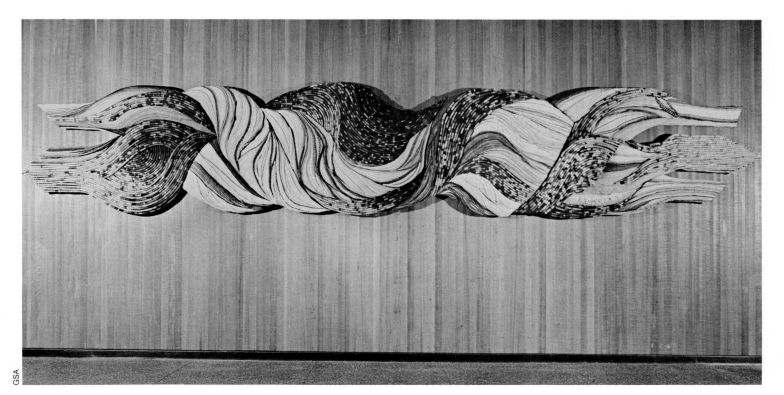

GYÖNGY LAKY

"The General Services Administration's Fine Arts Program is progressing spectacularly. The world of art is becoming increasingly aware of—and pleased with—your successes," wrote Nancy Hanks, chairman of the National Endowment for the Arts, to GSA administrator Arthur Sampson in the spring of 1975. Working cooperatively, GSA and NEA were attempting to set an example for other organizations interested in expanding the role of the nation's visual artists beyond museum walls.

Hanks's reference to the program's successes came in a letter transmitting the names of artists nominated by an NEA-appointed panel for commissions associated with the Social Security Administration (SSA) Western Program Center in Richmond, California. In October 1974, the panelists met with architect Robert D. Peterson to consider the tapestries, fiberworks, and sculpture

he had proposed on behalf of Pereira/ Bentley/Tudor in San Francisco (the joint-venture firm that designed the building). Outlining the suggested fine arts commissions, Peterson wrote,

> The building interiors have been developed using native and natural materials, which provide a fabric of warmth to compliment the exterior finishes. It is here we propose the use of large, intense tapestries designed to interact with the background [redwood] paneling. These tapestries should have positive and negative forms that relate to one another and reflect the geometry of the building.

Initially, the panelists doubted that adequate funds were available for all the artworks Peterson wanted—three large-scale tapestries and two exterior sculptures. They advanced photomurals as an alternative, should tapestries prove economically unrealistic.

Investigating the matter, however, Peterson and others found that tapestries and fiberworks were indeed feasible within the allotted budget.

In the course of his research, Peterson encountered the work of a number of America's leading textile artists, many of whom are clustered in the San Francisco Bay Area. In particular, he met Gyöngy ("Ginger") Laky, artist, instructor, lecturer in the textile arts, and founder and director of Fiberworks, a school of textile arts in Berkeley, California. Peterson was impressed with Laky's work and took her on a tour of the building while it was still in its early stages of construction in late 1974. She later wrote him about her impressions of the building and her thoughts on the possibility of a fiberwork:

> The building is exciting and very sensitively designed for human beings—a rare thing. I feel as if I know the building . . . from your enthusiasm in describing the details, movement of space, colors,

Gyöngy Laky's Inner Glyphs Out, *a fiber sculpture measuring ten feet high by twenty-five feet wide. The piece consists of richly colored, plaited, loom-woven tubes. It shows the influence of Laky's eight-month stay in India, where, in her words, "mirrors and metallic threads are incorporated into walls as well as textiles to use the magic of moving reflected light. I included in the piece occasional metallic threads to bring that magic to being indoors in Richmond, California."*

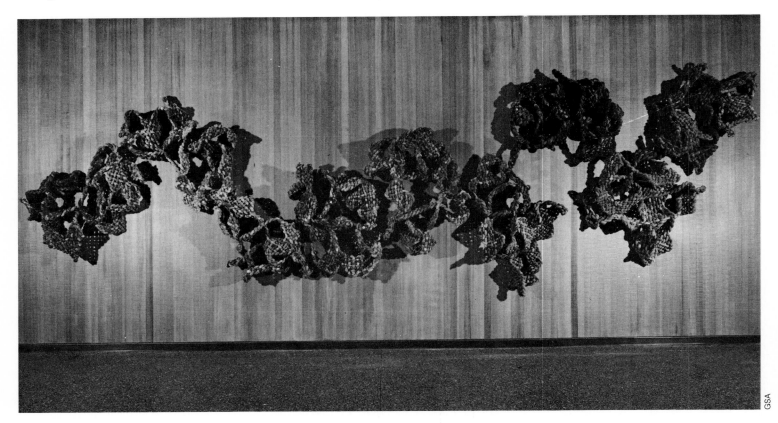

and textures. . . .

After giving some thought to the textile project, I feel a good approach might be something composed of parts—modular in a sense —so that color might be varied in each part and so that construction of the whole could be varied. . . . I think the spaces and the building can take strong color and mixed colors.

After receiving the NEA panel's nominations, Administrator Sampson approved Laky's selection for the Richmond commission on the recommendation of GSA's Design Review Panel. She was notified by telephone and later wrote, "I must say it was a surprise since my first visit with the architect, Robert Peterson, took place almost a year ago. The building at that time looked very good. I will enjoy working with that particular environment." The contract was negotiated in the autumn of 1975 for a fee of $20,000. Laky developed her concept during the spring and early summer of 1976; in July she presented it to the Design Review Panel, which quickly approved it.

★　★　★

Laky's "textile wall sculpture," as she termed it, was designed to "enhance the experience of passing through . . . the lobby—[to] change and move as the viewer passed, yet . . . have integrity and be inspiring if one stopped to view the whole work." Reflecting on the development of the piece, she elaborated further upon her objectives:

I wanted my work to relate in scale to the human body and also to the strength and size of the building. . . . I planned my work to move out from the wall, to create shapes which would be active in the space, and to bring to the lobby a sense of life.

Another consideration was color. This was somewhat difficult for two reasons: first, near my wall is a stretch of graphic treatment with dominant metallic diagonals, and second, the redwood wall itself is a rich, beautiful color establishing the character of the space. I expect my work to be strong, not by overpowering the environment, but rather by affecting, enhancing, and elevating the surroundings by its existence in them.

Laky began working on the

Laky makes the individual tubes, which were stuffed during the weaving process.

sculpture as soon as her proposal was accepted. Her design was also influenced by practical factors, among them "weight, ease of handling, durability, and cleaning." She purposely made the piece in fifty- to sixty-pound sections, each supported by three large hardwood hooks, to minimize the stress on the wall. "The basic elements of the piece are tightly woven tubes which are stuffed—my own manufacture of colorful rope—which I then plaited into positive and negative fluid forms within each section," Laky explained, adding, "The piece can be vacuumed and should last well into the twenty-second century."

The contract allowed ample time for the fabrication and installation of the work, which, like all other GSA projects, was funded from the construction budget. Construction money for the SSA building did not, however, come directly from tax revenues appropriated by Congress. Rather, special legislation enabled GSA to secure the money from private sources and repay it over a thirty-year period through a leasing arrangement with the tenant agency. At the end of the thirty years, the building would be owned by the government. The arrangement had one other restriction: all construction work associated with the building, including the artwork, had to be completed by December 31, 1976, which was several months prior to Laky's contractual completion date. Unaccountably, this

The artist and her creation, after all nine sections of Inner Glyphs Out *were complete and ready for installation.*

stipulation was never made known to the staff of the Art-in-Architecture Program.

Fortunately, despite this abrupt curtailment of her working time, Laky was able to finish on schedule. In fact, her sculpture, titled *Inner Glyphs Out*, was installed on December 15, 1976— two weeks ahead of the deadline. Laky was deservedly satisfied with her efforts. Writing to Administrator Solomon the following November, she conveyed her views on the commission and on the significance of the Art-in-Architecture Program. Her thoughtful letter deserves to be quoted at length:

. . . the Art-in-Architecture Program . . . enhances the quality of life for those great numbers of people who live and work in the vicinity of the public works of art. It is encouraging to experience the federal government's concern with the aesthetic, cultural, and spiritual aspects of life, and to have the tangible proof of this concern. In addition, the program is a major support and encouragement for artists collectively, as well as for those selected to create the commissioned works. The works created for this program are often magnificent, major, large-scale pieces that have few other potential sites . . . as large and accommodating as public buildings. . . . The desolate steel, glass, and concrete that increased the feeling of alienation and isolation earlier in the century are softened and humanized by this expanded use of art. Another impact of the program is that it stimulates the art economy, not only by actual purchases and setting examples to be followed by business, but also by increasing public awareness of and interest in art. I do not know if this influence is documented or even could be; however, . . . I speculate about more people visiting museums and galleries and more people purchasing works of art for their personal environments. . . .

Artists, as a group, have always been an economically depressed minority, yet art is a social need so basic that there has not been a single group nor a single period in history existing without it. The fact that the government of this country recognizes, appreciates, and purchases art gives me great confidence and a sense of well being.

JOHN RIETTA

[signature: John P. Rietta]

In October 1974, John Rietta was one of five artists nominated by an NEA-appointed panel to design an exterior, free-standing work for the plaza of the Richard H. Poff Federal Building and U.S. Courthouse in Roanoke, Virginia. Upon learning that the panelists and the building's architect wished to view his work, Rietta hopped on a plane and personally delivered a set of slides. "Although it was a long shot (I don't believe most sculptors fly around the country dropping off slides), I felt it was worth the effort," Rietta said later. As it turned out, he was right. In the spring of 1975, he was officially commissioned and set to work on the sculpture that eventually became *Force One: Consciousness Is Crucial.*

Rietta, a thirty-one-year-old artist of American Indian descent, earned his B.F.A. from the Art Institute of Chicago (1966) and his M.F.A. from the University of Georgia (1969) and subsequently achieved a considerable reputation. He has been the recipient of a number of awards and a participant in the Purdue University Artist in Residence Program (1973) and the NEA Art Train (1974). His work is represented in private and corporate collections. He was delighted by his selection for the Roanoke commission, of which he later said, "After being convinced it was not a hoax—I felt great! You get so few shots at big commissions. It's like you finally get a chance to really do your stuff."

In June 1975, the GSA Design Review Panel met to consider Rietta's completed design for the Poff Building sculpture. At that time the Design Review Panel had a shifting membership, with panelists whose interest in and knowledge of contemporary art ranged from extensive to virtually nonexistent. For this reason, and because the Art-in-Architecture Program's revised operating procedures—as reflected in the 1973 restructuring of GSA's standard contract for artists—recognize the artist's unique ability to determine the artistic expression (within the bounds of public decency), the panel normally confined itself to nonaesthetic criteria in evaluating design proposals. In Rietta's case, however, Karel Yasko, then counsellor to the administrator for fine arts and historic preservation, found fault with certain features of the design, and the panel was plunged into relatively uncharted waters.

Specifically, Yasko took issue with the bottom section of the proposed sculpture, contending that it "mim-

icked" the building. Rietta, understandably chagrined, wrote a letter to the panel explaining the reasoning behind his design.

> . . . in many instances pieces of sculpture blend neither with the building nor its site, with the result that the sculpture appears to be a foreign element. . . .

After visiting the Roanoke site, I decided there were two major elements to deal with, the reflective quality of the bronze glass and the buttress elements at either end of the building. To deal with the reflective surface, I would have had to go up 30 feet before I started with the sculpture. I therefore chose to work with the buttress element. . . .

> . . . I felt that the sculpture should be an accent or variation to the building so that a viewer could relate the sculpture to the building and to the site, as if [it] evolved from the ground as the building evolves from the plaza. The verticality of the buttress elements . . . is the strongest feature of the building. Therefore, in order to blend . . . , I strongly feel that the basic shape of the sculpture should make reference to [it].

Yasko was not convinced. In a memo addressed to the other panelists, he suggested that the sculpture would not be able to compete with "the powerful

form of the building" and that the attempt to accent the building by repeating the buttress motif was "doomed." Not without misgivings, Rietta was persuaded to attend a meeting of the full panel to present his ideas and answer questions in person. The meeting went smoothly, Yasko's doubts were allayed, and the dispute was resolved in the artist's favor.

Rietta's piece represented a structurally daring concept. Joe Ethridge, president of Steel Fabricators, was initially as skeptical about its construction as Yasko had been about its design ("At first I thought it was a pipe dream," he told Rietta), but he became quite enthusiastic as work progressed ("I have a lot more respect for modern sculpture now," he said after fabrication was complete). The workmen laughed at the project in the beginning, according to Rietta, but "at the end they were picking up scraps off the floor, isolating shapes, making sculpture. Each person . . . took a great deal of pride in seeing that all the work was done with the greatest of care."

The installation took place on a freezing day early in January 1976. The piece swayed a bit in the biting wind, then held as it was fixed in place, but it had not yet weathered its last storm. Along with the winter cold came a frosty reception from the citizens of Roanoke. In a flurry of articles, the local newspapers raised artistic and financial objections to Rietta's sculpture, and the GSA was bombarded with angry letters. From the standpoint of the Art-in-Architecture Program, the timing couldn't have been worse. We were fresh from a battle over the Goodman sculpture in Las Cruces, New Mexico, and the federal judges in Baltimore were in the midst of protesting the Sugarman sculpture in front of their courthouse. Jack Eckerd, the new GSA administrator, who had been on the job for

Rietta's maquette for Force One.

only two months, was rapidly—to say the least—becoming "aware" of the program's activities.

The tide began to turn late in January when the *World-News,* a Roanoke paper which had questioned Rietta's profit and invited its readers to comment on the sculpture, ran an editorial entitled "An Apology and a Comment on Replies" (January 23, 1976). Acknowledging that after costs Rietta netted only about $8,000 of the $58,000 paid to him (a fact they had not previously known), the editors took rueful note of the 148 negative and 10 positive responses they had received. "We have unleashed a monster," they lamented, and went on to add, "It is one thing to complain about the sum spent on the work, or to pick out specific shortcomings. . . . But to say, as so many readers did, that it could be duplicated

in a short trip to any junkyard, is not a judgment. It is an admission of partial 'blindness,' a form of see-nothingism. The lines are apparent in the sculpture, and the individual can like or dislike them. But it is obvious that a human being, a human mind, shaped the materials. It is hardly 'accidental art.' Cost aside, we happen to like it."

On February 8, the *Roanoke Times* chimed in with two articles supportive of the sculpture, "Artists Review Roanoke Sculpture" and "An Explanation of 'That Thing.'" In March Rietta himself visited Roanoke to address an audience at the Fine Arts Center. "John Paul Rietta—the Alabama artist who strung out a lot of Roanokers with his (Cor-ten) steel sculpture at the city's new federal building—came to town Friday, talking CB radio lingo and saying he didn't believe those who

don't like his sculpture are Philistines," the *Times* reported (March 6, 1976). Rietta discussed his work (saying he'd be happy to go into "environmental sculpture and its nuances . . . but you'll be bored to tears") and talked informally with the audience ("Rietta, when he agreed with a questioner, said 'fer sure, fer sure, 10-4' several times"). He showed slides of his sculptures, one of which had been compared to "a wing stuck in the ground," and commented that "many people didn't like them and that he didn't expect his own mother to understand it." The article continued, "When the long series of slides finally showed the curling steel in front of the federal building in Roanoke, Rietta stepped back from the lectern and said, 'There it is, folks. That's a dynamite piece.' . . . They gave John Rietta a big hand when he finished."

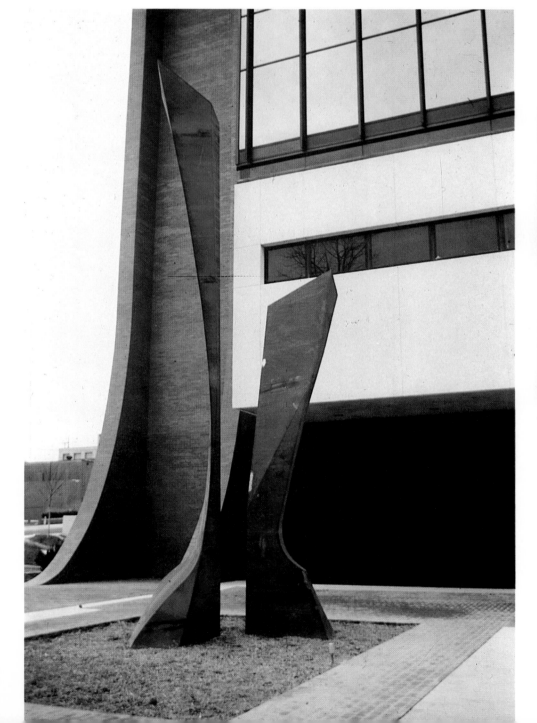

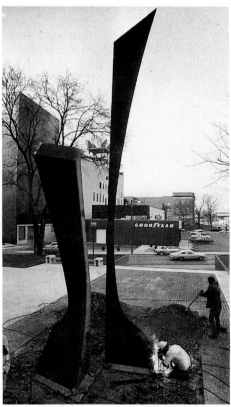

Above: Rietta's Cor-ten steel sculpture is fixed in place on the plaza of the Richard H. Poff Federal Building and U.S. Courthouse in Roanoke, Virginia.

Left: Force One: Consciousness Is Crucial, with one of the building's buttress elements in the background. The structurally daring work consists of two tall shapes, one thirty feet high, the other twenty feet high. Art writer Clark Thomas of the Roanoke Times *(February 8, 1976) interviewed several Virginia artists about Rietta's sculpture, which some local residents criticized vociferously. "That's one of the least controversial forms I could think of," commented one. "It's elegant. It has the grace of a cat," said another.*

DUAYNE HATCHETT

It was an expérience just meeting Duayne Hatchett for the first time. Hatchett had been selected for the GSA commission in Rochester, New York, and he came to Washington in December 1974 for contract negotiations. An imposing figure with a personality to match, he arrived wearing the most beautiful pair of new gray cowboy boots imaginable. He was serious and intense, yet relaxed and easygoing. We settled on a fee of $45,000, and Hatchett went right to work. His contract was officially awarded in late January 1975; by March his maquette was ready for submission. A meticulous and thoroughly professional craftsman, he documented the entire fabrication process in 35mm slides.

In an effort to build enthusiasm for the sculpture, GSA issued a press release in March stating that Hatchett, "a 49-year-old professor of art at the State University of New York at Buffalo . . . was enrolled in a weekly WPA [Work Projects Administration] art class in Oklahoma City at the age of about 10. He lived on a farm about 40 miles away, but every Friday night an aunt would put him on a bus for the city. He would spend the night with family friends so he could attend the Saturday class, and probably was the youngest artist enrolled in the WPA adult art program during the New Deal Era." The news release added that Hatchett was a prominent artist whose work was in major museum collections, and that he'd been selected through a carefully developed process involving the National Endowment for the Arts.

Three days later, the *Rochester Democrat and Chronicle* published a cartoon of a beret-topped sculptor standing on a ladder chiseling out a dollar sign (March 9, 1975). The accompanying article, however, was generally positive. It quoted portions of a telephone interview in which Hatchett described his work and said, among other things, "There's an angular dynamic involved in this piece that's dependent on planes forming solids that don't exist." People didn't understand. Hatchett's sculpture quickly became a target of criticism on the grounds that it represented a frivolous expenditure of federal funds. Many irate citizens wrote their representatives complaining of waste and suggesting other, allegedly more worthwhile uses for the $45,000. In turn, Representatives Barber B. Conable, Jr., and Frank Horton wrote to GSA administrator Arthur Sampson, citing

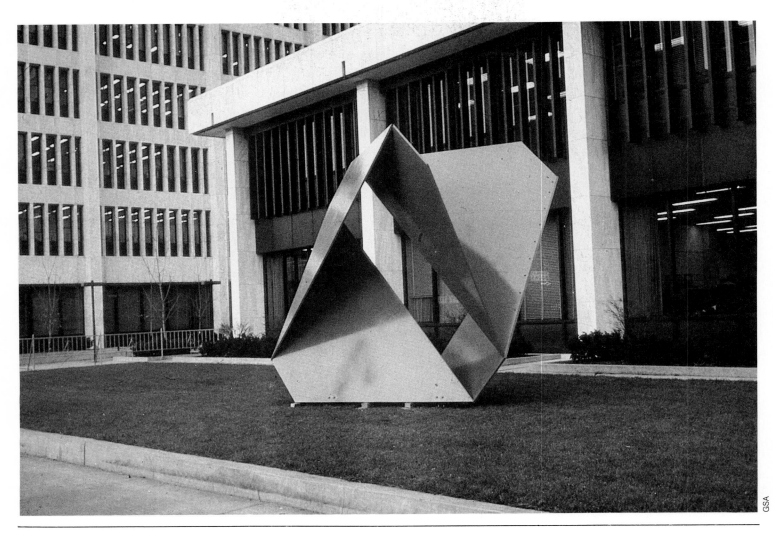

Duayne Hatchett's Equilateral Six *outside the federal building and U.S. courthouse in Rochester, New York.*

the letters they'd received from their constituents and requesting that the project be canceled.

The objections to Hatchett's piece were all too familiar to the staff of the Art-in-Architecture Program. As with many GSA art projects, money became the most sensitive issue in the debate. To the taxpayers, the $45,000 represented an outrageous extravagance. To the artist, however, it posed a major challenge: how to create for that sum a piece large enough in scale to hold the public's attention in an outdoor space. Hatchett himself put the dilemma well when he wrote, "The most difficult problem for the sculptor is finding a balance of idea and budget. The challenge is controlling the temptation to create concepts which require more than the approved financing."

In a careful and laboriously prepared response to Representatives Horton and Conable, Administrator Sampson also addressed the issue of money, taking a somewhat different tack. "It may be worthwhile to point out," he wrote in part, "that nearly all of the $45,000 will flow back into the economy of Rochester in the form of jobs and revenue to painters, truckers, material suppliers, photographers, utilities, studio rental fees, etc. Federal support for public art becomes dually beneficial as a catalyst to generate employment and as a sound investment source to enrich the nation's cultural heritage. During the Depression era, the Federal Government also supported the arts through the WPA art program. . . . In retrospect, those responsible for [this] program contributed immeasurably to a cultural heritage of ever-increasing aesthetic—as well as monetary—value."

Undeterred by the controversy, Hatchett continued to work, and the piece was ready for installation in November 1975. Hatchett described it as follows:

Six massive triangular planes of aluminum connect to form a symmetry in diagonal forces; the angular position of each unit contributes to the formation of a dynamic diagonal of rectangular space, which separates equal masses. The crossing angular axis of space and supporting planes emphasizes the proportion and scale of the dark yellow enameled construction. . . . The results of this celebration in form suggest a changing balance; as the viewer moves around or passes by, the concept of form moves from positive mass to more spatial negative spaces. Stability and precision predominate through the cycle of change.

Unfortunately, many of the viewers weren't aesthetically prepared to appreciate Hatchett's insight, and they found simpler ways of describing the piece in their letters to the *Democrat and Chronicle* (December 3, 1975). One called it a "yellow monstrosity," while another wrote, "It is an outrage that $45,000 was spent to thus mar the appearance of these beautiful premises." Not all were opposed, however; one defender, noting that the sum included the work's fabrication and installation, said, "It would be interesting to compare the hourly wage rate of the workmen involved in making the aluminum sections . . . with the hours Mr. Duayne Hatchett spent in conceiving, designing and supervising its execution." Robert Buck, director of the highly regarded Albright-Knox Art Gallery in nearby Buffalo, New York, wrote, "I find it strong and accomplished as a statement of modern aesthetic (lest we forget the 20th century is three-quarters over) and commend the GSA for awarding this commission to an artist of Hatchett's talent and national stature."

As for Hatchett, he called his involvement with the Rochester project "more rewarding . . . than expected" and said of his relations with the Art-in-Architecture Program, "It was impressive to experience the level of professional understanding and acceptance given to the artist." And it would be hard to improve upon his assessment of the problem of community acceptance: "Our need to experience more than the necessities becomes an open line for experiencing creative efforts. . . . An artist's responsibility to the public in a permanent installation is obvious, but unless it is a work of art first it is a misuse of the total effort."

I've since followed public reaction to Hatchett's work, which he titled *Equilateral Six*, with fine-tuned interest. Not only have I not heard one negative comment, but the building's manager (a community resident) has gone to the trouble of annually planting petunias around the sculpture's base. Though his efforts do not please Hatchett, they may be regarded as an act of respect and admiration for the creative achievement of one of America's leading artists.

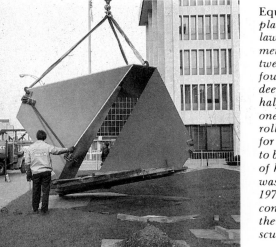

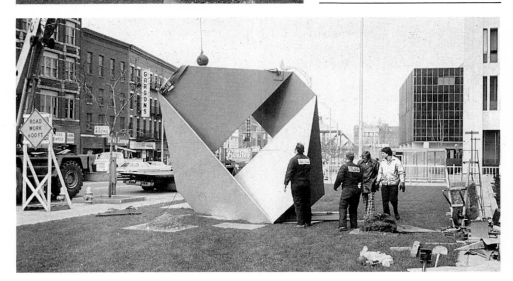

Equilateral Six is lowered into place on the building's front lawn. Hatchett's modular, symmetrical sculpture stands twelve feet six inches high and is fourteen feet wide by eight feet deep. Weighing in at three and a half tons, it is constructed of one-inch-thick plate aluminum rolled and milled especially for this project. "It's not going to bore anyone," said Hatchett of his creation. Equilateral Six was installed in November 1975 and was the center of a lively controversy for some months thereafter, thus confirming the sculptor's assessment.

CHARLES GINNEVER

Linda Filippi

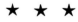

The art project for the federal building and U.S. courthouse in St. Paul, Minnesota, seemed jinxed from the very beginning. The architects, Haarstick Lundgren and Associates, had originally proposed an exterior sculpture for the site in 1965. Before a contract could be concluded, however, the GSA art program was suspended and remained dormant until late 1972, when it was reactivated by Administrator Arthur Sampson. On August 30, 1973, a panel appointed by the National Endowment for the Arts met with architect Louis Lundgren in St. Paul and nominated five sculptors.

Charles Ginnever, one of the nominees, was recommended for the commission by GSA's Design Review Panel and was subsequently chosen by the administrator. Unfortunately, Ginnever was out of the country at the time. When he returned, he was surprised to learn of his selection. "I had no knowledge of a GSA art program until I was notified in the early summer of 1974. . . . I'd just returned from a first global trip and was filled with the charge of energy one experiences in the presence of Mayan temples, the rock gardens of Kyoto, the Great Pyramids, the Acropolis, Stonehenge, etc.," he wrote.

Ginnever certainly was brimming with energy. At the contract negotiations, which were held in St. Paul in June 1974, he fought vigorously to have a permanent maintenance clause included in his contract, an excellent idea that GSA lawyers rejected because it would legally bind the agency to future action it could not guarantee; he also lobbied hard for a resale royalty clause, to which the lawyers again said no. Gin-

never wasn't at all pleased. "Contract negotiations were a Mexican standoff," he wrote. "The GSA agreed to let me do things my way with no nervous interference as long as I didn't press the issue of maintenance or resale. . . . GSA could either maintain or neglect the piece and even sell it for scrap if they so wished without my having any legal recourse." Consequently, Ginnever was not eager to sign the contract.

In the meantime, Congress had been looking into certain GSA expenditures on President Nixon's "Western White House" in San Clemente. A number of these improvements, which many considered extravagant, had been financed through the agency's "Construction Savings Account," and upon learning this, Congress abolished the account—which, unfortunately, was the very same one established to fund the work by Ginnever. The timing could hardly have been worse. It was late summer, and just as the money was being withdrawn, Ginnever decided to sign the contract. Without money, however, GSA could not validate the contract, and an exhaustive search for avenues of proper funding turned into a dead-end street.

Ginnever was understandably disappointed but still game. "Rather than sit on my disappointment I've made some inquiries of my own," he wrote. "I was talking to the new president of Windham College, where I teach, and as a former U.S. ambassador, he had some suggestions as to how we might aid you in your efforts to have the project reinstated or funded through another source." Options ranged from political pressure to separate funding from the NEA, but none seemed promising. GSA's simultaneous efforts to fund the project from alternate budget sources were equally unsuccessful. Finally, in January 1976—one and a half years later—special funds for the project were approved, Ginnever was officially notified

of his selection, and the contract previously negotiated at a fee of $42,500 went into effect.

Ginnever wasted no time developing his proposal. On March 8 he wrote to call attention to some problems with the originally designated site in the center of a rather small plaza directly in front of the main entrance: "When I present my model for consideration, I will . . . request the removal of the four light posts which are now in the location chosen for the sculpture. It will also be necessary to create another area of turf where the sculpture is to go." There were other difficulties with the site, however—among them, two very large planters crowding the periphery of the plaza, and a vertically dominant flagpole nearby. After a second look, Ginnever decided that the grass-covered area at the prominent intersection formed by Robert Street and Kellogg Boulevard would make a better site. As the architects had also considered this a prime location in their original proposal, GSA approved the change.

Ginnever submitted his maquette through the GSA regional office in Chicago, where Fine Arts Officer Bob Stewart took a special interest in the administration of Ginnever's contract. Stewart was quite pleased with the proposal and recommended that GSA's Design Review Panel in Washington, D.C., approve it; the panel did so on April 12. It was no doubt largely due to Stewart's efforts that Ginnever was able to write, "After [the contract was signed] everything went smoothly. My model was approved, and the work was executed and installed without incident."

★ ★ ★

"A flatbed truck loaded with sheet steel had a nasty accident at the corner of Robert Street and Kellogg Boulevard and spilled part of its cargo on the lawn outside the Federal Courts Building," wrote Ozzie St. George in the *St. Paul Pioneer Press* ("Our Government in Action—Sculpture Division," May 25, 1976). He then offered some imaginative interpretations of the configuration produced by this "accident": "potential machinegun nest," "disposable undercarriage of a UFO-type flying saucer," "modern set of stocks [for] delinquent taxpayers." Addressing his readers directly, St. George expostulated, ". . . this addition to the quality of life in our city is—Art. And that's Art with a capital A, fellow taxpayers. It's a work called

Charles Ginnever's Protagoras, *for the federal building and U.S. courthouse in St. Paul. The work is ten feet high by fourteen feet deep by thirty feet long and weighs five tons.*

Eric Sutherland/Sculpture Now, Inc.

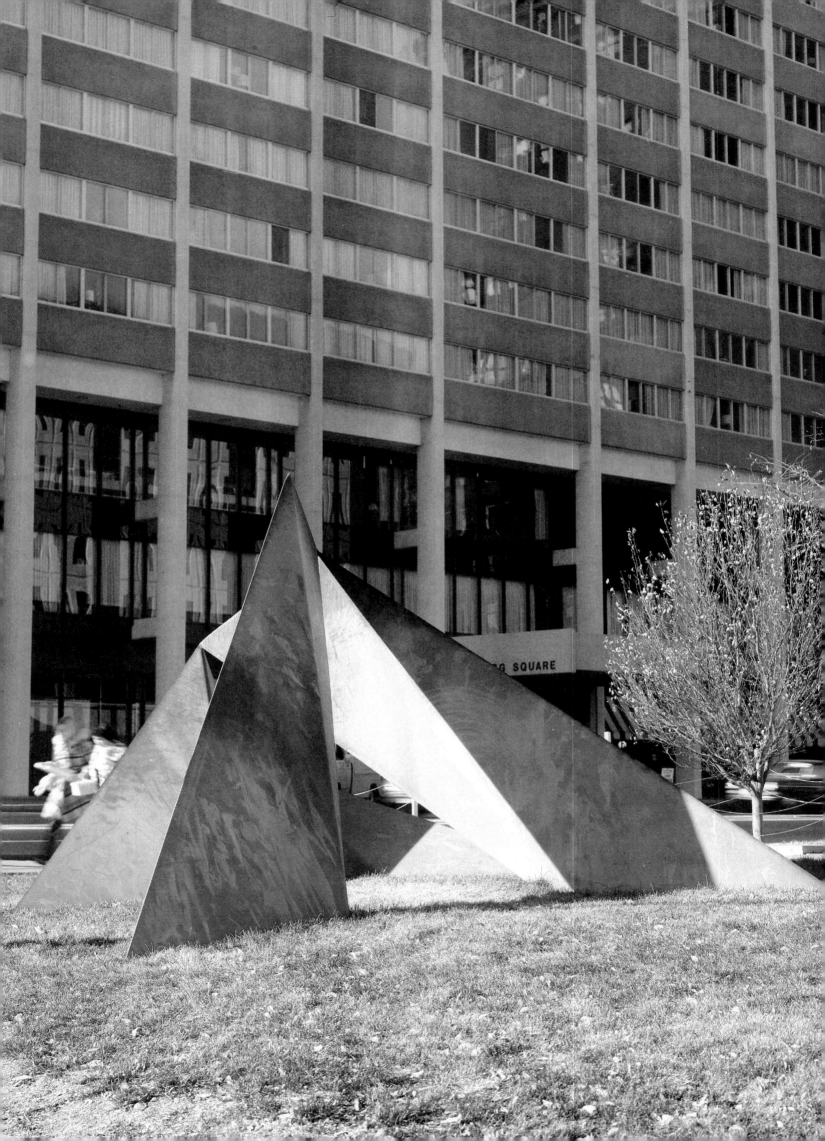

Protagoras." It was hardly the sort of article to engender support for Ginnever's newly installed work.

Realizing the importance of community support, GSA sent an SOS to Martin Friedman, the energetic director of the Walker Art Center in nearby Minneapolis. The Walker is widely known throughout the United States and is one of the nation's most respected museums, so we hoped that Friedman's support would stem the tide of public opposition. His response was quick and forceful. "Ginnever is a rising young artist who is carrying on the monumental steel sculpture tradition of the early twentieth century whose other interpreters include David Smith, Mark di Suvero and Anthony Caro. Their works concern themselves with balance, tension, weight and movement in space— all significant issues in modern sculpture." Friedman noted with pride that the Walker had just made its "first large-scale outdoor sculpture purchase in two years"—another of Ginnever's works from the same series of Greek-named sculptures as *Protagoras.*

Just as emotions were beginning to cool, Senator William Proxmire bestowed his "Golden Fleece of the Month" award on GSA for wasting the taxpayers' money on several artworks— including Ginnever's *Protagoras,* which he likened to "a rusty piece of farm machinery left out in the field" (it was Ginnever's intention that the Cor-ten steel sculpture, which was sandblasted and weathered after installation, should eventually rust to a rich tobacco brown).

The following week, the controversy over Ginnever's work was renewed in the local press. In an article by Dave Daley ("Art or Rusty Metal? Sculpture Debated," *Minneapolis Star,* September 9, 1976), Senator Proxmire was verbally clobbered by architect Lundgren: "Mr. Proxmire was incorrect as usual," Lundgren said. "He is totally incompetent in this field as well as others. I always get upset by people in politics [who] get into areas they aren't competent in." Daley also interviewed Martin Friedman, who called Ginnever "an artist of considerable eminence," adding, "Everyone, the senator included, is entitled to his own opinion, of course, but I think it's a very fine sculpture. It's anything but a waste of the taxpayers' money." Ginnever, who was aware of local criticism, later wrote thoughtfully, "As usual, there were a few citizens who expressed dismay at the U.S. government spending their tax money on art. . . . I've always found it hard to understand a society that thinks it's okay to spend so much on fear and immoral to spend anything at all on aspirations."

Proxmire would have been well advised to test the waters of public opinion in St. Paul before singling out Ginnever's piece for the Golden Fleece award. Had he done so, he would have discovered a marked shift in favor of the work, as reflected in freelance writer Margherita Glendenning's article for the August 13 edition of the *St. Paul Dispatch* ("Sculpture Rusting Well").

This classic sculpture is based on one of the oldest forms known to man—the triangle. . . . Fanning out the sections as though they were a deck of cards and positioning them at angles reveals a deft balancing act by Ginnever, who usually shows a defiance of gravitational forces in his work.

The more one walks around this sculpture, the more one sees. At first visually simple, it becomes dynamic. . . . A motion process starts in which several compositions occur. A multiplicity of angles are seen which foreshorten or alter the sections. The site and its relationship to the sculpture shifts radically as our position changes.

This is a fine example of the more recent sculpture which shares concerns with architecture, [particularly] that of spatial perception— movement through and around space and forms.

Since its installation, *Protagoras* has achieved both its anticipated deep brown color and public appreciation. Despite the slow start, Ginnever too was pleased with the results and eager for another GSA commission. "The overall experience of doing a GSA art project," he wrote in February 1979, "was beneficial to my art, and I hope the art will prove so to the public." In the same letter, Ginnever assumed the mantle of advocacy, just as he'd done during the contract negotiations when he argued for a maintenance clause and resale royalty rights: "I'd like to see an across-the-board one-percent-for-art law on all buildings where federal or state monies are used," he said, adding, "but I'd hate to see any such program administered so democratically that artists are cut off once they've received a commission. Art simply isn't democratic."

Opposite: Another view of Protagoras. *Ginnever's sculpture consists of five triangular steel sections, each twenty feet long. The arrangement of the sections alters traditional perspective, and the sculpture as a whole evokes a heightened sense of gravity through the use of massive, weighty constructions that appear to work against natural forces.*

Right: Ginnever's maquette for Protagoras, *submitted through the GSA regional office in Chicago, and approved by the Design Review Panel in Washington, D.C., on April 12, 1976.*

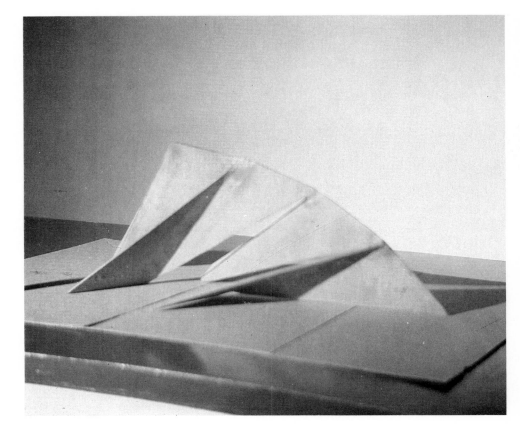

NED SMYTH

Every once in awhile, a perfect match is made between artist and environment. The fountain sculpture site in the courtyard of the federal building and U.S. courthouse in Charlotte Amalie, on the island of St. Thomas in the U.S. Virgin Islands, presented the NEA-appointed panelists with a real challenge in this respect—and meeting on August 26, 1977, they collectively exhausted every possibility. At one point, it seemed as if the best solution might simply be a "sound sculpture." The difficulties posed by the site were formidable indeed, largely owing to its restrictiveness: the proposed sculpture was to be set within a pool twenty feet in diameter, itself located in an enclosed courtyard, open at the top and surrounded by galleries on the upper levels, leaving a thirty- by forty-foot floor-to-ceiling space. In addition, the pool is surrounded by concentric rings of steps, and walls faced with blue ceramic glazed bricks; it can be viewed from all sides and above. Overwhelmed by these complexities, the architect, Tom Marvel, and the panelists fretted for hours—until the name of Ned Smyth was introduced.

Smyth, a serious young artist, was still in his twenties at the time. He had recently mounted an exhibition called *The Garden,* consisting of stylized palm trees in concrete, at the Holly Solomon Gallery in New York. His work seemed

ideal for the St. Thomas commission, and he was the panelists' first choice. Administrator Jay Solomon selected him in October 1977, and in November a contract was negotiated at the site. By mid-December Smyth was ready to make his design proposal to GSA. In addition to isometric drawings, he had prepared a large painting, six feet by twelve feet, depicting the tops, or capitals, of the palm trees in relationship to a central "blue box," which was rendered to scale in oil and wax on paper with a background of gold. The Design Review Panel was impressed and unanimously approved Smyth's proposal. Smyth was impressed too, both with how smoothly the review went and with the artistic freedom he was given and the trust demonstrated by the panelists.

★ ★ ★

Reverent Grove, as Smyth titled his sculpture, was completed in the spring of 1978. It consists of five stylized trees up to twelve feet in height, surrounding a blue cube and faced in venetian glass and ceramic tiles on concrete forms. "My intention in *Reverent Grove,*" Smyth wrote, "was to create a magnetic yet tranquil focus for the courtyard.... Entering the building from the intense tropical sun, one comes upon a cool, shaded spot quietly echoing with the sound of falling water. *Reverent Grove* acts as an oasis for the viewer. It should seduce and beguile with color, sound, texture, and articulated forms. At the same time its intention is to relax with its mass, stillness, and archetypal spiritual overtones."

The dedication ceremony held the following winter was a joyous occasion involving dignitaries from the islands, representatives from the New York art community, and members of the artist's family from as far away as California and Italy, joining with residents and building occupants as hundreds of helium balloons filled the bright blue sky. Coming upon the sculpture for the first time, Holly Solomon, director of the gallery of the same name, kept repeating, "Beautiful! Beautiful! Isn't it the most beautiful work you ever saw?,"

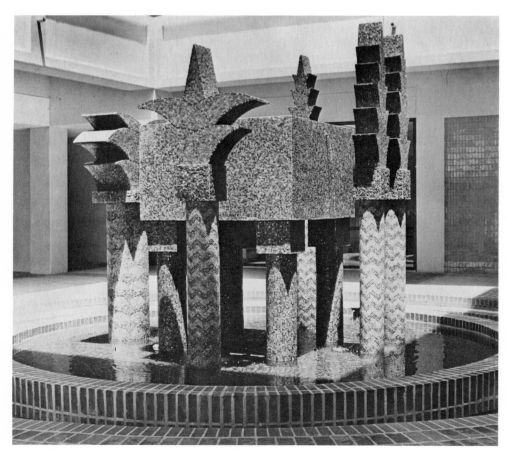

Reverent Grove, *Ned Smyth's fountain sculpture for the courtyard of the federal building and U.S. courthouse in Charlotte Amalie, St. Thomas, U.S. Virgin Islands. The work was commissioned in October 1977, completed the following spring, and formally dedicated in the winter of 1978. In the catalogue GSA prepared for the occasion, art critic Roberta Bernstein wrote, "Smyth's increasing use of symbolism in his recent work is related to what has been the most central and pervasive concern of his sculpture since the early 1970's—the quality of spiritual reverence. Reverent Grove is perhaps his most direct expression of this quality to date." Smyth declared that his intention was "to create a magnetic yet tranquil focus for the courtyard," and with* Reverent Grove, *he more than succeeded.*

while art critic Roberta Bernstein found it even more exciting than she'd imagined. Writing for the dedication catalogue, Bernstein said:

. . . Smyth uses the three types of columns from *The Garden* (his 1977 exhibition done in collaboration with painter Brad Davis) in *Reverent Grove*. Lacking a structural function, the columns are not architectural elements. Here they stand as trees, their green color suggesting foliage. In both works Smyth is interested in the decorative aspects of these columns as ornament *and* in their deeply rooted symbolic associations. One of the most important of these associations is the palm leaf as a pre-Christian symbol of rebirth, and as a Christian symbol of triumph over sin and death. Rebirth or regeneration has been a theme in Smyth's sculpture for several years through allusions to water as a cleansing element, and as an instrument of spiritual renewal. For this theme the fountain is especially appropriate.

The work is truly breathtaking. Every time a 35mm slide of it is projected for the benefit of interested audiences around the country, a now-predictable reaction of applause follows. The scale and the perfectly executed finish of the mosaics, not to mention the special difficulties and added costs of working in St. Thomas, make *Reverent Grove* one of the most appreciated works commissioned under the Art-in-Architecture Program—worth far more than the commission cost of $35,000. Smyth, too, was happy with the results. At the dedication, he expressed his gratitude to the GSA staff "for their encouragement and support," adding, "I am very pleased with the outcome and excited by the addtion of color to my work through mosaics. I am grateful for the opportunity to bring this work to fruition."

Two views of Reverent Grove. *"Following the first impression of stylized trees and a mysterious container (cube), the viewer gains great understanding of the piece as he ascends the stairs," says Smyth. "From the balconies, one becomes aware of the mandala-like layout of the fountain and the true nature of the central box. This box contains 'The Source' (a raised, secluded body of water filled with live plants), which pours into the main pool. My hope is that the work involves the public, not necessarily only on an intellectual level, but on a physical level as well."*

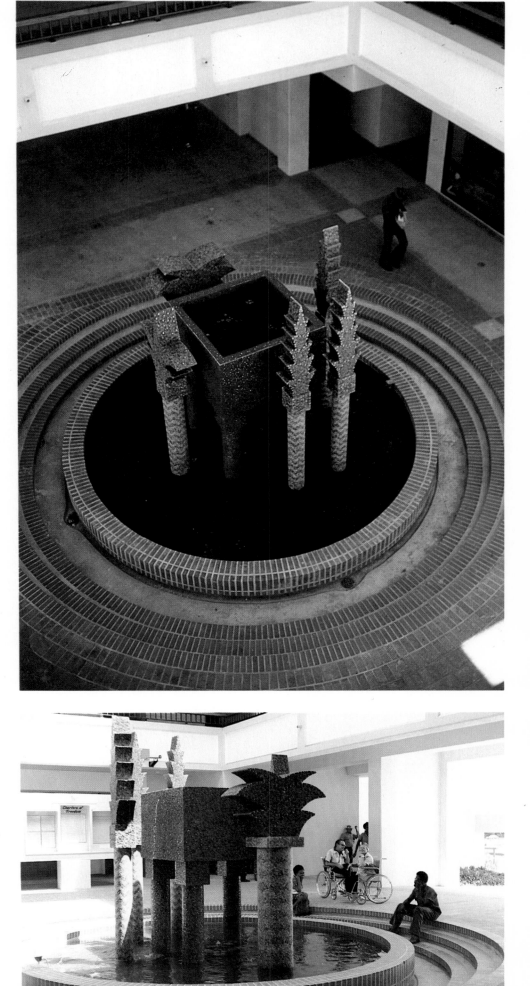

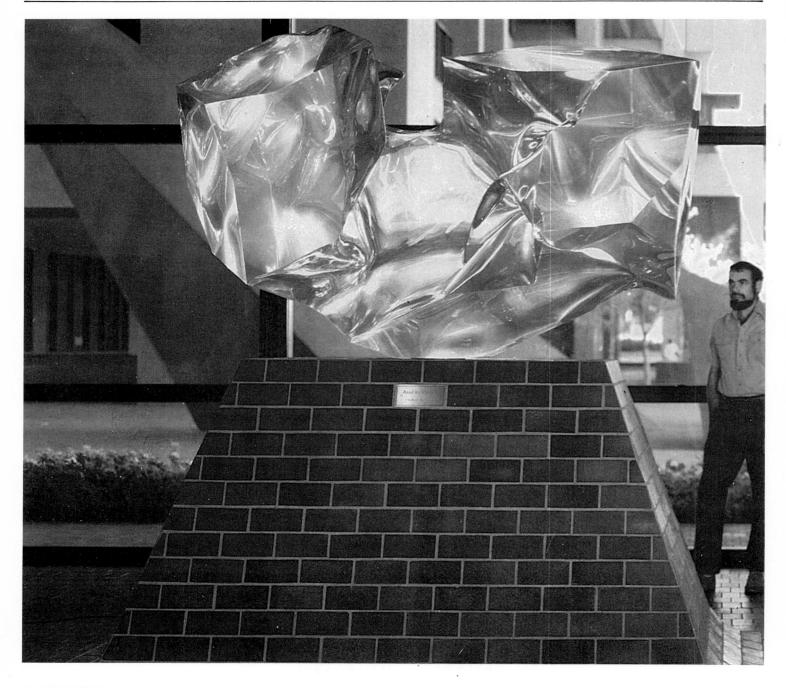

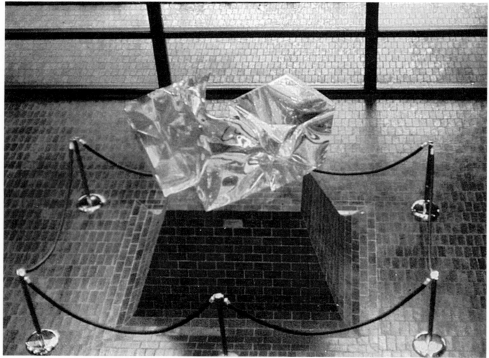

Above: Bruce Beasley inspects Axial Incidence, *a cast-acrylic sculpture he created for the lobby of the federal building in San Diego, California. Beasley began his artistic career working primarily in bronze and aluminum, but in the late 1960s he pioneered the use of cast acrylic as a medium for large, complex sculptural forms. Since then he has used cast acrylic extensively, employing an elaborate technical process to transform it from its raw state—a thin, clear liquid—into transparent sculptural solids like* Axial Incidence, *in which, in his own words, one can "see forms through other forms."*

Left: A view of Axial Incidence *from the first floor of the federal building. The sculpture, which was commissioned in the summer of 1974 and installed in August 1976, measures five feet high by eight feet wide and rests on a five-foot-high brick base. It resembles a piece of fine crystal but has an added dimension of softness and fluidity that seems to radiate from within.*

BRUCE BEASLEY

In the summer of 1974, Bruce Beasley was chosen to create a sculpture for the lobby of the federal building in San Diego, California. He had no idea that the National Endowment for the Arts had nominated him for the commission, and we were unable to reach him at his home in Oakland, California. We finally tracked him down in Portland, Oregon, where he was working on a sculpture, and I called from Washington, D.C., to notify him of his selection. Beasley didn't know anyone in Washington and at first thought there must be some mistake. When he realized that the call *was* for him, he was even more surprised. He later wrote me, describing his reaction:

I came in, and it was you on the phone. You were very nice, and you said, "Bruce, it's my pleasure and honor to inform you that you've been awarded a commission by the federal government." And I said, "No, no, they must have told you wrong"—I didn't understand who you were—"You're asking me to participate or to submit something for a program?" And you said, "No, you've been awarded the job." "But, but it doesn't work that way." . . . [Then] I realized that I, for the first time, had been given a job because you believed in me and not because I'd submitted a model for a competition. And it was a *wonderful* feeling!

Given Beasley's credentials and his contribution to the technology of casting acrylic, it was small wonder that he was nominated for a major commission. In 1961, while he was still a student at the University of California at Berkeley, his work was included in the Museum of Modern Art's Assemblage exhibition—making him the youngest sculptor ever to be so honored. Two years later, at the Biennale de Paris in the Musée d'Art Moderne, he received a purchase award for his metal sculpture *Icarus*, thereby becoming only the second American to be represented in the museum's collection. He was then only twenty-four years old, and he had been out of school barely one year. Before that year was over, both the Guggenheim and the Los Angeles County Museum owned Beasley sculptures.

By 1967, Beasley's interests had turned from bronze and aluminum to transparent materials, notably plastic—and specifically acrylic. At the

time, however, acrylic had never been cast into large, complex forms. As a raw material, acrylic is a thin, clear liquid. To turn it into a transparent solid is a complicated process that involves casting the desired shape and processing it inside a pressure chamber (called an autoclave) under exacting temperature and time controls. Beasley turned to the Du Pont Corporation for advice, but as William H. Elsner, associate curator of the M. H. de Young Memorial Museum in San Francisco, explained in his catalogue introduction for a 1972 exhibition of Beasley's work, Du Pont "frankly admitted that their experience had not encompassed any casting that approached the scale of the sculpture envisioned." Beasley therefore perfected the process himself while working on a monumental sculpture commission in Sacramento, California. The feat of bringing, for the first time in history, a brilliant, near-flawless 13,000-pound cast acrylic sculpture from its mold—not knowing in advance whether it would have bubbles or be cracked or cloudy—was a drama of such force that Beasley still recalls it with emotion. It earned him widespread critical attention and was even covered in *Time* magazine (February 1968).

★ ★ ★

The GSA contract was negotiated for a fee of $65,000 and awarded to Beasley in the autumn of 1974. The following spring, he presented a gemlike maquette through the San Francisco regional office, where photographs of it were taken and submitted to GSA's Design Review Panel. The proposal was approved. The San Francisco GSA employees had marveled at the maquette and wanted to keep it on display in the regional office, but it was later relinquished to the GSA office in Wash-

ington, D.C., much to their sorrow (they even considered trying to raise enough money to acquire a duplicate). In the spring of 1976, it was exhibited along with other GSA-commissioned maquettes at the New Orleans Art Museum, and to no one's surprise, the fifteen-inch-long piece became a glittering centerpiece of the display. If the small version could attract such attention, how would the public receive the full-scale piece, measuring eight feet wide by five feet high?

By August 1976, the sculpture base had been constructed and was ready to accept the completed work. On August 8, *Axial Incidence*, which had been trucked from Beasley's studio in Oakland, California, was exactingly lowered onto a steel dowel projecting from the five-foot-high base. "It all went so smoothly," said Peter Witmer, the GSA architect who made the final inspection for the government. Obviously impressed with Beasley's professionalism and creative energy, Witmer added, "Beasley has a basic sense of engineering—a total technical command—for every facet of his work. I admire him very much."

The respect expressed by Witmer on behalf of the GSA was fully reciprocated by Beasley. In a letter to Administrator Solomon dated July 25, 1977, Beasley described his experience with the Art-in-Architecture Program as "extremely smooth, better than I have had with private commissions. There were no particular problems, but considerable challenges. The primary challenge was that I felt [GSA] wanted the best quality work, and I was trusted to produce it. The general attitude of belief and trust challenged me to be sure it was justified." With *Axial Incidence*, Bruce Beasley more than rose to the challenge.

BEVERLY PEPPER

Beverly Pepper has a way with people—even judges. When the principal judge in the new San Diego courthouse discovered that Pepper had been selected for the exterior sculpture commission, he requested that she meet with him at her earliest convenience. Before she started on her design proposal, he wanted her to know that he had no use for any of those "abstract things." Lively and charming, she put the judge at ease and reassured him that she knew just what he meant. "In fact," says Pepper, recalling with amusement the story she told him, "a painting of Custer's Last Stand had recently been commissioned, . . . and when it was unveiled before the crowd, the horrified patron saw a scene of copulating Indians on a sea of mackerel with halos. The patron exclaimed that this wasn't what she'd wanted and asked what in the world it had to do with Custer's Last Stand, to which the artist responded, 'Custer's final words as he went into battle were, "Holy mackerel, look at all those fuckin' Indians!"'" With that, the judge cracked up and never uttered another word about not wanting an abstract sculpture."

★ ★ ★

Beverly Pepper was nominated for the San Diego commission in September 1973. At the time, she was living in Italy, and nearly a year passed before the contract was negotiated. Everyone was pleased when she decided to accept it, especially when she was featured in *Time* magazine nine months later ("A Red-Hot Mamma Returns," June 16, 1975). "Pepper . . . is one of the most serious and disciplined American artists of her generation," wrote Robert Hughes, and this testimonial helped quiet mounting criticism within the agency that the $96,000 commission was excessive.

By February 1975, Pepper was ready to present her concept. She had taken her work seriously indeed, constructing not only a steel maquette of the piece but a model of the building facades as well. After thorough study, she had decided that the originally proposed site—a relatively small lawn directly in front of the courthouse— was too restrictive for "a building consisting of strong perpendiculars and sloping laterals formed by a series of vertical and horizontal pink stonelike beams that create a visual pattern of a huge, elegant grate." From her point of view, the problem was how to deal with this "immense web background that is inevitably in strong competition with whatever is placed next to it." Her solution was to close off the street between the courthouse and the nearby federal building, which are situated at right angles to each other and linked by an enclosed pedestrian overpass. "This would change the environment by creating a brick plaza," Pepper concluded, "allowing for a pedestrian walk-through devoid of cars, and the possibility of a dialogue between the site and the people. Most important, the space would accommodate a sculpture commensurate in size to the monumentality of the building."

The architects (Frank Hope and Associates/Richard George Wheeler and Associates) and GSA agreed to the proposal. The city agreed to close the street. There were miles of red tape involved in this decision, and it took time to cut through it, but by December 1975, the piece was complete. Julie Brown of the GSA staff inspected the sculpture in Pepper's studio, and it was approved. Awaiting it on the West Coast was Peter Witmer, GSA architect and project supervisor for the sculpture, who kept Pepper informed of each new development and served as a valuable liaison between the artist, the GSA headquarters staff, and the GSA office in San Francisco.

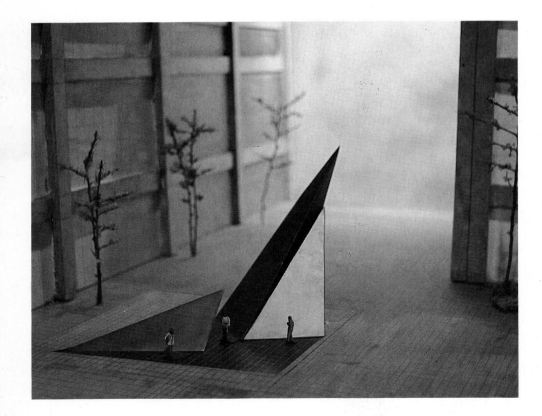

Beverly Pepper's maquette for Excalibur, *an exterior sculpture for the plaza of the federal building in San Diego. Pepper not only designed a sculpture but also proposed an entirely new site after concluding that the original location was too restrictive. She constructed the maquette of steel and set it against a model of the building facades to show how the piece would function in the new site. "What I sought in designing* Excalibur," *she said, "was to interrelate the work with the lives of people while remaining within the context of the given architecture."*

THE PLACE OF ART IN THE WORLD OF ARCHITECTURE

Pepper's concept for Excalibur arose from a careful consideration of how the sculpture would interact with the human and architectural environment. She decided to use solid elements because they serve, in her words, "to detach the work from its background." Excalibur "stretches out and fills the space, doing so in proportion to the building's scale and thereby inviting the observer into the interior of the plaza." Pepper also took into account possible observation points. "The sculpture was to be seen from various levels. Besides the direct plaza view, there are overhead windows and balconies, as well as cars passing on adjacent streets. All this required a work which has sufficient strength and power to endure and attract from multiple angles and elevations, drawing people into the plaza."

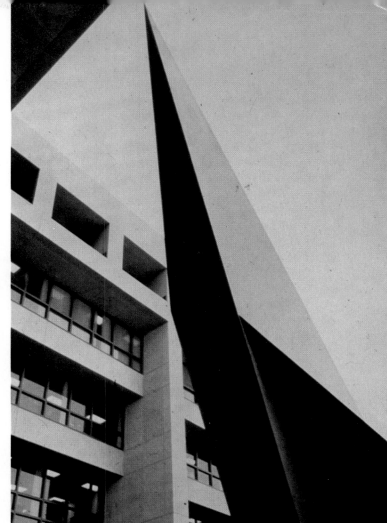

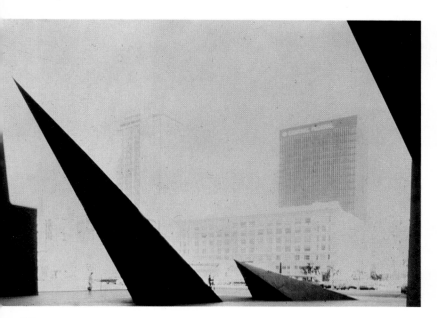

GSA

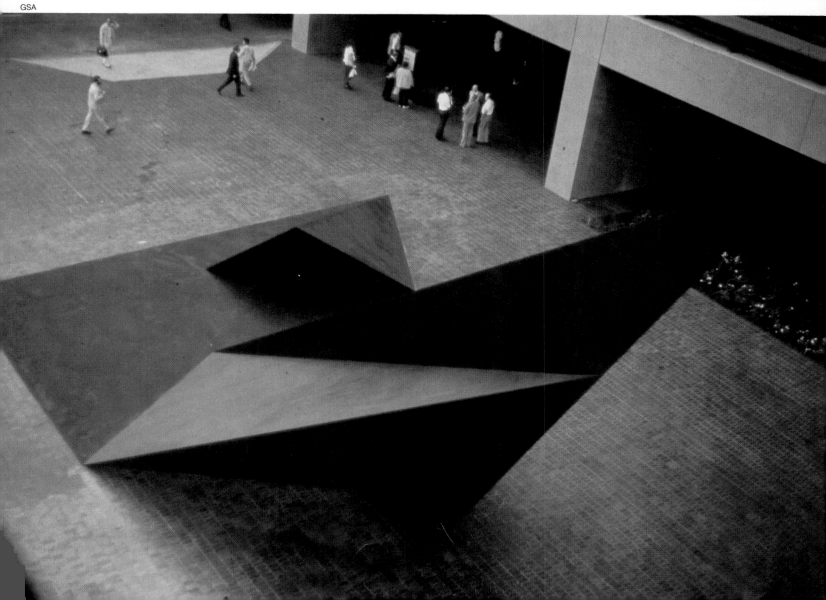

Shipment of the piece was delayed while it was sandblasted again and its surface reworked according to the requirements of Pepper's revised painting procedure. By July 1976, it had arrived in San Diego, and installation began. Complications arose when the construction workers threatened to strike if Pepper didn't use union welders; Pepper reluctantly obliged, even though the government doesn't require union labor and though her own work force had been brought in for the installation.

Excalibur, as the work was titled, caused an instant sensation once in place. Measuring forty feet high by thirty-two feet deep by sixty feet wide, it is one of San Diego's major conversation pieces and has been the subject

of countless articles in the local press. Richard Reilly, art critic for the *San Diego Union*, advised readers to listen to Wagner at top volume before going to see *Excalibur*: "As Wagner is to music, Pepper is to modern sculpture: big, soaring, forceful, someone to be reckoned with" (August 10, 1976).

Not everyone shared Reilly's enthusiasm, however. In a front-page feature story, the *Evening Tribune*'s John Fabina interviewed sidewalk critics, most of whom confined themselves to guessing what *Excalibur* was. Hazarding a few similes of his own, Fabina continued,

The multi-ton structure, which soars upward like a whale breach-

ing the ocean, or a cornstalk straining for the sun or a vessel under construction in a shipyard, has become a source of controversy. . . .

The best clue to the sculpture's identity, of course, is its name—Excalibur.

In Arthurian legend, Excalibur was a sword that King Arthur was able to draw from a rock as a boy, when no one else could.

But another version of the legend is that Excalibur was given to King Arthur by the Lady of the Lake. So even here there is controversy.

However, there is agreement among legend makers that upon King Arthur's death, Sir Bedivere threw Excalibur into the lake and a strange hand grasped it, brandished it three times, then disappeared.

Excalibur was never seen again—until it surfaced recently at the federal buildings.

Beverly Pepper had her own, rather different views of *Excalibur* and its function:

. . . monumental sculpture differs from the architecture around it. It shares, of course, many of the built-in problems of public safety: weight limits, extreme climate, hurricanes, earthquakes—even an accessibility for wheelchairs. Yet it is directed to man and his perceptions, not bound to serve his earthly needs. There is no need to adapt, to use this work. The only inescapable need is to create an interaction between man and the aesthetic experience, which here—in a public place, sharing an experience with others—becomes a social act.

In this sense, the sculpture should invite the participation of the public. Not that it should affect friendliness or suggest easy invitation, but rather make possible a dialogue between the people and the site itself. The need to participate is more than physical: it is also to enter a shared space consciousness. This was my goal in San Diego.

Pepper succeeded beyond her greatest hopes. As staff writer Gina Lubrano reported in the *San Diego Union* (August 24, 1977):

Excalibur . . . was crowned with a milk carton yesterday. But how it got there, nobody knows. Spider-

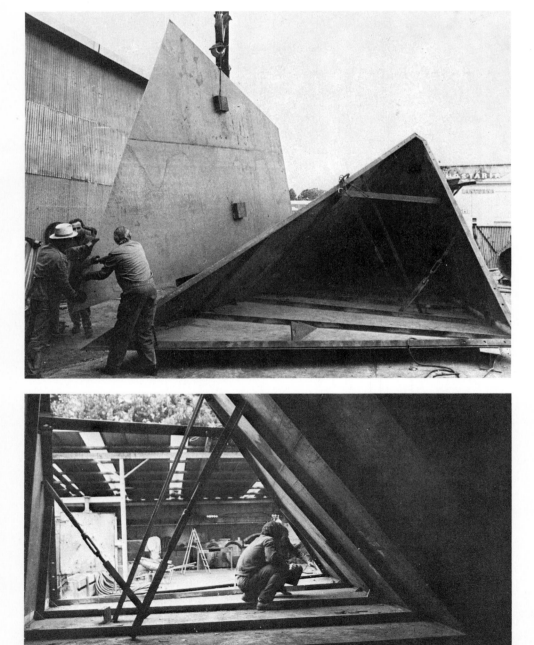

Excalibur *during installation in the summer of 1976. The massive steel sections were lowered into place and welded together at the site.*

man, said some. Superwoman, said the libbers.

To some, the sculpture looks as if it is ready to be launched into space. Youngsters, however, use it to launch themselves on their skateboards. . . .

It was Elsie the cow who [put the milk carton on the tip], suggested Assistant U.S. Atty. Howard Matloff. When pressed for an explanation, he said she did it in retaliation. "She was indicted last week for uddering a bad check."

Beverly Pepper had approached the project with a sense of humor accompanying her serious purpose; the citizens of San Diego responded in kind, appreciating her work and enjoying themselves immensely in the process.

Two views of Excalibur. *Describing her intentions for the work, Pepper said, "I wanted the soaring steel forms to energize and activate . . . the plaza—not as territorial space revealing the distance between individuals, but rather as one that allows them to move and experience a closeness, a relationship not only with the work itself but also with others and their own inner selves."*

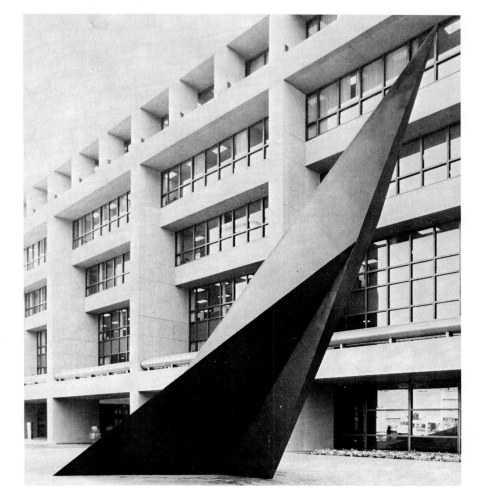

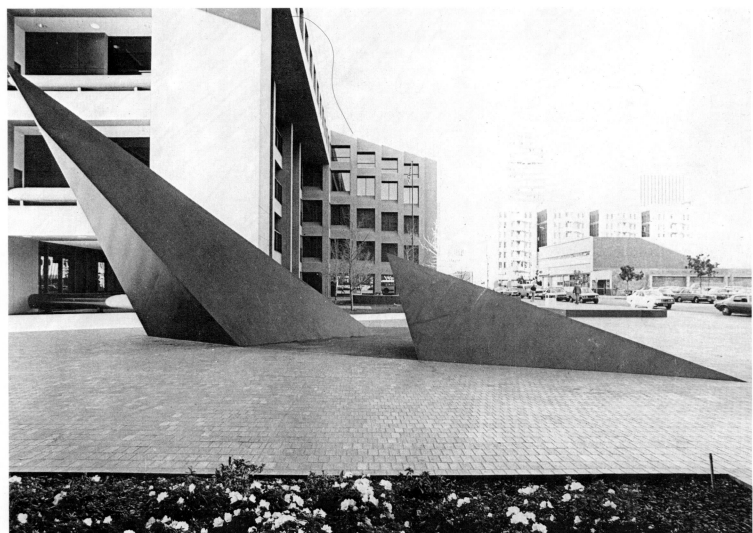

LENORE TAWNEY

Meeting in July 1975, an NEA-appointed panel deliberated for hours in the Santa Rosa, California, offices of Craig Roland, partner in the firm of Roland/Miller Associates, which had designed the handsome new Santa Rosa Federal Building and U.S. Post Office. The task of nominating fiber artists capable of fulfilling the architect's fine arts proposal was not an easy one, primarily because the space to be filled was large, and the budget small. Only $17,500 could be allotted for the design, fabrication, installation, and photography of a work that was to hang in an immense lobby area. "The space now is essentially empty," Roland wrote to GSA, adding, "It looks like a space waiting to be filled. I believe it is important, however, that whatever work hangs in the space be open or transparent in some manner . . . and that the work be designed to be seen from a variety of angles."

After looking at the site, the panelists viewed slides of the work of hundreds of competent artists, but without making much headway. It was late in the afternoon when someone said, "If you had a magic wand and could nominate anyone, whom would you select?" Suddenly the panelists had no doubt: Lenore Tawney.

Justly renowned as "Queen of the Fiber Works," Lenore Tawney is one of the great figures of twentieth-century art. As *Saturday Review* art critic Katharine Kuh has said, "Lenore Tawney stands alone, a weaver who never forces her material to perform in ways inimical to its underlying character. De-

pending on no eye-catching novelties or tricks, she is one of those rare artists who thoroughly respects her medium, and for that reason produces wall hangings of transcendent purity and nobility" (catalogue statement accompanying the New Jersey State Museum's Lenore Tawney exhibition, April 28–June 17, 1979). Tawney's work commands very high prices, and because the lobby required such a large-scale piece, the panelists doubted she would accept the commission. Nevertheless, in a optimistic spirit, they submitted her nomination.

★ ★ ★

The NEA panel meeting was followed by eighteen months of delay (first by the GSA Design Review Panel, which questioned the site conditions, and then by Administrator Eckerd's directive that no new works be commissioned until new artist selection procedures could be devised). The hope that Tawney might accept the commission faded

with the passing days as her works sold for ever-higher prices (according to the *Craft Collector*'s charter membership letter of May 1979, "A Lenore Tawney fiber hanging appreciated 1,000% in eight years"). To make matters worse, the Santa Rosa project had a completion date of March 31, 1978, after which funds would no longer be available. Finally, in January 1977, one month before leaving office, Administrator Eckerd followed the advice of the GSA Design Review Panel and chose Tawney to execute the Santa Rosa fiber work (she was the only artist whose selection he approved during his fifteen-month tenure as administrator, though he did approve the purchase of eleven existing works for two government buildings).

By then, however, Tawney had left the country and was somewhere in India. For awhile it seemed that the NEA panelists needn't have worried—after all, Tawney could hardly refuse a commission she was never offered. After weeks of trying to ascertain her whereabouts, GSA finally reached a friend of hers, Mr. Po Kim, who was going to India to visit her in early March and agreed to hand-carry a letter offering her the commission. As Tawney recalled, "The letter invited me to fill a space in the lobby of the federal building . . . with a work of mine. This was a surprise—a very pleasant surprise. It was a way into work after a six-month interval of travel and introspection." Vaguely aware of the Art-in-Architecture Program, Tawney replied that she would consider accepting the commission if GSA was willing to wait until she was back in the United States and had an opportunity to visit the site.

Left: Lenore Tawney spreads the painted "sky" of Cloud Series IV *in a field to dry.*

Opposite: The completed work in the lobby of the Santa Rosa Federal Building and U.S. Post Office. Over 2,550 rainlike threads fall from Tawney's blue canvas firmament.

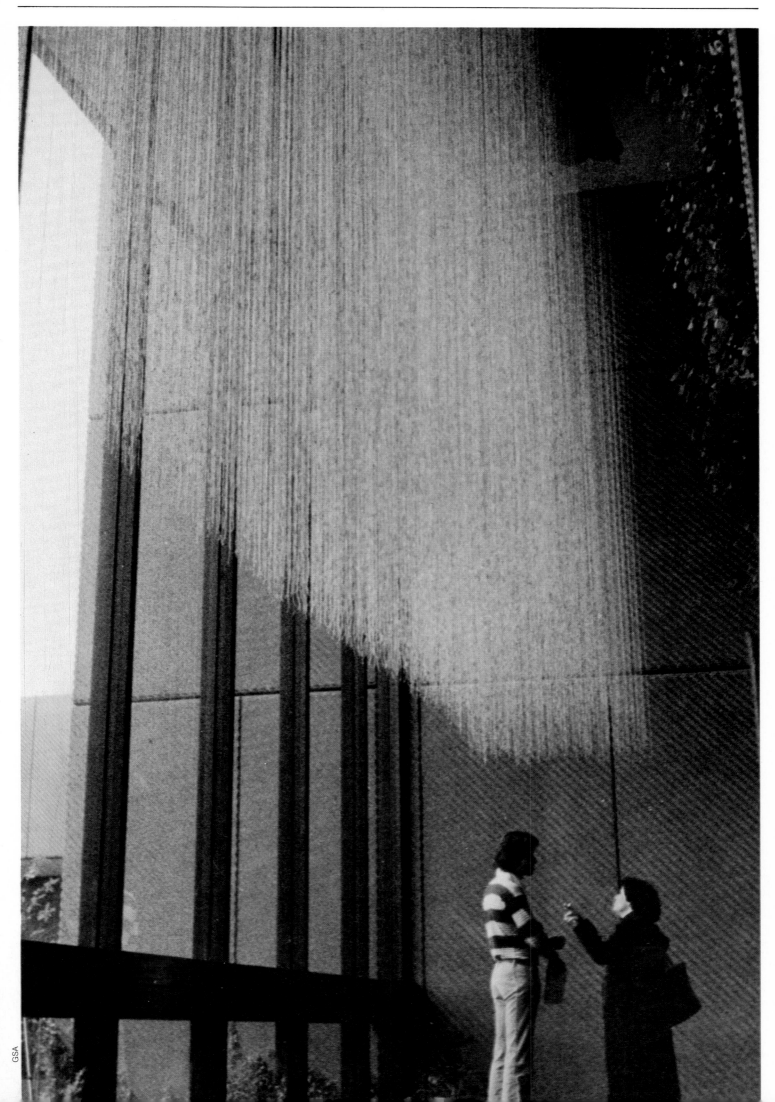

GSA was indeed willing to wait.

Meanwhile, a copy of the contract had been forwarded to Tawney, and she found it rather intimidating. "That is a formidable contract you sent me," she wrote from India.

. . . it made me feel like an ant. I am not a big operator—no helpers, no subcontracts. I do everything myself. Don't you have a less weighty contract? I feel . . . I'm stepping into a sea of legalities or illegalities, like shark's teeth. They can bite anytime, anywhere, for the rest of my life. I'm not ready to be hemmed in by the government.

Tawney returned to New York in May, and contract negotiations were scheduled for the following month. I flew to San Francisco to go over the contract with her and accompany her to the site. Recalling the occasion, Tawney wrote:

I met Don . . . at a GSA office —many floors, clacking sounds, many important persons. Together with Leon Donat, an architect from the San Francisco office, Don and I drove up to Santa Rosa to see the *building*! The lobby was a hundred sixty feet long, twenty-five feet high, and the outside wall was glass. This space was divided imperceptibly into four sections of forty feet.

We walked up and down and around. Don spoke of a "ceiling piece." I could not see anything I had done hanging in this space. But I . . . knew that if I waited, without impatience, an inspiration would arise out of silence. I chose one of the forty-foot spaces.

Mystical, quiet, and alert, with the ever-present hint of a smile, Tawney listened attentively as the contract was explained. After a thorough discussion and interpretation of its provisions, the specter of *Jaws* receded, and she agreed to accept the commission at a fee of $17,500. As she put it, "Though I did not know what I would do in the space—the next day I signed the contract. *That* contract."

After the negotiations were concluded, Tawney remained in the San Francisco area for some time, and the inspiration for the work arose in much the way she had foreseen. She later described how her concept came into being.

There was a dreadful drought there at that time, I think it was the second year of drought—no rain for two years. The water supply was cut back; there were penalties for overuse. People stole water from each other. . . . Water was sold at high prices by the gallon. Where I stayed, one could not take a full shower but must shower from a bucket and cup, as in India.

All of this finally affected me in such a way that the idea for the *Cloud Series* arose by degrees from somewhere inside. It took shape. It became thirty feet long by sixteen feet high by five feet wide. It was blue, the blue of the sky on a beautiful clear day. Threads fell from this canvas sky at close intervals, over 2,550 threads, which everyone recognized as rain. The threads were linen, three shades of blue, with touches of blue paint from the sky. Before I left California, my inspiration was complete.

As if by magic, the birth of Tawney's proposal coincided with the end of California's drought.

On September 1, 1977, Tawney traveled to Washington, D.C., to make her presentation to GSA's Design Review Panel. With the help of her friend Toshiko Takaezu, herself a distinguished clay artist, Tawney had hung a thirty-inch-square, six-foot-high maquette from the ceiling of the Public Buildings Service commissioner's conference room. At the meeting, Tawney remembers, "The panel discussed fire and water hazards and other unheard-of hazards. In a fireproof building what could happen? Water wouldn't hurt my 'cloud.' After a call to California about sprinklers, it was over, accepted. Now I only had to do it. I had six months, almost."

★　★　★

The process of creating *Cloud Series IV* was a painstaking one. As Warren Hadler (director of Hadler Galleries) commented, "Just to think about all those threads, each one individually handled so often, rolled up, down, painted, dyed, is mind-boggling!" In Tawney's words,

My canvas was painted in a friend's driveway. I had lost my big loft in New York before going to India. I left it in a field to dry.

Then I brought it inside and drew on it a three-inch grid. It was then rolled and placed on a table in the little room in the country which was now my studio. The threads were measured in seventeen-foot lengths and knotted into the canvas, both sides, at three-inch intervals. Each thread was rolled and attached to the canvas to keep order, to be able to roll it without a mass of threads tangling.

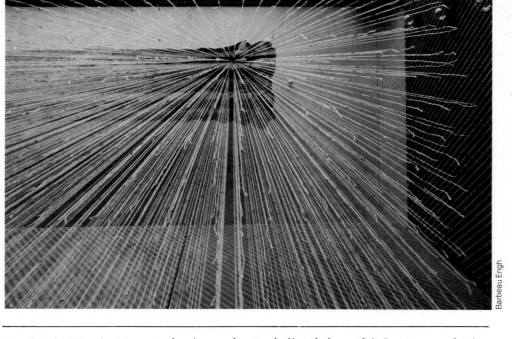

Barbeau Engh

Cloud Series IV *as it appears to the viewer who stands directly beneath it. In a poem-reflection written for the dedication brochure, Tawney said: "I sometimes think of my work as breath. / Breath is life. / Breath moves. It is inspiration and aspiration. In and out. . . ."*

This was the meditation—every morning, every day: threads, measuring, counting, knotting, rolling.

While Tawney was right in the middle of making the work, with a tight time schedule for its completion, disaster struck. "At Thanksgiving I went to the woods for a weekend. The ice threw me, my left elbow shattered into a mosaic. New York Hospital, three-and-a-half-hour operation, cast shoulder to fingers for a month. Can I finish the piece? . . . I am working. I work. Then I know I can finish on time. It is a miracle." By mid-February 1978, the piece was complete.

On February 22, writing to GSA architect Leon Donat in San Francisco, Tawney outlined the installation—an operation almost as intricate as the fabrication process. In an effort to keep the threads straight and make the cloud hang evenly one and a half feet below the ceiling, Tawney planned to fasten nearly invisible monofilament threads to the canvas at 174 places. Metal rings would then be attached to the threads and slipped over ceiling hooks.

Excitement was building in the San Francisco GSA office as the installation date approached. On March 23, Tawney arrived in San Francisco, bringing her friend Jim Lecky to assist her. They traveled to the site, where Donat and Fine Arts Officer Ted Reid had arranged for electric platform lifts to make the job easier. Using these, Tawney and Lecky began the delicate job of putting the thirty-one-pound cloud in place. "Jim marks a twelve-inch grid on the ceiling with chalk. We hang it. Then the work begins. To unroll each thread and let it down, so that each is separate. We spent five and a half long days, until dark, putting it up (or letting it down)," Tawney recalled.

No sooner had the work been installed than the *Santa Rosa Press Democrat* reported, "The fragile blue fiber cloud hanging in the Federal Building in Santa Rosa was conceived during the recent drought by an artist who hoped it might bring us some relief. It appears that what it's brought is an angry storm of complaints from federal employees and others who question both the artistic merit and wisdom of spending $17,500 on 31 pounds of canvas and thread" ("Federal Building Art Project Poses Question 'Do They Mix?,'" March 31, 1978). The writer of the article Sophia Jensen, recorded some typical comments: "That horrible whatever, overblown life raft"; "My personal opinion is that it's unpleasant and I

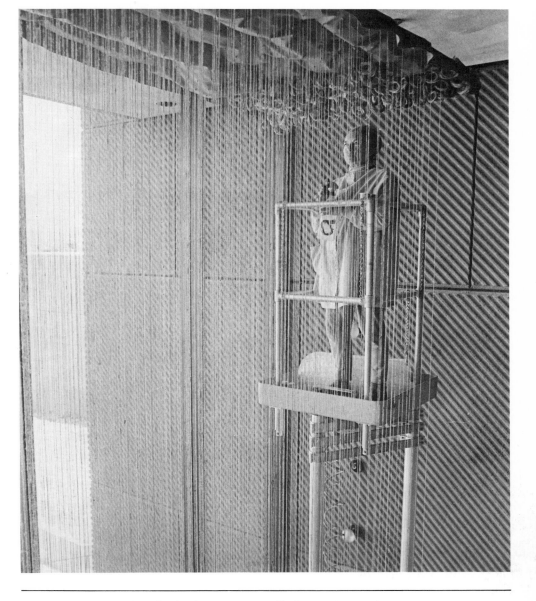

Cloud Series IV *during the final stages of installation. Using a platform lift, Tawney painstakingly unrolled each individual thread. The entire process took five and a half days.*

hate to see another agency spend money on this when we have inadequate supplies and equipment."

The art community, however, was quick to recognize in *Cloud Series IV* a beautiful addition to the city, and the Santa Rosa Arts Council formed a coalition of individuals and arts organizations to join GSA in dedicating the work on May 24. Music was provided by the Music Performance Trust Fund of the Santa Rosa Musicians Union (Local 292), wine by the Sonoma County Arts Council, and a slide show of Tawney's work of the past twenty years by Tawney herself. Afterwards she wrote, "The dedication took place . . . among orchids and roses and a crowd of two hundred. They are beginning to hate it less." The day after the ceremony, Martin Pearlmutter, GSA's director for business affairs in San Francisco, reported on the enthusiastic reception of Tawney's talk and slide

show, which lasted for more than an hour. "There was hardly a murmur or a cough to be heard during the entire time; the audience was never restless and was under Lenore's spell," he wrote to the Washington office.

For Tawney, the creation of *Cloud Series IV* was laborious and time-consuming, but the effort was abundantly repaid by the result. Until the installation, because of the size of the work, she had never seen it in its entirety. When it was finally in place, floating ethereally from the ceiling, she was thrilled and moved. "For the first time I see my work," she wrote.

I think it is beautiful. It is not mine. It is a gift.
Now we celebrate. We go to Yosemite.
We climb a high mountain. We walk among waterfalls.
We are at the top, lying in a waterfall. At the source.

ISAMU NOGUCHI

Michio Noguchi

Isamu Noguchi [signature]

On the morning of July 23, 1974, a panel appointed by the National Endowment for the Arts met in the office of Fred Bassetti, design architect for the Seattle Federal Building. Bassetti had recommended several artworks for the building, with the emphasis on a sculpture "of horizontal composition and of bronze or dark stone." It was the panelists' responsibility to nominate appropriate artists for the commissions. Though they worked until nearly midnight to complete their task, they quickly and unanimously agreed upon Isamu Noguchi, for the main commission, and he was subsequently selected by the GSA.

The contract was negotiated at Noguchi's Long Island City studio in November, and it was one of the most emotionally draining negotiation experiences I have ever had. It was the first time I'd met the internationally acclaimed Noguchi, and I couldn't help but feel reverent in his presence. Although cordial, he seemed somewhat formal and distant, and his healthy intolerance for bureaucratic detail didn't make things any easier. For example, when I asked him how much time he would need to develop his artistic concept, he replied that he found such a "stupid question" difficult to answer. He said that artistic inspiration might take "five minutes or five years" and asked me to put that in the contract. Then his eyes seemed to twinkle, and he agreed that 150 calendar days would be sufficient for the proposal, with the work to be completed and installed within 270 calendar days after he signed the contract.

In April 1975, Noguchi transmitted photographs of the work as it stood in his studio garden on the island of Shikoku, Japan. It consisted of five carved natural granite boulders covering an area thirty feet by fifty feet, and ranging in height from one foot six inches to eight feet three inches, with a total weight of twenty thousand pounds. In the accompanying letter, Noguchi wrote, "You will note from the photographs that the composition is predicated on the particular site, on the location of the trees and the old arch, the direction of traffic toward and from the entrance, from the street and up the steps, . . . and the view from all these points. The composition in a sense will be completed by all the factors of use over the years." On the basis of the

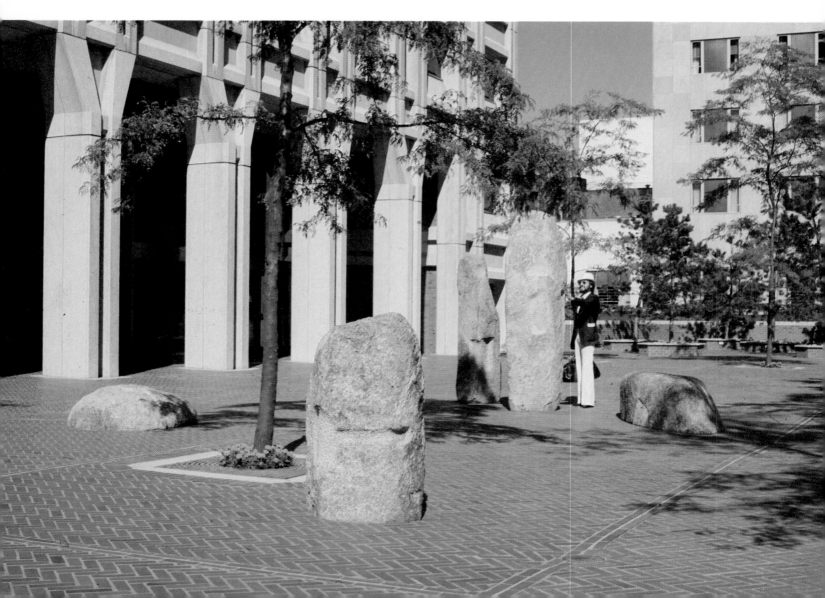

photographs, the GSA Design Review Panel approved the proposal, and Noguchi proceeded with final plans for the shipping and installation of the work.

The five-piece environment of pinkish granite arrived in Seattle in August. It was originally to be placed on a raised podium, but Noguchi decided to eliminate this feature. With the boulders on the ground, he pointed out, "the sculpture [is] less restricted; people will be able to walk at will between them, and there will be no hindrance in the circulation. Viewed from the street, the plaza is itself a podium, and another one on top would be a redundancy." Cranes hoisted the ponderous boulders onto the site, and as Noguchi supervised the placement and grouting, a full rainbow arched across the sky as though to consecrate the moment. Isamu Noguchi had fulfilled his covenant with GSA.

★ ★ ★

On September 9, 1975, Noguchi returned to Seattle for the formal dedication, which was one of the most dignified ever conducted by GSA, thanks to Noguchi's efforts. He had tied a rope around the boulders, and to the accompaniment of contemporary music played by the Floyd Standifer Sextet, several dancers began a modern ballet to "unwrap" the rocks. In his speech, Noguchi explained the significance of the rope and discussed the meaning of his work.

. . . I called up . . . a theatrical fabric supplier (in New York) and said, "Look, I got a rope from you forty years ago. Have you got one like it?" They said yes. I went down and got it. Forty years ago exactly, I did my first set for Martha Graham. It consisted of this one-inch (in diameter) cotton rope which went from the back of the stage at the center to the top of the proscenium in front and bisected the space of the theater in an extraordinarily three-dimensional perspective so that you felt that the whole volume of the theater space came out at you.

The continuity of time is most important for us, and that everything—old buildings, old friends, old acquaintances, new acquaintances—all have a continuity which eventually brings meaning to life. . . . our whole life is made up of continuities, and this rope which ties things together—that also is a linkage.

. . . I wanted to do something that I really sincerely believed is the necessary future step—my next step, so to speak. . . . This is not a Japanese rock composition. It is not a Stonehenge. . . . the trees are part of the composition. I mean all of nature, everything about us, around us, relates to ourselves, and that is why I call it *Landscape of Time.*"

★ ★ ★

No sooner had the work been dedicated than the GSA came under fire for "wasting tax dollars on that junk you call art." Writing in the *Seattle Times* on September 18, 1975, John Hinterberger weighed in with his objections under the droll headline "A Work of Art No One Will Take for Granite."

Rocks.
Five rocks.
Five pink rocks.
Five pink rocks at $20,000 a rock.
A hundred thou for five pink rocks and I bought them.
Don't sneer. You did, too. . . .

I know quite a bit about rocks. All of my life I have been involved with rocks. Big rocks I climbed; little rocks I threw. In the army I painted rocks.

Having thus established his critical credentials, Hinterberger ended by saying, "We must have rocks in our head!" To nobody's surprise, the *National Enquirer* eagerly if somewhat belatedly chimed in on February 3, 1976. What *was* surprising was that a U.S. congressman, Ted M. Risenhoover, wrote the article, linking Noguchi's sculpture to "a pet rock craze sweeping the country," and adding, "In my home state of Oklahoma, they mine granite and sell it for about $5.50 a ton. Based on that figure, a reasonable price for our 'work of art' in Seattle would be about $44."

In light of the *National Enquirer*'s vast circulation, it was little wonder that hostile letters began to pour in. The art-in-architecture staff tried to answer each one carefully, but in the end it was Noguchi who was best equipped to reply to his detractors. In January 1976, he wrote a long letter describing the expense and effort that went into *Landscape of Time.* He pointed out that the

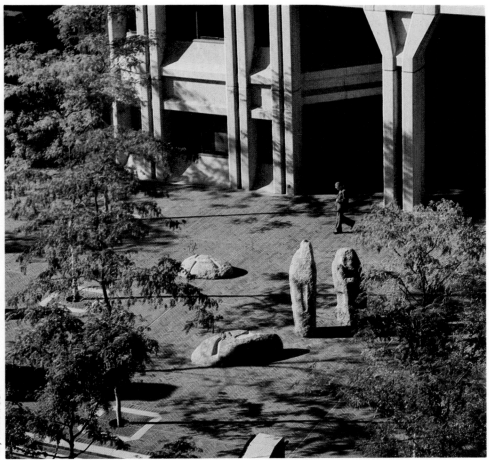

Two views of Isamu Noguchi's Landscape of Time, *a five-piece granite sculptural environment created for the Seattle Federal Building in 1975. Noguchi estimated that he examined some sixty tons of natural boulders before finding five that suited his purposes. The stones were carved at his island studio in Japan and shipped to Seattle for installation.*

Mary Randlett/GSA

work was based not on quarried granite but on natural boulders that had to conform to the requirements of the total conception. The task of locating suitable boulders and trying them out in a mock-up of the site was a formidable one, and Noguchi estimated that he made three search trips and transported sixty tons of boulders before he found exactly what he wanted. Only then could he proceed with the carving—another painstaking process.

. . . The actual act of carving . . . is a give-and-take intimately involved with the placement of the stones, their contact to the earth, the paving, their relationship to each other and to the sculptor. The carving is thus improvisational and cannot be predetermined. It is the Zen of sculpture, where the stone and the artist is one.

I must say it is not pleasant when the artist is criticized for what in his search he thinks leads to the best—a reconciliation with nature and not pretentious monuments.

Fortunately, Noguchi's critics were not the only ones to make themselves heard. GSA's confidence in him never wavered, and Vice President Nelson Rockefeller publicly applauded his efforts in a letter that was read at the dedication ceremony. "I was pleased to see that the marvelously gifted Isamu Noguchi had been commissioned . . . to create a sculpture for the plaza of the Seattle Federal Building," he wrote. "It is rewarding to see works of this caliber becoming part of our federal buildings for the benefit of all the people." Just after the dedication, influential Seattle architect Ibsen Nelsen wrote to thank GSA "for an outstanding event, and even more important, for a great work of art in this city." And Victor Steinbrueck, describing the quality of the boulders as "both gentle and overwhelming," said, "A marvelous and wonderful thing has occurred in downtown Seattle. . . . Noguchi has transformed an already pleasant space . . . into a very special aesthetic experience" (*The Arts*, October 1975). One of the

most sensitive appreciations of Noguchi's sculpture came from actress Marjorie Nelson (*Northwest Arts*, October 10, 1975):

The stones—five—emerge miraculously placed through and beyond the busyness and indifference of the metropolis, creating an urban oasis—a wellspring of quiet serenity and great power. . . .

I have been drawn back to the stones many times since I first viewed them. . . . They always surprise and delight me with their quality of stillness as they elusively move and change with the day and the season. I find them hauntingly beautiful, and I feel that I have never been so affected by another work of modern sculpture. . . .

[Noguchi's] "step forward," placed lovingly in Seattle's downtown, pays our city a great honor.

What price could we pay for his artistry?

It is priceless and it is with us.

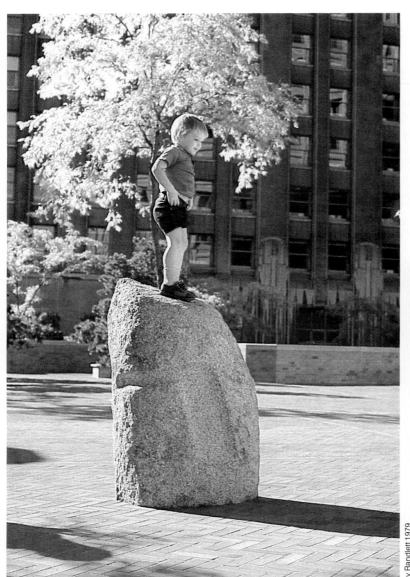

© Mary Randlett 1979

Left and below: For those who pass through the plaza, Landscape of Time *represents—in some cases, quite literally—a stepping-stone to aesthetic experience. For Noguchi, it was a kind of milestone. "I wanted to do something that I really sincerely believed is the necessary future step—my next step, so to speak," he said. "There may be other steps, but, you know, one comes a long way and keeps taking one step after another, and this is my ultimate step. . . ."*

Opposite, top: The carved boulders awaiting shipment to Seattle at Noguchi's studio on the island of Shikoku, Japan.

Opposite, bottom: A passerby rests contemplatively on one of Noguchi's boulders. Reflecting on Landscape of Time *in* Northwest Arts *(October 10, 1975), Marjorie Nelson was moved to quote Walter Gropius: "We should compare with each other the deeper motives of our existence in order to find out what unites us rather than what divides us."*

©Mary Randlett 1979

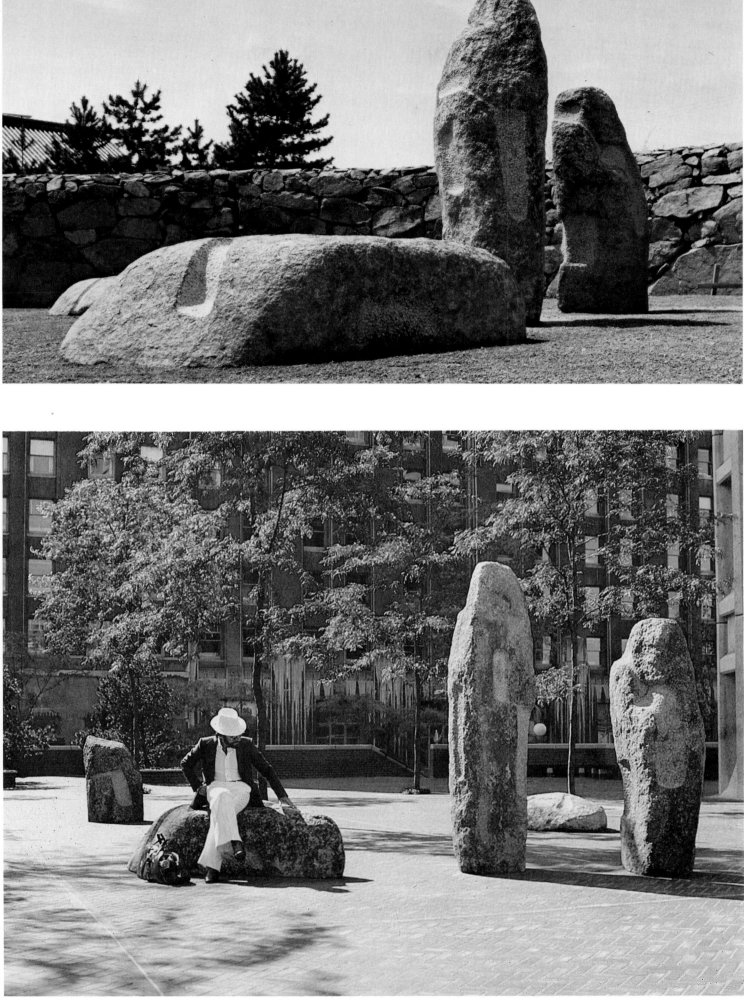

HAROLD BALAZS

Several years before Harold Balazs was selected to do the sculpture for the west plaza of the Seattle Federal Building, he was asked by the project's architect, Fred Bassetti, to give a statement about the kind of proposal he might make and about his work in general. Balazs's response:

If there is one question in the contemporary art scene that stands out, it has to be "What is it?" or one of the two million variations on that same question. The question has been put to me many times, and the answer gets harder all the time.

Basically I answer as follows when anyone asks, "Why put art in public buildings?" At any given time within a society, I suppose it is possible to determine what percentage of the people are actively interested in watching ballgames, going fishing, going hunting, reading books, etc. The state has in varying degrees helped in providing ballparks and arenas, buying access to lakes, stocking pheasants, providing libraries, etc. I maintain that the state can therefore logically provide works of art for the percentage of the populace so interested.

Since some would rather fish for stingrays while others prefer trout, the state provides both. If, in the selection of public art, the state becomes censor, we have done wrong. For, if we profess freedom, the state must take a chance on the artist and his work. I maintain that our "national theme" is freedom and that any serious artist will respond reasonably to that kind of license. . . .

If you ask me what would I do for a federal building, I can only reply, "Something I hope people will come to enjoy living with." No more promise than that—and I would like to think our government has the courage to take that kind of a chance.

The government did take the chance. On October 15, 1974, Administrator Sampson, acting on the recommendations of GSA's Design Review Panel, selected Balazs from the list of nominations provided by the National Endowment for the Arts.

★ ★ ★

Harold Balazs was born in Westlake, Ohio. A resident of Washington State since 1949, he has been a self-employed "sculptor, craftsman, designer" since 1951. He has worked in nearly every material imaginable, making sculptures of steel, concrete, carved brick, copper, wood, and porcelain. Much of his work was commissioned for churches (enamel doors, baptistry gates, crucifixes, grillwork), schools (benches, wall designs, free-standing and wall-mounted sculpture), and a wide variety of other projects (such as a rock-and-concrete pool bottom for the Washington Water Power Company, brass and copper screens for the Seattle Opera

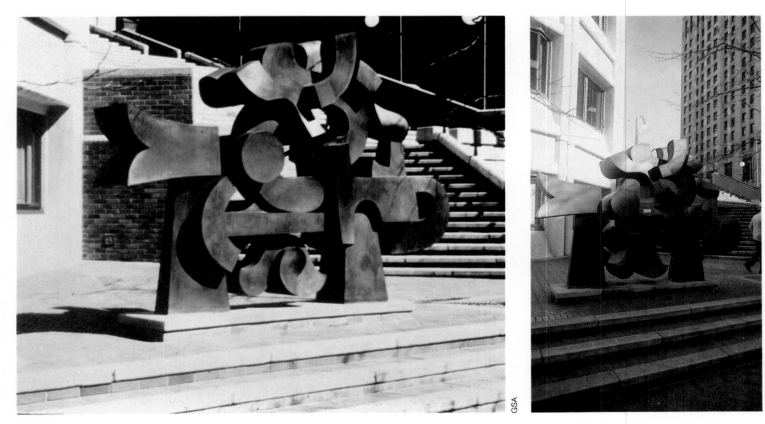

House, and a tapestry for Farm Credits Bank in Spokane). Indeed, to say that Balazs is versatile is something of an understatement. In 1960 he was named Craftsman of the Year by the Seattle American Institute of Architects (AIA), and six years later he won the national AIA Gold Medal for Architectural Craftsmanship. Since then, he has continued to receive sculpture commissions from both the public and private sectors.

The Seattle sculpture was Balazs's second GSA commission; the first, a wood screen for the lobby of the federal building and post office in Richland, Washington, had been awarded under the present program's forerunner (1962 – 1966). Balazs was happy to learn of his selection, and additionally pleased because he hadn't expected it. As he later wrote, ". . . that Seattle project had been brewing for about six years, and the artists Fred [Bassetti] had recommended met with some disapproval in some quarters. . . . There were articles around Seattle saying all sorts of things. The last one I bothered reading had a list that did not include me, so I figured that was that. So I *was* surprised when I got the word that I was one of the chosen."

In January 1975 the contract was negotiated in Seattle for a fee of $11,000, and the following month it was awarded through the GSA regional office in Auburn, Washington. Balazs, one of only three artists ever to receive a second GSA commission, contrasted the Art-in-Architecture Program favorably with its predecessor. "Going over the contract was a pleasant surprise. During the other GSA thing I had done about ten years before, I got the feeling that only the building designer cared about what happened. . . . but [now] I was dealing with someone knowledgeable and sympatico to the art and the artist."

By the end of June, Balazs had completed a maquette and submitted it through the Auburn office for consideration by GSA's Design Review Panel. It was made of painted styrofoam. "I do not like making fancy models," Balazs later explained. "I grew up in the Depression on a farm, and I guess I shall always be frugal. So I was glad you accepted my chintzy painted styrofoam so I could put more effort into the actual piece."

The completed sculpture, titled *Seattle Project,* was installed on March 1, 1976, without incident. According to Balazs, "Installation was relatively smooth, as my erections go. I usually have millions of snafus." Public reaction was relatively favorable, although a number of people at the installation raised the burning question of contemporary art that Balazs had pinpointed in his original statement for Fred Bassetti: "What is it?" The sculptor was undismayed. "The jeers, catcalls, and snide remarks were no more or less than I have ever encountered anywhere else," he recalled, adding the following footnote:

Some apes climbed all over it and wracked it back and forth, rupturing a couple of welds. So I went over to repair it, and as I was doing so, a sweet little old lady came and asked if I was taking it away. When I told her no, she said she was so glad; when it was first put up she thought it was just awful, but now that she had been walking by it every day it had become like an old friend. Several other people allowed the same.

I should also like to say that I visit it occasionally and find that it is very nicely taken care of. It is always free of dust, etc., and has a lovely hand-rubbed look. So someone is looking after it well.

Opposite and below: Three views of Harold Balazs's Seattle Project, *one of three sculptures commissioned for the Seattle Federal Building. Balazs, a sculptor and craftsman whose work has been influenced by Oriental art, accepted the Seattle commission in January 1975, and the completed piece was installed in March 1976.* Seattle Project *is made of welded copper internally weighted with concrete in the bottom sections. It measures eight feet high by two feet six inches deep by eleven feet six inches wide and stands in the building's west plaza. Balazs constructed the sculpture in sections, and it was assembled at the site. "If I had made it all in one piece, it would have been more sound structurally but would have caused more expense in erection and installation," said the sculptor.*

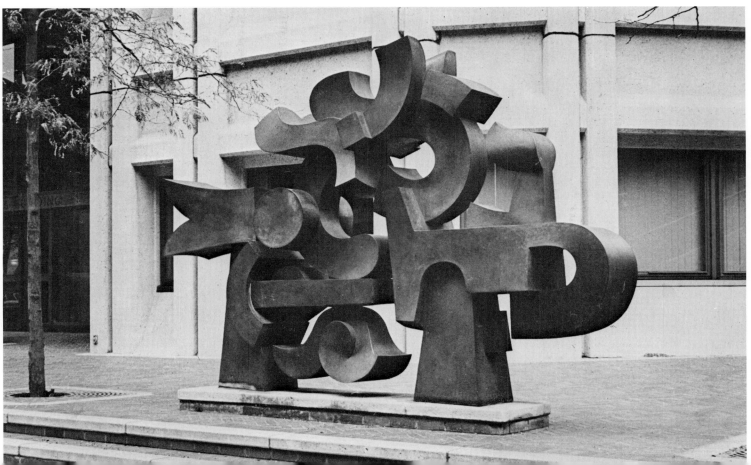

From the very first, Fred Bassetti envisioned artwork as an integral part of the Seattle Federal Building, for which he was the principal design architect. Bassetti prepared a fine arts proposal for the building in 1971 and submitted it to GSA on behalf of the joint-venture architectural firm of John Graham and Company/Fred Bassetti and Company. The proposal, in the form of a bound booklet containing statements from artists and color photographs of artworks, was in itself a creative achievement, as well as a powerful argument in favor of public art:

> The reason to have artworks in and around our buildings is the same as the reason for art itself—to interpret our world and ourselves visually. It is literature, it is the drama, it is music, speaking to us graphically. Public art should not, however, be commissioned primarily to embellish buildings, although that purpose should not be disregarded. Its primary purpose is that it enlighten us.

Bassetti wanted artists from the Pacific Northwest to create several types of works he had incorporated into the design of the building. At the time, however, GSA's fine arts program was inactive (it had been "temporarily suspended" in 1966 and was to remain dormant until late 1972). Along with his specific suggestions, Bassetti therefore included a plea that GSA reactivate the program. "This administration has recently taken very bold steps in other areas of public concern. We urge that it be equally bold in adoption of this program." Although several years elapsed before Bassetti's proposal for artworks was implemented, it was in large measure due to his foresight and strength of conviction that the Seattle Federal Building was not overlooked when GSA renewed its commitment to art in architecture under a revived program of that name.

★ ★ ★

Among the artists originally recommended by Bassetti was sculptor Philip McCracken, a native of Washington State. McCracken was then living on Guemes Island, a dot of land off the coast of Washington, where he had spent many boyhood summers at his family's cottage. His reputation as a sculptor extended far beyond the confines of the Pacific Northwest, how-

PHILIP McCRACKEN

©Mary Randlett 1979

ever. In 1954, Henry Moore accepted McCracken as an assistant in his studio in England. McCracken's work was subsequently exhibited throughout the United States and Canada, with one-man shows at the Seattle Art Museum (1961), the Art Gallery of Greater Victoria, British Columbia (1964), and the LaJolla Museum of Art, LaJolla, California (1970), among others. His work has also appeared in group shows at the Chicago Art Institute, the Detroit Institute of Arts, the Dallas Museum of Contemporary Art, the Portland Art Museum, the Walker Art Center in Minneapolis, the San Francisco Museum of Modern Art, the Museum of Modern Art in New York, the Corcoran Gallery in Washington, D.C., and the Grand Rapids Art Museum, to name only a few. This broad recognition is all the more significant in light of his geographical isolation from the hub of the national art scene in New York.

Bassetti presented McCracken's work for the consideration of an NEA-appointed panel that met in his office on July 23, 1974. The panelists nominated McCracken and three other sculptors for an exterior work to be located on an intimately scaled plaza—one of many such mini-plazas within an elaborate series of stairs, ramps, and terraces extending along the entire south side of the building. In addition to visual material, Bassetti introduced a statement by McCracken (from a catalogue prepared by the Willard Gallery, New York, for a 1968 exhibition) that provided insight into the sculptor's philosophy:

> In certain recent work I define as specifically as I can the elements of life and the human condition that I find the most perplexing and arbitrary. They are social commentary but only in that they relate to the vast and senseless incongruities found throughout our brief life on earth. They are not anti-social com-

mentary, for they are meant to explore and decode and so to understand something of our mystery, not to condemn it. They are sample cores taken from beneath intended meaning and beyond available memory. . . .

> Now . . . I am in a new mainstream of experience and discovery. One aspect of this has been the translation of the *instant of occurrence* into a constructed physical presence. The instant someone tells you they love you for the first time; the instant before an automobile accident; the instant you see your first-born child; the instant you realize you are being shot at. These moments in experience that call forth the full mystery of the blood and the species. The deep penetrating awareness that so quickly disappears beneath the surface of consciousness, *key* instants of experience.

On September 25, GSA's Design Review Panel recommended McCracken for the commission, and the following month Administrator Sampson approved his selection. However, availability of funds for the project was uncertain until the following spring, when an $11,000 contract was negotiated with McCracken for the design, execution, and installation of the work. In August 1975, McCracken submitted photographs of his maquette to GSA's Design Review Panel, which approved the proposal.

Working at the site, McCracken determined both the scale and the position of the sculpture in relation to the limited space and pedestrian traffic. The completed work, titled *Freedom*, is of cast bronze on a cast-concrete base approximately four feet high, tapering from two feet square at the bottom to one foot two inches square at the top. Together, the sculpture and base are slightly over five feet high. According

to McCracken, *Freedom* "is not intended to represent a specific religious or political condition but is meant to be translated into terms each viewer personally sees as representing his own freedom. The ancient medium of cast bronze has an unmistakable authority that I have immense respect for. It is a powerful, fluent, and unambiguous form carrier. It is also very durable and relates well with the other materials used in the federal building." McCracken said he devoted the same care and attention to *Freedom* as a public sculpture that he would have given to a work destined for a museum or private collection, except that he felt "a further obligation to have the sculpture meaningful to a broad spectrum of viewers who may be compelled to look at it during the course of their everyday activities."

Freedom was installed in October 1976. Nearly a year later, McCracken reflected on his GSA commission in a letter to Administrator Solomon:

> In reviewing the experience . . . I find that it was [not only] a challenging project, but a positive and valuable one also in terms of human relationships. The people I worked with from GSA were outstanding. . . . As far as I know there has been no historic basis for mutual trust between artists and government, but it worked for us. The contract and its administration were fine.
>
> I think that keeping the program flexible, able to grow in divergent ways, is important. Here is a case in which a resolution of direction should not be sought after or crystallized into a fixed program and approach. It should be kept open so it can respond to the new directions and needs of artists.

©Mary Randlett 1979

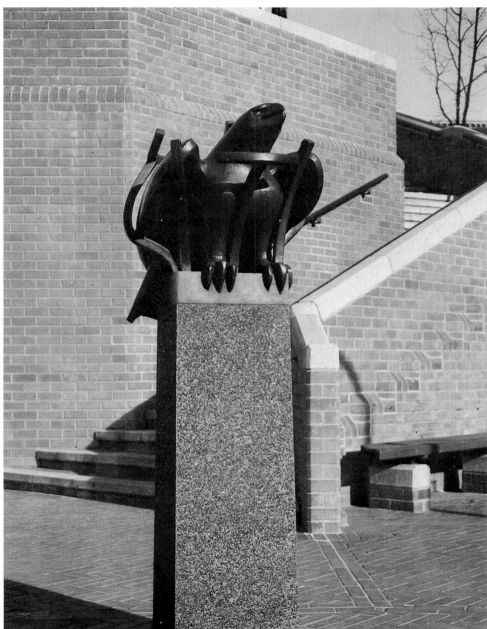

©Mary Randlett 1979

Philip McCracken's Freedom, *a cast-bronze sculpture for one of the mini-plazas along the south side of the federal building in Seattle, Washington. In McCracken's own words, "This sculpture is among the first in a reappearance in my work of bird forms, which have been absent from it since 1966. Although I have done many bird-form sculptures, specific birds seldom appear in my work, and that is true of this piece. It is* birdness *as a vehicle for the expression of a vast range of life currents that interests me." Commissioner Nicholas A. Panuzio of GSA's Public Buildings Service called* Freedom, *which was installed in October 1976, "an important and appropriate symbol of the Bicentennial" and "an example of a well-balanced art program, . . . a program that offers the best in both figurative and abstract contemporary art."*

In September 1973, the Los Angeles architectural firm of Honnold, Reibsamen and Rex submitted its fine arts proposal for the federal building and post office in Van Nuys, California. Writing on behalf of the firm, architect Jay W. Nickels recommended "a major sculpture piece, contemporary in style and preferably of a material which would contrast in color and texture with the masonry and cast stone visually predominant in the building complex." Nickels, a young architect with a clear admiration for modern art, added that the forecourt to the west of the building had been designed for a sculpture that "would serve as a focal point . . . of the principal future pedestrian gateway into what will become the San Fernando Valley Government Center." The GSA regional architect in charge of the project, Dick Clayton, reviewed the proposal, adding in his transmittal letter to GSA in Washington, D.C., that the sculpture should be "bold in its elements, and without fussy details." It was almost as though all concerned had set out to describe the work of Lyman Kipp.

Kipp, a young sculptor relative to his international reputation, has been called "one of the first Minimalists in sculpture" (*Contemporary Art 1942–72*, Albright-Knox Art Gallery, Buffalo, New York, 1973). At twenty-five, he was producing works for the Betty Parsons Gallery in New York, and he has since had numerous one-man shows in cities from Boston to Houston. His work was featured in group exhibitions at the Baltimore Museum and the Detroit Museum of Arts and is part of the permanent collections of the Whitney Museum of American Art, the Storm King Art Center, the High Museum of Atlanta, the Chase Manhattan Bank, and the Massachusetts Institute of Technology, among others. His serious and visually adventurous approach to sculpture has influenced countless artists who have studied under him at Bennington College, Pratt Institute, Dartmouth, and Hunter College, where he was chairman of the art department.

★ ★ ★

On April 19, 1974, an NEA-appointed panel chaired by Richard Koshalek (currently director of the Hudson River Museum in Yonkers, New York) nominated several artists for the Van Nuys commission, among them Lyman

LYMAN KIPP

Kipp. After studying the nominations, GSA's Design Review Panel recommended Kipp, and he was subsequently selected. Notified by telephone, he traveled to Washington, D.C., in September to negotiate the contract. As he recalls,

> . . . I must say I had no idea that I was being considered, and the feeling of elation over the fact that I was given this commission was overwhelming. I . . . went to Washington to discuss the fine points. I of course accepted the commission

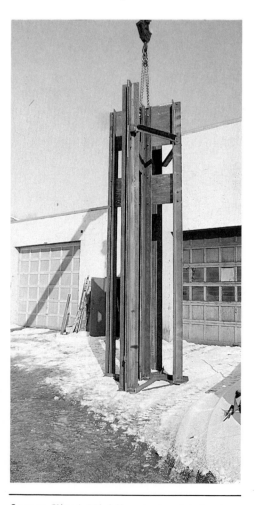

Lyman Kipp's Highline *during fabrication. Subsequently painted in vibrant red and blue, the piece weighs 3,800 pounds and consists of 15 steel units bolted together.*

in spite of the low amount of money involved. Afer signing the contract, I flew to L.A. to inspect the site and meet the architect, Jay W. Nickels. . . . I was given plans of the building and a site plan . . . marked with an *X*—the "spot" for the sculpture.

Having thus gained a firm idea of where the sculpture was to go, Kipp began looking for potential fabricators on the West Coast. He had no success and consequently decided to return to the East, where he was familiar with a number of fabricators. Back in his New York studio, he began designing maquettes for the Van Nuys commission and eventually chose one called *Highline* as best suited to the site and its surroundings.

GSA's Design Review Panel approved Kipp's maquette, and after getting estimates from several fabricators, he chose Segre's Iron Works in Waterbury, Connecticut. The fabrication proceeded smoothly, and *Highline* was complete and ready for installation by the summer of 1976. GSA issued an enthusiastic press release to herald the event, which Kipp later described as follows:

> [*Highline*] was shipped as painted steel to Western Ornamental Iron Works in Los Angeles, where it was reassembled, trucked to Van Nuys, and erected on the plaza. (I spent three weeks in L.A., the first two waiting for the sculpture to arrive—I found out later it had changed trucks.) The weather was fantastic, except for the day it was erected—of course, it rained. . . .
>
> I started to paint the flat shapes red with the assistance of Nick Spina, a former student and assistant of mine in New York, now living in Santa Barbara. The next day we painted the verticals blue

and completed it late that afternoon. The following day I photographed *Highline* and proceeded back to New York via San Francisco.

★ ★ ★

Throughout the commission, Kipp had gone out of his way to accommodate GSA. In the first place, he'd accepted a contract with a maximum budget of $15,000—well below his market prices, and certain to negate any chance of profit. He was thoroughly professional in developing his work, sparing no effort and executing the sculpture to his usual exacting standards. All along he wrote to GSA officials in Washington and San Francisco to keep them informed of his progress. It was somewhat mind-boggling, therefore—both to Kipp and to the other GSA officials involved—to read the blunt language of Eisei Kato, GSA's regional contracting officer, who had written to Kipp on July 8, 1976.

Stating that the sculpture needed grouting under the upper bases and dry packing between the angles, Kato said in part, "You must correct, immediately, all of the above and any and all other defects which are not in accordance with the contract requirements. Until all corrections are made, approved and accepted by the Government no further payment will be made." Though annoyed by the brusque and imperious tone of the letter, Kipp quickly took steps to "correct the defects." Western Ornamental Iron Works modified the installation in August, informing Kipp by memo ("Re: Your Van Nuys Headache") that GSA inspectors had approved the work, and expressing the hope, "for your sake, and ours, that it is now behind us."

Undaunted by his encounter with bureacracy, Kipp later wrote GSA, including advice on the maintenance of the work (". . . the paint used is Sherwin Williams Kem Lustral Industrial Enamel in Vermilion and Bright Blue"), and graciously thanking the agency "for the opportunity to make this sculpture, which is a strong piece and an addition to the site." As for so many artists, the creative opportunity afforded by the Art-in-Architecture Program remained paramount in his mind: "The experience 'government rules/ regulations/red tape' was something to deal with but was overcome with the realization of the sculpture existing in a public space."

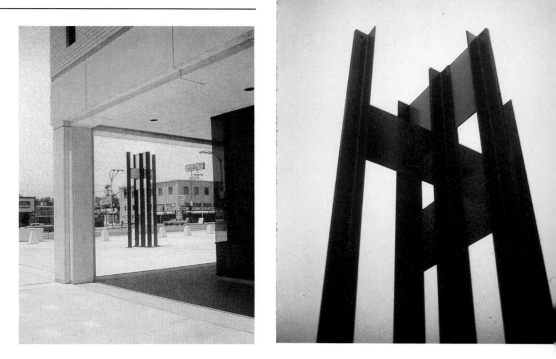

Three views of **Highline** *after installation. "It has been designed to give human perspective and color to the plaza," says the sculptor. "The piece 'reads' from a distance, yet the intricate inner space offers another interesting, more personal dimension."*

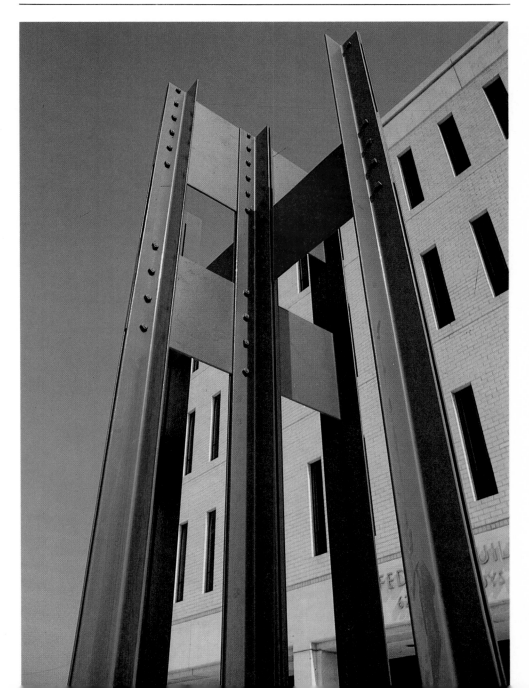

HUBERT H. HUMPHREY BUILDING

"You can't pin a label on Marcel Breuer, one of the foremost architects of our time, and most likely our foremost living architect," wrote architecture critic Wolf Von Eckardt (Introduction, Marcel Breuer exhibition catalogue, Metropolitan Museum of Art, 1972). Indeed, the versatile Breuer, though primarily known for his distinguished architectural work and revolutionary furniture designs, has maintained a vigorous commitment to the visual arts throughout his career. "It must be remembered that Breuer's youth emphasized an interest in painting rather than architecture," said Breuer's longtime associate and friend Herbert Beckhard. "In recent years," Beckhard added, "even before his retirement from the practice of architecture in 1976, he has had an opportunity to work as a sculptor and as a designer of tapestries."

Breuer designed the federal facility that houses the Department of Health, Education, and Welfare in Washington, D.C. His broad background and diverse artistic interests appeared to provide a golden opportunity to integrate art and architecture. Beckhard, who coordinated the HEW project for Breuer's office, submitted the fine arts proposal for the building in December 1974. "It is somewhat incumbent upon architects to include sculptors and painters when they can," he wrote. "This was recognized by the Greeks, Romans, in Romanesque and Gothic architecture and during the Renaissance. We hope that . . . sculpture will be a part of this important government building."

GSA's Art-in-Architecture Program fully shared this hope, but the ways of government are often tortuously slow. Almost a year had passed before the requisite clearances were obtained

and an NEA-appointed panel could meet to nominate artists for a sculpture commission at the HEW building.

Beckhard had proposed a sculpture of monumental scale for the building entrance lobby. Aware that $172,000 was available for artworks (one half of one percent of the building's construction costs), the NEA panelists asked Beckhard if he had also considered an exterior sculpture for the large plaza. He responded affirmatively but said he thought the funds were insufficient for two major pieces. The panelists convinced Beckhard that there was money enough for both works, but at this juncture Karel Yasko, GSA's counsellor for fine arts and historic preservation, stepped in, insisting that the panelists work on the basis of Beckhard's original proposal. Thus, sculptors were considered only for the interior lobby space.

Subsequently Beckhard began having second thoughts, which he conveyed to Yasko in a letter dated March 4, 1976. "Breuer and I have had additional dialogue concerning the possibility of an outdoor sculpture, . . . and in fact our feelings towards the outdoor sculpture have become rather positive," he wrote. "A good sculpture would help to activate this public area, which in fact, at this time, appears as a rather large and empty space." Economics permitting, Beckhard advocated both an exterior and an interior sculpture, but "if it comes down to one sculpture only," he concluded, "then I would say that our sentiments at this time lean toward the outdoor sculpture. Time flies by. We would appreciate hearing from you about this."

Time was indeed flying by, and with it the opportunity to commission works for the HEW building. By the summer of 1976, two decisive events had intervened to alter the entire character of the project. First, GSA's new administrator, Jack Eckerd, had reduced the fine arts budget to three eighths of one percent ($129,000 in this case). Responding to congressional criticism of the Art-in-Architecture Program and adverse public reaction to certain artworks, he had also placed a moratorium on new commissions until artist selection procedures could be reviewed and overhauled. Second, in August 1975, Congress had enacted legislation (Public Law 94-91) eliminating from GSA's budget for fiscal year 1977 funds for certain projects (including this one)

Clockwise from top: James Rosati, Jan Yoors, Marcel Breuer, and Annette Kaplan, the four artists whose works grace the Hubert H. Humphrey Building in Washington, D.C.

that were not obligated as of September 30, 1976. Unfortunately, this provision was not announced until July 29, 1976, when the Public Buildings Service sent a memo to all GSA regional administrators.

Thus, with barely two months left before the cutoff date, the question of exterior sculpture versus interior sculpture paled to insignificance before the stark fact that it would be impossible to commission any sculpture at all. However, there was still a possibility of directly purchasing completed works, as had been done in New Orleans. In mid-August, GSA decided to follow this route.

At this point, an SOS went out to the NEA, which was now faced with assembling an entirely new panel—a task that proved more arduous than usual because of the tremendous time pressure. The NEA also had to comply with the revised procedures that emerged from Administrator Eckerd's review of the Art-in-Architecture Program (these required greater community involvement in the selection process in order to minimize the risk of negative reaction). In addition, the panel had to be tailored for the evaluation of a completely different art form, because in the meantime, Beckhard had modified the proposal; it now included only tapestries, as "the severely limited time would

make the selection of a sculpture most difficult."

On September 20, only ten days before the deadline, Beckhard met with the second NEA panel. The session opened with a venting of frustrations about the haste of the procedure and the types of art being considered. Everyone agreed to make the best of the situation, to find the most appropriate and distinguished artworks possible, and to include sculpture among the selections. After hours of looking at slides, the panelists presented their recommendations to Nicholas Panuzio, commissioner of the Public Buildings Service, who subsequently chose three tapestry artists and one sculptor: Marcel Breuer (tapestry for the lobby), Jan Yoors (tapestry for the lobby), Annette Kaplan (tapestry for the cafeteria lobby), and James Rosati (sculpture for the east front plaza). With the exception of the Kaplan tapestry, which had been completed in 1974, the works had been designed but not executed to the desired scale.

Once the selections had been made, GSA's Julie Brown negotiated contracts with the artists with record speed. Just in the proverbial nick of time, the funding was saved from an untimely demise, and the HEW building acquired four distinguished artworks.

★ **JAMES ROSATI** ★

The most visible of the four works is the sculpture by James Rosati, "one of America's most accomplished sculptors, . . . an artist of deep convictions, probing intellect and poetic sensibility" (catalogue introduction by William C. Seitz, director of the Rose Art Museum, for the exhibition James Rosati Sculpture 1963–1969). In the course of their deliberations, the panelists had seen a slide of Rosati's *Shore Points I*, first conceived in 1966, and fabricated by the Lippincott company in 1968. They thought an enlarged version of the piece would work well in the plaza, and Rosati was asked to make a sculpture one and a half to two times the size of the original. He agreed to do so, later writing,

. . . The problems to resolve were primarily scale and color, and that I did not wish it to be a decorative fixture or just fill in a space. The building, being of prefab concrete, was a drab and deadly color. The driveway was designated by awesome, ferocious concrete pylons reminding me of the Maginot Line.

Since my sculpture has no front view, no back view, it became apparent to me that scale and color must be united as one. Non-color—

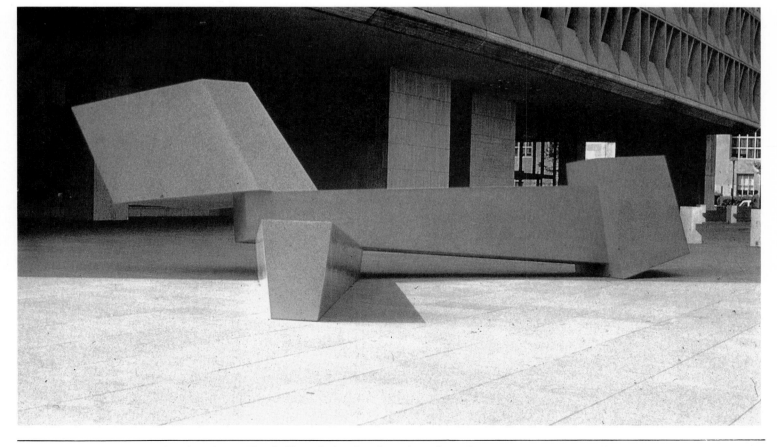

Another view of Heroic Shore Points I, *enlarged for the scale of the plaza from a smaller work originally conceived by Rosati in 1966.*

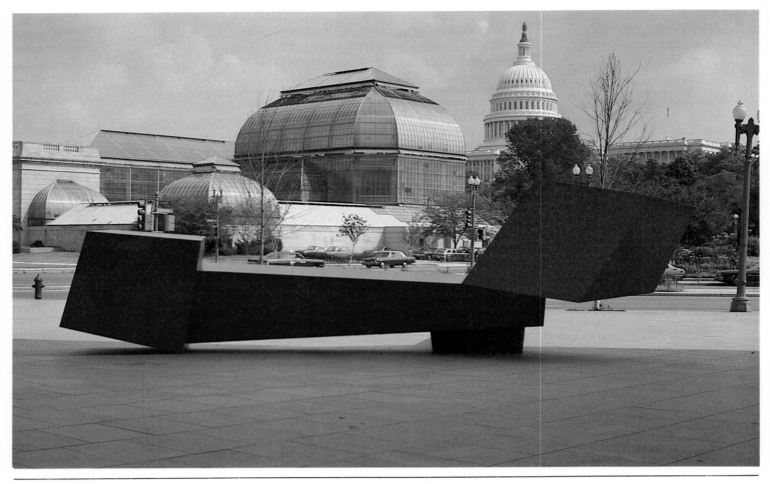

Heroic Shore Points I, *James Rosati's painted aluminum sculpture for the Humphrey Building plaza, with the Capitol in the background.*

black or white—was out of the question; it would only emphasize the drabness of the concrete.

For me color and form are one; I do not use color to cover a surface, but to unite with form to give the form its sole identity. So [it was important to choose] the correct red, not one screeching bright, but a red with depth and a red that would reflect light.

One does not know until it all is put to rest as to its success. We try to do our very, very best in hopes that all efforts will enhance the environment. It is for all who can approach it without prejudice, for all persons of good will.

The work, which was fabricated in aluminum by the Lippincott company, measures nine feet nine inches high by thirty-one feet ten inches wide by twenty-four feet deep. Titled *Heroic Shore Points I,* it was executed at a cost of $64,000 and installed by Rosati and a Lippincott crew. It is a sensational work by one of America's leading artists. As William Seitz said, discussing Rosati's work in the context of large-scale public sculpture,

Rosati's new works are kinesthet-

ically attuned to human presence by a radarlike recognition of human proportions, perception, empathy and conditioning. Such works as the . . . *Shorepoints* groups, it is crucial to realize, are more optical than tactile, but both levels of response are asked of the necessarily ambulatory viewer. Executed at dimensions larger than, but not challenging to human proportions, these works will bring into existence an all but untouched aesthetic of sculpture.

★ JAN YOORS ★

The work of Jan Yoors was introduced to the panelists by architect Beckhard. Born in Belgium, Yoors left home at the age of twelve, joining a *kumpania,* or tribe, of gypsies to roam through Western Europe and the Balkans. He came to the United States in 1950, when he was twenty-eight years old, and devoted himself to weaving tapestries. In 1962 and 1965, his work was selected to represent the United States at the Biennale Internationale de la Tapisserie in Lausanne, Switzerland. In 1975, the city of Ghent, Belgium, honored Yoors by holding a retrospective exhibition of fifty of his large tapestries in the majes-

tic architectural setting of the twelfth-century St. Peter's Abbey. The following year, the Sears Bank of Chicago presented his tapestries in its third series of special exhibitions of large-scale contemporary work (the first two were devoted to the work of Frank Stella and Richard Hunt).

In November 1977, just six months after the installation of *Symphony,* his magnificent tapestry for the HEW building, Jan Yoors died suddenly—a tragic and deeply felt loss for all who knew him, even briefly. His work, which is primarily architectural in scale, hard-edge and abstract, continues to be woven by and under the supervision of his widow, Marianne. Writing in December 1978, Mrs. Yoors described her husband's approach to his art. She explained that his father, a stained-glass maker, had influenced him in his use of glowing, intense colors highlighted by black, and that he compared his own chosen medium, large-scale tapestries, to symphonic music (hence the title of the HEW building work). "Jan was fascinated by the heroic quality of man," she said.

He would ask himself: "What made Beethoven compose the Fifth Sym-

phony? From where comes this urge to create?"

In the vibrant red, orange, purple, and blue [of *Symphony*], Jan so well recreated the intensity and fullness of his personality.

Jan wrote: "There are moments in life like sparks of timeless ecstasy, cosmic, eternal, overwhelming...." These moments he shared with us in his art.

Jan was a visionary artist who paid homage to man's despair and hope, who lived life fully and who gave generously and shared with us all through his art.

Symphony, commissioned at a cost of $16,000, is twelve feet high by fifteen feet wide. It hangs in the main entrance lobby of the Hubert Humphrey Building. Like Jan Yoors himself, it is vibrant and inspiring—a fitting tribute to him and to the great political leader for whom the building is named.

★ **ANNETTE KAPLAN** ★

Annette Kaplan's dramatic black-and-white tapestry, *Evolutionary Notes to Wk*, was purchased for $7,000 and was the first of the four pieces to be installed. It was woven in seven sections and measures seven feet high by twenty-three feet wide. Working sixteen to eighteen hours a day for three months, Kaplan completed it in December 1974. It is made of hand-dyed domestic wools, and like all her work, it is "reversible": the "back" side of this hand-loomed tapestry is as visually finished as the side presented to the viewer. As Kaplan says,

Environments have been a major concern of mine—both within my tapestries and [as to] how they augment the space they hang in. All the tapestries are double-woven to be seen from both sides, thus having an "inside and outside" personality. While working on each piece, I am concerned with the dynamics between linear space relationships, tension, asymmetry, and the total reading by the eye as it travels over the entirety.

Kaplan, who has been weaving for almost fifteen years, is largely self-taught. At the time of her selection for the HEW project, she was only twenty-seven years old, and her career was advancing steadily. Her work was in-

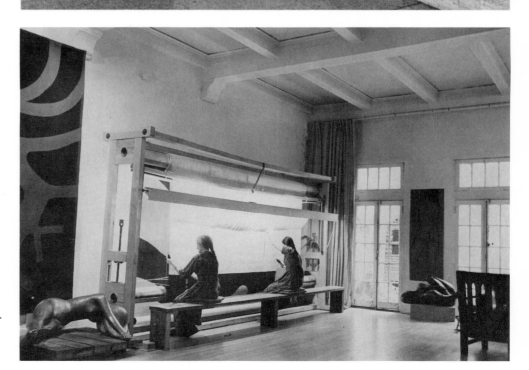

Above: Jan Yoors's Symphony.

Right: Weavers at work in the Yoors atelier.

cluded in the Oakland Museum Christmas Art Show (1975) and in four other exhibitions in California. The following year she had a solo exhibition at Knoll International in San Francisco, and IBM purchased two of her tapestries for their executive headquarters in Armonk, New York. In the spring of 1978, an exhibition of her work was held at the prestigious Phillips Collection in Washington, D.C.

According to Kaplan, when she first began weaving, she divided the world of textiles into three categories: the textile industry, textiles as crafts, and textiles as art. "After experimenting with all three forms, I finally evolved my style of black-and-white tapestries, finding them to be the most personally satisfying and challenging," she says. They are also satisfying and challenging to a broad spectrum of appreciative viewers. As Elena Canavier, Mrs. Mondale's arts advisor, wrote in her introduction to the Phillips Collection ex-

hibition catalogue, "Annette Kaplan is one of the highly talented and disciplined artists who have been inspired by the processes of a particular medium to create unique works of art."

★ MARCEL BREUER ★

Occupying a place of honor is Marcel Breuer's silk tapestry *Floating*, which can be seen through the glass wall of the east front lobby. In December 1976, Breuer sent his proposed design to GSA along with some actual thread samples, noting that "the effect of the silk material to be used is most difficult to match in painted colors." GSA panelists unanimously and enthusiastically approved the proposal but expressed concern about the intended location of the completed work, opposite a glass wall with a northern exposure. "Of primary importance, of course, is that a valuable and important work of art not be subject

to factors that could sharply decrease its lifetime," Breuer was informed.

To reassure GSA, Breuer forwarded a copy of a letter he had received from William D. Weber, director of Modern Master Tapestries. "In our more than twelve years' experience as the largest gallery in this country producing pile-weave tapestries, . . . no noticeable fading will occur if the tapestry is installed out of direct sunlight," Weber said. Breuer added that he himself possessed two silk tapestries that had been exposed to full daylight (but not to the direct rays of the sun) for two years without suffering any color alteration. In the end, GSA agreed to locate the tapestry in the main entrance lobby, out of direct sunlight, as Breuer had originally proposed.

Breuer proceeded to have the tapestry woven, informing GSA of his progress in February 1977. "The making of the tapestry is already in process, and delivery can be expected in the end of

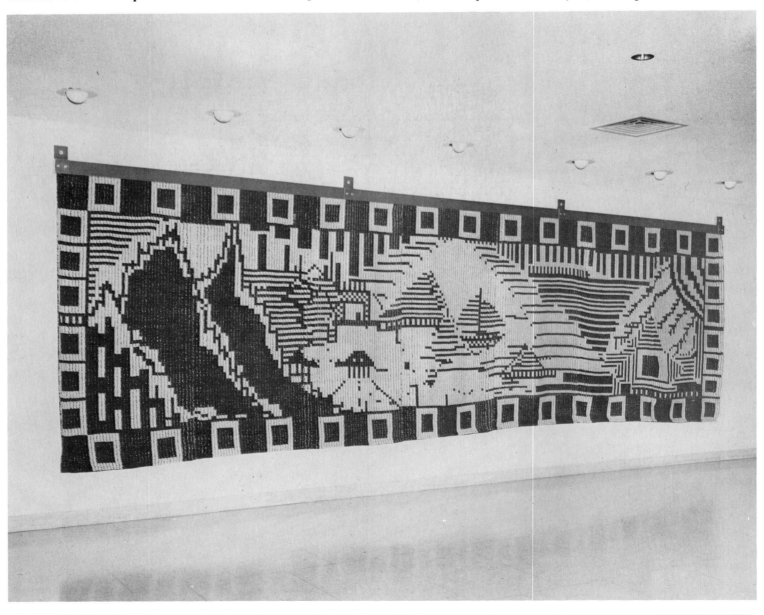

Evolutionary Notes to Wk, *a hand-loomed wool tapestry by Annette Kaplan.*

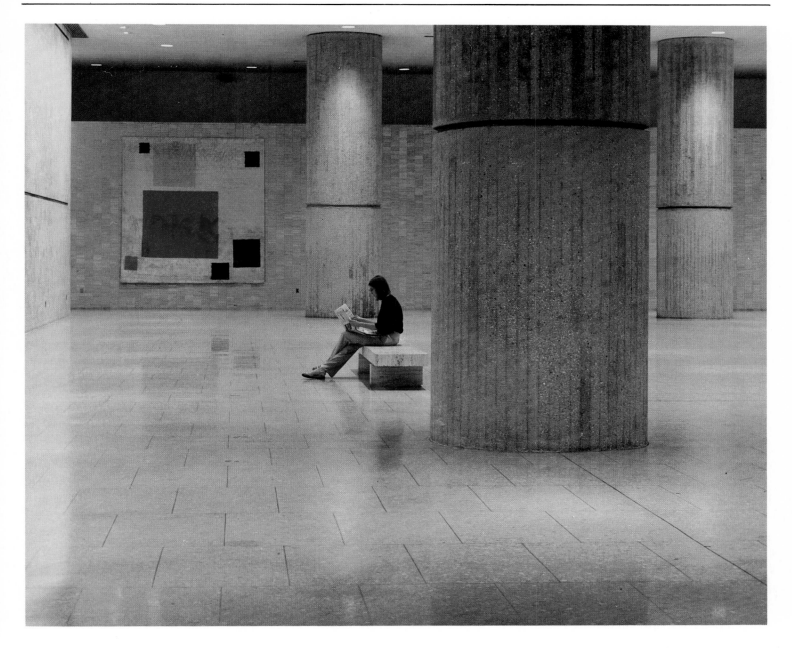

Marcel Breuer's Floating, *a silk tapestry in the east front lobby of the Humphrey Building.*

May or beginning of June." True to his word, he completed the work in mid-May. Notifying GSA of its arrival in New York, Beckhard wrote, "The tapestry seems to be well executed, and I hope that it will be favorably received by the population of and visitors to the building."

Both the Breuer and Yoors tapestries were installed in early July. *Floating,* which measures fourteen feet five inches high by eleven feet eleven inches wide, was commissioned at a cost of $21,000. According to Beckhard, it provided Breuer with the opportunity "to work in art forms other than architecture, [which] seems merely to be a continuance of a long-interrupted interest." Discussing Breuer's work in a letter dated May 4, 1979, Beckhard wrote:

[Breuer's] tapestries seem to fall into two categories—one which is very much architecturally oriented

and seems almost to be regulated by what might be building shapes. The second is a freer type of work dealing in other than geometric forms. The colors allow for the full range of the color spectrum and usually are juxtaposed . . . to produce rather daring combinations.

The tapestry for the Hubert H. Humphrey Building obviously is of the disciplined and geometric variety, dealing in a series of squares of varying sizes and colors, arranged in a square format. The tapestry was designed specifically for the space in which it is hung—the background having a rather subtle relationship to the adjacent travertine walls. The relationship of the squares in the tapestry is rather daring, producing a tension among the elements.

According to Wolf Von Eckardt

(Introduction, Marcel Breuer exhibition catalogue, Metropolitan Museum of Art, 1972), Breuer "once tried to define his work. In the end, in the agony of search for a precise formulation, he came up with a poem, the first and only one he created with words."

Colors which you can hear with
 ears;
Sounds to see with eyes;
The void you touch with your
 elbows;
The taste of space on your tongue;
The fragrance of dimensions;
The juice of stone.

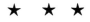

"The Labor Department Mural; A Complicated Voyage," read the headline of a long article by Betsy Carter in the May 1977 edition of *Artnews*. The voyage began in the summer of 1973, when Undersecretary of Labor Richard F. Schubert wrote GSA's administrator, Arthur Sampson, "It is the intent of the Department of Labor that a mural depicting the role of labor in American life and history be commissioned for [our] new building. . . . I would appreciate it if your office would begin to make appropriate arrangements for construction of the mural."

After several consultations with the building architects, Kirby M. Keahey and Max Brooks (of Brooks, Barr, Graeber and White/Pitts, Mebane, Phelps and White, Austin, Texas), GSA approved Schubert's request; the mural was to be one of two artworks for the building, the second being an abstract sculpture. As Betsy Carter reported, the NEA-appointed panel that met to consider the Labor Department commissions nominated pop artist James Rosenquist and abstract sculptors Louise Nevelson and George Sugarman for the murals even though Labor representative Dick Conn had insisted that "only a realist painter could communicate the message of the working people to the working people." The sentiment against an abstract work was so strong that Secretary of Labor Peter J. Brennan was asked to intervene. Supported by Brennan, the Department of Labor officially requested that the NEA panel be reconvened to nominate realist painters.

By means of a telephone poll coordinated by Brian O'Doherty, director of NEA's Visual Arts Program, the panelists (one of whom went so far as to suggest that there were no good realist painters working in America at the time) approved a new list of names. Slides of these artists' work were provided by John Arthur, curator of Boston University's Art Gallery, who was in Washington, D.C., to help organize America 1976, an exhibition of realist paintings for the Department of the Interior's Bicentennial project. Of the five nominees, Jack Beal was the first choice both of the Department of Labor and of GSA's Design Review Panel.

On September 26, 1974, Administrator Sampson selected Beal, who arrived in Washington one month later for contract negotiations. Beal agreed to a fee of $150,000 and accepted the commission against the advice of his wife and his dealer, who both thought it would be "more a burden than a re-

JACK BEAL

Robert Frumkin

ward." What did disturb him, however, was the proposed outside location of the mural. In an eight-page letter written in five colors of ink on fourteen- by seventeen-inch paper, Beal made an impassioned plea for relocation. Having researched the possibilities of media and installation—from the use of mosaics to hermetically sealed cases with glass fronts, filters, and heaters—he concluded, *"Move the painting(s) inside, where they belong."* Recognizing the problem, the architects agreed that an interior location would be most suitable and suggested the end walls of the museum area. The revised location was approved, and Beal went to work. (Subsequently, the location was changed again when the Department of Labor decided to use the walls for computerized slide projection. Beal's work now hangs in the entrance vestibule of the museum.)

★ ★ ★

Beal decided that the mural should be in four parts, depicting the role of the American worker in the seventeenth, eighteenth, nineteenth, and twentieth centuries, but he had no space large enough to accommodate such a monumental undertaking. At a cost of $15,000 (which came from his contract fee), he built and equipped a special studio adjacent to his home in Oneonta, New York.

On May 23, 1975, Beal appeared before GSA's Design Review Panel to present his concept, which was illustrated by four pastel drawings. The panel approved his proposal, but the Department of Labor's Dick Conn (who was very supportive of Beal's work and acted as a liaison between the artist and the two agencies throughout the commission) wrote Beal to convey the objections of other Labor Department officials to the twentieth-century rendition. In a letter dated June 5, 1975, he said:

Despite the excellent allegorical intent . . . [the electrical worker's] pose is totally unprofessional, . . . and because it was a black worker, this would cause additional unhappy comments! . . . Another observation was that while women workers are depicted, it appears that their occupational roles are subservient to the males.

But on a deeper, more substantive level, there was this reaction to the twentieth-century panel, Jack: there was a general feeling that the thrust of the final panel should not be a negative or questioning one concerning the future of the American worker, but rather a more positive statement based on the triumph of man and the human spirit over the machine.

Beal was distressed and responded immediately, taking vigorous exception to the interpretation of his twentieth-century painting as a pessimistic statement. "It would have been easy to make a distorted negativistic painting of our century—to show man being exploited by his creations," he wrote. "It would have been equally easy to make a Pollyanna picture. Both would have been lies. The twentieth century is confusing, dynamic, often disorderly, and at cross-purposes, but there is hope." Continuing, Beal addressed the specific criticisms:

. . . I am stunned that anyone felt the women were placed in positions subservient to the men. . . . I *am* sensitive to these issues and am disturbed that no one read this situation as I depicted it. With that in mind, I shall probably . . . have the woman scientist pointing . . . at a specific item on the piece of paper the technician is holding.

The black man on the ladder is not *standing* with his back to the ladder—he is seated on top of the ladder. He does look precariously perched, but he is engaged in an

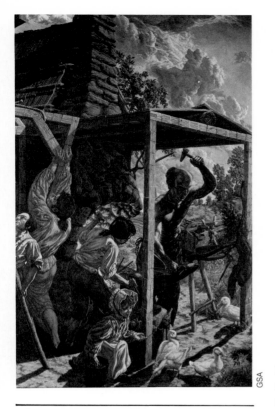

Above: "Everyone will have his or her favorite passages, of course—high on my own list is the rendering of ducks in the lower corner of the "Settlement" painting—and this is, by its very nature, the kind of painting in which one is bound to discover new things with each visit," wrote Hilton Kramer.
Below and next page: The History of Labor in America, in the entrance vestibule of the Labor building's museum area.

occupation which involves some danger and some fear. . . . Your own Labor Department statistics show the black blue-collar worker is more precariously perched than any other class of worker and thus stands to fall the furthest. . . .

I am a twentieth-century person, and I believe in our time. I see its problems and its promise. I am neither a cynic nor an apologist. Both in my art and in my philosophy, I am a realist. I believe in the pride and dignity of work and the worker —the subject of good work has long been a central issue for me. For these and other reasons I am enormously excited at the opportunity to make these paintings—they give me the chance to express in paint those ideals I had heretofore been able to express mostly in words.

Leaving nothing to chance, Beal returned to Washington to meet with the new secretary of labor, John T. Dunlop, and explain his reasoning in person. By all accounts, Secretary Dunlop was persuaded by the force of Beal's convictions and encouraged him to proceed. For his part, Beal wrote Dunlop that the meeting "served as a positive reinforcement for me, and I hope the effect was mutually beneficial."

Beal began to paint, assisted by his wife, Sondra (herself a painter), and

three apprentices, Dana Van Horn, Bob Treloar, and Bill Eckert. According to Beal, ". . . none of us ever worked harder or more diligently in our lives: ten to twelve to fourteen hours a day, six and a half or seven days a week, from July 1975 through March 1977—and this experience of working and living together was the best part of the entire project." Beal used his friends and neighbors, frequently costumed in period clothes loaned by the State University of New York in Oneonta, as models for the thirty-four figures that populate the paintings. The project progressed steadily, and along with it, as Beal said, "All of us grew in our work, we moved on to new levels of accomplishment, and we achieved something few people in modern times have accomplished— the feeling that we had made good public art that speaks directly to people."

By the beginning of January 1977, the four murals were nearly complete, and Beal moved them to New York City for final touches and viewing by the New York art community. "I worked on them so long that I didn't want them to pass through New York without people seeing them. . . . New York, it's the capital of the universe," Beal told Roberta Olson ("When Jack is Trump: Beal's Murals," *Soho Weekly News*, January 20, 1977). In her article, Olson assessed the total effort: "The labor

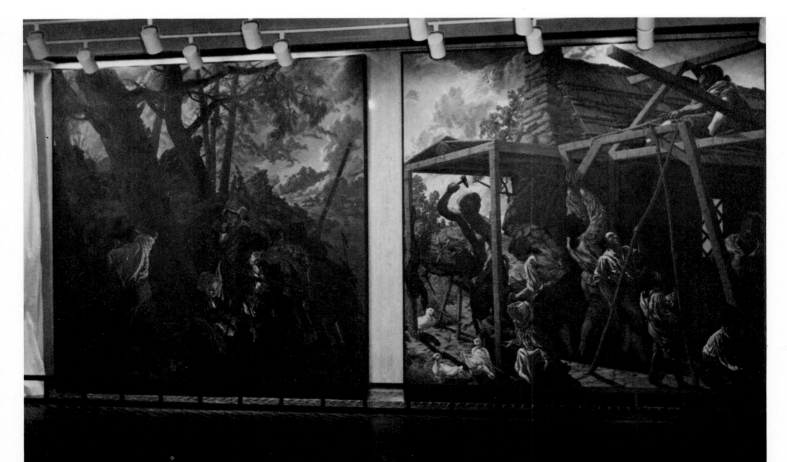

paintings are works in the grand tradition of historical paintings. . . . Perhaps Beal's canvases will initiate a revival so that painting may once again join sculpture and architecture as an integral part of the urban environments and of the design of public spaces."

Olson wasn't the only critic to use the word *revival*. Writing in the *New York Times* (January 7, 1977), Hilton Kramer headlined his review "One-Man Mural Revival," noting that Beal "is well-known to followers of the current revival of figurative art for his vigorous paintings." Kramer continued:

Mr. Beal has approached this daunting assignment in a spirit of epic adventure. . . .

Simply as a painting experience, the murals abound in visual incident, dramatic shifts of space and light, and an unflagging energy. Each of the many figures . . . is vividly realized, and the handling of so broad a range of detail, from the light of the campfire and the setting sun in "Colonization" to the multicolored wires and the contour map and television screens in "Technology," is often breathtaking.

Mr. Beal clearly brought great conviction to this work.

Without admiring every detail of each picture with equal enthusiasm, I still found the experience of looking at them an unexpected thrill. I think the Department of Labor should be pleased.

"Pleased" was not the word. "Ecstatic" describes far more accurately the mood of viewers and officials who assembled for the dedication on March 4, 1977. The ceremony was co-sponsored by GSA and the Department of Labor, and a large audience listened with rapt attention to Joan Mondale's keynote address. Covering the festivities for the *Washington Post,* Jo Ann Lewis wrote:

The elite of Washington's art world were run ragged this weekend trying to keep up with the parties given for artist Jack Beal and his retinue of artist friends, collector friends, dealer friends, and just plain friends. They flew in from New York, Chicago, Princeton and Richmond to share what Beal called "the biggest night . . . of my life in 21 years."

. . . as the voices of the Sea Chanters swelled to a stirring crescendo, the lights came up and the curtain slowly opened to reveal the paintings one by one. The artist described them and identified the models, most of whom were in the audience.

Following the official dedication, Beal and friends joined the Washington-area art community for a party at which Jack took off his Irish tweed jacket and danced well into the night in his shirt sleeves.

★ ★ ★

Beal's murals, titled "Colonization," "Settlement," Industry," and "Technology," each measure twelve feet two inches high and twelve and a half feet wide. Known collectively as *The History of Labor in America,* they have been well received and widely applauded by visitors and workers in the new Department of Labor Building. As Secretary of Labor Ray Marshall said in his statement for the dedication brochure,

Down through the years the artist has brought insight, dignity and purpose to man's often noble, sometimes bumbling journey upward toward a civil, rational existence. Jack Beal, as artist . . . and worker, . . . has done precisely this in his inspired set of murals depicting the American worker during four tumultous centuries of existence. . . .

The United States Department of Labor is the proper repository for this visual legend and statement of hope so beautifully expressed by Jack Beal.

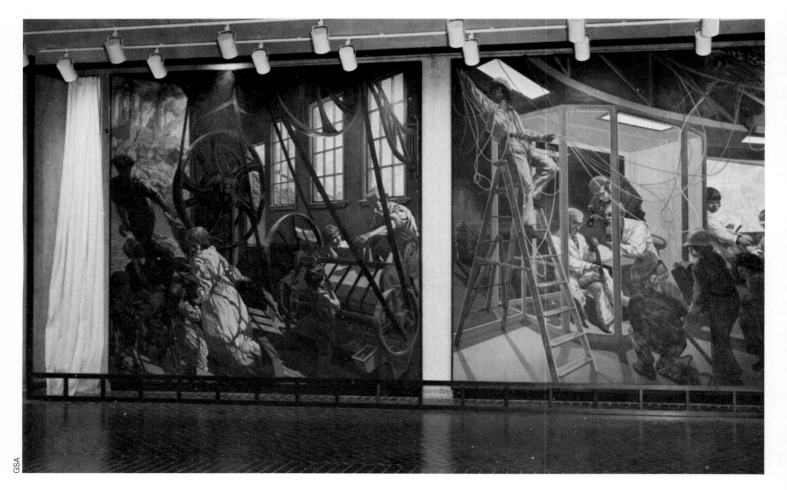

GSA

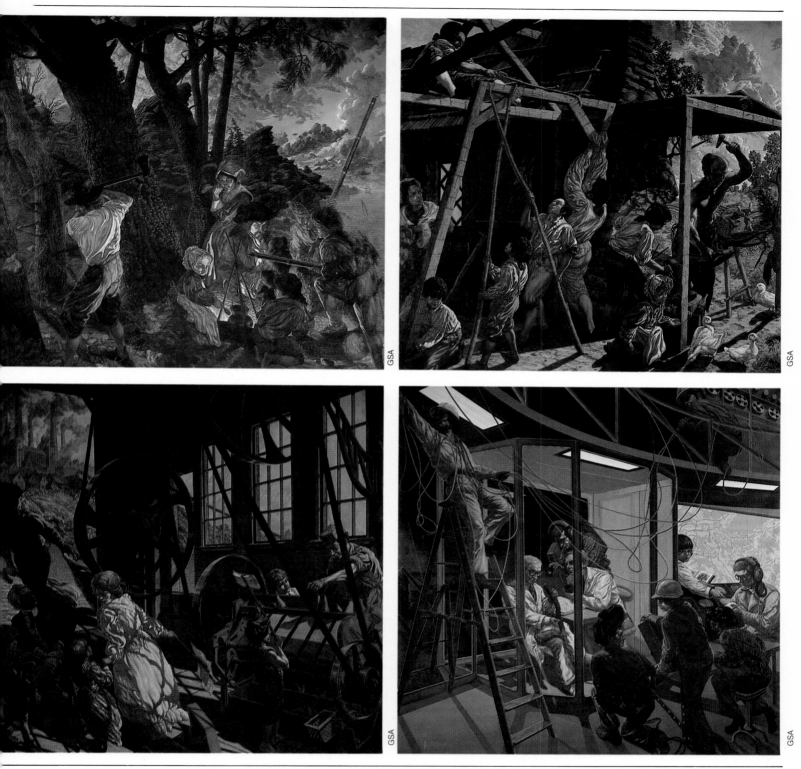

Above: The four murals comprising Jack Beal's monumental History of Labor in America. Beal spent nearly two years on this project and covered more than six hundred square feet of canvas. The murals are populated by thirty-four life-lize figures rendered from living models who often appear in more than one painting, thus symbolizing the interrelationship of past, present, and future in human endeavors. Praising Beal's work, President Carter said, "The murals on display in our nation's capital speak to us both as genuine works of art and as a vivid pictorial history of the challenges overcome and the progress achieved by American workers.... In public buildings such as this [the arts] can be effectively used to depict the vitality of our cultural heritage as well as the continuing ability, resourcefulness, and imagination of our people cop-

ing with problems of everyday life."

Top, left: The first mural, "Colonization," depicts the seventeenth-century settling of a new continent. It shows a pioneer family clearing land to create a home in the wilderness. As day breaks over the distant horizon, two fur trappers huddle around the campfire bartering with an English trader.

Top, right: "Settlement" is set in the eighteenth century and portrays settlers raising a house in the midday sun while a blacksmith and his young apprentice hammer away at the anvil. "Settlement" captures the labor of building and farming in minute detail. Like "Colonization," it sets a tone of determined purpose in the forging of a new nation.

Bottom, left: The third mural, "Industry,"

represents the Industrial Revolution of the nineteenth century. The harsh interior of a textile mill provides the background as children labor in the grim conditions of early factory life. "The seventeenth-century colonists attacked the wilderness, those of the eighteenth century tamed it, and by the nineteenth century they had subdued the natural environment," says Beal.

Bottom, right: "Technology," Beal's portrayal of the twentieth century, takes place in a laboratory where scientists are trying to restore the environment through ecological experimentation. The scientist in the center studying a pine seedling is Jack Beal's self-portrait. "For me, that seedling is a symbol of hope, living into the next century," Beal says. "The twentieth century, as I see it, is confusion and hope at the same time."

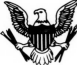

TONY SMITH

Tony Smith

In 1973, when Max Brooks and Kirby Keahey first proposed a free-standing sculpture for the new Department of Labor building in Washington, D.C., Tony Smith was one of the few sculptors whose work they considered suitable for the site. Consequently, the two architects (from the firm of Brooks, Barr, Graeber and White/Pitts, Mebane, Phelps and White) were delighted when an NEA-appointed panel nominated Smith for the commission in March 1974; and they maintained their high level of interest and cooperation until the sculpture was installed in October 1976.

It was fortunate that the architects' enthusiasm for Smith's work was shared by officials of GSA and the Department of Labor, because the project demanded a collaborative effort. The sculpture was to be installed directly over a freeway that tunneled beneath the site, requiring special attention to the engineering and construction of its foundations and belowground support system. It was likewise fortunate that Smith had studied to become an architect (he had worked on projects for Frank Lloyd Wright and had designed and built about two dozen homes on his own). Because of his background, he could understand and appreciate the structural complications involved in siting the work.

Notified of his selection, Smith

arrived in Washington, D.C., on October 22, 1974, accompanied by his wife, Jane. His sparkling blue eyes and cheerful manner gave no hint of the seriousness with which he approached the project, but before anyone had a chance to show him the site, he announced that he'd already been there and had spent several hours thinking about it. Throughout our discussions of the work and its scope, he was pondering the site, eager to study it further, and later that evening he and Jane returned. "I always like to look at the sites in the dark because I feel that a lot of the detail is eliminated, and you can grasp the major features better," he said.

GSA's standard fine arts contract holds the artist responsible for design, fabrication, and installation, including any necessary foundation work. In this case, however, given the freeway below the site, it was clear that providing ade-

quate structural support would be a highly complicated and expensive undertaking. GSA therefore agreed to take care of the site preparation, and a contract was negotiated for $98,000 on June 4, 1975. In the end, the taxpayers got more than a bargain. Smith made not a dime of profit on the commission and in effect gave his sculpture to the people. "I felt very honored to do something in the national capital. As far as I was concerned, I would be perfectly willing to supply it at cost," he said, adding, "After all, it's right near the Capitol, and it's a very nice place to be."

★ ★ ★

By the end of July, Smith was prepared to present his concept to GSA's Design Review Panel in Washington. Carefully wrapped and carried as though it were a newborn child, his maquette had a safe journey from Smith's studio in South Orange, New Jersey, to Washington's National Airport. There Smith hailed a cab, and the driver, insisting that the maquette would be safer in the trunk than on the seat (it had had its own seat on the plane from Newark), proceeded to slam the trunk lid on one of its edges. The maquette was slightly mashed, and Smith was more than slightly angry.

Notwithstanding the damage, the GSA panelists were obviously impressed by the maquette and approved it unanimously. Beneath its innocent coat of sky-blue paint, they found it intriguing and optically deceptive. At first glance geometric and easily understood, it changed in quite unanticipated and startling ways when viewed from different perspectives. This phenomenon is even more pronounced in the full-scale piece, whose geometry seems to distort unpredictably—a result Smith has come to expect from his work. As he says,

Above: The maquette for She Who Must Be Obeyed, *Tony Smith's sculpture for the east plaza of the Department of Labor building in Washington, D.C.*

. . . If you look at the end, it is very difficult to know what it looks like head on. But then, if you look at it from any of the angles, it's also difficult to be able to project what the opposite angles are. This is something that I have never incorporated in my work on any conscious basis, but I think it's somewhat inherent in the character of the components that I use, either the tetrahedra and octahedra or the rhomboidal elements. . . .

[This work] is based on a shape which is the cross-section of a space frame made up of tetrahedra and octahedra. It's called simply a rhombus. It's also a surface shape of a rhomboidal dodecahedron—that's a twelve-sided figure with rhomboidal sides—and it's one of the three geometric figures which can close-pack.

The maquette had come into being after much reflection and numerous visits to the site, during which Smith studied the building's architecture, its textures and designs, the effect of the shifting sunlight, and all the elements of the sculptural environment.

I had already decided that the grid of the building was so strong that I couldn't do a piece that had any notable features without creating some static. And then I thought of *She* [a black plywood mockup of which had been made earlier for an exhibition at the Whitney].

I felt it was blank enough to reduce any possible static between it and the grid, and because of the break in it, it was unrelated to the building in any structural way. And then I thought about it some more, and I decided that if it were black, it wouldn't work against that recessed wall of the building, so I decided to paint it a color.

. . . My first thought was to paint it red. But then I realized that for the Labor Department to paint something red—especially since it looked like a flag anyhow—really wasn't very appropriate. . . . So I decided on blue.

Smith had a particular blue in mind—the blue of the chalk used for pool cues. Though there are probably more shades and hues of blue than of any other primary color, he found it was almost impossible to duplicate the one he wanted. Looking for a substitute, he turned to the standard colors for automobile lacquers. "After hours

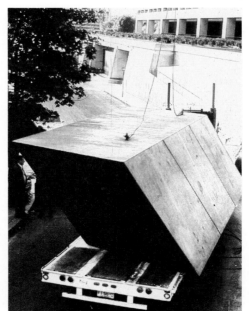

Left: One of She*'s steel sections arrives at the Department of Labor building in October 1976, after being trucked from the fabricators, Industrial Welding Company of Newark, New Jersey.*

Above: Smith and a bystander look on as the top section of She Who Must Be Obeyed *is lowered into place. After installation,* She *was sandblasted and painted to match the color of the maquette, then repainted a darker blue. The massive sculpture, measuring thirty feet high by twenty-four feet wide by eight feet deep, has a geometric design based on nine modular rhomboidal forms. "We're pleased to unveil this artwork, which pays tribute to the strength and stability of America's workers," said Commissioner Nicholas A. Panuzio of GSA's Public Buildings Service. "It's particularly appropriate for it to be at the Labor Department."*

and hours—you know, the book is about sixteen or eighteen inches deep, with as many as twenty colors on a page —I took seventeen colors and had them made up on one-foot-square masonite sheets," he said. With the help of Gene Baro, former director of the Corcoran in Washington, Smith pored over the samples and finally selected the sky-blue color he used on the maquette.

From August 1975 to April 1976, while the sculpture was being fabricated by the Industrial Welding Company in Newark (which, under the guidance of its president, Bill Schmidt, has fabricated all but three of Tony Smith's pieces), Smith and architect Kirby Keahey collaborated on the site modifications for the placement of the sculpture. "It will be necessary to raise the sculpture approximately eighteen inches in order to provide adequate depth for the supporting structure," wrote Keahey to Smith (September 17, 1975), adding, "We propose to conceal the structure with an earth berm planted with grass." After studying this idea, Smith decided that the rise of the grass platform was too abrupt. "This seems like a pedestal—sculptural in itself. If it is possible to do so, I think the grading should begin at the retaining wall and continue to the actual base of the sculpture," he wrote (April 30, 1976). In the solution that was eventually adopted, the steel beams that span the freeway to support the sculpture allow for a gradual rise to the base, in keeping with Smith's suggestion.

By the end of April, fabrication was complete and the siting details had been worked out. In October, with the steel support system ready, *She* was shipped to the site by truck in three twenty-four-foot-long sections. Smith was on hand as a giant crane lowered each section, placing one on top of the other until the finished piece stood thirty feet high. The entire process took less than one day and went remarkably smoothly.

The following spring, the work was sandblasted and painted. Smith was very pleased with everything except the color. "I like it very, very much," he

She herself, at the site.

"I think that the history of our culture has tended to make us look at things more or less frontally or in a way that is perpendicular," says Smith, discussing the optically deceptive qualities of She Who Must Be Obeyed. *"We don't really have a tremendous grasp of three-dimensional forms, and when people see forms that are three-dimensional, they find an element of surprise in them."*

Tom Crane / GSA

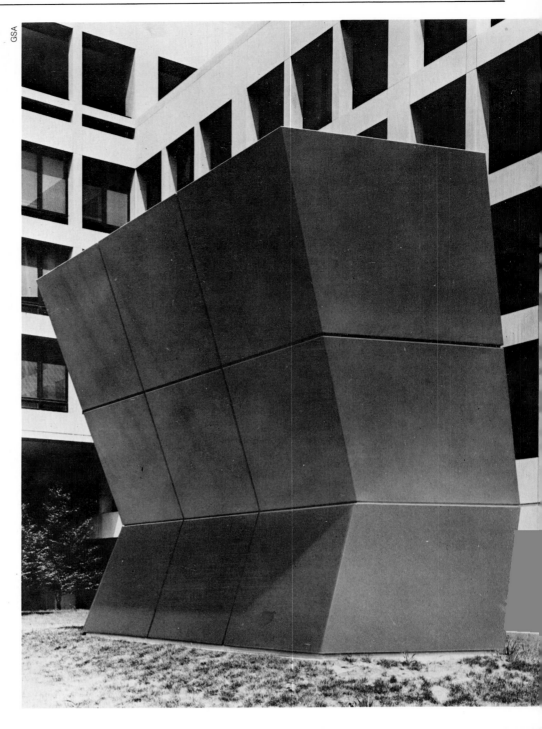

GSA

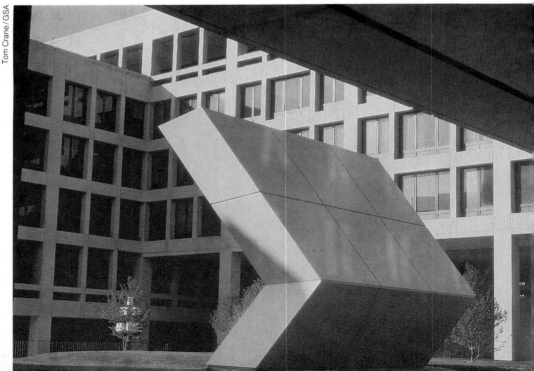

Tom Crane/GSA

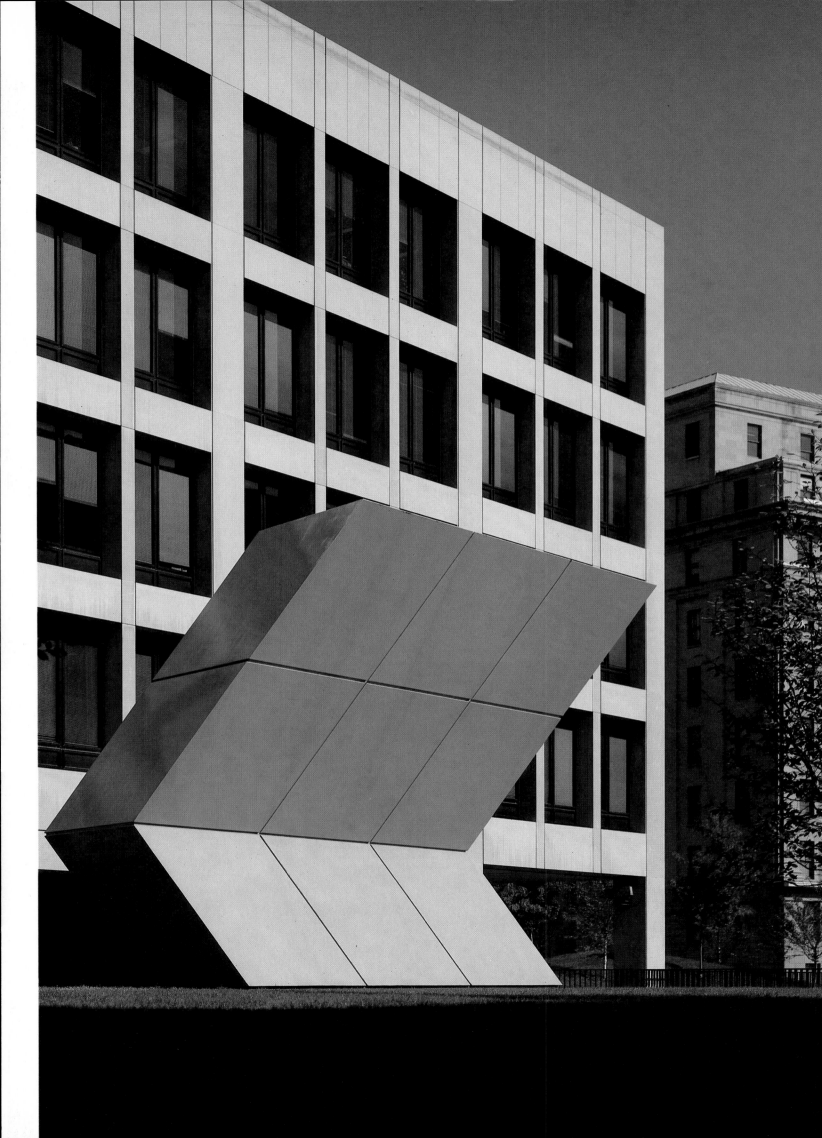

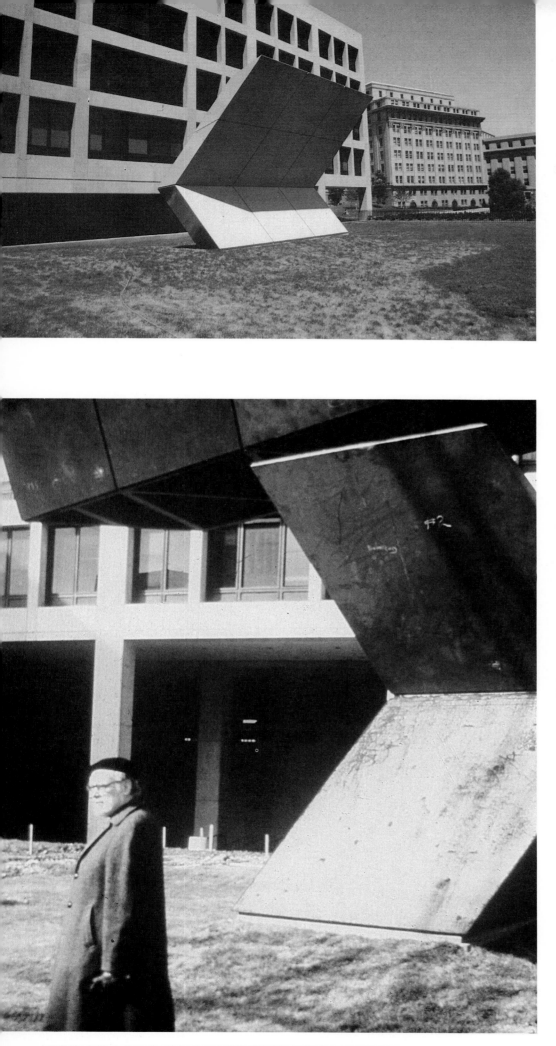

Above: She *hovers over her creator during installation.*

Top: Another view of She Who Must Be Obeyed.

said in a taped interview (May 25, 1978), ". . . and my only regret is that even though the color of the piece is a perfect match for the color of the maquette, it seems somewhat bleached because of the whiteness of the limestone of the building that surrounds it. . . . I'm going to have it repainted a little bit darker in order to overcome that bleaching." *She* was repainted later that year to everyone's satisfaction.

Commenting on the title of the work, Smith said,

> I tend to name all of my works— or "refer," I should say—in the style of *Variety,* the stage publication, by using a single word. For instance, just as *Variety* will refer to *Streetcar,* rather than *Streetcar Named Desire,* . . . I refer to this piece as *She.* That was the actual name of Rider Haggard's novel, but in the novel, he refers to the central figure as "She who must be obeyed." I would think of that as being the official title, although I just call it *She.* I never say, *"She Who Must be Obeyed."*

Neither do officials at the Department of Labor. Upon learning the theme of Haggard's novel, they also expressed a distinct preference for the shorter form. By *She* or any other name, however, Smith's sculpture is an imposing and magisterial addition to the building's east plaza lawn.

As for the Art-in-Architecture Program, Smith praised its accomplishments generously.

> I think that it's given a great variety of artists an opportunity to have their work erected in different parts of the country. . . . If we're going to develop the kind of culture that we have all the resources for, we've got to start putting up some samples. . . .
>
> Where other great societies have had men of extraordinary self-discipline, experience, and education and could create great societies by fiat, we're just not organized in that way. . . . It isn't as though we're in a position of having a pharaoh saying this is the way it's going to be—or a caste of high priests or [anyone else] saying that. The fact is there's no such class of people in this country. . . . The works have to be put before the public so they can experience them, and somehow or other the image of the North American continent will emerge.

FRANK STELLA

Francois Meyer, courtesy Leo Castelli Gallery

really applicable. With this in mind, the first draft of a new contract was developed with Ordover and subsequently reviewed by GSA lawyers. Reduced from endless pages of tiny print to ten and a half typewritten pages (plus cover, index, and signature pages), the final version had only seventeen articles and was both readable and understandable. This was the contract Stella received and signed in early spring. GSA then validated it, returning it to Stella as a fully executed contract, with a "notice to proceed with the work" dated June 24.

Frank Stella was the first artist to execute a GSA commission under the Art-in-Architecture Program's standard fine arts contract. In fact, GSA developed the contract with Stella and his lawyer, Jerald Ordover, and it became the model for all future contracts.

In December 1972, John F. McCune III, the architect for Wilmington's federal building, courthouse and customhouse, wrote GSA requesting that fine arts be incorporated into the building's design, "possibly in the form of a sculptural mural on one wall of the entrance lobby, so that the lobby's somewhat sanitary appearance might be relieved." The agency responded that funds in the amount of $34,000 would become available for such a work "when the revised procedures on the nomination and selection of the artists are finalized." Eight months later, in August 1973, panelists appointed by the National Endowment for the Arts nominated Frank Stella for the Wilmington commission.

By January 1974, Stella had been formally selected, and contract negotiations were held in Wilmington. Stella and Ordover arrived by Metroliner from New York, and we started to go over the contract that had been used previously (notably for artists selected during the 1962–66 era and for the first work commissioned under the present program, Alexander Calder's *Flamingo* in Chicago). This contract was the one GSA used for architectural and engineering services, with a preface noting that where the term "architect-engineer" appeared, it referred to the artist. Forbiddingly long and complicated, it had many clauses and terms that were not

An exterior view of Joatinga, *Frank Stella's lacquered aluminum wall sculpture for the lobby of the Wilmington Federal Building, Courthouse and Customhouse.*

Stella had agreed to present a preliminary proposal to GSA within thirty days, but his artistic concept took time to develop, and he was granted several extensions. By November, he had settled on the design and technology for the work, using shapes made of specially fabricated honeycombed aluminum. Ordover sent GSA two black-and-white photographs of the unpainted construction, "which the artist currently plans to submit in fulfillment of the contract, reserving the right to submit a different sculpture, of similar shape, depending upon which one he believes will be better, once the surface is painted."

On the basis of the photographs, GSA's Design Review Panel approved Stella's concept, and he began to paint the works later known as the "Brazilian series," named after neighborhoods of Rio de Janeiro. Describing Stella's working technique in a catalogue essay (reprinted in *Art in America*, March–April 1978) for the Stella Since 1970 exhibition he organized, art history professor Philip Leider wrote:

> The factory-fresh aluminum surfaces needed to be treated in order to hold the paint in the manner Stella desired. The surfaces were first thickly scumbled with lithographic grease crayon, after which a caustic solution was poured over them. As the solution dried it etched those parts of the surfaces not protected by the grease crayon. A coat of clear lacquer was then applied to form a base coat. . . . After drying, colors were applied with transparent, lacquer-based silk-screen inks over those broad areas in which we can see through the color to the etched aluminum beneath, . . . and oil stick was used for the scumbled and scribbled planes.

Leider also noted that Stella hadn't prepared the drawings for the "honeycombed aluminum Brazilian pictures" until late 1974. The "sculptural mural" initially proposed by the architect, if it didn't exactly inspire Stella's Brazilian series, at least came at a time when he was interested in developing it and gave him the impetus to go forward.

On April 11, 1975, program assistant Dee Dee Brostoff, contracting officer Claude Bernier, and I met Ordover and Stella at the artist's New York studio to look at the series and select the piece most appropriate for the Wilmington building. We chose *Joatinga*, a work measuring eight feet high by fifteen feet wide. Two months later, on June 20, *Joatinga* was dedicated in Wilmington. Both Stella and Ordover came to the unveiling, which was followed by a reception hosted by Sophie Consagra, executive director of the Delaware State Arts Council. Stella spoke briefly, as is his custom when talking about his work.

GSA had solicited a statement from the artist for the dedication brochure, but as of June 4, Ordover wrote that Stella had been unable to come up with anything. Happily Dee Dee Brostoff was able to entice one from him by telephone:

> The aluminum wall sculpture was surfaced, etched, and painted with brilliant lacquers. The colors are vivid and look very Brazilian to me. That's why I named the piece *Joatinga*, which is a district of Rio de Janeiro. The angular shapes and brilliant colors were designed to enliven the lobby area of the Wilmington Customhouse, Courthouse and Federal Building.

Brian O'Doherty, art critic for NBC's *Today* show, and director of the NEA's Visual Arts Program, had also prepared a statement for the dedication brochure:

> Frank Stella's new work is raw, exciting, and challenging. It will look better and better, as such work does, as time goes by. I think it is marvelous that the General Services Administration has caught Stella in one of those moments when his art leaps forward to something fresh, tough, and unprecedented. The General Services Administration has acquired a very important work, and so have the citizens of Wilmington, Delaware.

Unfortunately, though the national art press agreed with O'Doherty's assessment, the occupants of the building did not. The month after the dedication, angry letters began arriving to complain about the "waste" of tax dollars, especially when there were "thousands of starving people" in the country. Over three dozen building employees signed a petition requesting that the abstract work—which they did not classify as art—be removed.

In March 1976, one of *Joatinga*'s angular planes began to blister and peel—which didn't help matters any.

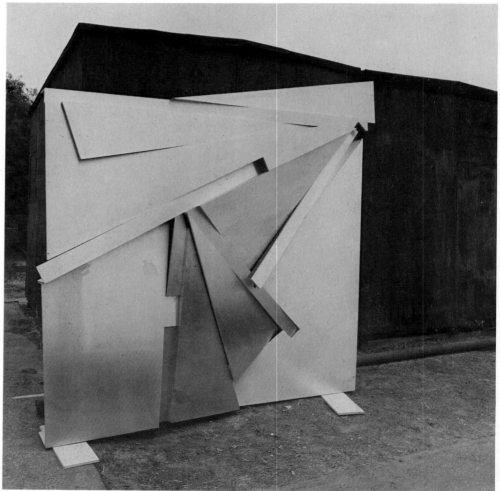

One of two photographs submitted to GSA as part of Stella's presentation of his artistic concept.

Malcolm Lubliner

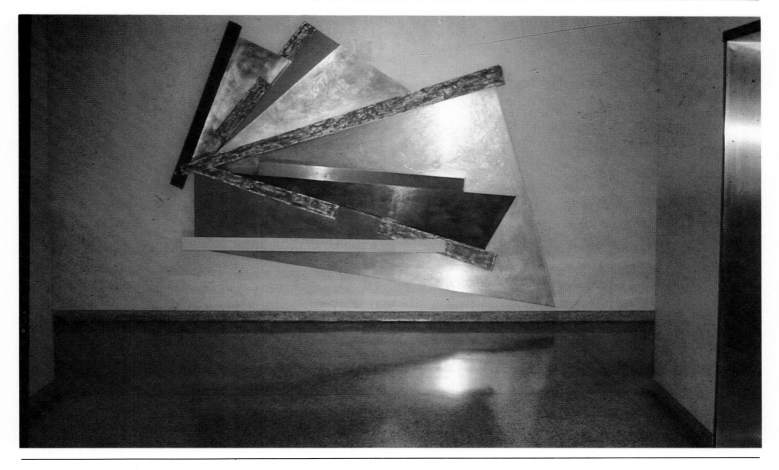

An interior view of Joatinga *on the entrance lobby wall.*

"It's probably peeling because our thoughts are searing the paint," said one employee, according to an article by Eric Smith in the *Wilmington Morning News* (March 25, 1976). Immediately an SOS went out to Stella, and the damage was repaired in June. By December the panel was peeling again. This time Stella discovered that the magenta paint he'd used, both initially and in the first repair, was "bad." A new batch was mixed, and *Joatinga* was repaired permanently at no additional cost.

Still Stella's critics wouldn't be silenced. On December 2, columnist Bill Frank of the *Morning News* wrote, "Every time I enter the King Street lobby, I am horrified at the sight of a horrible monstrosity on the wall, classified as 'modern three-dimensional wall sculpture.' . . . It is really an outrage. I might even say insult." Predictably, Frank's renewed assault on *Joatinga* elicited a fresh batch of letters to the agency and to the editors; one writer, a vice president of a local salvage company, said that although he'd not seen the work, he'd gladly buy it from the government at twenty cents a pound as "scrap metal."

The climate began to change with the publication of an informative and generally supportive article by Edith DeShazo in the *Wilmington Sunday News Journal* (February 6, 1977). Noting that since the dedication "the furor hasn't stopped," De Shazo said, "What has bothered me about the brouhaha is that nowhere have I seen an attempt to tell the citizens of this city who Frank Stella is. I think if you are going to dismiss a man's sculpture as a monstrosity, you should at least know whom you're talking about." DeShazo detailed Stella's career and the significance of his work, concluding, "The city did not take just anyone when he was chosen to do the relief for the Federal Building. It got a recognized, famous, serious, accomplished artist. The citizens may not like the sculpture very much but facts are facts." Apparently building occupants and residents of Wilmington, their eyes newly opened by DeShazo, began to take a second look, for the agency has not received a single negative comment about *Joatinga* since her article was published.

In any case, Frank Stella liked the work so much that he wanted it to represent the Brazilian series in the Stella Since 1970 exhibition. However, the Art-in-Architecture program has always operated in the conviction that fine arts are an integral part of public buildings, not a decorative afterthought; and GSA commissions have been justified to members of Congress as vital and indispensable to the architect's design proposal ("as necessary as the bricks and mortar"). To put *Joatinga* on loan for the two-year duration of the traveling Stella exhibition would have undermined the whole philosophical basis of the program, as well as jeopardizing its political support. Therefore, to the great regret of all concerned, GSA was unable to honor Stella's request.

Stella was understandably disappointed, for the exhibition was a major one, going to nine different museums in the United States and Canada. "He is still feeling pretty badly about the refusal of your agency to lend his work *Joatinga*," Ordover wrote on March 10, 1978, adding that the work was "one of the best pieces of that year." Ordover explained that Stella understood GSA's decision intellectually, but that it "still rankled him." Writing again in August 1978, he summed up Stella's experience:

Apart from that, as you well know, Frank's dealings with you and the agency were smooth and harmonious, the building staff was very cooperative, and I feel that the work had a strong educational effect on many of the people who have had occasion to see it, despite the initial adverse comments.

RUDOLPH HEINTZE

Locations, an environmental sculpture done by Rudolph Heintze for the plaza of the federal building and U.S. courthouse in Winston-Salem, North Carolina, evolved from two prior proposals developed for the same commission. Not that Heintze had planned to submit three proposals, but for better or worse, that's what happened.

On the basis of his previous work, which was considered object-oriented, Rudy Heintze was among several artists nominated for the Winston-Salem commission by a National Endowment for the Arts panel in October 1974. By the time GSA received the formal nominations from the NEA, appointed a review panel to make recommendations, and selected Heintze, seven months had elapsed. In June 1975, a $55,000 contract was negotiated with Heintze in Winston-Salem, and six months later he presented his first design for the proposed piece. It was a conceptual sculpture, one with deep personal meaning for the artist; it was also "minimal" sculpture, and the GSA panel believed it lacked the visual strength to hold its own in the expansive plaza, which was a rather busy space with competing design elements. After thorough discussions, Heintze agreed to develop a new proposal.

Two months later, in February 1976, Heintze presented a design for a cylinder twenty-four feet high and twelve feet in diameter that could be entered through a frontal opening. It was to be made of wood and steel and surrounded by eighteen equally spaced eight-foot-high vertical T-bars. It would function as an object but would also work conceptually by evoking the ordered movement of the solar system. Finally, it would constitute an environment within an environment—an inner space with an outer form. The GSA panel approved the concept, and Heintze received his first payment of $19,000.

One and a half months later, the building's architect, Lloyd G. Walter, Jr., wrote Heintze to say that in his opinion the piece was visually too massive for the site. A copy of this letter was sent to the GSA regional office in Atlanta, and Walter's concerns were brought to the attention of Nicholas Panuzio, commissioner of the Public Buildings Service. Shortly thereafter, the art-in-architecture staff was informed that Heintze was not to proceed with the construction of the sculpture without the approval of the architect. In a letter to GSA dated May 12, 1976, Walter explained that his comments to Heintze represented his initial reaction, that he was an architect and not an art critic, that his response was subjective, that the execution of the piece might remove his doubts, and that judgment must be reserved until the piece was completed. In short, he made it clear that he didn't intend his views to be taken as a veto of Heintze's second proposal. Panuzio was not satisfied, however, and on June 15 the contracting officer in Atlanta instructed Heintze to "suspend implementation" of the project.

Heintze, who might have been for-

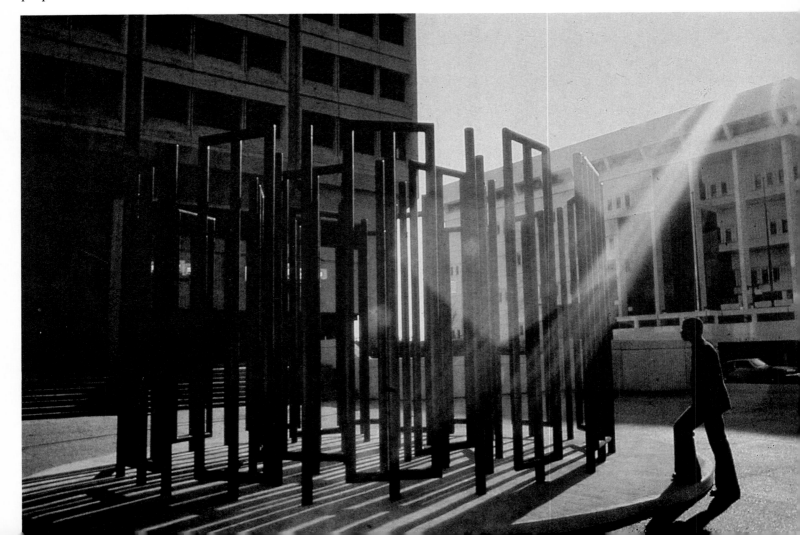

given for throwing up his hands at this juncture, returned to the drawing board and developed yet another proposal, which was approved and executed without further incident. Frustrating and painful as the sequence of events had been, Heintze responded very philosophically throughout. He was led to think more deeply about his work, and he ultimately came to believe that the whole experience was important to the growth of his aesthetic. As he later wrote,

> . . . The first model was "minimal," open, spatial, and environmental. The second model reflected a considerable change over the first. It was massive, and its energy was concentrated within a specified central area. The interior space was separated from its surroundings. The result was a very private inner space that had only one entrance. . . . The final piece emerged as yet another survival symbol, but its overall impression was considerably different from the first two. I kept the central plan of the second model but increased the number of circles to three concentric bands. The feeling of openness and accessibility carried over from the first model. The columns and "swivel doors" created a sense of visual density yet were penetrable from all directions. Separation of an inner and outer space gave way to an integration of the two.

<p align="center">★ ★ ★</p>

Many artists are reluctant to discuss the conceptual underpinnings of their creative forms, but Heintze is both articulate and enlightening. In a long, reflective letter written after the installation of *Locations,* he elaborated upon its meaning and its impact on spectator and environment, stressing its inherent dynamism. He pointed out that the sculpture was meant to be encountered in a number of ways, depending upon the viewer's position. The basic design of three concentric circles can be seen most clearly from the upper floors of the courthouse overlooking the plaza. These provide the most "objective" view, revealing "the ordered patterns or random combinations, the movements of others turning the swivel

Opposite: Rudolph Heintze's Locations, *in the plaza of the federal building and U.S. courthouse in Winston-Salem, North Carolina.*

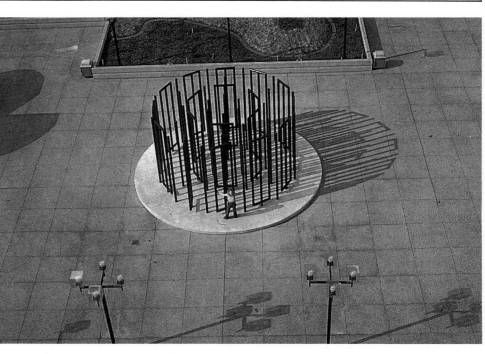

A view of Locations *from the upper floors of the courthouse. The work is made of painted steel and measures twelve feet high by twenty-one feet in diameter. Describing it, Heintze wrote, "The sculpture embodies both a holistic and a fragmented sensibility. This paradoxical quality was very important to me. I wanted a structure that created defined areas, limits, and boundaries yet was open to chance, change, and unpredictability. I saw in this a symbol of adaptability and change without necessarily sacrificing integrity or order." The sculptor also elaborated upon his choice of a circular structure: "As we all know, the circle is a universal symbol. It is directly accessible to everyone yet can be interpreted in many ways. In my environment, . . . depending upon the positioning of the 'swivel doors,' [there is] potential for both indirect and direct access to the central space—but in all situations the center is experienced as an area of calm."*

doors, and the strong patterns created by the shadows as the sunlight passes through the openings between the vertical members." The perspective thus afforded also serves to "reinforce the dialogue between the two environments" by "integrating the building as an 'observation deck'" and suggesting comparisons: "the courthouse is multileveled, square, static, massive, self-contained; the sculpture has one level and is circular, open, changing, and accessible."

At ground level, as the spectator approaches the sculpture, the overall impression of patterned massiveness gives way to a sensation of openness and flickering visual effects created by "changes in the spatial intervals between the vertical elements." At the same time, the spectator's involvement with the piece becomes increasingly subjective as the circular structure and swivel doors provoke an "awareness of choice-action-change" that supersedes a merely contemplative appreciation. The *Winston-Salem Sentinel* also pointed to this quality of *Locations* in a September 24, 1977, editorial:

> . . . for the traditionalist who thinks "sculpture" means a pigeon-roost general on horseback or a musclebound athlete pitching a

discus, Heintze's work probably will be a disappointment—at least at first.

But in an age when we are always supposed to be "getting into" things, this is a sculpture that you can, quite literally, get into, wander about inside, even change to suit your own taste. . . .

How Downtown folks choose to participate in the two-way artistic experience that Heintze's work mutely proposes should be an interesting study in human nature. As soon as people get used to the idea of hands-on art, we suspect that some will want to line up all the poles, others to scramble them, still others to turn all the outside ring flatwise, to make a giant drum.

And for those within GSA who had been unhappy with the conceptual ramifications of Heintze's first and second proposals, the *Sentinel* perhaps had the final word: "As for the appropriateness of the sculpture for its location, what better adornment for a federal building than a structural maze, composed of fixed parts that go nowhere, and moving parts that go nowhere? Indeed, Heintze's sculpture is the mirror image of the federal bureaucracy in all its complex, solid, silent splendor."

WORKS IN PROGRESS

As of this writing, there are twenty-nine projects underway for federal buildings and U.S. courthouses from Anchorage, Alaska, to Jackson, Mississippi. In addition, there are contracts in the negotiation stage, as well as commissions for which artists have just been nominated or selected.

This chapter provides a glimpse of ongoing art-in-architecture activities, reflecting the state of the program in mid-June 1979. Some of the works discussed here will be completed and installed while this book is in production, and such information is included where possible. However, projects for which artists have not made contract commitments as of mid-June have been omitted. The works in progress appear alphabetically by city.

ROBERT MORRIS ★

AKRON, OHIO

In February 1978, NEA-appointed panelists and the design architect for the recently completed federal building and U.S. courthouse in Akron, Ohio, nominated Robert Morris to create a work for the building's southwest plaza area. The following month, Administrator Solomon selected Morris for the commission, and the contract was negotiated in June for a fee of $68,000.

Morris developed a proposal for a work consisting of five pairs of granite blocks, each pair weighing about twelve tons, and each block measuring approximately eight feet high by five feet wide by three feet deep, placed on a diagonal sight line. In September 1978, Morris presented the proposal to GSA's Design Review Panel in the form of small wooden blocks set on a drawing of the plaza. The panel approved his concept, and he proceeded to have the work fabricated. It is scheduled for installation in the fall of 1979.

ALVIN AMASON ★

ANCHORAGE, ALASKA

Alvin Amason was nominated to create a large painting for a prominent stairway landing leading to the courtrooms and judges' chambers of the U.S. courthouse in Anchorage, Alaska. Amason, an Aleut born in Kodiak, Alaska, in 1948, is a serious artist with a keen sense of humor. He received his B.A. and M.A. from Central Washington State College, and his M.F.A. from Arizona State University (1976). His work was featured in the Contemporary Art from Alaska exhibition sponsored by the National Collection of Fine Arts in 1978.

GSA administrator Jay Solomon selected Amason for the Anchorage commission in August 1978, and the contract was negotiated in October for a fee of $11,000. Amason presented his design to GSA in Washington, D.C., on March 1, 1979, and it was enthusiastically approved. "This painting is probably the most profound journey I've had to date, concerning the concepts involved, the materials used, the levels of play," Amason said about his proposed work. He continued:

I've titled it *Papa Never Seen a Walrus Neither*. We don't have any around Kodiak Island. This image has been on my mind a lot lately, as I will be fishing in walrus country this spring.

The site I was given to work with was the major factor concerning the nature of the painting. This is a serious space to hang something in. It . . . will see briefcases, uniforms, robes, and handcuffs. Although the painting has many levels of concept, the literal surface is light.

Shortly after making his presenta-

Alvin Amason's Papa Never Seen a Walrus Neither, *for the landing outside the courtrooms and judges' chambers of the U.S. courthouse in Anchorage, Alaska. Describing the painting, Amason says, "I like to put things back where they came from: feathers in a carved bird, the birds back in the sky. In this case, the tusks back in the bull, scrimshawed with strawberries. We have strawberries in Alaska now. The levels of play go on and on, but as a visual artist, I hesitate to write more. Grandma likes this one."*

tion, Amason wrote GSA to describe his experience with the commission thus far. He noted that government contract fees tend to be rather low, especially for Alaska, where the cost of living is high and travel is expensive. Nevertheless, his overall assessment of the program and his participation in it was positive.

I think government commissions are an important step in the growth of an artist. It's also like a seal of approval. . . . I'm all for supporting the work of living artists as opposed to expensive paintings of those gone to the big studio in the sky. . . .

Another positive thing about these commissions is that they will expose Alaskans to some high-grade contemporary art—although a lot of people won't feel this way. It will be a good visual education to have these works around.

Papa Never Seen a Walrus Neither is scheduled for installation in late autumn 1979. It will no doubt be applauded by those who appreciate a light (though thoughtful) touch to the somber workings of the federal government.

DAN FLAVIN ★
ANCHORAGE, ALASKA

Dan Flavin represents a bright spot on the GSA horizon in more ways than one —for he is currently in the process of creating an innovative fluorescent work for the federal building and U.S. courthouse in Anchorage, Alaska. Flavin was nominated on July 14, 1978, by NEA-appointed panelists and a representative of the architectural firm that designed the building. According to NEA's official letter transmitting the names of the nominees (dated August 28, 1978), "The panel urged that Flavin be chosen for the north wall of the public main entrance area . . . to compensate for the unusual darkness of the Alaskan winters. . . . The architect and panelists strongly believed that this . . . is a unique and perfect opportunity for Dan Flavin's work." The GSA Design Review Panel and Administrator Solomon both agreed, and Flavin was selected for the commission in September. The following month a contract was negotiated for a fee of $80,000.

Flavin expressed interest in creating a work not only for the sixty-foot-wide by eight-and-a-half-foot-high wall but also for the mezzanine wall above it, which is visible from the first-floor lobby. Writing to GSA in May 1979, he said, "My final sketch is ready for the draftsman. Only another color confirmation might be useful." Flavin plans to use a finely brushed stainless-steel finish on the fluorescent fixtures to match the metal trim used in the lobby. "I want installational-architectural coordination in that lobby," he wrote. "I want a total artistic realization, even if I have to sacrifice relatively—the private artist at work and play in the public service."

Flavin presented his concept to GSA in the summer of 1979, and the installation is expected to be complete by midwinter 1980.

SAM FRANCIS ★
ANCHORAGE, ALASKA

In July 1978, an NEA-appointed panel met to consider the architect's fine arts proposal for the new federal building and U.S. courthouse in Anchorage, Alaska. Among the works to be commissioned was a painting for the building's entrance, a vast space that would require a visually commanding, brilliantly colored work. Panelist Henry Hopkins, one of the most respected museum directors in the country, said that given the site conditions and the NEA's determination to maintain the highest level of quality in its nominations, he could think of few painters more gifted or more appropriate for the commission than Sam Francis. The other panelists were also familiar with Francis's work and enthusiastically agreed.

Francis was subsequently selected by Administrator Solomon, and contract negotiations were held in Anchorage in mid-October. During the talks, he expressed some reservations about the space assigned for the painting on the first-floor lobby wall. Already in the midst of three other commissions, he was also concerned about the proposed completion date (fall 1979), but he nevertheless agreed to accept the contract for a fee of $98,000.

GSA had every reason to be pleased, but the residents of Anchorage are even more fortunate, for they will have a daily opportunity to see Francis's work, as well as three other artworks commissioned for the building. In a lengthy and scholarly article for the highly regarded *Alaska Advocate* (December 14, 1978), Margaret J. Firmin discussed the Anchorage commissions.

[The] artists' biographies are pages long, and read like chapters in some survey of contemporary art: degrees from this or that prestigious art school, one-man and group shows at numerous galleries both obscure and famous, fellowships and awards, works in major collections; critical acclaim. But to those of us to whom the names and art styles are unfamiliar, this information is still only so much black-on-white type. Who are these people, and why were they chosen to make their marks on the public buildings of Alaska?

Then, in answer to her question, she examined the work of each artist in detail. Recounting Francis's career, she wrote, "Abstract expressionist Sam Francis is acknowledged not only in America but also in Europe and Japan as one of the greatest painters of today."

Francis is currently developing his concept for the painting, which will be completed and installed by fall 1980.

ROBERT HUDSON ★
ANCHORAGE, ALASKA

With infectious energy and spirit, NEA-appointed panelist Dianne Vanderlip nominated Robert Hudson to create a sculpture for the pool in the huge atrium, complete with tropical gardens, of the new federal building and U.S. courthouse in Anchorage, Alaska. Considering the long, dreary Alaskan winters and Hudson's imaginative use of color and materials, the other panelists unanimously agreed. Hudson was selected for the commission in September 1978, and the following month he arrived in Anchorage for contract negotiations. Easygoing and likable, he agreed to a fee of $90,000 and accepted the contract. Hudson is currently working on his concept, and the completed piece is to be installed by autumn 1980.

Upon learning of Hudson's acceptance of the contract, Margaret J. Firmin described his selection, background, and work in an article for the *Alaska Advocate* ("A Very Public Display," December 14, 1978):

West Coast artist Robert Hudson was born in Salt Lake City, raised in Richland, Washington, near the Yakima Indian reservation, schooled in art at the San Francisco Art Institute, and currently lives in Cotati, California. His work, which he sees as a "two-way conversation," covers the media of sculpture, painting, assemblage, collage, and ceramics. At first he used these media independently, but in the sixties he began painting

sculptures and adding parts including identifiable, everyday objects like hats and buckets as well as non-representational forms of his own creation. At the time he began combining media in this manner, his was a unique approach.

Hudson, who is keeping his design closely guarded until its presentation and approval, will say only, "There's going to be a lot of painting on it. I'm *really* excited about this commission!"

JENNIFER BARTLETT ★
ATLANTA, GEORGIA

For the long main lobby of the new Richard B. Russell Federal Building and U.S. Courthouse in Atlanta, an NEA-appointed panel nominated Jennifer Bartlett, whose paintings first won critical acclaim in the early 1970s. Since 1972, her work has been featured in more than sixty group exhibitions and seventeen solo exhibitions at many of the nation's most respected museums and galleries (including the San Francisco Museum of Modern Art, the Museum of Modern Art and the Whitney Museum of American Art in New York, the Art Institute of Chicago, the Virginia Museum of Fine Art in Richmond, and the Walker Art Center in Minneapolis, to mention just a few). Prior to accepting the GSA commission, Bartlett's largest undertaking was *Rhapsody,* a work consisting of 988 one-foot-square units, each silk-screened over baked enamel on steel plates and then painted with Testor enamels. It brought an outpouring of praise from art critics; John Russell, writing for the *New York Times* (May 16, 1976), called it "the most ambitious single work of new art that has come my way."

Bartlett, who received her M.F.A. from the Yale School of Art and Architecture in 1965, was selected for the commission by Administrator Solomon in October 1978. At first, however, she wasn't sure she wanted to accept the commission, citing the following reservations: "(1) Interruption of own work; (2) Time involved for large-scale project; (3) Whether award would cover the actual costs (including my own labor) of the project; (4) What is the function of public works? Who are they to please —the artist, the public, the people giving the award?" In fact, Bartlett said, "Decided not to accept until I had a concrete idea that would interest me to do, that would be a contribution to my work in a general way."

In December 1978, a contract for

Studies for "Seaweed" (top) and "Flare," two of the nine paintings in Jennifer Bartlett's series Swimmers for Atlanta. *"My attempt in this wall work is to bring all the . . . elements and sections into a cohesive whole, neither totally representational nor nonobjective," says Bartlett.*

multiple paintings was negotiated for a fee of $110,000, and Bartlett agreed to accept the commission the following January. As she later wrote, "Got idea, did drawings, . . . shelved philosophic questions. Negotiated contract with sympathetic group of people from GSA and my New York dealer, Paula Cooper." By February 1979, Bartlett had developed her concept, taking into consideration the unusual dimensions of the lobby—"The Space: two-hundred-foot rectangle twenty feet long twenty feet wide," as she describes it. "Space you walk through fast—narrow and long. Wanted work to stop people. Make space appear larger. Wanted to use entire space."

Bartlett presented her concept to GSA's Design Review Panel on February 5. Unlike *Rhapsody,* which utilizes only twelve-inch-square painted panels, the Atlanta work consists of nine paintings, each equally divided into painted steel plates and oil-on-canvas panels, and "each differing largely in size, color, and way of painting." Bartlett noted that the sizes vary according to a pattern based on the numbers 1 through 9 ("The number 9 interests me," she told the panel). Continuing with her description, she wrote:

> Placement: alternating large and small ptgs. to change viewers' relationship to overall space.
> Image: from ptg. *Tidal Wave II.* Swimmers either swimming or drowning.
> Color: each ptg. different color. White, black, red, yellow, blue, green, orange, violet, all colors.
> Each ptg. one different additional image: ship, whirlpool, iceberg, flotsam, rock, eels, seaweed, flare, buoys. Each ptg. has weather condition, time of day. Trying to make each one specific.

If Bartlett's description seems intriguing, the completed work, which is still being developed, will no doubt be even more so. Making a literary analogy, Bartlett told the GSA panel that the overall composition should be likened to a series of short stories rather than a novel. Titled *Swimmers for Atlanta,* it is scheduled for installation by the early spring of 1980.

SAM GILLIAM ★
ATLANTA, GEORGIA

It's a long way up to the twenty-third floor lobby of the ceremonial courtrooms in the new Richard B. Russell

The canvas portion of Sam Gilliam's painted construction Triple Variants, *for the lobby of the ceremonial courtrooms in the Richard B. Russell Federal Building and U.S. Courthouse in Atlanta, Georgia. The completed work will also incorporate aluminum and marble. As Gilliam describes it, "The canvas structure, which [is] fifteen feet by forty feet, was fabricated as a huge collage of various colored canvas fabrics used in making awnings. It was sewn over a structure of nylon webbing for support. . . . The aluminum beam, which is seventeen feet in length and will rest on the floor, will be used to frame the painted construction to be hung above. . . . The final element will be one or possibly two marble stones."*

Federal Building and U.S. Courthouse in Atlanta, but it will be worth the elevator ride. On the twenty-two-foot-high granite wall opposite the entrance, building occupants and visitors will be able to view a large wall-mounted painted construction by Sam Gilliam. Gilliam was recently honored with a retrospective at the University Gallery for the University of Massachusetts in Amherst—the gallery's first major exhibition devoted to the work of a single painter. Hugh M. Davies, director of the gallery, has called Gilliam "indisputably one of America's leading artists, whose work has been known internationally for more than a decade" (*Sam Gilliam Indoor and Outdoor Paintings 1967–1978,* catalogue introduction acknowledgments).

Gilliam was nominated by an NEA-appointed panel in February 1978. Selected the following month by Administrator Solomon, he accepted the commission for a fee of $50,000. In December, he submitted his proposal for a work consisting of "three differently fabricated elements—a canvas structure, an aluminum beam, and marble stones." These elements, seemingly quite discrete, are related by the artist's creative activity, both theoretical and practical. As Gilliam later wrote, reflecting on the development of the piece and the interaction of its constituent parts,

The interest of the work lies thusly, not only in the completion of it, but also in the procurement and development of the component materials. The fabric collage was the first section to be completed by a fabricator. Before I painted it in Washington, I was able to observe it lying on the studio floor as I thought about the stones and the aluminum beam. About this time, I visited the Georgia Marble Company, where I was surrounded by large piles of rough-cut marble. This experience helped to prepare me for the textured paint surface I wanted in the painting.

At his presentation to GSA's Design Review Panel, Gilliam was extremely well prepared—and wisely so, for his work is in no way "easy" (people who prefer a blue-and-green painting to match their blue-and-green sofa will have to dig a little deeper into their intellectual resources to appreciate it). With the aid of several black-line prints, a sewn, painted canvas of considerable size and complexity, and a complete model encased in Plexiglas, Gilliam explained his concept; the total effect was dazzling.

The proposal was unanimously approved by the Design Review Panel, and Gilliam wasted no time getting to work on "one of the largest wall-mounted painted constructions I have made." Describing his technique and materials, he wrote:

The painting, which is mixed media, predominantly acrylic and oil with aluminum powder, took at least a month to complete. The colors were sought for rather than made. The work was made on the floor by continuously folding the material. The final colors were the result of a rough raking of the wet surface of predominantly green, white, and gray colors over red, yellow, and blue ground to produce a softened effect relative to the texture of the stones involved. The cuts and fabric openings are to allow the actual surface of the stones to come into the work.

Whereas the beam was not easy to find/fabricate, it really does belong.

The work, titled *Triple Variants*, is scheduled for installation in the fall of 1979; no doubt, it will be greeted by a good amount of critical fanfare. As the project approached completion, Gilliam expressed his "appreciation . . . to the General Services Administration's Public Buildings Service and its personnel for helping me to experience my first granite wall seriously in art." He also thanked those who helped him assemble the materials and fabricate the work, "particularly Clarence Wood, James Whitley, Lou Stovall, Larry Wood, and Don Kaiser."

LLOYD HAMROL ★
ATLANTA, GEORGIA

"The name of a building being built in a city I'd never seen. An abstract volume of architectural space in need of sculpture. How devoid of reality it seemed," wrote Lloyd Hamrol in April 1979, reflecting on the preceding year's events.

In February 1978, Hamrol had been nominated by NEA-appointed panelists to create a sculpture for the auditorium-cafeteria lobby of the new Richard B. Russell Federal Building and U.S. Courthouse in Atlanta, Georgia—a considerable distance from Hamrol's home in Venice, California. The following month, Administrator Solomon selected him, and a contract was subsequently negotiated for a fee of $45,000. "I accepted the commission because, frankly, I wanted to work in a large public context without interference," he said. "While the GSA contract is tediously thick, the actual operating mechanism between agency and artist seems to function quite well."

Hamrol submitted his proposal in December, and the GSA Design Review Panel approved it readily. "It was a great relief, after many enervating encounters in other situations with funding problems, payment delays, and ambivalent commitments, to get the green light at the presentation meeting and then rest assured that my only concern would be the work itself," wrote Hamrol. He remembers thinking when he first began to develop his concept that creating a work for an enclosed lobby was "too easy." After visiting the fifty- by seventy-foot space, however, he "began to understand its dimen-

sional nature and limits, [and] the situation grew in complexity."

The ceiling height restriction (ten feet) presented conceptual problems: how to achieve scale within that limit while taking into account the multiple directions and movement of foot traffic through this "link" to the adjoining service areas. Since one of my commitments was to have the work engage the audience at a tactile and kinetic level, I was afraid that in this flat, boxlike space a furniture scale would be inevitable and would overwhelm all other perceptions of the piece. The answer to that was not to hedge on the issue, but to jump headlong into the furniture idiom.

Hamrol did precisely that. He designed a spiral of nineteen "proportional reiterative chairlike segments" ranging in size from two feet high (to the top of the chair back, with the seat at midpoint) to six and a half feet high. The spiral, with axes extending twenty feet in one direction and twenty-six feet in the other, will be made of three-inch-thick red oak and centered in the lobby.

Describing the kind of participation he hopes his work will invite, Hamrol wrote:

I remember, when I was younger and smaller, several of us rearranging the family furniture—chairs, tables, couches, desks—into some new kind of "architecture"; transforming the stolid presence of those ordinary adult objects into mountains, thickets, caves, fortresses, or field tents—for long moments beheld by us, ourselves in turn trans-

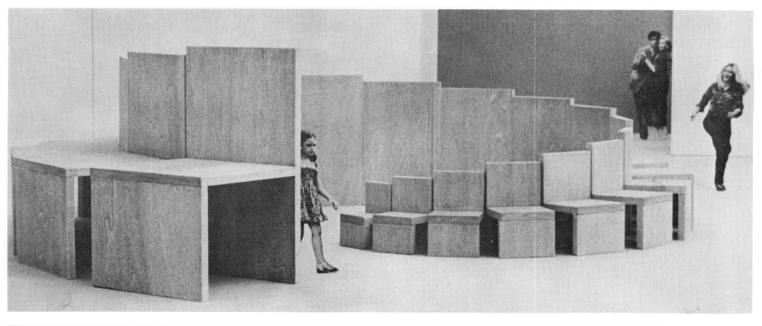

The model for Thronapolis, *Lloyd Hamrol's wood sculpture for the federal building and U.S. courthouse in Atlanta, Georgia.*

formed by that which we had dared to change.

Most parents have observed such joys in their children's creative environment-making. Hamrol's concept will enshrine them in a permanent, serious, and delightful sculpture (one could, among other things, crawl through the spiral or sit on the very large chair, pretending to be very little), which is scheduled for completion in late summer 1979. At that point, according to Hamrol, "the formal hierarchy is established. Fantasy and phenomena begin to assimilate one another."

DALE CHIHULY ★
BLAINE, WASHINGTON

Dale Chihuly, one of the foremost glass artists in the country, was born in Tacoma, Washington, in 1941. Founder of the Pilchuck School in Stanwood (fifty miles north of Seattle), he pioneered a number of influential, innovative techniques, and he presently heads the Rhode Island School of Design's glass program. Meeting in October 1977 with architect Ken Richardson (of Durham, Anderson, Freed), an NEA-appointed panel nominated Chihuly to create a glass wall for the Peace Arch Border Station in Blaine, Washington. He was selected for the commission by Administrator Solomon in May 1978, and Julie Brown of the Art-in-Architecture Program staff negotiated an $11,500 contract with him in August.

Accompanied by his assistant, Mark McDonnell, Chihuly presented his concept to GSA's Design Review Panel in mid-June 1979. As he explained it, the work will consist of twenty-two hand-blown rondels, each about two feet in diameter. The rondels, individually mounted on the glass wall at a thirty-degree angle, will overlap, spanning twenty-five feet. Each will contain an image—loose, simple drawings in glass on glass—and be colored in brilliant pastels, notably blue, yellow, pink, and green. As the rondels overlap, new and unexpected colors will emerge and be projected on the surrounding surfaces by the sun's movement. GSA panelists David Dibner, Karel Yasko, and Walter Roth unanimously voted to "accept with enthusiasm" Chihuly's proposed work, which is scheduled for installation in autumn 1979.

JACKIE FERRARA ★
CARBONDALE, ILLINOIS

Meeting on August 23, 1978, NEA-appointed panelists nominated Jackie

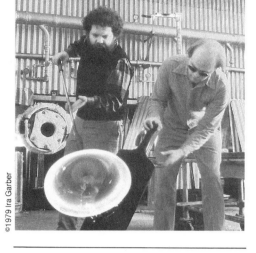

Dale Chihuly (left) and an assistant work on one of twenty-two rondels for a glass wall at the Peace Arch Border Station.

Ferrara to create a free-standing sculpture for the main entrance plaza of the federal building in Carbondale, Illinois. She was selected by Administrator Solomon in October, and a contract was negotiated for $17,000 in February 1979, when construction of the building had just gotten underway.

Ferrara is presently developing the concept for her sculpture. "I am very excited about the project," she says. "When I first saw the building in an early stage of construction, I strongly felt that I could build a piece that would work well with it." Installation is scheduled for the summer of 1980.

MARLA MALLETT ★
COLUMBIA, SOUTH CAROLINA

In January 1978, NEA-appointed panelists nominated Marla Mallett, a fiber artist from Atlanta, to create a major work for the entrance lobby wall of the new Strom Thurmond Federal Building and U.S. Courthouse in Columbia, South Carolina. In March, Administrator Solomon selected her for the commission, and a contract was negotiated in mid-April for a fee of $25,000. Seven months later, Mallett presented her proposal to the GSA Design Review Panel, and it was enthusiastically approved. Mallett was pleased, later writing, "The creative freedom granted by the GSA in this project has been re-

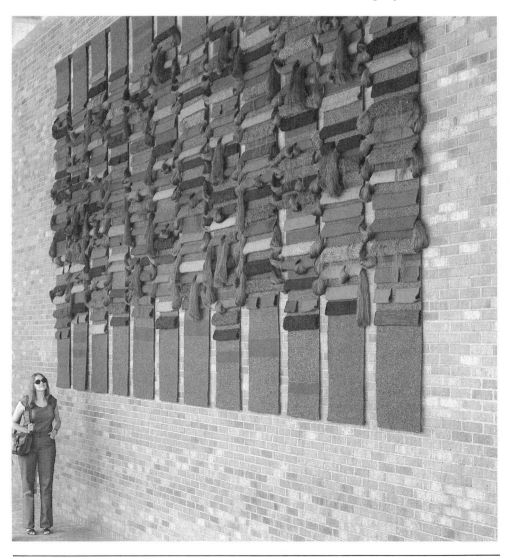

Marla Mallett admires her fiber work for the lobby of the Strom Thurmond Federal Building.

©1979 Ira Garber

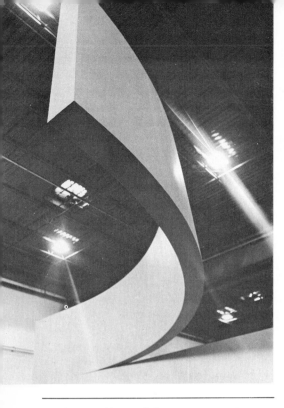

Barbara Neijna's Right Turn on White *during fabrication at the Lippincott company.*

markable. It has allowed me to deal directly with the challenge of the architectural and spatial requirements."

Mallett had carefully studied the site, a dark reddish-brown brick wall facing a huge window wall with a southern exposure: Her proposal reflected an awareness of possible damage from indirect sunlight, as well as from constant touching. "The heavily used corridor required a tightly constructed, durable textile, placed high to discourage handling," she wrote. She also took into account the interior lateral approach to the piece, from the main lobby entrance to the ceremonial courtroom, and the frontal view, which is partially obscured by window mullions and columns. "To me," she said, "these limitations suggested a sequential piece with a random, allover kind or organization."

The piece I have created is a double-woven structure, contrasting soft, lustrous, flexible elements with stationary components which are bulky and stiff. Twelve vertical interlaced panels of natural gray-brown wool support great numbers of colorful horizontal tubular pockets. Some of these blue, ochre, and brown pockets are of heavy, rough hand-spun wools; others are smooth. The lacings are massive, loose coils of fine, red-brown polished cotton cord. They will intersect, twist, and interweave randomly across the width of the piece, packing tightly within the pockets,

and falling loosely between them.

The completed work, measuring fourteen feet high by twenty-eight feet wide, will be installed by autumn 1979.

BARBARA NEIJNA ★
COLUMBIA, SOUTH CAROLINA

On January 12, 1978, an artist nominating panel appointed by the NEA met with architect Herbert Beckhard (of Marcel Breuer and Associates) to consider a large-scale sculpture commission for the plaza of the Strom Thurmond Federal Building and U.S. Courthouse in Columbia, South Carolina. Among the panelists' choices was Barbara Neijna, a sculptor who lives in southern Florida. In March, Administrator Solomon selected her for the commission, and she was notified of the offer by telephone. As she later recalled, ". . . when I received the phone call . . . I couldn't help but put to rest that false assumption that careers can only flourish from the New York 'center.' I found it particularly thrilling and rewarding to know that I was recognized—in spite of the fact that I reside out of the mainstream, almost hermetically sealed off by tropical palms, ocean spray, and children. I felt great about it all and couldn't wait to get started."

With Paul Abernathy representing the GSA regional office in Atlanta, contract negotiations were conducted in mid-April, and a fee of $65,000 was agreed upon. Neijna found the whole experience unexpectedly straightforward and described the atmosphere of the talks as one of "suspended pleasure."

I've signed many contracts. They are usually accompanied by anxieties of varying degrees. The basic "paranoia" I bring to such meetings is not wholly unwarranted. However, in this instance, . . . all fears seemed to lie at rest. The document was cumbersome, complex, and contained minutiae that would probably make great legal minds stand at attention. Nevertheless, . . . all of my predecessors had signed this same document—and survived. . . . Additionally, it was crystal clear to me that there would be absolutely no intervention with my aesthetics. All problems pale in light of this major point. . . . The whole experience was fair—all issues were open to discussion and/or change. I am convinced that all representatives of GSA were there to assist me and "protect" me from complications of any nature.

For the next three months, Neijna worked on developing the design concept for the piece, which will be set on a plaza between the towerlike federal building and the two-story rectangular courthouse. When she first saw the site, she had "very decided ideas," which she described as follows:

Neither building dominated that space, and it seemed that this neutral area would only be determined by the quality and intention of my sculpture.

I chose to involve my viewer on the lower level, and visually, as well as psychologically, to tie in the spaces. A vertical concept would compete with the tower and dwarf the low courthouse building. I concentrated on creating a horizontal kind of polarized energy with strong directional patterns. I felt a need to set boundaries and points of reference. My intention was to create a structure for behavioral experience—to create an awareness of space through new relationships. I wanted to involve people on the ground level in the process of integrating their minds and bodies while traversing both real and implied limits. I wanted to create a space that was personal.

Neijna also spoke of her desire to stimulate the viewer's awareness of other boundaries, such as those defined by the building and even the sky. In order to experience the work, one has to spend time walking around it, ". . . getting to the other side—another side, in order to fully see and know," in Neijna's words.

On July 21, Neijna presented her concept to the GSA Design Review Panel; she came thoroughly equipped with a scale model, siting drawings, structural engineering drawings, foundation drawings, photographic overlays, etc. The panelists were impressed with her command of the project. As she later recalled, "I spent forty-five minutes going over the smallest details. When I finished everyone applauded. I was stunned. They seemed to love it, and I always love people who love my work. I left feeling relieved, exhilarated, and anxious to get to work. It felt good to be an artist in America today."

Neijna's sculpture, titled *Right Turn on White,* was fabricated by the Lippincott company in North Haven, Connecticut, and was installed in midsummer 1979. Summarizing its meaning, Neijna wrote:

My work in South Carolina is a

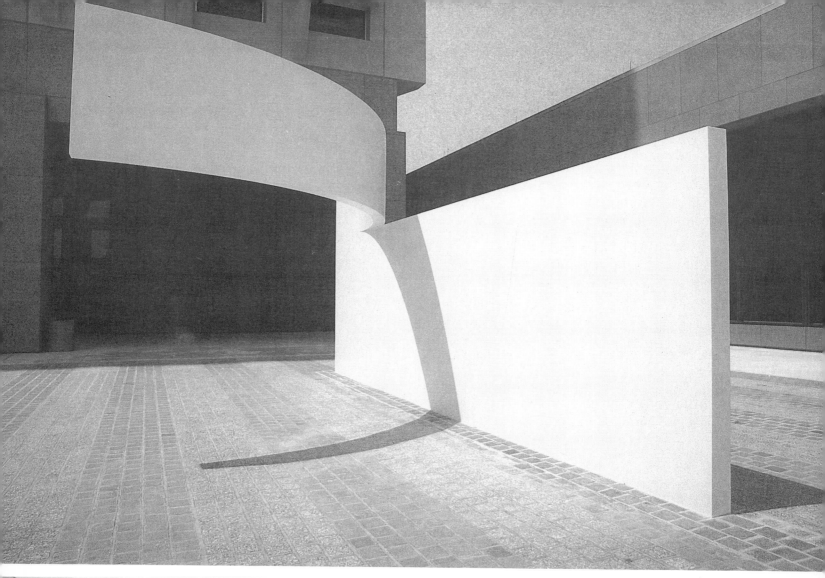

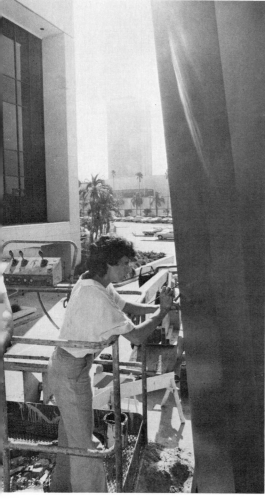

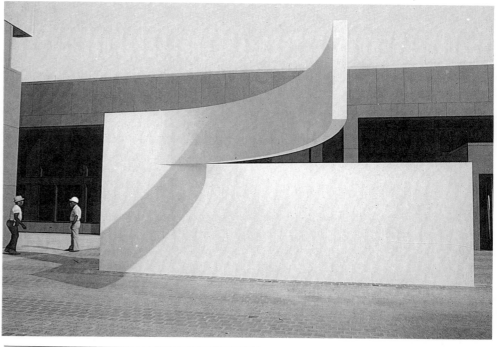

Left: Neijna puts the finishing touches on her sculpture as the installation crew works to secure its foundations.

Above: Two views of **Right Turn on White** *after installation in the plaza of the Strom Thurmond Federal Building and U.S. Courthouse in Columbia, South Carolina. Discussing her intentions in the design of the work, Neijna wrote, "I was interested in the mysterious act of researching what might have been a known space by establishing an element that interrupts the continuum and in so doing creates an anticipation of approaching the unknown —in this case, it is beyond the wall, the next step, the next turn, etc. I wanted to be able to turn the experience inwards toward the observer's private space of being and provide a space where he could establish his own boundaries."*

non-enclosure, giving my concerns for inside and outside space a sense of freedom within confinement; it is a sanctuary—a track system—fragmenting time, moving on. My control of public work must extend beyond my form into the entire space. In so doing it becomes not less important, but less self-important. It all counts when creating an outdoor sculpture—not as part of the "object," but as part of the environmental experiential process. I feel that the truth in the work is in the intervention of the viewer within the shared space.

JOHN CHAMBERLAIN ★
DETROIT, MICHIGAN

Over the past several decades, Detroit, like so many other large cities, has witnessed the flight of residents, corporations, and cultural institutions to the suburbs. And, like other urban areas, Detroit needs attractions capable of drawing people back to the inner city. If preliminary reactions are any indication, John Chamberlain's sculpture for the plaza of the McNamara Federal Building will become just such a magnet.

Even before Chamberlain was commissioned, the drive to acquire artworks for the McNamara Building had galvanized Detroit and generated an unprecedented outpouring of local support. Associate editor David Cooper of the *Detroit Free Press* was the first to sound the call to action. Noting that GSA had taken no steps to commission artwork for the McNamara Building, Cooper kicked off a campaign with a lead editorial on June 18, 1977 ("A Little Effort Could Net City 2 Major Art Pieces"). "When the new McNamara

Federal Building was completed in downtown Detroit, the city got cheated out of a major American art work that could have given both the building and downtown another touch of class," Cooper began. Nearly twelve column inches later, he concluded:

> Art in public places helps enhance the human spirit; it makes cities more interesting and fun. And cities that people enjoy are likely to become more stable, more economically healthy. With effort by a variety of people in the metropolitan area, we have a chance to add two new important art works to the hope and promise of Detroit.

The following month, in another editorial, Cooper again urged citizens to "Write for Art" and listed relevant names, addresses, and zip codes. This time, he included endorsements of the art crusade from prominent public figures: "Among those who have urged [GSA] to bring great works of public art to downtown Detroit are Gov. Milliken, Henry Ford II, Mayor Young, Dr. Frederick Cummings, the director of the Detroit Institute of Arts, George Gullen, president of Wayne State University, and many others." Indeed there were others, among them Mrs. Charles N. (Katherine K.) Blunt, who wrote GSA on August 1, 1977:

> Today, when so much of the Federal budget goes for items of destruction, depressing even to think about, [the GSA] program is one of the few that spends any money ensuring that what remains of spontaneity, creativity, and joy and beauty in the American spirit can be nurtured and stimulated by the excitement of art in public places.

Consider this letter not only an appeal for Detroit, but a vote of thanks and confidence in what you have done thus far for the U.S. in general.

GSA responded, thanking Mrs. Blunt for her letter and informing her that the search for funding was underway.

Such assurances weren't enough for Cooper. In August he wrote a third editorial, announcing that GSA had located $70,000 for the McNamara project, and encouraging citizen contributions to a fund-raising drive that would augment GSA's sum. "Art," he reiterated, "is important to the vitality of cities." At this point, leading citizens of Detroit sprang into action, forming the McNamara Sculpture and Art Committee. Led by the energetic Irene Walt, legendary benefactor W. Hawkins Ferry, and architect Charles T. ("Tom") Harris, the committee canvassed all of Detroit to enlarge the budget. Unions responded; small and large businesses made donations; the list of contributors grew and grew. It was more than impressive; it was astounding. By the time the campaign ended, over $30,000 had been collected.

Though the effort to raise additional money slowed the commissioning process down, the delay had no serious consequences. On August 30, 1978, an NEA-appointed panel met in Detroit to nominate artists, and the panelists from the Detroit area urged the selection of John Chamberlain. Administrator Solomon concurred. Contract negotiations were held in Detroit toward the end of November, after Chamberlain had studied the site and met with representatives from the McNamara Sculpture and Art Committee. Assisting him was Julie Sylvester of the Heiner Friedrich gallery, which handles Chamberlain's work. He agreed to a fee of $100,000 and began working on his proposal.

Four months later, in March 1979, Chamberlain and Sylvester arrived in Washington, D.C., for the presentation of his concept. On hand were the entire Art-in-Architecture Program staff, representatives from the McNamara Sculpture Committee and from the GSA administrator's office, and the full Design Review Panel. At the meeting, Chamberlain submitted a proposal for a work measuring thirty to thirty-five feet high, made of crushed motor-vehicle parts painted yellow, or perhaps yellow and white. He had made a rather elaborate model, complete with partial building facade, plaza area, trees, and a

John Chamberlain's maquette for a sculpture tentatively titled McNamara's Band, *to be installed in the plaza of the McNamara Federal Building in Detroit, Michigan.*

facsimile of his proposed piece, set in a sunken sculpture court faced with stainless steel (represented in the model by mirrors). Chamberlain explained that stainless steel would make the immediate siting "more formal" in contrast to the sculpture itself. "Considering the material involved, if [the base] isn't formal, some may not believe that it's what should be there," he said wryly. The meeting alternated between serious discussion and laughter as the details of the proposal were examined. When panelist David Dibner asked how the piece was to be secured to the base, Chamberlain replied, "Any way you want to." Later, Dibner inquired how Chamberlain planned to paint the work, anticipating his answer: "With a paint brush."

At the conclusion of the presentation, the committee members from Detroit expressed their complete satisfaction with Chamberlain's proposal. Dibner was in favor of accepting the maquette, stating that he thought the work would be "a fascinating addition to Detroit." Panelist Karel Yasko said, "I'll go along with it—not enthusiastically—but I'll go along with it." Panelist Dennis Keilman, who had arrived midway through the meeting, asked Yasko about his reservations, and Yasko said he was concerned about the "symbolism of smashed-up cars" for the city of Detroit. Responding to Yasko's concern, Chamberlain said, "I don't know why it symbolizes cars, because there are no wheels, no tires, no upholstery, no glass, no oil, no engines." Keilman asked the citizens' committee from Detroit if the people of Detroit would be prepared to accept the work; speaking for the committee, Irene Walt answered affirmatively. Hawkins Ferry said, "I'm all for it—I think it's very, very strong." Keilman also gave his approval, and GSA photographer John Holland took pictures of a triumphant Chamberlain explaining the work to the citizens' committee.

The work is scheduled for installation in the spring of 1980. Chamberlain says he has tentatively named it *McNamara's Band*.

TOM DOYLE ★

FAIRBANKS, ALASKA

After viewing a large wooden sculpture by Tom Doyle at the 55 Mercer Gallery in New York, art critic Hilton Kramer wrote;

The medium is constructed wood, and the form is rather like that of an immense bird, with two ramp-like "wings" and an elongated beak. Although difficult to see in this confined space—one would prefer to observe it in the open air . . . —it is nonetheless impressive. Its forms are monumental, even a little grandiose, yet there is an underlying delicacy in the gesture that is traced in the image as a whole. [*New York Times*, March 6, 1976]

Given this appreciation, Kramer would no doubt be impressed with Doyle's latest effort, a considerably larger work that will be placed in front of the federal building and U.S. courthouse in Fairbanks, Alaska, on a semicircle of grass one hundred feet in diameter.

Doyle was nominated by an NEA-appointed panel in April 1978. Impressed with the industrial quality of the building, the panelists believed that Doyle's massive wood sculpture would work well with the architecture. Administrator Solomon agreed and selected Doyle for the commission. Upon hearing of the award, Doyle was eager to accept. "I was naturally excited by the possibility of building a permanent public sculpture," he said later. "The fact that the location is Alaska made the prospect especially exciting to me because it is a place I'd always been interested in visiting. Since my work has many early building principles, it seems an especially appropriate location."

Accompanied by his wife, Jane, Doyle arrived in Fairbanks several days prior to the scheduled contract negotiation date of October 21. Investigating local fabrication possibilities, he found that lumber mills in the area were not equipped to cut wood to his unusual specifications. (Consequently, the wood for his piece is being milled in Pennsylvania.) The contract was nego-

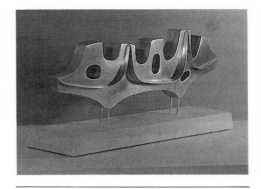

The maquette for Arctic Amphibian, *Gerald Conaway's sculpture for the Fairbanks Federal Building and U.S. Courthouse. "A most important consideration for this form was how the northern snowfall would interact with it, covering up portions while retaining visibility of other portions," says the sculptor.*

tiated for a fee of $49,000, and Doyle was satisfied. "I thought they were fair and appreciated the thorough explanation of the contract," he wrote.

Doyle invested a great deal of time and energy in the development of the maquette. "The weather, wind, and location of the site were all taken into consideration when I began work on the model," he explained. "I did six different maquettes until I arrived at the one that I felt satisfied all the conditions of the site. The sculpture had to meet the physical as well as the aesthetic demands of the space." GSA enthusiastically approved Doyle's proposal.

The sculpture is scheduled to be installed by the fall of 1980. Measuring twelve feet high by forty-eight feet wide by forty-seven feet deep, it will consist of two-inch by eight-inch planks and of ten beams, each twenty-four feet long and tapered (from four inches by twelve inches at the base to eight inches by twelve inches at the top). It will be made of polyurethane-coated white pine and

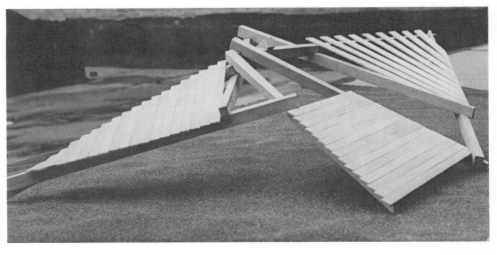

Tom Doyle's maquette for a massive wood sculpture, as yet untitled, to be installed in front of the federal building and U.S. courthouse in Fairbanks, Alaska.

bolted together. "I intend to build the sculpture myself, with the help of an assistant," said Doyle.

GERALD CONAWAY ★
FAIRBANKS, ALASKA

At their meeting in Fairbanks on April 20, 1978, NEA-appointed panelists were treated to a complete presentation of the work of Alaskan artists, assembled by the Alaska State Council on the Arts. Their first choice to execute an exterior sculpture for the intimate plaza of the Fairbanks Federal Building and U.S. Courthouse was Gerald Conaway, a resident of Anchorage. Conaway has had numerous one-man shows in the Anchorage area and was an art instructor for ten years at Alaska Methodist University (1965–75).

Recommended for the commission by GSA's Design Review Panel on August 18, Conaway was selected by Administrator Solomon in September. In October a contract was negotiated in Fairbanks for a fee of $21,000. By January 1979, Conaway had completed his maquette. At his presentation to the Design Review Panel in early February, he described the work as "a composite of forms and space shapes as a retrospective memory of my formative years."

The cross-sectional shapes of a dugout canoe, in which I spent many hours studying other aspects of nature—such as the eye of an arctic loon or the fins of a surfacing fish—are visually suggested. There is the spirit of something which might either fly or swim. You don't know whether to think feathers or scales—it's just that the next time you see a bird or a fish, you'll seem more closely akin to it without knowing why.

Using quarter-inch aluminum, Conaway welded the work himself in his Anchorage studio. It is officially titled *Arctic Amphibian*, but Conaway uses a more personal name. He has always called it *One Thirty-five* because, as he says, "It is one sculpture with three holes and five bumps." Fabrication was completed on June 11, and according to Conaway's contracting officer in GSA's Auburn, Washington, office, "The welding job is fantastic—a work of art in itself!" Conaway himself said, "You can't imagine my delight over the whole commission project."

Arctic Amphibian was installed in June 1979.

Carmen Quinto Plunkett presents her proposal for three carved wood panels based on Tlingit Indian legends. The Thunderbirds *(left) portrays the mythical creatures who cause thunder by flapping their wings, and lightning by blinking.* Tlingit Conception II *represents the union of an eagle and a raven, from which a Tlingit is born. Not shown is* The Protector, *in which a grieving mother is comforted by a vision of the Thunderbird.*

CARMEN QUINTO PLUNKETT ★
HAINES, ALASKA

In April 1978, an NEA-appointed panel met with W. J. Wellenstein, the design architect for the U.S. Border Station in Haines, Alaska, to consider a fine arts commission for the building. The Alaska State Council on the Arts had assembled information on Alaska's foremost artists for the benefit of the panelists, who were particularly intrigued and impressed by the work of Carmen Quinto Plunkett. Plunkett, a Tlingit Indian, is one of the very few women, if not the only one, to successfully break into the otherwise male-dominated tradition of Tlingit wood carving. She was the panelists' first choice for a commission to carve exterior wood panels for the Haines Border Station.

In August, GSA's Design Review Panel recommended Plunkett's selection, which was confirmed by Administrator Solomon in September. Contract talks were held in Wellenstein's office,

with the assistance of Christine D'Arcy, Visual Arts Program coordinator for the Alaska State Arts Council, and Harold Broomell, Plunkett's contracting officer from the GSA regional office in Auburn, Washington. A fee of $12,000 was negotiated.

In mid-May 1979, Plunkett arrived in Washington, D.C., to present her concept to GSA's Design Review Panel. Using large paintings on paper, she explained that the work would consist of three large wood panels, each carved, painted, and sealed, with portions of the surfaces finished in a combination of abalone shell, stainless steel, and copper. Each panel would tell a story based on Tlingit legend. For the presentation, her husband, architect Mike Plunkett, had helped her prepare a nicely bound booklet containing complete working drawings and a set of specifications for construction and materials.

The GSA panelists were enchanted with Plunkett's proposal and unanimously approved it. She too was pleased, not only because of their en-

thusiastic response, but also because she had been selected for the commission in the first place. As she later wrote:

Hearing that I had received a commission from the GSA, I was very excited, realizing that these commissions are a rare occurrence for most artists. The commission given to a native artist is a step forward for us, who so often have sat in the background while recognition has been given to others who copy our traditional artwork. With this commission I hope to set an example for other native artists to use their imagination and creative ability to again produce the high-quality works of art for which we were once noted.

Carmen Quinto Plunkett's works are scheduled for installation in late autumn 1979.

GUY DILL ★
HURON, SOUTH DAKOTA

On January 19, 1978, Guy Dill was nominated by NEA-appointed panelists to create an exterior sculpture in front of the federal building in Huron, South Dakota. His subsequent selection by Administrator Solomon was unexpected but welcome, as he later said. "Since I dislike juried shows and competitions regarding my work, the call from Julie Brown asking if I would accept the commission was a great surprise. I didn't have to experience any anxiety awaiting word on it."

In early July, Dill traveled to Huron from his Venice, California, home for contract negotiations, which were conducted by GSA's regional fine arts officer and Dill's contracting officer, Oliver J. Bryant. The chemistry between negotiators and artist was good, the site was acceptable, and Dill agreed to a fee of $25,600.

The first meeting in Huron to view the project site was, I suppose, as simple and straightforward as possible. My first impression of the building was that indeed it was federal—a four-story red-brick building with a flagpole positioned in the center front courtyard. Since previous outdoor projects have taught that you rarely, if ever, reposition the flag, I then selected the next closest site for visibility and proximity within and without the building.

The following October, Dill pre-sented his concept to GSA's Design Review Panel. Speaking of the development of his ideas, he said, "When I conceive a work for a particular site, the region, architecture, light, surrounding space, and community are all factors. . . . I think that the major influence of Huron was its farm equipment and terrific feeling of spaciousness. As with most farm communities, order is always present and visible." As for the meeting itself, the sculptor remarked, "Prior to presenting my concept to the GSA, I had understood that no aesthetic judgment was to be passed on the work, which was the case. As an engineering review, there were no problems and few questions, since the structure of my work is always a visible element."

Dill's concept was unanimously approved, and he titled the work *Hoe Down*. It consists of four plates of cold-rolled steel, each a half-inch thick, seven feet high, and eight feet wide. Four Douglas fir poles fourteen feet long and nine inches in diameter "puncture" each plate. Overall, *Hoe Down* measures seven feet high, fifty feet wide, and about twelve feet deep and weighs a total of eleven hundred pounds. The plates are painted black (over four coats of rust primer), and the timbers have been weather-treated. The piece, which rests on a concrete pad, was installed in the summer of 1979.

WILLIAM CHRISTENBERRY ★
JACKSON, MISSISSIPPI

The federal building in Jackson, Mississippi, was under construction when NEA-appointed panelists met in January 1978 to nominate artists for two works: an exterior sculpture and a work for the interior face of the main entrance's screen wall. In March, Administrator Solomon selected William Christenberry for the wall commission. Christenberry, who was born in Tuscaloosa, Alabama, in 1936, received his B.F.A. (1958) and M.A. (1959) from the University of Alabama. A professor at the Corcoran School of Art since 1968, he has had seventeen one-man exhibitions since 1961, and his work has been featured in well over thirty group shows at such museums and galleries as the Baltimore Museum of Art, the Corcoran Gallery of Art, the Walker Art Center, the New Orleans Museum of Art, and the Art Institute of Chicago.

Christenberry, who lives in Washington, D.C., traveled to Jackson in April for contract negotiations. He agreed to a fee of $30,000, and in July he presented his proposal for *Southern Wall*, a mixed-media piece using both color and black-and-white photographs, found objects, corrugated tin, the weathered siding of a barn, and advertising signs. "When informed in March 1978 that I had been awarded the commission . . . I began to think of ways I could incorporate all aspects of my work into the idea," said Christenberry.

For the past several years I have been using rural architecture as a major reference in my sculpture. . . . Since 1959 I have photographed the landscape and architecture of my native Alabama. These photographs also influenced my thinking. One large panel of *Southern Wall* will include a real window with photographs of Mississippi

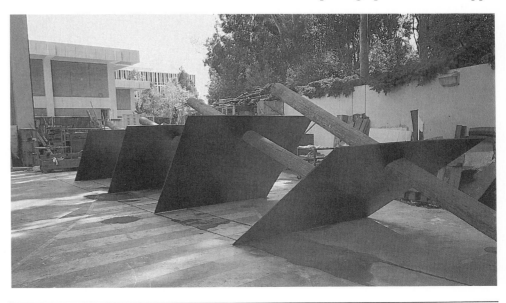

Guy Dill's Hoe Down *in front of the federal building in Huron, South Dakota. The sculpture is made of cold-rolled steel and Douglas fir poles.*

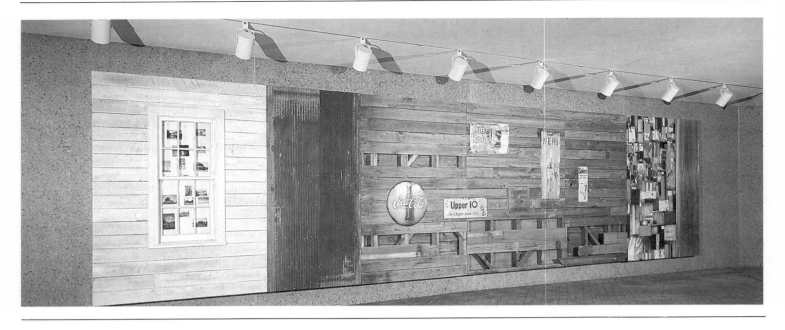

William Christenberry's Southern Wall, *a mixed-media construction for the main entrance of the federal building in Jackson, Mississippi.*

mounted inside. . . .

. . . One panel measuring four feet by eight feet is made of rusting tin, and another panel (two feet by eight feet) is made of new corrugated tin. Often in country buildings one sees the rusty corrugation mixed with the new.

The central panel (eight feet by sixteen feet) is made of barn boards . . . weathered gray, with touches of red and green color. The boards actually came off a barn that is over one hundred years old, . . . for there was no way I could successfully duplicate the natural weathering process. Attached to this section will be several old signs such as Coca-Cola, Nehi, or Royal Crown. . . . Since 1964 I have collected such signs, and they have had an influence on my photography and sculpture. . . .

In another panel (four feet by eight feet) I have used pieces of signs to form a collage. This panel is the most complex and required many hours of cutting and nailing metal; the result reminds one of a crazy quilt.

Taken as a whole, *Southern Wall* measures eight feet high by thirty-two feet wide by six inches deep. It was installed in late June 1979.

With the piece nearly completed, Christenberry was able to evaluate the impact of the commission on his art. "It afforded me the means and place to execute a work that I have only dreamed about," he said. "The opportunity has also had a dramatic effect on other work I am producing, and planning

for future work has been positively influenced."

ED McGOWIN ★

JACKSON, MISSISSIPPI

Ed McGowin, who was born in Hattiesburg, Mississippi, sprang into action when he first heard of the architect's proposal to incorporate a sculpture into the plaza design of the new federal building in Jackson. He also kept a running account of his tactics, in what he called "a stream-of-consciousness manner":

I jump the gun and call the architect in Mississippi after receiving a form letter announcing the commission from his office.

. . . I send off lots of photos and letters to the architect.

I start to make drawings and plans before receiving any notice of the commission. I feel I must receive the commission because (1) I am from the area and identify with the people and the region, and (2) I have just developed a new concept for outdoor sculpture that is perfect for the project.

Meeting with the architect, Paul Roberson (of Barlow, Plunkett, Virden, and Roberson in Jackson), an NEA-appointed panel eagerly nominated McGowin on January 11, 1978. In March, Administrator Solomon selected him, and a contract was negotiated for $50,000 in April.

McGowin's concept involved creating a "permanent outdoor sculpture that uses the volume of the sculpture for an interior tableau." He had done

his initial work on the assumption that the contract fee would be considerably larger, but he nevertheless decided to stick with his original idea and make certain alterations in the design. "I reduce the total surface area by using three-sided instead of four-sided pyramids—and start to make more models. I build three complete models to arrive at a final plan," he said. "I am insisting with this concept that the work be intelligible to the public without their having to have an art historical background—a contemporary populist sculpture, yet a work that contributes in a formal way to the sum of art."

In September McGowin presented his concept to GSA's Design Review Panel in the form of an elaborate maquette. As he explained to the panelists, in the completed work, two interlocking concrete pyramids finished with crushed black obsidian will house a tableau lit by neon, visible through a small glass window, and consisting of an old iron bed with a quilt, a cutaway section of a sharecropper's house, Mississippi red clay supporting a stump with a lantern on top, a sign saying "New Hope Church—3 Miles," and other objects. On the surface will be tiles bearing selected passages from Faulkner's *As I Lay Dying*.

The panelists were impressed and intrigued by McGowin's proposal, which even included provisions for the handicapped (a ramp instead of stairs, mirrors reflecting the interior view); it was approved, and McGowin went to work immediately.

I hand-made twenty ceramic tiles imprinted with photoengraving

plates of actual text of Faulkner's *As I Lay Dying*, with the written permission of Random House. These tiles will be randomly placed on the black surface of the sculpture, both creating a decorative motif and adding to the narrative aspect of the work. Numerous items also relating to *As I Lay Dying* are bronzed—a shovel, work boots, hat, gloves, pick, etc.—for inclusion in the interior tableau of the sculpture. . . .

[Using the sculpture's interior volume] allows items not usually able to withstand the elements to be put outside. . . . Certain details were brought to my attention by the architects [McGowin had hired two architects from Jackson, Bob Canizaro and David Trigiani, to do final working drawings and supervise day-to-day construction]—the need for ventilation due to the intense heat in Mississippi, the need to keep bugs out, and a way to enter the piece if necessary. . . .

I choose to refer to Faulkner in the piece because of his importance to Mississippi. I am being put in touch with members of his family and hope to have an actual artifact of his enclosed in the interior.

As yet untitled, the sculpture is McGowin's most ambitious undertaking to date. It should have special meaning to the citizens of Mississippi, not only because of its homage to Faulkner, but also because the artist is a native son who has achieved international recognition, and whose work is in the permanent collections of the National Collection of Fine Arts in Washington,

D.C., and the Whitney Museum of American Art, among others. The installation, which began in June 1979, was completed in mid-July.

TOM SHELTON ★
MEMPHIS, TENNESSEE

Meeting in Memphis on June 16, 1978, NEA-appointed panelists considered many artists to fulfill the architect's original proposal for two large murals to hang in the lobby of the Clifford Davis Federal Building and U.S. Courthouse. Among their nominees was Tom Shelton of Columbus, Indiana, who was selected by Administrator Solomon in October to create one of the two eighteen-foot-high by thirty-seven-foot-wide works.

In May 1979, Shelton went to Memphis to negotiate the contract with Julie Brown of the Art-in-Architecture Program staff and Paul Abernathy of GSA's Atlanta regional office. He agreed to a fee of $27,000 for what will be his largest work to date, scheduled for completion by autumn 1980. (As of this writing, the

artist selected for the other mural has not entered into contract negotiations.)

LILA KATZEN ★
NEWARK, NEW JERSEY

Lila Katzen was nominated to create an exterior sculpture for the plaza of the Newark Federal Building in August 1974, but the official offer of the commission was a long time coming. Shortly after her nomination, Congress blocked GSA from using construction funds for all but specifically identified projects. Since the Newark Federal Building was already complete, it was not included among the projects for which construction funds could be spent. And since GSA-commissioned artworks are paid for out of the construction account, funding for Katzen's sculpture was no longer available. In short, it was a vicious circle.

On the eve of fiscal year 1978 (October 1, 1977–September 30, 1978) Administrator Solomon announced that money was to be furnished from the Repair and Alteration account for

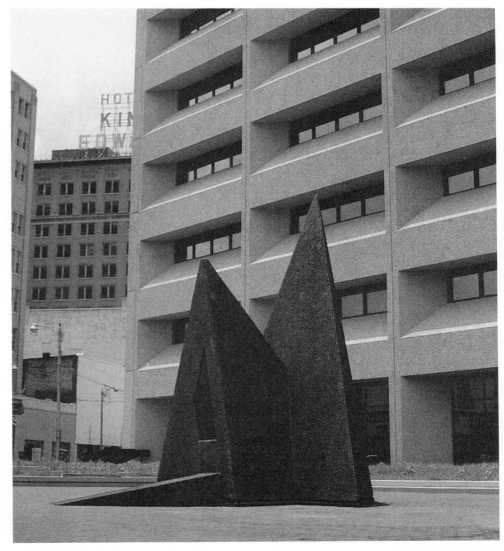

Interior and exterior views of William McGowin's sculpture in Jackson, Mississippi. The work, not yet titled, is twenty-five feet high, twenty-five feet wide, and seventeen feet deep.

art-in-architecture commissions previously planned but never implemented. Under this policy, long-dormant projects could be budgeted for fiscal year 1979; the Newark Federal Building's exterior sculpture was finally on its way to becoming a reality.

In the spring of 1979, the commission was awarded to Lila Katzen, who accepted it in June for a fee of $62,000. She is currently developing the proposal for her work, which is scheduled for completion by the autumn of 1980.

ALEXANDER LIBERMAN ★

NEW HAVEN, CONNECTICUT

Alexander Liberman was the first choice of an NEA-appointed panel that met with architect William F. Pedersen on January 23, 1978, to nominate artists for New Haven's new federal building. He was also the first choice of the architect (representing William F. Pedersen and Associates in New Haven), who had written GSA on December 11, 1975, "We strongly recommend Alexander Liberman as our choice and hope you will concur with this recommendation." Acting on the advice of Pedersen and the panelists, Administrator Jay Solomon selected Liberman for the commission in early March, and a contract was negotiated later that month for a fee of $50,000.

Liberman, an internationally acclaimed sculptor and painter, has countless one-man exhibitions to his credit, as well as group shows too numerous to mention. His works are in the permanent collections of most of the important museums in this country—the Albright-Knox Art Gallery, the Art Institute of Chicago, the Corcoran Gallery of Art, the Metropolitan Museum of Art, the Museum of Modern Art, the Smithsonian Institution National Collection of Fine Arts, the Guggenheim Museum, the Storm King Art Center, the Whitney Museum of American Art, and on and on.

Not one to rest on his considerable laurels, Liberman went directly to work on his proposal, later describing his objectives and inspiration for the New Haven piece:

In 1977, I decided to attempt a more religious sculpture. I was inspired by the elevation of Gothic cathedrals, so I tried to translate the shapes I had been working with, which were truncated cylinders, into a more elongated—I would call it Gothic—form. On my own, for my own purposes, I tried to experi-

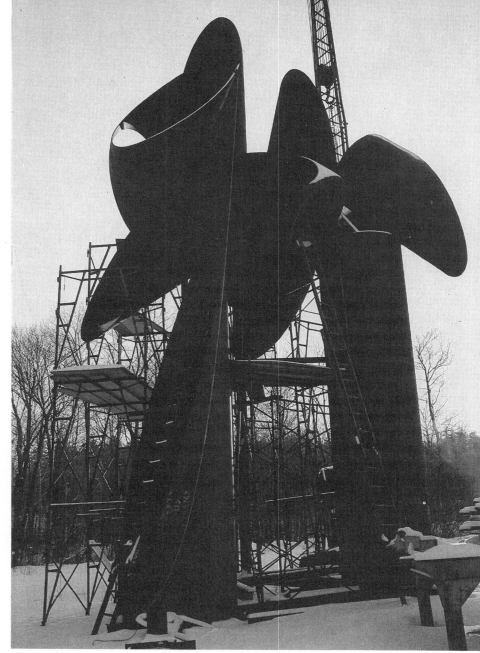

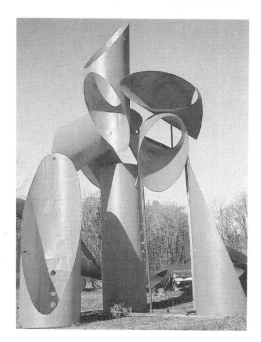

Left: Alexander Liberman built this thirty-five-foot-high mock-up of On High *out of cheap, discarded materials. Then, using a smaller model made from it, he arrived at the design and proportions of the final piece, which is forty-four feet high, twenty-three feet wide, and twenty-six feet deep.*

Above: On High, *before painting, is assembled at the site. "I . . . wanted to penetrate the sculpture, to walk into it and, by looking up, to experience a sensation that would be comparable, perhaps, to what I experienced when I entered St. Peter's in Rome," said the sculptor. "This explosion of forms above one's head is perhaps a baroque approach to form; but it is one that stimulates, in my mind, very special visual experiences. That is one of the reasons why I have called the sculpture* On High—*because I feel that the sense of physical elevation is associated with spiritual elevation."*

ence building a structure that, in my mind, resembled Bramante's Tempietto—a little temple that could then stand within a greater space. The sculpture's original concept is based on one column and two truncated columns—plus, of course, a proliferation of forms above, which are meant to create a sense of verticality and awe.

Straightforward and eloquent, Liberman presented his maquette to GSA's Design Review Panel in Washington, D.C., in early spring. He had taken great pains to arrive at the appropriate scale and proportions for the work, even going so far as to build a full-scale mock-up and consult with two architects (Pedersen and Paul Rudolf, design architect for New Haven's city hall). After thorough study, he came to the conclusion that his initially conceived thirty-five-foot-high sculpture had to be larger. As he later wrote:

... Both architects felt that ... [the increased scale] would allow one to view the piece with maximum effect as one walked through the new architectural space. We also agreed that instead of the sculpture being a single, compact object, its being based on a sort of tripod structure would allow the public —who would be walking in the square—to penetrate and participate in the sculpture. I have always felt that one of the great excitements of modern abstract monumental sculpture is just this involvement of the spectator with the given object. This sort of choreography— people walking in public places and, if possible, experiencing a given work by walking through it —gives an added excitement to a work's conception.

The GSA panel was quick to approve Liberman's design—and somewhat awed by his generosity in submitting such an ambitious proposal. Considering his reputation, the enormous scale of the work, and the contract fee, it is clear that the sculpture is essentially a gift to the American people from its creator.

Liberman oversaw the complex engineering, calculating, and cutting of the steel cylinders in his own workshop, where the final piece was built by his assistant, William J. Layman, "with the help of many others." Currently all but complete, *On High,* as it is titled, is scheduled for installation in the fall of 1979. "The magnitude of

the piece, and the agreed-upon red color in the gray environment of the federal building and the plaza, will, I hope, create a strong focus, and also allow for moments of wonder and meditation," said Liberman.

ATHENA TACHA ★
NORFOLK, VIRGINIA

"I believe that contemporary art, like art in earlier cultures, should have a use in everyday life. It should be made to be lived with, not to be stuck in a museum," began Athena Tacha's prepared statement for the dedication of her *Tide Park* in Smithtown, New York, on June 5, 1977. Four days later, she wrote GSA, noting, "Most of my work of the last five or six years has been landscape environmental sculpture with terraces and steps." Given Tacha's interests and convictions, it was not at all surprising that an NEA-appointed panel, meeting with the architect for the new federal building in Norfolk, Virginia, nominated her for an environmental sculpture commission in January 1978. In March, GSA administrator Solomon selected Tacha, and she was notified by telephone shortly thereafter.

In early May, Tacha met GSA's Julie Brown in Norfolk for contract negotiations. Uncertain whether she could create an appropriate work with the available funds ($50,000), Tacha decided that before accepting the commission, she'd have to develop a concept, have it reviewed for economic feasibility by a building contractor, and have her lawyer check the contract on her behalf. In the meantime, she was off to Italy and Greece, where her proposal crystallized as cost estimates were made by mail.

Returning to the United States at the end of July, Tacha signed the contract on October 3. Exactly one month later, she presented a proposal for a work that would measure approximately eighty feet long by sixty feet wide and would undulate from two and a half feet below ground level to five or six feet above ground level. She expressed a desire to incorporate water as a design element of this ambitious free-form concrete "landscape sculpture," as she called it. "The stimulus for the form of the proposed sculpture," she said, "was the map of Greater Norfolk, with its innumerable fjordlike bays and its unusual interpenetration of land and water." GSA's Design Review Panel approved the concept on the condition that Tacha assume finan-

cial responsibility for the water system, which the panelists considered an integral part of the work.

As Tacha proceeded to plan the implementation of her concept, complications began sprouting at every turn. The water system proved too expensive; delays boosted the cost of concrete; finally, the discovery of a water table that could rise as high as eighteen inches below ground level during high tides (thus necessitating a valve for the drain and an expensive watertight container for the pump system) led Tacha to conclude that either GSA would have to increase the commission fee or she would have to submit a new proposal. Having already invested considerable time and money in the project, she added a third option: "Pay me for my expenses to date ... and look for another sculptor."

In the end, Tacha developed a second proposal, which was presented on May 2, 1979. Accompanying her maquette was a written statement describing a "rectangular step-sculpture."

The new proposed sculpture for this site is somewhat smaller (forty by eighty feet) and much more geometric in form than my first design, but equally low-key in profile (it actually rises only three feet above the ground). I believe that its forms, although very different from those of the first proposal ... are equally appropriate for the building and the adjacent mall.

... In a very abstract way, my new design has to do with water, a predominant feature in Norfolk, without the presence of a real pond. The steps will offer sitting places for pedestrians on the mall and a playful climbing area for children. The surrounding trees and possibly several others in the midst of the sculpture should offer refreshing shadow for the hot months.

The GSA panel liked Tacha's second proposal and unanimously approved it, with the understanding that proper drainage would be provided and that at least three trees would be included in the piece.

Tacha went to work immediately and on June 9 wrote GSA of her progress. "I have all good news to report," she said. She had found it necessary to decrease the size of the work by one row of units (thereby making it thirty feet wide by eighty feet long), but this reduction "harms my design very little (there are still three units per row to establish each of the four rhythms) and in fact

Jim Buchman's Tablet, *in front of the federal building in Pittsfield, Massachusetts. The work is made of cast concrete, black granite, and unpainted steel.*

makes it fit better on the site and within the pattern of its pavement. I ascertained on the site yesterday that I will be very happy with this size and placement of the sculpture." She added that she was ready to sign contracts for construction of the work. Now the only remaining problem was the inclusion of the trees:

> . . . Your committee had stipulated three trees, but I really think there will be plenty of shade, since the steps are closely surrounded by eight trees. . . . Any trees planted in the midst of the sculpture would not only impair the contractor's work during construction, but they would seriously impair my design visually. Each tree would need to interrupt three steps . . . and now that the design is reduced in size, any such interruptions would really ruin my rhythmic effects.

Not wanting the public to be unable to see the sculpture for the trees, GSA agreed.

Tacha's work, now under construction, is scheduled for completion by September 1979. She is considering the use of color in the work. "My present inclination is to use white concrete and dye all the risers with pale green on the one side of the steps . . . and pale blue on the other side," she wrote. "If possible, I would use four shades of the same green for the four sets of steps, and the equivalent for the blue. . . . These pale colors will give a *soupçon* of cool hues on the vertical surface and blend with the shadows."

JIM BUCHMAN ★
PITTSFIELD, MASSACHUSETTS

Meeting on March 31, 1978, NEA-appointed panelists recommended Jim

Buchman to create an exterior sculpture for the federal building in Pittsfield, Massachusetts. Administrator Solomon selected Buchman in April, and the contract was negotiated for a fee of $9,500 in May. "I was delighted to be offered the sculpture commission," he said. "Although I found the building uninspired, the proposed site in front of a quiet niche was acceptable. . . . I wanted to make the sculpture, so naturally I signed the contract."

In July, Buchman presented his maquette to GSA's Design Review Panel in Washington, D.C. The panel approved the proposal, requesting only one modification (that he use Cor-ten steel rather than mild steel for the support so that it would not rust out). Describing the work, which measures thirteen feet four inches high by six feet one inch wide by four feet six inches deep, Buchman said:

> The sculpture I have made (rather than have fabricated by a third party) for Pittsfield grew out of a larger work I spent a year on in Annville, Pennsylvania. The piece, made of cast concrete, unpainted steel, and black granite, is flat and frontal. The colors of the sculpture will contrast with the brick of the building and set the sculpture off from it. At the same time the niche in front of which it stands will serve as a frame. That, anyway, is what I hope will happen once it is installed. For the idea of the piece, I was influenced by the work of Barnett Newman as well as by the monumental sculpture of the Persians and Egyptians. The title of the sculpture is *Tablet*.

The work was installed in late summer 1979.

SOL LeWITT ★
SYRACUSE, NEW YORK

It took six years of persistent effort to commission an exterior sculpture for the federal building and U.S. courthouse in Syracuse, New York, but Sol LeWitt's decision to accept the commission in early 1979 made the prolonged wait worthwhile.

Throughout the process, architect Arthur C. Friedel (of Sargent, Webster, Crenshaw and Folley in Syracuse) remained active and supportive. Friedel had initially proposed the sculpture project in April 1973. Subsequently, in letters written to GSA and members of Congress before, during, and after the building was completed, he continued to stress the importance of having "a large metal work located conspicuously on the plaza." GSA, though anxious to commission such a work, was unable to do so. Because of the complex arrangements under which construction of the building had been financed, no funds had been set aside for fine arts. After Administrator Solomon took office, however, he directed that money from GSA's Repair and Alteration account be made available for projects such as the one in Syracuse.

Early in 1978, with the funding difficulties resolved, Administrator Solomon transmitted GSA's official request for artist nominations to NEA chairman Livingston L. Biddle, Jr. Meeting in May, architect Friedel and the NEA-appointed panelists nominated Sol LeWitt, and Solomon later selected him for the commission.

At this point, however, before the contract could be finalized, local artists began protesting their exclusion from the selection process, expressing their displeasure both to the press ("GSA Rebuff Angers Area Artists; None Recommended to Create Federal Office Building Sculpture," *Syracuse Herald American,* September 3, 1978) and to Congressman William F. Walsh. Writing to Administrator Solomon on October 6, Walsh stated,

> . . . I asked for and was assured by your office that the local community would be involved in the selection process and that local artists would be notified about the process of submitting their proposals to the selection panel.
> . . . I believe you owe it to us to start the process over again, and I urge you to do so as soon as possible. I do not want Syracuse to end up with an unidentifiable piece

Sol LeWitt's maquette for One, Two, Three, *an exterior sculpture for the plaza of the federal building and U.S. courthouse in Syracuse, New York.*

representation (which he termed not a maquette but a work of art in itself).

The Syracuse work will consist of open cubes made of six-inch-square aluminum tubing painted a cool white. Measuring fourteen feet nine inches in height and width, and twenty-nine feet in length, it will be LeWitt's largest permanent outdoor piece to date. He has titled it *One, Two, Three* because "it's three cubes pushed together," as he said. "Actually, it's one by one, two by two, three by three, but I'll call it *One, Two, Three.*" The finished sculpture, which is designed to be visually interesting in the snow as well as on its own, is expected to be in place by late autumn 1979.

ROSEMARIE CASTORO ★

TOPEKA, KANSAS

"All of Rosemarie Castoro's art is about a fine bond between mind and body—gestural, but above all disciplined," wrote Lucy R. Lippard in a lengthy and captivating essay for *Artforum* (summer 1975). Continuing, Lippard offered some intriguing examples:

> In March, 1969, Castoro rode her bicycle at midnight from Spring Street to 52nd Street, leaking white enamel paint from a pierced can and leaving behind a linear trail. In April she "cracked" a block of the sidewalk on 13th Street with a meandering line of thin silver tape; in May she used the same medium

such as that in front of the federal building in Rochester [a reference to Duayne Hatchett's *Equilateral Six*].

Though there was no written record of such an assurance to Walsh, GSA officials concluded that in the overall best interests of the project and of the Art-in-Architecture Program, the panel should reconvene. It did so on December 1, 1978. LeWitt, who had attended Syracuse University, was again recommended by the panelists and was selected by Administrator Solomon in January 1979. Julie Brown, who was coordinating the project for GSA in

Washington, D.C., wrote to LeWitt on January 26, "Congratulations on your (re)selection." After describing the site conditions, she concluded, "I hope very much that the site and the project interest you. No matter what you decide, I am happy that the project is back on the right track."

In mid-February, Brown met with LeWitt, Friedel, and Regional Fine Arts Officer Bill Carew to negotiate the contract at the snow-covered site. LeWitt agreed to accept the commission for a fee of $63,000, and by May he had developed his concept. Explaining the proposal to GSA's Design Review Panel in Washington, LeWitt presented a small

Rosemarie Castoro's maquette for Six Tree Three-legged Dancers.

to splinter the rooms of the Paula Cooper Gallery, and in September, she made a gigantic cracking at the Seattle World's Fair Center. It visually evoked a seismic disturbance quite out of proportion to the material expended. These curious kinetic remains were accompanied by a similar activity—the "moving" of ceilings, or parts of them, by marking out a rectangle overhead with four wheeled "casters" (the pun was intended).

In December 1976, although she probably doesn't remember it, Castoro sent slides, a résumé, and several clippings to GSA, as dozens of artists (sometimes hundreds) do every month. GSA responded with a form letter that concluded, "We appreciate your interest and wish to assure you that your work will be reviewed for appropriate building projects in the future."

And indeed it was. In May 1978, when NEA-appointed panelists met to nominate artists for an exterior sculpture for the plaza of the federal building and U.S. courthouse in Topeka, Kansas, they recommended Castoro, who was officially selected by Administrator Solomon in June. Notified by telephone, she was rather noncommittal at first, asking to see photographs of the site before expressing any definite interest. When she received the photographs, however, she decided she was going to sign the contract—even before it was negotiated. "I accept the commission," she wrote GSA's Julie Brown on September 8, 1978.

Contract negotiations were held in Topeka on November 20, and Castoro agreed to a fee of $19,000. Without waiting for the contract to be officially executed, Castoro went right to work. Recalling her impressions of the city and her response to the contract talks, she wrote:

> Topeka is a desolate city. From the airport to the courthouse, whatever was aboveground looked like Europe during the Second World War. In the Topeka telephone book I ordered in New York, concrete shelters were abundantly advertised. The taxi driver spoke reverently of the Great Tornado. My idea for a sculpture was reconfirmed by the powerfully limbed trees that survived the cold and windy seasons.
>
> I photographed the empty plaza and measured the walkable area. The contract was negotiated in the courthouse, with cost estimates

covering materials, fabrication, trucking, installation, and photographs. I felt a sense of completion before accomplishment.

She also described the development of her concept and its presentation to GSA's Design Review Panel on March 21, 1979.

> By the time [the contract] arrived, . . . I had finished the model. The contract stipulated that now I could begin the model. I made an appointment that day to present my proposal to the GSA in Washington, D.C., five weeks away. I had already spent over $500 and still did not know if my proposal was acceptable to the committee.
>
> The four-hour Amtrak ride was over very quickly. I read a book on running, which gave me the sense I was getting there on my own energy. I taxied with my bundles to headquarters. I was in conference for twenty minutes. The panel's acceptance was unanimous. My *Six Tree Three-legged Dancers* would be six to seven feet tall and strong enough to brave the storms.

Castoro's piece is scheduled for installation in the autumn of 1979. The people of Topeka are in for a treat, especially if they have an opportunity to get acquainted with its imaginative, sincere, no-nonsense creator.

ROCKNE KREBS ★
TOPEKA, KANSAS

"Approved unanimously!" concluded Julie Brown's notes on a GSA Design Review Panel meeting held on October 12, 1978. The panel had convened to review a proposal by Rockne Krebs for the four-story atrium of the federal building and U.S. courthouse in Topeka, Kansas.

In October 1975, Krebs, a native of Kansas, had been nominated by an NEA-appointed panel for the Topeka commission. By the time GSA received the formal nomination letter (dated February 12, 1976), the Art-in-Architecture Program was beginning to come under attack. Several months later, Administrator Jack Eckerd suspended all new projects pending approval of revised procedures. To make a long story short, Krebs's commission was delayed for almost two years, until GSA's new administrator, Jay Solomon, selected him in the late summer of 1977. Negotiations were held in Topeka in October, and Krebs agreed to accept the

contract at a fee of $50,000.

The proposal the panelists applauded so enthusiastically at their October meeting was for a ceiling-mounted mixed-media construction combining glass prisms, white neon, and aluminum tubing painted a matt white. In combination with sunlight captured and refracted through the prisms, it will cast rainbow spectra on the walls, ceiling, floor, and trees in the atrium. It will be more than dazzling —it will be a revelation. As the viewer moves to the center of the atrium directly beneath the object (surely to be thought of as an allusion to a "white tornado"), the white neon, which appears as random straight lines (or sticks) from any other spot in the atrium, forms a perfect five-pointed star. Above the star, a spiral of white neon forms the outer perimeter of the work, which is fifty-three feet in diameter and forty feet high. The neon sticks will be affixed to swirling forms made of aluminum tubing, and the glass prisms, varying in length from a half-inch to five and a half inches, will be attached to a wire rack suspended between the white neon spiral and the outside perimeter of the center ceiling structure.

Krebs is currently fabricating the work in Topeka, and it is scheduled for completion by autumn 1979. It promises to be a real show-stopper.

ROGER NELSON ★
WILLIAMSPORT, PENNSYLVANIA

In late October 1978, NEA-appointed panelists David Armstrong (artist, Williamsport), David Katzive (director of education, Brooklyn Museum), and John Dowell (artist, Philadelphia) joined architect Tom Potter (from the firm of Burns and Loewe) to nominate artists for a commission at the new federal building in Williamsport, Pennsylvania. Their first choice to create a work for the eight-foot-high by twenty-eight-foot-wide lobby wall was thirty-four-year-old Roger Nelson, a gifted painter who was born and raised in Willmar, Minnesota, and presently works in New York.

The nomination was formally transmitted in January 1979, and the following month GSA's Design Review Panel recommended Nelson for the commission. Administrator Solomon officially selected him in March, and Nelson met in Williamsport with Art-in-Architecture Program staff member Julie Brown and Regional Fine Arts Officer Quinton Smith. The contract

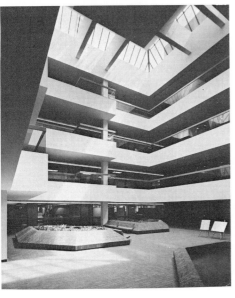

Hayes Architectural Photography

Top: Part of Rockne Krebs's proposal for a ceiling-mounted mixed-media piece.

Above: The four-story atrium where Krebs's work is to be installed.

was negotiated for a fee of $11,500, and Nelson is expected to present his concept in the fall of 1979. The finished work is scheduled for installation by midsummer 1980.

According to Nelson, "I'm planning on doing a large canvas—at this point, approximately six feet six inches high by twenty feet long, painted with oils. It will be a large landscape—expanding the space of the lobby, and drawing the viewer into the landscape as well." He concluded, "I'm very excited about this commission!"

RICHARD FLEISCHNER ★

WOODLAWN, MARYLAND

One of the most ambitious sculpture projects currently underway is being created by Richard Fleischner for the new Social Security Administration (SSA) Computer Center in Woodlawn,

Maryland (near Baltimore). Fleischner was nominated by NEA-appointed panelists and the design architect in March 1978. Selected by Administrator Solomon the following month, he made his presentation to GSA in March 1979. The work, an environmental site sculpture, will consist of seven major elements positioned along two primary axes over an area about three hundred feet square, most of it wooded. Writing to GSA in June 1979, Fleischner described the proposed sculpture in detail:

. . . Along [the north-south] axis . . . one will encounter a steel column wall about thirty feet high and forty-one feet long, through which one will be able to walk. After passing through this first wall, crossing a road, and walking about fifty feet to the tree line, one will encounter a second wall (a mirror image of the first) beyond which, another one hundred feet deeper into the woods, is a flat, horizontal steel square, thirty feet across, level with the high point of the ground under it and supported by gray granite pilings—almost a tablelike structure with the ground dropping off steeply under it. The south end of this axis terminates with two small granite elements, the furthest being a thresholdlike slab.

The second axis runs almost east and west (perpendicular to the first axis) and passes through the center of the steel square. On the west end of that axis will be a steel wall ten feet high by thirty feet long, made of steel plate, and running north and south. Behind it is a cubelike structure constructed out of large granite block. At the east end of the axis will be two rubble granite structures approximately eight feet high, on either side of the axis. (The cubelike stone structure is ten feet high by twelve feet by twelve feet.) There will be several other stone elements working as site and boundary markers.

The work is scheduled to be installed by spring 1980. With its multiple elements and woodland setting, it will bring an aura of mystery and intrigue to the SSA building. As Fleischner says, "All of [the] elements could be read as either rooms from the past or foundations for things to be built. Their scale and the distance between them has been arrived at by working closely with the idiosyncrasies of the site: topography and particular trees."

Artworks in Federal Buildings, 1962 - 1966

This appendix lists the artists and artworks commissioned by GSA between 1962 and 1966, under the forerunner of the Art-in-Architecture Program. The list is arranged alphabetically by city.

Anacortes, Washington
U.S. Post Office
Philip McCracken, sculpture

Bethesda, Maryland
Library of Medicine, National Institute of Health
Paul Jennewein, sculpture
Frans Wildenhain, mural

Billings, Montana
Federal Building and U.S. Courthouse
Lyndon Pomeroy, sculpture

Boston, Massachusetts
Federal Building
Herbert Ferber, sculpture
Dimitri Hadzi, sculpture
Robert Motherwell, mural

Brooklyn, New York
Federal Building and U.S. Courthouse
Harry Bertoia, sculpture
Mary Callery, sculpture
Fred Conway, sculpture
Joseph Kiselewski, sculpture

Camden, South Carolina
U.S. Post Office
Jean McWhorter, mural

Cheyenne, Wyoming
U.S. Courthouse and Post Office
Robert Russin, sculpture

Cincinnati, Ohio
Federal Building
Marshall Fredericks, sculpture
Charles Harper, mosaic

Cleveland, Ohio
Federal Building
William McVey, sculpture

Denver, Colorado
Federal Building and U.S. Courthouse
Edgar Britton, sculpture
William Joseph, sculpture
Robert Russin, wood panels

Fort Worth, Texas
Federal Building
Seymour Fogel, mural

Gainesville, Florida
U.S. Courthouse and Post Office
Joseph Escuder, stained-glass panels

Harrisburg, Pennsylvania
Federal Building and U.S. Courthouse
Theodore Barbarossa, sculpture

Jacksonville, Florida
Federal Building
Albert Vrana, sculpture

Juneau, Alaska
U.S. Courthouse and Post Office
Tom Hardy, sculptures

Kansas City, Missouri
Federal Building
Constantino Nivola, sculpture

Long Beach, California
Federal Building
John Reistetter, sculpture

Los Angeles, California
Federal Building
Richard Haines, mosaic

Macon, Georgia
Federal Building and U.S. Post Office
George Beattie, mural

Milledgeville, Georgia
U.S. Post Office
Frank Herring, mural

New York, New York
Federal Building and U.S. Courthouse
Seymour Fogel, mural
Theodore Roszak, fountain sculpture

Ocala, Florida
U.S. Courthouse and Post Office
Hollis Holbrook, mural

Ogden, Utah
Federal Building and U.S. Courthouse
James Fitzgerald, sculpture

Oklahoma City, Oklahoma
Federal Building and U.S. Courthouse
Bernard Frazier, sculpture

Reno, Nevada
Federal Building and U.S. Courthouse
Richard Walten, mural

Richland, Washington
Federal Building and U.S. Post Office
Harold Balazs, sculpture

St. Louis, Missouri
Federal Building
Robert Cronbach, sculpture

Salt Lake City, Utah
Federal Building
Angelo Caravaglia, fountain sculpture

Sparta, Georgia
U.S. Post Office
Lucille Blanch, mural

Spokane, Washington
Federal Building and U.S. Courthouse
Thomas Adkison, sculpture

Tampa, Florida
Federal Building
Frank Prince, mosaic

Washington, D.C.
Federal Building
Marshall Fredericks, sculpture
Theodore Roszak, fountain sculpture

Washington, D.C.
Howard University
Michael Lantz, sculpture

Washington, D.C.
Smithsonian Institution
José De Rivera, sculpture

Nominating Panels

This appendix lists the architects and NEA-appointed panelists
who comprised the nominating panels for artists commissioned
between 1972 and 1979. The list is arranged alphabetically by
city, and the panelists' titles reflect their positions at the time
of the panel meetings. The meetings were held on the dates in
parentheses after the artists' names. Where only one date appears
with several artists, it applies to all of them.

Akron, Ohio
Federal Building and U.S. Courthouse

Artists
William King, Robert Morris (2/16/78)

NEA Panelists
Edward Levine, chairman, Art Department, Wright State
 University, Dayton
John Coplans, director, Akron Art Institute
Donald E. Harvey, director, The University Galleries,
 University of Akron

Architect Panelist
Gordon W. Canute, representing Tuchman, Canute, Ryan
 and Wyatt, Architects, Akron, Ohio

Anchorage, Alaska
Federal Building and U.S. Courthouse

Artist
Robert Hudson (4/19/78)

NEA Panelists
Richard Koshalek, director, Hudson River Museum, Yonkers,
 New York
Dianne Vanderlip, curator, Denver Art Museum
Ronald Senungetuk, professor of art, University of Alaska,
 Fairbanks

Architect Panelist
David McKinley, representing Associated Architects of Alaska,
 Anchorage, Alaska/John Graham Company, San Francisco,
 California

Artists
Dan Flavin, Sam Francis, Alvin Amason (7/14/78)

NEA Panelists
Richard Koshalek, director, Hudson River Museum, Yonkers,
 New York
Henry T. Hopkins, director, San Francisco Museum of
 Modern Art
Saradell Ard Frederick, professor of art, University of Alaska,
 Anchorage

Architect Panelist
David McKinley, representing Associated Architects of Alaska,
 Anchorage, Alaska/John Graham Company, San Francisco,
 California

Ann Arbor, Michigan
Federal Building

Artist
Sherri Smith (7/25/77)

NEA Panelists
Diane Kirkpatrick, professor of art, University of Michigan,
 Ann Arbor
Bret Waller, director, University of Michigan Museum,
 Ann Arbor
Ronald Watson, chairman, Art Department, Aquinas College,
 Grand Rapids, Michigan

Architect Panelist
Glen Paulsen, representing Tarapata MacMahon Paulsen
 Associates, Inc., Bloomfield Hills, Michigan

Atlanta, Georgia
Richard B. Russell Federal Building and U.S. Courthouse

Artists
Sam Gilliam, Lloyd Hamrol (2/8/78)

NEA Panelists
Gudmund Vigtel, director, High Museum, Atlanta
Betty Gail Gunter, art patron, Atlanta
Michael Lomax, director, Atlanta Parks and Recreation

Architect Panelist
Bernard B. Rothchild, representing Finch, Alexander, Barnes,
 Rothchild and Paschal, Inc. (FABRAP), Atlanta, Georgia

Artist
Jennifer Bartlett (4/27/78)

NEA Panelists
Gudmund Vigtel, director, High Museum, Atlanta
Donald Kuspit, art critic and professor, University of North
 Carolina at Chapel Hill
Lisa Lyons, assistant curator, Walker Art Center, Minneapolis

Architect Panelist
Jon Carlsten, representing FABRAP

Baltimore, Maryland
Edward A. Garmatz Federal Building and U.S. Courthouse

Artist
George Sugarman (8/14/74)

NEA Panelists
Anne d'Harnoncourt, curator of 20th-century art, Philadelphia
 Museum of Art
Thomas Freudenheim, director, Baltimore Museum of Art
Dean Swanson, chief curator, Walker Art Center, Minneapolis

Architect Panelist
Charles Lamb, representing RTKL, Baltimore, Maryland

Blaine, Washington
Peace Arch Border Station

Artist
Dale Chihuly (10/4/77)

NEA Panelists
Anne Gerber, art patron, Washington State
Norie Sato, artist/member, Seattle Arts Commission
Lawrence Hanson, professor of art, Western Washington State
 College, Bellingham, Washington

Architect Panelist
Ken Richardson, representing Durham, Anderson, Freed, of
 Seattle, Washington

Buffalo, New York
Federal Building

Artist
George Segal (11/18/74)

NEA Panelists
Robert T. Buck, director, Albright-Knox Gallery, Buffalo
James T. Wood, associate director, Albright-Knox Gallery,
 Buffalo
David von Schlegell, sculptor, professor, Yale University

Architect Panelist
Theodore A. Biggie, representing Pfohl, Roberts, Biggie, of Buffalo, New York

Carbondale, Illinois
Federal Building

Artist
Jackie Ferrara (8/23/78)

NEA Panelists
Everet A. Johnson, director, University Museum and Art Galleries, Southern Illinois University at Carbondale
Irene Siegel, artist, associate professor of art, University of Illinois, Chicago
Jack Cowart, curator, St. Louis Art Museum

Architect Panelist
Hans Fischer, representing Fischer, Stein Associates, Carbondale, Illinois

Chicago, Illinois
Federal Center

Artist
Alexander Calder (nominated by architect's letter, 1/29/73)

NEA Panelists
None (NEA participation in artist selection process not in effect at time of nomination)

Architect
Carter H. Manny, Jr., representing Chicago Federal Center Architects (Schmidt Garden & Erikson/Ludwig Mies van der Rohe/C.F. Murphy Associates/A. Epstein & Sons, Inc., Chicago, Illinois)

Chicago, Illinois
Social Security Administration Great Lakes Program Center

Artists
Claes Oldenburg, Ilya Bolotowsky (10/24/74)

NEA Panelists
Anne Rorimer, curator, Art Institute of Chicago
Ira Licht, curator, Museum of Contemporary Art, Chicago
Tracy Atkinson, director, Milwaukee Art Center

Architect Panelist
William Baker, representing Lester B. Knight & Associates, Inc., Chicago, Illinois

Columbia, South Carolina
Strom Thurmond Federal Building and U.S. Courthouse

Artists
Barbara Neijna, Marla Mallet (1/12/78)

NEA Panelists
Blue Sky, artist, Columbia, South Carolina
Donald Kuspit, art critic and professor, University of North Carolina at Chapel Hill
Ted Potter, director, Southeastern Center for Contemporary Art, Winston-Salem, North Carolina

Architect Panelist
Herbert Beckhard, representing Marcel Breuer & Associates/Davis & Floyd Engineers, Inc./James C. Hemphill, Jr., Greenwood, South Carolina

Columbus, Ohio
Federal Building

Artist
Robert Mangold (8/31/77)

NEA Panelists
Betty Collings, director, Ohio State University Gallery, Columbus
Edward Levine, chairman, Art Department, Wright State University, Dayton
Ruth Meyer, curator, Contemporary Arts Center, Cincinnati

Architect Panelist
Kent Brandt, representing Brubaker-Brandt, Inc., and George S. Rider Co., Columbus, Ohio

Dayton, Ohio
Federal Building and U.S. Courthouse

Artists
Stephen Antonakos, Joseph Konzal (7/14/75)

NEA Panelists
Edward Levine, chairman, Art Department, Wright State University, Dayton
Ira Licht, curator, Museum of Contemporary Art, Chicago
Daniel Robbins, artist, teacher, and lecturer, Randolph, Vermont

Architect Panelist
Otto Bauer-Nilsen, representing Gartner, Burdick, Bauer-Nilsen, of Cincinnati, Ohio

Detroit, Michigan
Patrick V. McNamara Federal Building

Artist
John Chamberlain (8/30/78)

NEA Panelists
Edward Levine, dean of faculty, Minneapolis College of Art and Design
W. Hawkins Ferry, author, art patron, Detroit
Jack Boulton, acting director, International Exhibitions Office, American Federation of Art

Architect Panelist
Tom Harris, representing Smith, Hinchman & Grylls Associates, Inc., Detroit, Michigan

Eugene, Oregon
Federal Building and U.S. Courthouse

Artist
Robert Maki (4/17/74)

NEA Panelists
Harold Cohen, artist, instructor, University of California, San Diego
Virginia Wright, art patron, Seattle
John Fitzgibbons, artist, instructor, Art Department, Sacramento State

Architect Panelist
Charles W. Endicott, representing Wilmsen, Endicott, Green and Bernard, Eugene, Oregon

Fairbanks, Alaska
Federal Building and U.S. Courthouse

Artists
Tom Doyle, Gerald Conaway (3/20/78)

NEA Panelists
Ronald Senungetuk, professor of art, University of Alaska, Fairbanks
Richard Koshalek, director, Hudson River Museum, Yonkers, New York
Dianne Vanderlip, curator, Denver Art Museum

Architect Panelist
Charles R. Morgan, representing Ellerbe-Alaska, of Fairbanks, Alaska

Florence, South Carolina
John L. McMillan Federal Building and U.S. Courthouse

Artist
Blue Sky (3/16/76)

NEA Panelists
Janet Kardon, lecturer, Philadelphia College of Art
Ted Potter, director, Southeastern Center for Contemporary Art, Winston-Salem, North Carolina
Elayne Varian, trustee, Loch Haven Art Center, Orlando, Florida

Architect Panelist
Larry Judkins, representing GSA Atlanta Regional Office (building designed by GSA architects)

Ft. Lauderdale, Florida
Federal Building and U.S. Courthouse

Artists
Lynne Golob Gelfman, Sylvia Stone, Doug Moran (12/15/77)

NEA Panelists
Karen Valdez, artist, professor, Miami Beach Community College
Dr. Arnold Lehman, director, Metropolitan Museum and Art Center, Miami
Carol Weinhardt, director, Vizcaya-Dade County Museum of Art, Miami

Architect Panelist
James E. Rink, representing William Morgan Architects/H.J. Ross Associates, Inc., Miami, Florida

Grand Rapids, Michigan
Gerald R. Ford Federal Building and U.S. Courthouse

Artist
Mark di Suvero (3/21/74)

NEA Panelists
MaryAnn Keeler, patron, member of Mayor's Cultural Committee, Grand Rapids
Dr. Fred A. Meyers, director, Grand Rapids Art Museum
Ronald Watson, chairman, Art Department, Aquinas College, Grand Rapids

Architect Panelist
James M. Bentley, representing Kingscott Associates, Inc., Kalamazoo, Michigan

Haines, Alaska
Border Station

Artist
Carmen Quinto Plunkett (4/18/78)

NEA Panelists
Christine d'Arcy, Visual Arts Program director, Alaska State Council on the Arts
Richard Koshalek, director, Hudson River Museum, Yonkers, New York
Dianne Vanderlip, curator, Denver Art Museum

Architect Panelist
Wally Wellenstein, representing W.J. Wellenstein, Inc., Anchorage, Alaska

Honolulu, Hawaii
Prince Jonah Kuhio Kalanianaole Federal Building and U.S. Courthouse

Artists
George Rickey, Peter Voulkos, Sharyn Amii Mills, Ruthadell Anderson (9/30/73)

NEA Panelists
Alfred Preis, executive director, Hawaii Foundation on Culture and the Arts, Honolulu

Neongy Prishwinsh, chairman, Art Department, University of Hawaii, Honolulu

Architect Panelists
Joe Farrell and David Miller, representing Haines, Jones, Farrell, White, Gima, Architects, Honolulu, Hawaii

Houma, Louisiana
Allen J. Ellender Federal Building and U.S. Post Office

Artist
Lin Emery (8/6/74)

NEA Panelists
Robert Murdock, curator of contemporary art, Dallas Museum
William Fagaly, chief curator, New Orleans Museum of Art
Thomas Young, chairman, Department of Art, University of New Orleans

Architect Panelist
John Desmond, representing Desmond-Miremont-Burks, Baton Rouge, Louisiana

Huron, South Dakota
Federal Building

Artist
Guy Dill (1/19/78)

NEA Panelists
Graham Beal, curator, Walker Art Center, Minneapolis
Lisa Lyons, assistant curator, Walker Art Center, Minneapolis
Joe Stuart, director, Brookings Art Center, Brookings, South Dakota

Architect Panelist
Lin Meese, representing Meese, Peterson & Foss, Inc./Koch, Hazard Associates, Inc./Kirkham, Michael & Associates, Inc., Huron, South Dakota

Indianapolis, Indiana
Federal Building

Artist
Milton Glaser (10/20/73)

NEA Panelists
Richard Hunt, artist, Chicago
James Rosati, artist, New York
Carl J. Weinhardt, director, Indianapolis Museum of Art

Architect Panelist
Evans Woollen, representing Woollen Associates, Indianapolis, Indiana

Jackson, Mississippi
Federal Building

Artists
William Christenberry, Ed McGowin (1/11/78)

NEA Panelists
William Fagaly, chief curator, New Orleans Museum of Art
Sam Gilliam, artist, Washington, D.C.
M.J. Czarniecki III, director, Mississippi Museum of Art, Jackson

Architect Panelist
Paul Roberson, representing Barlow, Plunkett, Virden & Roberson, Jackson, Mississippi

Las Cruces, New Mexico
Federal Building and U.S. Courthouse

Artist
William Goodman (7/11/73)

NEA Panelists
Benjamin Gonzales, sculptor and architect, Phoenix, Arizona

Robert Ellis, associate professor of fine arts, University of
New Mexico, Albuquerque

Architect Panelist
Phillippe Register, representing Register and Brunet, Santa Fe,
New Mexico

Lincoln, Nebraska
Federal Building

Artist
Charles Ross (10/18/74)

NEA Panelists
Norman Geske, director, Sheldon Memorial Art Gallery,
University of Nebraska, Lincoln
James T. Demetrion, director, Des Moines Art Center
Ellen Oppenheim, assistant curator, Kimbell Art Museum,
Ft. Worth

Architect Panelist
Joe W. Johnson, representing Leo A. Daly Company/Dean E.
Arter Associates, Omaha, Nebraska

Louisville, Kentucky
Federal Building

Artist
Robert Howard (4/26/74)

NEA Panelists
Ellen Johnson, art historian, Oberlin College, Oberlin, Ohio
Sarah Lansdell, art critic, *Louisville Courier-Journal*
Ted Potter, director, Southeastern Center for Contemporary Art,
Winston-Salem, North Carolina

Architect Panelist
Lawrence Leis, representing Thomas J. Nolan & Sons/
Hartstern, Louis & Henry/Watkins, Burrows & Associates,
Louisville, Kentucky

Manchester, New Hampshire
Norris Cotton Federal Building

Artist
Louise Bourgeois (10/3/77)

NEA Panelists
Jan van der Marck, director, Dartmouth College Galleries and
Collections, Hanover, New Hampshire
Carl Belz, director, Rose Art Museum, Brandeis University,
Waltham, Massachusetts
Daniel Robbins, artist, professor, Williams College,
Williamstown, Massachusetts

Architect Panelist
Andrew C. Isaak, representing Isaak and Isaak, Manchester,
New Hampshire

Marfa, Texas
Border Patrol Sector Headquarters

Artist
Roberto Rios (3/2/78)

NEA Panelists
Jay Belloli, director, Ft. Worth Art Museum
Laurence Miller, director, Laguna Gloria Art Museum, Austin
James Harithas, director, Contemporary Art Museum, Houston

Architect Panelist
Joe Federico, Jr., representing Joe Federico Architect, Dallas,
Texas

Memphis, Tennessee
Clifford Davis Federal Building

Artist
Tom Shelton (6/16/78)

NEA Panelists
Priscilla Colt, director, University of Kentucky Art Museum
Edwin Rust, director, Memphis Academy of Arts
Max Kozloff, art critic, executive editor, *Artforum*

Architects
A.L. Aydelott & Associates/Thomas F. Faires & Associates,
Memphis, Tennessee (architects retired, no direct participa-
tion in nominating panel)

Nashville, Tennessee
Federal Building

Artist
Leonard Baskin (9/17/74)

NEA Panelists
Jack Boulton, director, Contemporary Arts Center, Cincinnati
Budd Bishop, director, Hunter Museum of Art, Chattanooga,
Tennessee
Earl J. Hooks, assistant director, Carl Van Vechlen Gallery of
Fine Arts, Fisk University, Nashville

Architect Panelist
Bruce Crabtree, representing Taylor and Crabtree, Nashville,
Tennessee

Newark, New Jersey
Federal Building

Artist
Lila Katzen (8/1/74)

NEA Panelists
Samuel C. Miller, director, Newark Museum
Suzanne Delehanty, director, Institute of Contemporary Art,
University of Pennsylvania, Philadelphia

Architect Panelist
Bernard Hacker, representing W.E. Lehman and W.O.
Biernacki-Poray, Newark, New Jersey

New Bedford, Massachusetts
Hastings Keith Federal Building

Artist
James Surls (8/19/77)

NEA Panelists
Tracy Atkinson, director, Wadsworth Atheneum, Hartford,
Connecticut
Linda Cathcart, curator, Albright-Knox Art Gallery, Buffalo,
New York
Diana Johnson, chief curator, Museum of Art, Rhode Island
School of Design, Providence, Rhode Island

Architect Panelist
Tom Bernier, representing C.E. Maguire, Inc., Waltham,
Massachusetts

New Haven, Connecticut
Federal Building

Artist
Alexander Liberman (1/23/78)

NEA Panelists
Andrea Miller-Keller, curator, Matrix Gallery, Wadsworth
Atheneum, Hartford, Connecticut
Rainer Crone, art history professor, Yale University
Bernard Hanson, dean, Hartford Art School of the University
of Hartford

Architect Panelist
William F. Pedersen, representing William F. Pedersen &
Associates, Inc., New Haven, Connecticut

New Orleans, Louisiana
Hale Boggs Federal Building and U.S. Courthouse

Artists
Silvia Heyden, Annette Kaplan, Clement Meadmore, Ann
 Mitchell, Lucas Samaras, Carol Shinn, Terry Weldon
 (6/30/76)

NEA Panelists
Geoffrey Platt, director, Arts Council of Greater New Orleans
Luba Glade, art critic, *New Orleans States-Item*
William Fagaly, chief curator, New Orleans Museum of Art

Architect Panelist
James Rivers, representing Mathes, Bergman & Associates, Inc./
 August Perez & Associates, Inc.

Norfolk, Virginia
Federal Building

Artist
Athena Tacha (1/18/78)

NEA Panelists
John Beardsley, curator, Hirshhorn Museum, Washington,
 D.C.
Mario Amaya, director, Chrysler Museum, Norfolk, Virginia
Richard Kevorkian, painter, chairman, Department of Painting
 and Printmaking, Virginia Commonwealth University,
 Richmond, Virginia

Architect Panelist
R. Randall Vosbeck, representing the VVKR Partnership,
 Alexandria, Virginia

Oklahoma City, Oklahoma
Alfred P. Murrah Federal Building

Artists
Michael Anderson, Sally Anderson, Anna K. Burgess, Karen
 Chapnik, Curt Clyne, Richard Davis, Albert Edgar, Fred
 Eversley, David Halpern, Betty Jo Kidson, Jane Knight,
 Gerhardt Knodel, Dena Madole, Terrie H. Mangat, Jerry
 McMillan, Joyce Pardington, Charles Pebworth, Rebecca
 Petree, Charles Pratt, William Scott, Franklin Simons, Grant
 Speed, Bud Stalnaker, James Strickland, Melanie Vandenbos,
 Carol Whitney (8/23/77)

NEA Panelists
Ronald Hickman, director, Phoenix Art Museum
Norman Geske, director, Sheldon Memorial Art Gallery,
 University of Nebraska, Lincoln
Alice Parrot, weaver, Santa Fe
Dr. Joy Reed, associate director, Oklahoma Indian Affairs
 Commission, Oklahoma City

Architect Panelist
William Shaw, representing Shaw Associates/Locke Wright
 Foster, Oklahoma City, Oklahoma

Orlando, Florida
Federal Building and U.S. Courthouse

Artist
Geoffrey Naylor (8/1/75)

NEA Panelists
Eleanor Lloyd, trustee, Philadelphia Museum of Art
Ted Potter, director, Southeastern Center for Contemporary
 Art, Winston-Salem, North Carolina
Elayne Varian, patron, former director, Finch College Museum
 of Art, New York

Architect Panelist
Warren Smith, representing Smith and Swilley, Architects/
 Wellman-Power Gas, Inc./Schweizer Associates, Inc.,
 Architects, Lakeland, Florida

Philadelphia, Pennsylvania
Social Security Administration Mid-Atlantic Program Center

Artist
Al Held (8/15/74)

NEA Panelists
Thomas W. Leavitt, director, Herbert F. Johnson Museum of
 Art, Cornell University, Ithaca, New York
Gudmund Vigtel, director, High Museum, Atlanta
Dianne Vanderlip, director, Moore College of Art, Philadelphia

Architect Panelist
Frank Knobel, representing Deeter, Ritchey, Sippel Associates,
 Pittsburgh, Pennsylvania

Philadelphia, Pennsylvania
James A. Byrne Courthouse and William J. Green, Jr., Federal
 Building

Artists
Louise Nevelson, Charles Searles, David von Schlegell (9/19/74)

NEA Panelists
Suzanne Delehanty, director, Institute of Contemporary Art,
 University of Pennsylvania, Philadelphia
Thomas W. Leavitt, director, Herbert F. Johnson Museum of
 Art, Cornell University, Ithaca, New York
Anne d'Harnoncourt, curator of 20th-century painting,
 Philadelphia Museum of Art

Architect Panelists
Theodore Bartley, J. Roy Carrol, Jr., and Alfred Clauss,
 representing Federal Court Architects and Engineers of
 Philadelphia, Philadelphia, Pennsylvania

Pittsfield, Massachusetts
Federal Building

Artist
James Buchman (3/31/78)

NEA Panelists
Rick Stewart, professor of art, Williams College, Williamstown,
 Massachusetts
Hugh M. Davies, director, University Galleries, and adjunct
 professor, Art Department, Amherst College, Amherst,
 Massachusetts
Betsy B. Jones, associate director and curator of Smith College
 Art Museum, Northampton, Massachusetts

Architect Panelist
Victor C. Bieniek, Sr., representing Calo & Bieniek Associates,
 West Springfield, Massachusetts

Portland, Oregon
Federal Building

Artists
Dimitri Hadzi, Jack Youngerman (10/10/74)

NEA Panelists
Harold Cohen, professor, Art Department, University of
 California, San Diego
Barbara Haskell, curator, San Francisco Museum of Modern Art
Francis Newton, director, Portland Art Museum

Architect Panelist
Tom Houha, representing Skidmore, Owings & Merrill,
 Portland, Oregon

Richmond, California
Social Security Administration Western Program Center

Artists
Lia Cook, Richard Hunt, Janet Kuemmerlein, Gyöngy Laky
 (10/9/74, 4/28/75)

NEA Panelists
William Agee, director, Houston Museum of Fine Arts
Brenda Richardson, curator, Baltimore Museum of Art
Jan Butterfield, art critic, professor, San Francisco Art Institute

Architect Panelist
Robert D. Peterson, representing Pereira/Bentley/Tudor,
 William L. Pereira, Associates, and Bentley Engineering
 Co., San Francisco, California

Roanoke, Virginia
Richard H. Poff Federal Building

Artist
John Rietta (10/30/74)

NEA Panelists
James Brown, director, Virginia Museum of Fine Arts,
 Richmond
Dianne Vanderlip, director, Moore College of Art, Philadelphia
Ted Potter, director, Southeastern Center for Contemporary Art,
 Winston-Salem, North Carolina

Architect Panelist
William P. Bowling, representing Hayes, Seay, Mattern and
 Mattern, Roanoke, Virginia

Rochester, New York
Federal Building and U.S. Courthouse

Artist
Duayne Hatchett (7/30/74)

NEA Panelists
John Arthur, assistant professor and gallery director, School of
 Fine and Applied Arts, Boston University
Ira Licht, art historian, University of Rochester
Jack Boulton, director, Contemporary Arts Center, Cincinnati

Architect Panelist
Norman Anderson, representing Northrup, Kalbe & Kapf,
 Rochester, New York

St. Paul, Minnesota
Federal Building and U.S. Courthouse

Artist
Charles Ginnever (8/30/73)

NEA Panelists
Martin Friedman, director, Walker Art Center, Minneapolis
Paul C. Smith, dean, Department of Fine Arts, Hamline
 University, St. Paul
Dean Myhr, executive director, Minnesota State Arts Council

Architect Panelist
Louis Lundgren, representing Haarstick Lundgren &
 Associates, Inc./Walter Butler Company, St. Paul, Minnesota

St. Thomas, U.S. Virgin Islands
Federal Building and U.S. Courthouse

Artist
Ned Smyth (8/26/77)

NEA Panelists
Alanna Heiss, director, Institute for Art and Urban Resources,
 New York
Howardena Pindell, artist, curator, Museum of Modern Art,
 New York
Carl Weinhardt, director, Vizcaya Museum, Miami

Architect Panelist
Thomas S. Marvel, representing Reed/Torres/Beauchamp/
 Marvel, San Juan, Puerto Rico

San Diego, California
Federal Building and U.S. Courthouse

Artists
Beverly Pepper, Bruce Beasley (9/4/73)

NEA Panelists
Barbara Haskell, curator, Pasadena Museum of Modern Art,
 Pasadena
Harold Cohen, professor, Art Department, University of
 California, San Diego
Jan van der Marck, associate professor of art history, University
 of Washington, Seattle

Architect Panelist
Frank Hope, representing Wheeler & Hope, San Diego,
 California

Santa Rosa, California
Federal Building & U.S. Post Office

Artist
Lenore Tawney (7/9/75)

NEA Panelists
Janet Kardon, director of exhibitions, Philadelphia College of
 Art
Henry T. Hopkins, director, San Francisco Museum of Modern
 Art
Cecile N. McCann, editor, *Artweek*, Oakland, California

Architect Panelist
Craig W. Roland, representing Duncombe, Roland, Miller/
 Frank L. Hope & Associates, Santa Rosa, California

Seattle, Washington
Federal Building

Artists
Isamu Noguchi, Philip McCracken, Harold Balazs (7/23/74)

NEA Panelists
Henry T. Hopkins, director, San Francisco Museum of Modern
 Art
Robert M. Murdock, curator of contemporary art, Dallas
 Museum of Fine Arts
LaMar Harrington, acting director, Henry Gallery, Seattle

Architect Panelist
Fred Bassetti, representing John Graham & Company/Fred
 Bassetti & Company, Seattle, Washington

Syracuse, New York
Federal Building and U.S. Courthouse

Artist
Sol LeWitt (12/1/78, 5/22/78)

NEA Panelists
Ron Kuchta, director, Everson Museum, Syracuse
David Katzive, director of education, Brooklyn Museum
Barbara Haskell, curator, Whitney Museum of American Art,
 New York
Diane Waldman, curator, Guggenheim Museum, New York

Architect Panelist
Arthur C. Friedel, Jr., representing Sargent-Webster-Crenshaw
 and Folly, Syracuse, New York

Topeka, Kansas
Federal Building and U.S. Courthouse

Artist
Rosemarie Castoro (5/26/78)

NEA Panelists
Jeanie Weiffenbach, curator and exhibitions director, Fine Arts
 Gallery, University of Colorado
Dianne Vanderlip, curator, Denver Art Museum
Dr. Martin H. Bush, director, Edwin A. Ulrich Museum of Art,
 Wichita State University

Architect Panelist
Dale P. Glenn, representing Kansas Architects and Planners,
 Associated (KAPA), Lawrence, Kansas

Artist
Rockne Krebs (10/17/75)

NEA Panelists
James Demetrion, director, Des Moines Art Center
Ira Licht, curator, Museum of Contemporary Art, Chicago
Janet Kardon, chairman, Institute of Contemporary Art,
 Gladwynne, Pennsylvania

Architect Panelists
Clarence Kivett and Dick Peters, representing KAPA

Van Nuys, California
Federal Building and U.S. Post Office

Artist
Lyman Kipp (4/19/74)

NEA Panelists
Barbara Haskell, curator of painting and sculpture, Pasadena
 Museum of Contemporary Art
Robert M. Murdock, curator of contemporary art, Dallas
 Museum of Fine Art
Peter Plagens, artist, critic, professor, California State
 University, Northridge

Architect Panelist
Jay W. Nickels, representing Honnold, Reibsamen and Rex,
 Los Angeles, California

Washington, D.C.
Hubert H. Humphrey Building

Artists
Marcel Breuer, Annette Kaplan, James Rosati, Jan Yoors
 (9/20/76)

NEA Panelists
Donald Wyckoff, president, American Crafts Council, New York
Walter Hopps, curator, National Collection of Fine Arts,
 Washington, D.C.
E.A. Carmean, curator, National Gallery of Art, Washington,
 D.C.
Richard Koshalek, director, Hudson River Museum, Yonkers,
 New York

Architect Panelist
Herbert Beckhard, representing Marcel Breuer & Associates,
 New York, New York, and Nolen-Swinburne & Associates,
 Plymouth Meeting, Pennsylvania

Washington, D.C.
Department of Labor Building

Artists
Tony Smith (3/20/74), Jack Beal (5/2/74)

NEA Panelists
James Rosati, artist, New York
Thomas Freudenheim, director, Baltimore Museum of Art
Benjamin A. Gonzalez, sculptor and architect, Phoenix, Arizona

Architect Panelists
Max Brooks and Kirby Keahey, representing Brooks, Barr,
 Graeber & White/Pitts, Mebane, Phelps & White, Austin,
 Texas

Williamsport, Pennsylvania
Federal Building

Artist
Roger Nelson (10/24/78)

NEA Panelists
David Katzive, director of education, Brooklyn Museum
John Dowell, artist, Philadelphia
David Armstrong, artist, Unityville, Pennsylvania

Architect Panelist
Tom Potter, representing Burns & Loewe, Architects &
 Engineers, Scranton, Pennsylvania

Wilmington, Delaware
U.S. Courthouse, Customhouse, and Federal Building

Artist
Frank Stella (8/24/73)

NEA Panelists
Suzanne Delehanty, director, Institute of Contemporary Art,
 University of Pennsylvania, Philadelphia
William Innes Homer, professor, art historian, University of
 Delaware, Newark, Delaware
Rowland Elzea, curator, Delaware Art Museum, Wilmington

Architect Panelist
John F. McCune, representing Pope, Kruse, & McCune,
 Architects, Wilmington, Delaware

Winston-Salem, North Carolina
Federal Building and U.S. Courthouse

Artist
Rudolph Heintze (10/29/74)

NEA Panelists
Ted Potter, director, Southeastern Center for Contemporary Art,
 Winston-Salem
Gudmund Vigtel, director, High Museum, Atlanta
Jack Morris, director, Greenville County Museum of Art,
 Greenville, South Carolina

Architect Panelist
Lloyd G. Walter, Jr., representing Colvin, Hammill & Walter,
 Associates, Inc./Register & Cummings, Winston-Salem,
 North Carolina

Woodlawn, Maryland
Social Security Administration Computer Center

Artist
Richard Fleischner (3/9/78)

NEA Panelists
Dr. Phoebe Stanton, art/architecture critic, *Baltimore Sun*, and
 professor, Johns Hopkins University
Diana J. Jacquot, City of Baltimore Department of Housing and
 Community Development
John Beardsley, author, critic

Architect Panelist
George Qualls, representing Woodlawn Associated Planners &
 Architects, Baltimore, Maryland

Artworks in Federal Buildings, 1972–1979

This appendix functions as a cross-reference to the chapters in the book, which are arranged alphabetically by city. It is divided into two categories, Completed Works and Works in Progress, and lists the artworks alphabetically by artist's name.

COMPLETED WORKS

Anderson, Michael
Sculpture
Oklahoma City, Oklahoma

Anderson, Ruthadell
Tapestry
Honolulu, Hawaii

Anderson, Sally
Fiber work
Oklahoma City, Oklahoma

Antonakos, Stephen
Sculpture
Dayton, Ohio

Balazs, Harold
Sculpture
Seattle, Washington

Baskin, Leonard
Sculpture
Nashville, Tennessee

Beal, Jack
Murals
Washington, D.C.

Beasley, Bruce
Sculpture
San Diego, California

Bolotowsky, Ilya
Murals
Chicago, Illinois

Bourgeois, Louise
Sculpture
Manchester, New Hampshire

Breuer, Marcel
Tapestry
Washington, D.C.

Burgess, Anna
Fiber works
Oklahoma City, Oklahoma

Calder, Alexander
Sculpture
Chicago, Illinois

Chapnik, Karen
Tapestry
Oklahoma City, Oklahoma

Clyne, Curt
Photographs
Oklahoma City, Oklahoma

Cook, Lia
Tapestry
Richmond, California

Davis, Richard
Sculpture
Oklahoma City, Oklahoma

di Suvero, Mark
Sculpture
Grand Rapids, Michigan

Edgar, Albert
Photographs
Oklahoma City, Oklahoma

Emery, Lin
Kinetic sculpture
Houma, Louisiana

Eversley, Fred
Sculpture
Oklahoma City, Oklahoma

Gelfman, Lynne Golob
Painting
Ft. Lauderdale, Florida

Ginnever, Charles
Sculpture
St. Paul, Minnesota

Glaser, Milton
Mural
Indianapolis, Indiana

Goodman, William
Sculpture
Las Cruces, New Mexico

Hadzi, Dimitri
Sculpture
Portland, Oregon

Halpern, David
Photographs
Oklahoma City, Oklahoma

Hatchett, Duayne
Sculpture
Rochester, New York

Heintze, Rudolph
Sculpture
Winston-Salem, North Carolina

Held, Al
Murals
Philadelphia, Pennsylvania

Heyden, Silvia
Tapestries
New Orleans, Louisiana

Howard, Robert
Sculpture
Louisville, Kentucky

Hunt, Richard
Sculpture
Richmond, California

Kaplan, Annette
Tapestries
New Orleans, Louisiana
Washington, D.C.

Kidson, Betty Jo
Fabric construction
Oklahoma City, Oklahoma

King, William
Sculpture
Akron, Ohio

Kipp, Lyman
Sculpture
Van Nuys, California

Knight, Jane
Fiber work
Oklahoma City, Oklahoma

Knodel, Gerhardt
Fiber sculpture
Oklahoma City, Oklahoma

Konzal, Joseph
Sculpture
Dayton, Ohio

Kuemmerlein, Janet
Fiber sculpture
Richmond, California

Laky, Gyöngy
Fiber sculpture
Richmond, California

McCracken, Philip
Sculpture
Seattle, Washington

McMillan, Jerry
Sculpture
Oklahoma City, Oklahoma

Madole, Dena
Fiber work
Oklahoma City, Oklahoma

Maki, Robert
Sculpture
Eugene, Oregon

Mangat, Terrie H.
Quilt
Oklahoma City, Oklahoma

Mangold, Robert
Mural
Columbus, Ohio

Meadmore, Clement
Sculpture
New Orleans, Louisiana

Mills, Sharyn Amii
Fiber works
Honolulu, Hawaii

Mitchell, Ann
Tapestry
New Orleans, Louisiana

Moran, Doug
Constructed painting
Ft. Lauderdale, Florida

Naylor, Geoffrey
Fountain sculpture
Orlando, Florida

Nevelson, Louise
Sculpture
Philadelphia, Pennsylvania

Noguchi, Isamu
Sculpture
Seattle, Washington

Oldenburg, Claes
Sculpture
Chicago, Illinois

Pardington, Joyce
Fiber works
Oklahoma City, Oklahoma

Pebworth, Charles
Sculpture
Oklahoma City, Oklahoma

Pepper, Beverly
Sculpture
San Diego, California

Petree, Rebecca
Fiber work
Oklahoma City, Oklahoma

Pratt, Charles
Sculpture
Oklahoma City, Oklahoma

Rickey, George
Kinetic sculpture
Honolulu, Hawaii

Rietta, John
Sculpture
Roanoke, Virginia

Rios, Roberto
Mural
Marfa, Texas

Rosati, James
Sculpture
Washington, D.C.

Ross, Charles
Sculpture
Lincoln, Nebraska

Samaras, Lucas
Sculpture
New Orleans, Louisiana

Scott, William
Sculpture
Oklahoma City, Oklahoma

Searles, Charles
Mural
Philadelphia, Pennsylvania

Segal, George
Sculpture
Buffalo, New York

Shinn, Carol
Tapestry
New Orleans, Louisiana

Simons, Franklin
Sculpture
Oklahoma City, Oklahoma

Sky, Blue
Mural
Florence, South Carolina

Smith, Sherri
Fiber work
Ann Arbor, Michigan

Smith, Tony
Sculpture
Washington, D.C.

Smyth, Ned
Water sculpture
St. Thomas, Virgin Islands

Speed, Grant
Sculpture
Oklahoma City, Oklahoma

Stalnaker, Bud
Fiber work
Oklahoma City, Oklahoma

Stella, Frank
Relief painting
Wilmington, Delaware

Stone, Sylvia
Sculpture
Ft. Lauderdale, Florida

Strickland, James
Sculpture
Oklahoma City, Oklahoma

Sugarman, George
Sculpture
Baltimore, Maryland

Surls, James
Sculpture
New Bedford, Massachusetts

Tawney, Lenore
Fiber sculpture
Santa Rosa, California

Vandenbos, Melanie
Finger weaving
Oklahoma City, Oklahoma

von Schlegell, David
Fountain sculpture
Philadelphia, Pennsylvania

Voulkos, Peter
Sculpture
Honolulu, Hawaii

Weldon, Terry
Painting
New Orleans, Louisiana

Whitney, Carol
Ceramic figures
Oklahoma City, Oklahoma

Yoors, Jan
Tapestry
Washington, D.C.

Youngerman, Jack
Tapestry
Portland, Oregon

WORKS IN PROGRESS

Amason, Alvin
Painting
Anchorage, Alaska

Bartlett, Jennifer
Mural
Atlanta, Georgia

Buchman, Jim
Sculpture
Pittsfield, Massachusetts

Castoro, Rosemarie
Sculpture
Topeka, Kansas

Chamberlain, John
Sculpture
Detroit, Michigan

Chihuly, Dale
Glass work
Blaine, Washington

Christenberry, William
Assemblage
Jackson, Mississippi

Conaway, Gerald
Sculpture
Fairbanks, Alaska

Dill, Guy
Sculpture
Huron, South Dakota

Doyle, Tom
Sculpture
Fairbanks, Alaska

Ferrara, Jackie
Sculpture
Carbondale, Illinois

Flavin, Dan
Neon work
Anchorage, Alaska

Fleischner, Richard
Site sculpture
Woodlawn, Maryland

Francis, Sam
Painting
Anchorage, Alaska

Gilliam, Sam
Painted construction
Atlanta, Georgia

Hamrol, Lloyd
Sculpture
Atlanta, Georgia

Hudson, Robert
Sculpture
Anchorage, Alaska

Katzen, Lila
Sculpture
Newark, New Jersey

Krebs, Rockne
Spectral environment
Topeka, Kansas

LeWitt, Sol
Sculpture
Syracuse, New York

Liberman, Alexander
Sculpture
New Haven, Connecticut

McGowin, Ed
Sculpture
Jackson, Mississippi

Mallet, Marla
Fiber sculpture
Columbia, South Carolina

Morris, Robert
Sculpture
Akron, Ohio

Neijna, Barbara
Sculpture
Columbia, South Carolina

Nelson, Roger
Painting
Williamsport, Pennsylvania

Plunkett, Carmen Quinto
Wood panels
Haines, Alaska

Shelton, Tom
Mural
Memphis, Tennessee

Tacha, Athena
Sculpture
Norfolk, Virginia